THE BEST WE CAN BE

THE LIFE AND WISDOM OF JOSEPH PHELPS

By Paul Chutkow

Val de Grace Books
Napa, California

THE BEST WE CAN BE
The Life and Wisdom of Joseph Phelps

First Edition 2018

Published by Val de Grace Books, Napa, California

Copyright © Joseph Phelps Vineyards

All rights reserved. No part of this book may be reproduced in any form
without written permission from Joseph Phelps Vineyards.

ISBN 9780997640526

Library of Congress Control Number: 2017910411

Original photography by Matthew Klein. Other photo credits on page 394.
Design by Connie Hwang
Printing by Toppan Printing

Hey Cuz! Best!
You're the for being
Thanks every a tap
There! the way!
Enjoy!
Paul

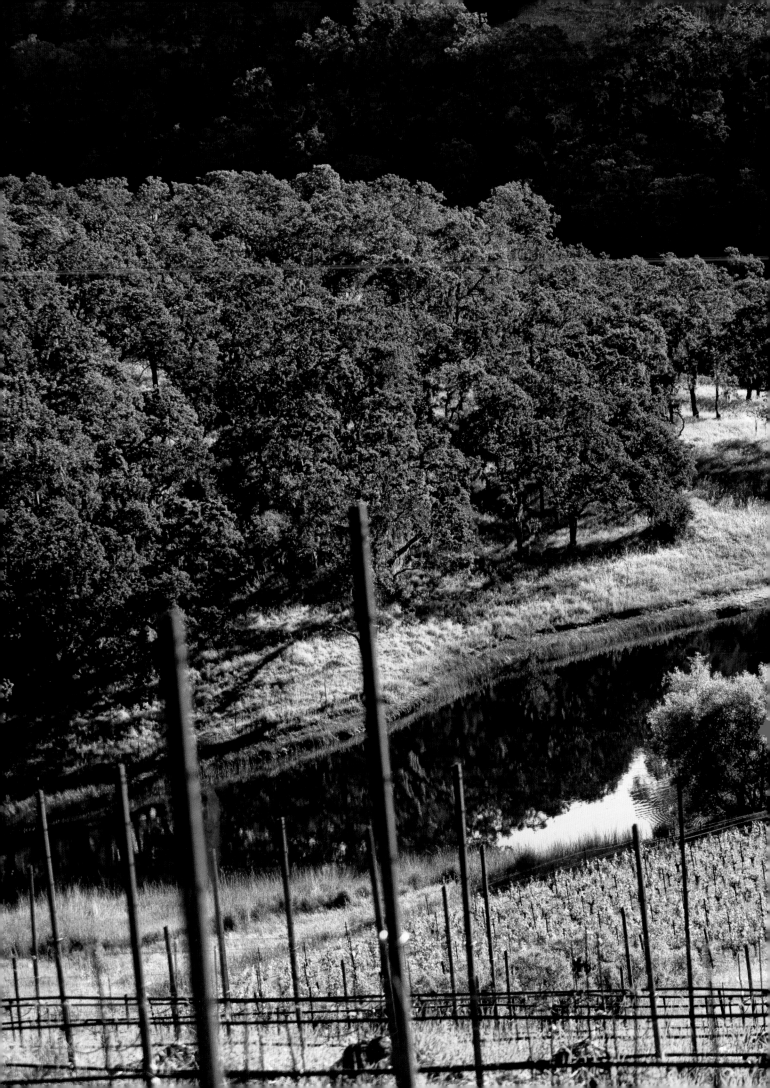

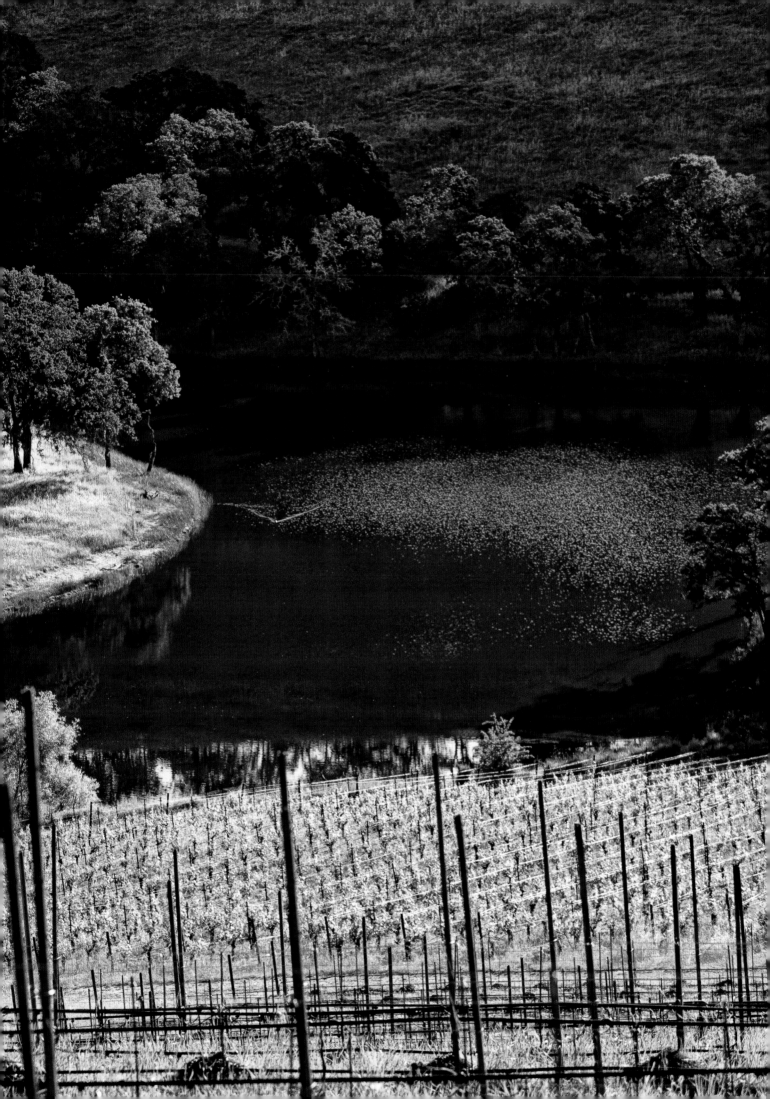

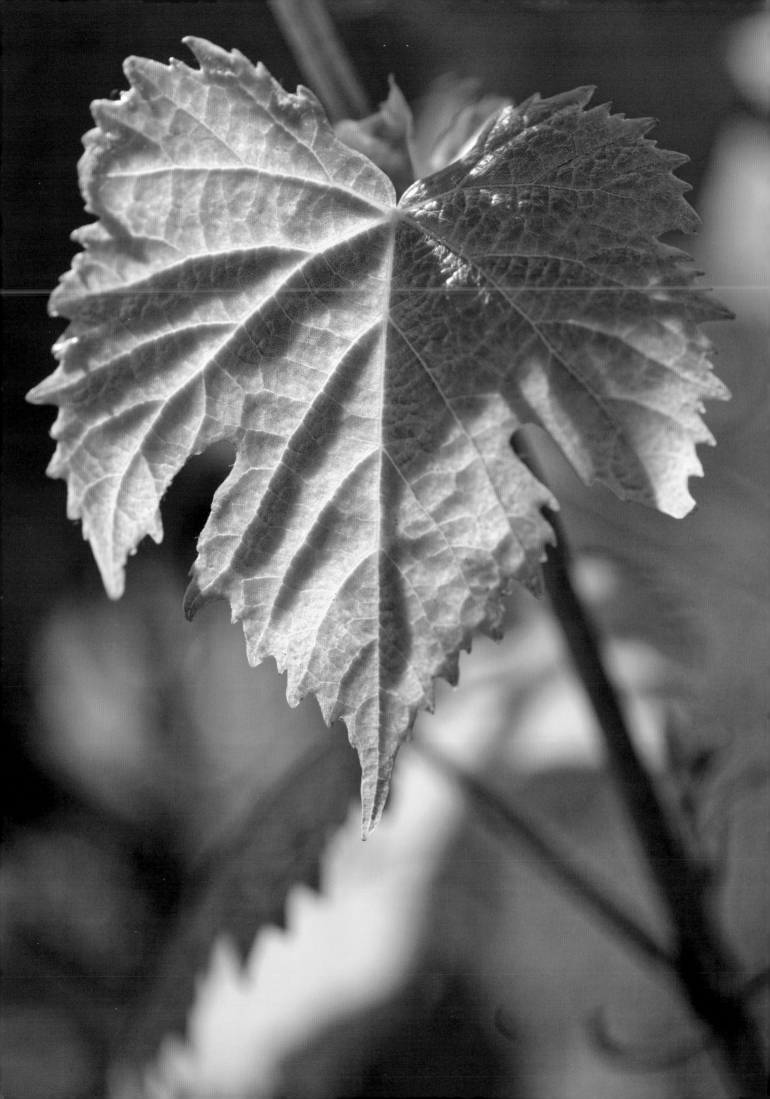

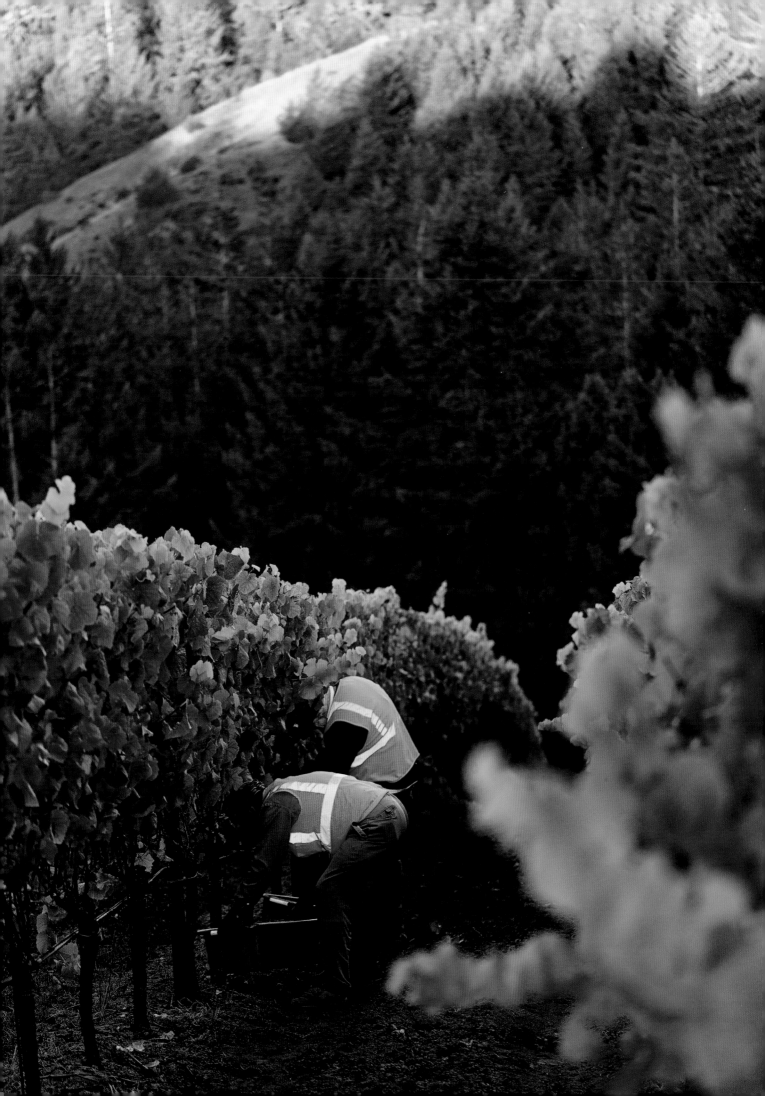

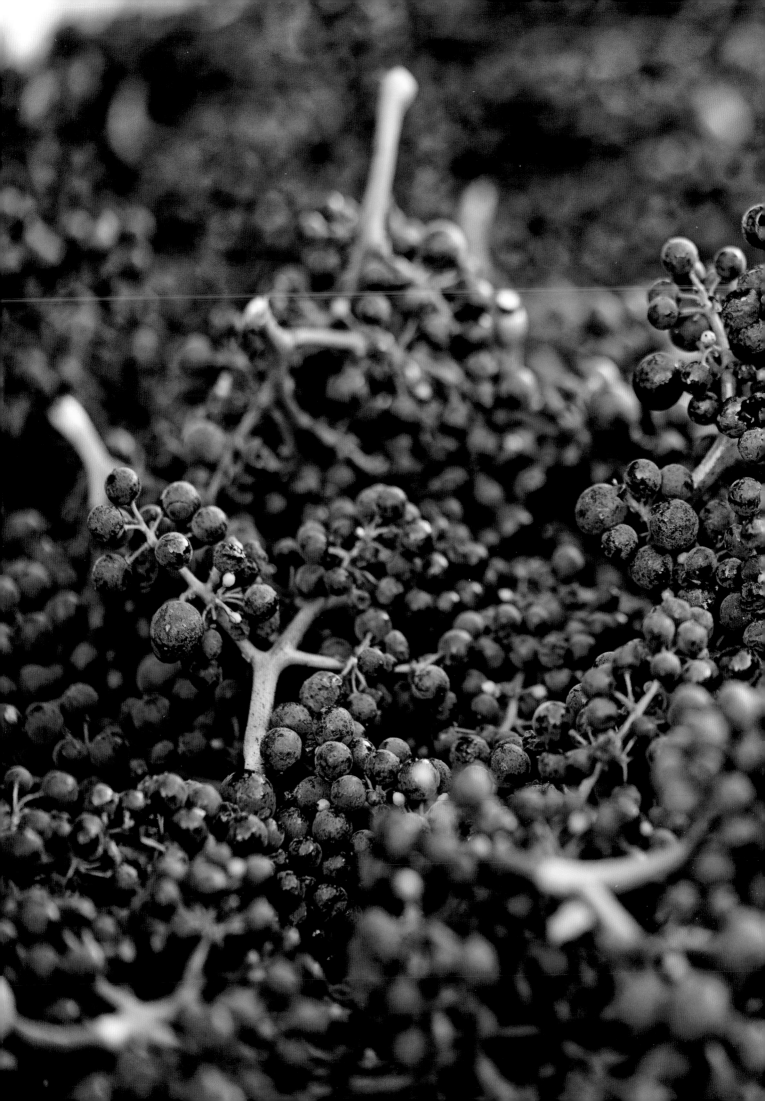

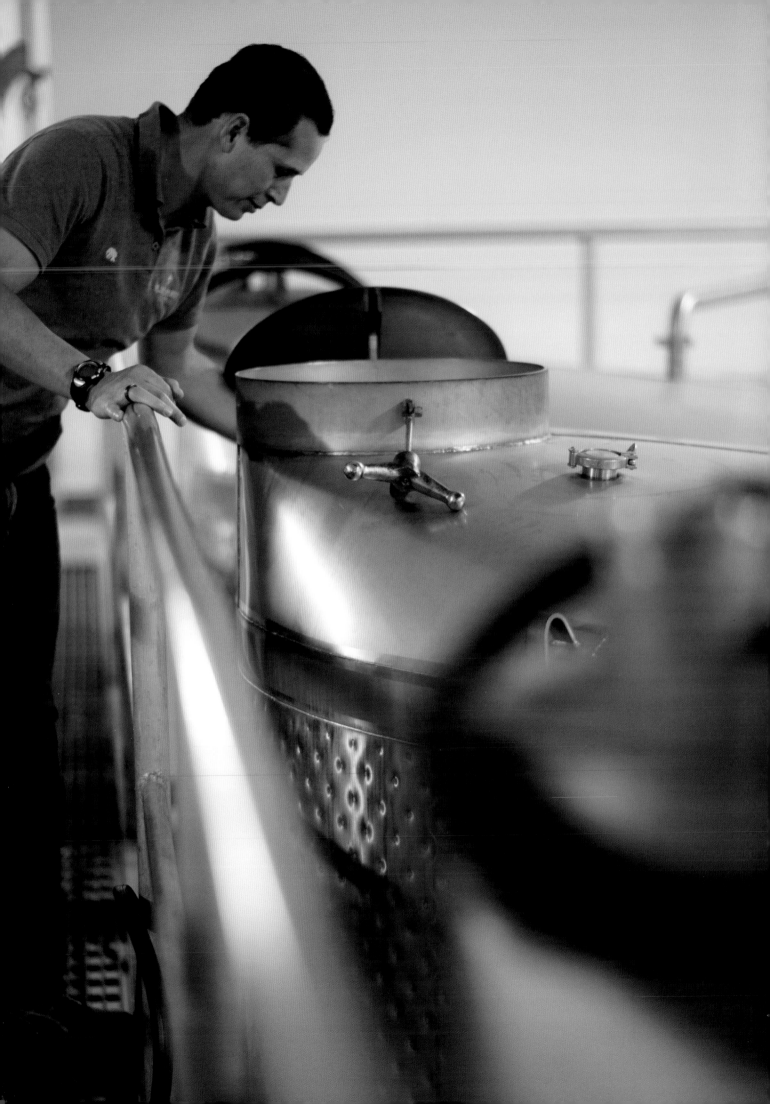

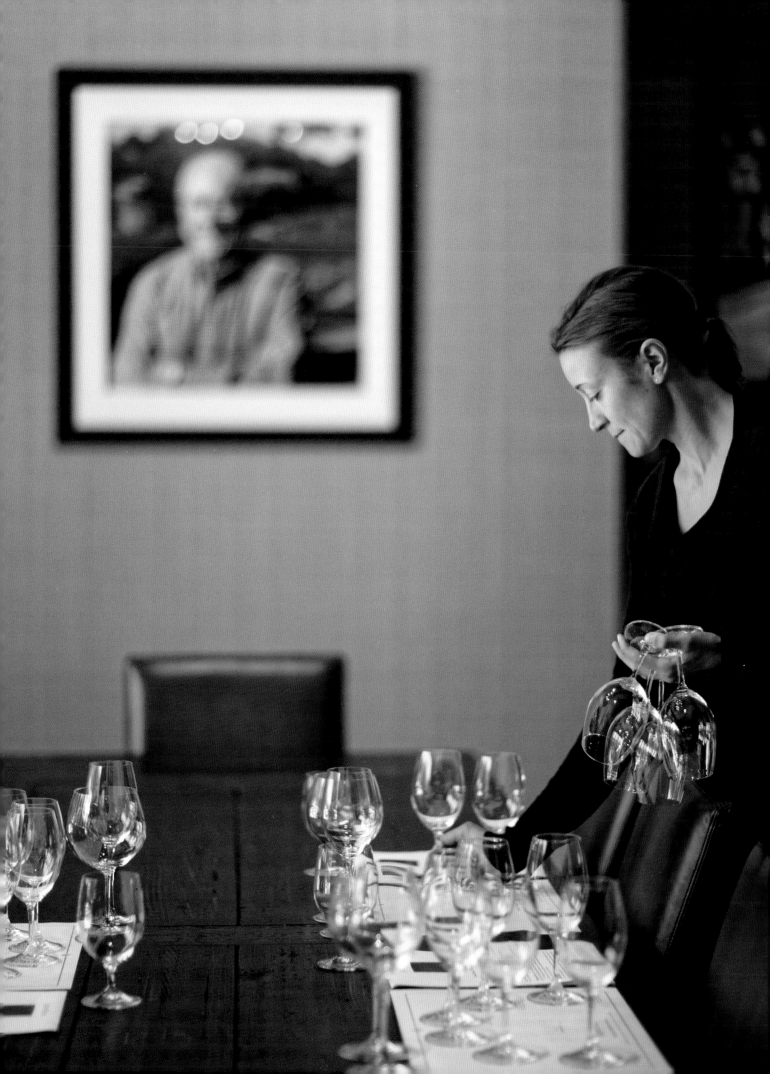

"JOE PHELPS IS THE UNSUNG HERO
OF THE NAPA VALLEY AND AMERICAN WINE."

The pioneering vintner Bob Trinchero

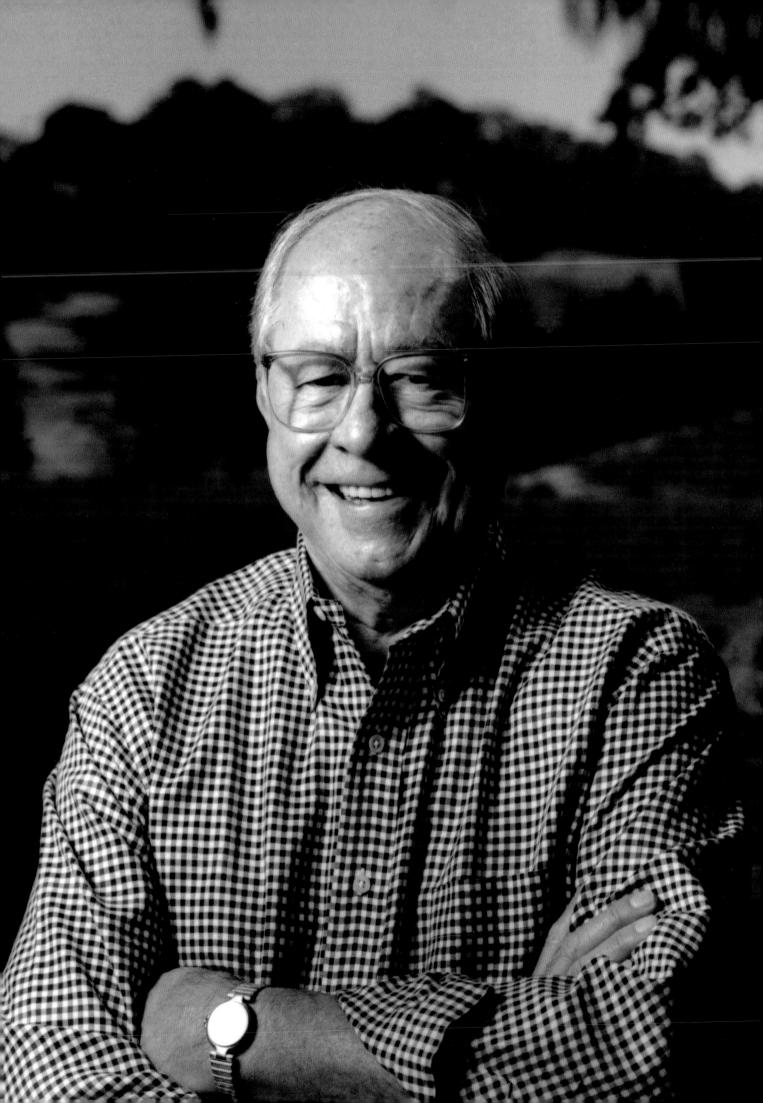

TO TEACH AND INSPIRE

The four of us knew for many years that the life story of our dad merited a significant and thoughtful book. He led a fascinating life, full of achievement, full of excitement, and full of beauty. The arc of his life paralleled and mirrored the spectacular American era in which he lived, and which he so richly embodied.

We, as his children, often urged him to commit his memories and his stories to paper, but he always resisted. His hesitancy to do so perhaps reflected a reluctance to acknowledge mortality, but more likely was rooted in his innate and deeply held sense of modesty. He was not a man who liked to talk about himself; rather, he wanted his accomplishments and creations to speak for him.

Finally, in his latter years, he began to accept his frailties and allowed each of us, in our own different ways, to get much closer to him and to help him in ways he had been reluctant to accept while in his prime. This acceptance on his part went hand in hand with his decision, finally, to take part in committing his life story to paper.

In sharing his life story, through conversations with the author Paul Chutkow, Dad told us he had one guiding ambition: "To Teach and Inspire." He was especially eager to reach young people and share with them the wisdom and lessons he had learned in the course of his life.

We believe he succeeded, and we are hopeful that you will enjoy the entirety of this book as a tribute to, and a reflection of, a remarkable life.

Leslie, Bill, Laurie and Lynn

1

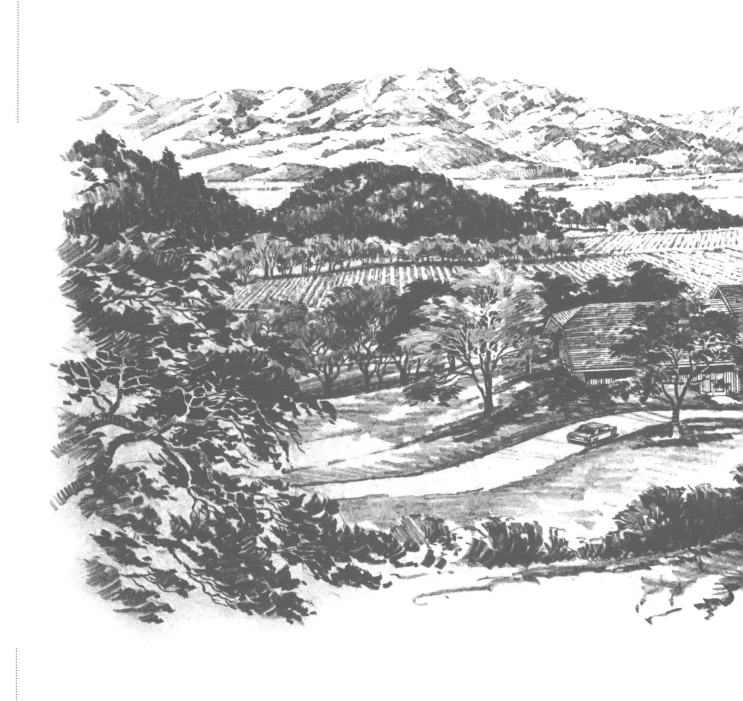

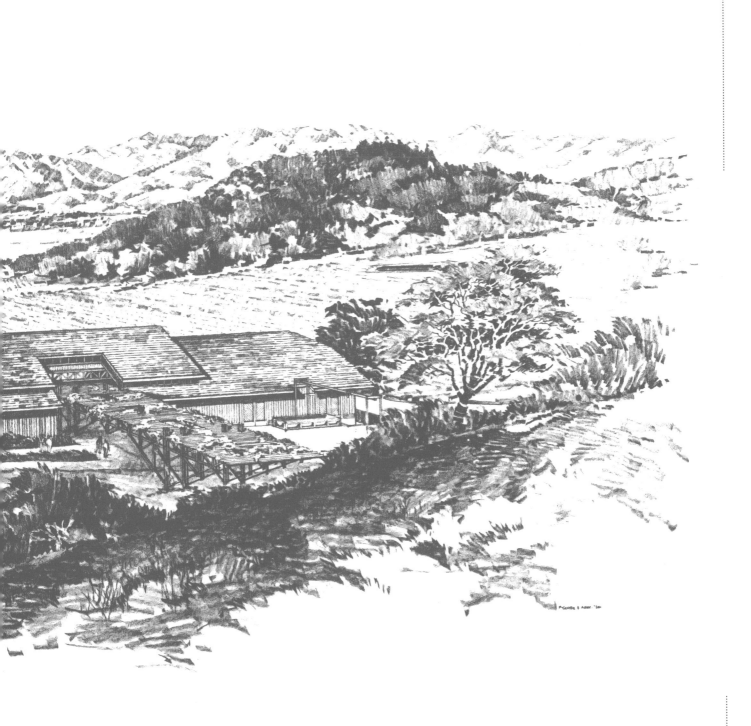

THE ORIGINAL
VISION FOR
JOSEPH PHELPS
VINEYARDS

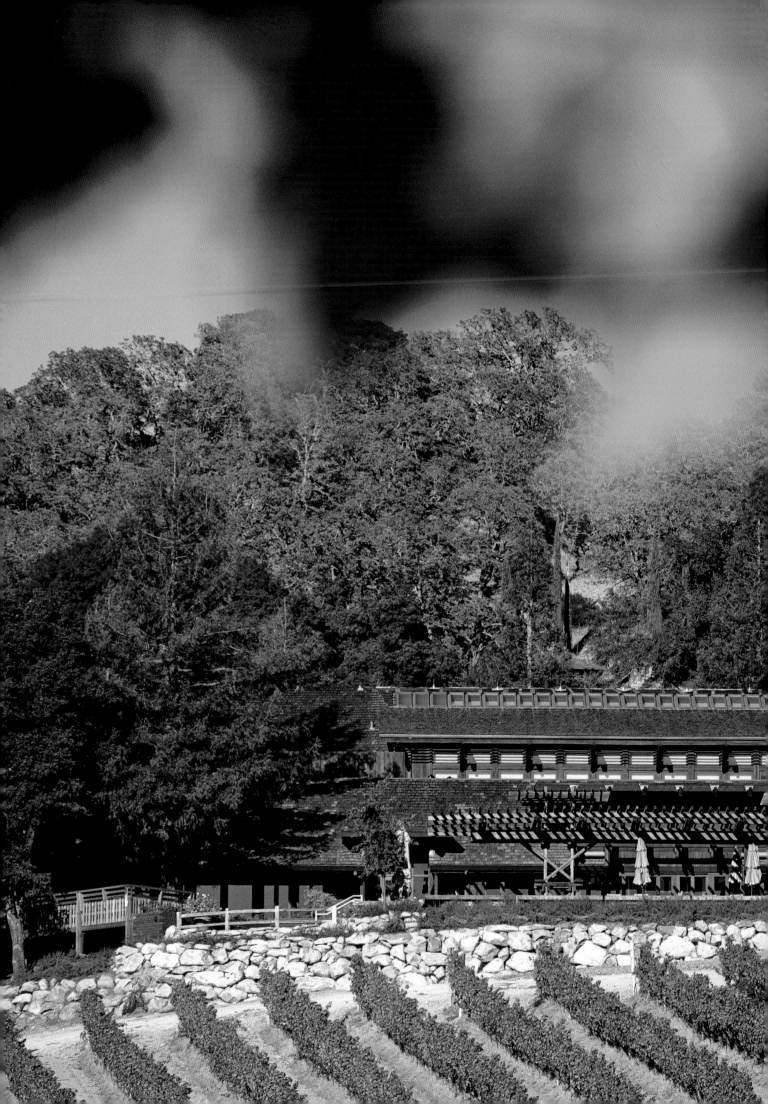

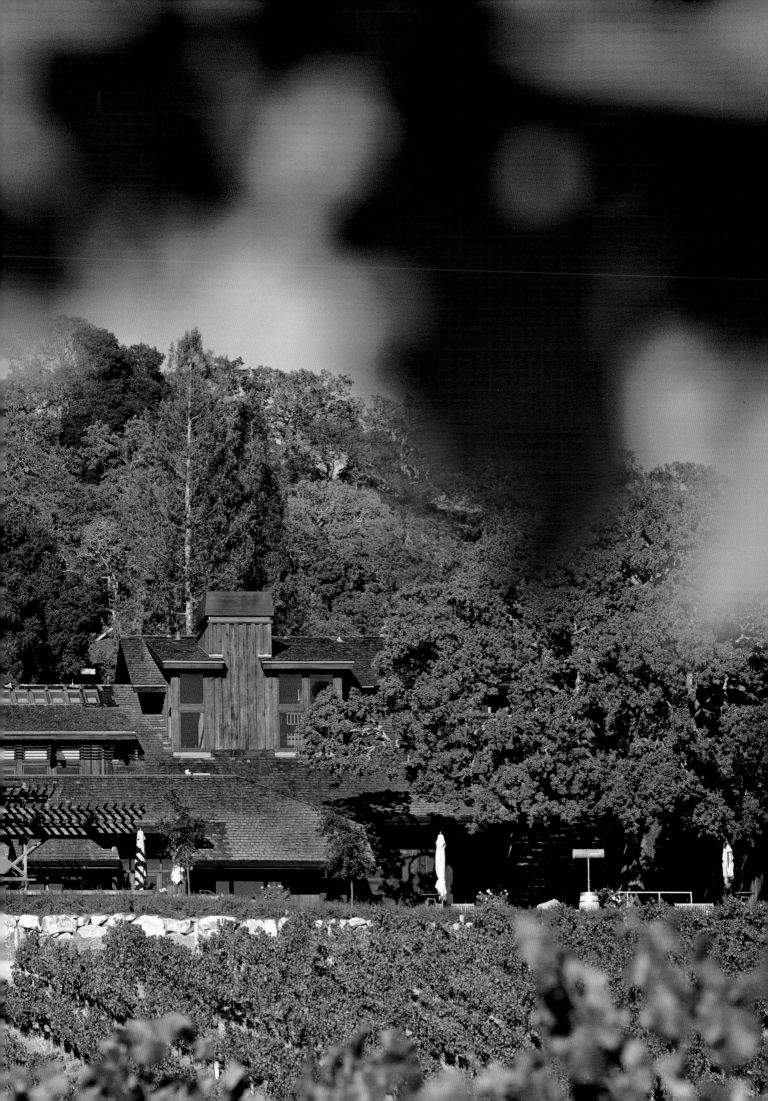

INTRODUCTION: THE FEAST

You are about to meet a remarkable man.

As you will see throughout this book, Joseph Phelps was a true American pioneer and he was a man with a very special gift: he knew how to take a project or even the wisp of a dream and build it into a glorious reality, perfectly suited to its mission and purpose.

Joe was largely self-taught. He was born and raised on a humble farm in Missouri, and he was never a brilliant student. But he was smart, pragmatic, and creative, and he was blessed with a hard-driving energy and a ferocious, unstoppable will to succeed.

In the 1950s, fresh from serving in the Korean War with the U.S. Navy, Joe took over his father's small general contracting business in Greeley, Colorado, and very quickly transformed it into Hensel Phelps Construction, a national powerhouse that has built airports, bridges, city halls, libraries, museums, hospitals, research labs, and many other critical facilities across America, including a high-tech launch pad for NASA and a new protective casing for The Pentagon in the wake of the 9/11 attacks. In the process of doing all that, Joe and his key people built Hensel Phelps Construction into a model of innovation and enlightened management and leadership, with a system of employee ownership and generous profit sharing that produced dedicated, highly motivated teams and turned more than 240 hard-working staffers into very contented millionaires.

And that was just the beginning.

In the early 1970s, during leisurely trips with his wife Barbara through Italy and France, Joe fell in love with fine wine and with

the richness of culture and civilization that fine wine represents. Inspired, and now with a whole new dream to build, Joe began to explore the Napa Valley, back when it was still a sleepy, inward-looking farm and ranching community, with few wineries, few good places to eat, and next to nothing by way of art, music, or culture.

In a quiet corner of the valley, just off the Silverado Trail, Joe found a sprawling cattle ranch, where no grapevine had ever grown, and in about two blinks of an eye he transformed it into Joseph Phelps Vineyards, growing magnificent grapes, innovating, and crafting wines that are now considered among the very best in the world—including Insignia, a legendary wine whose creation is considered a milestone in the history of American wine.

Again, though, that was just the beginning.

Soon Joe spotted another golden opportunity: the Napa Valley's landmark Oakville Grocery. The store was ideally located, right in the heart of the valley, but at the time it was struggling, both financially and creatively. So Joe became a partner in the venture and he and his team quickly turned it into a model gourmet shopping experience, featuring locally crafted wines, fresh organic produce, and a wide array of hand-crafted culinary delights. Joe then opened four more Oakville Groceries around the Bay Area, and they quickly became popular attractions and pillars of America's growing sophistication regarding food, nutrition, and sustainable farming.

There was more. To help build the Napa community, Joe led the creation of two breast cancer clinics for women and he led the campaign to provide much-needed housing for the migrant farm workers who come in every year to help with the harvest. In a like spirit, Joe led the creation of a centralized wine co-op, enabling local wineries to store and ship their wines at lower cost and with lower stress on the valley's roads and idyllic landscapes.

With these and similar initiatives, Joe worked hand in hand with like-minded, like-spirited winemakers, chefs, entrepreneurs, and political leaders and together they built the Napa Valley into what it is today: one of the great wine-growing regions of the world, a vibrant center of art, culture, and education, a proving ground and showcase for the latest advances in sustainable agriculture and environmental protection, and, of course, a dream destination for wine and food lovers from all over the globe.

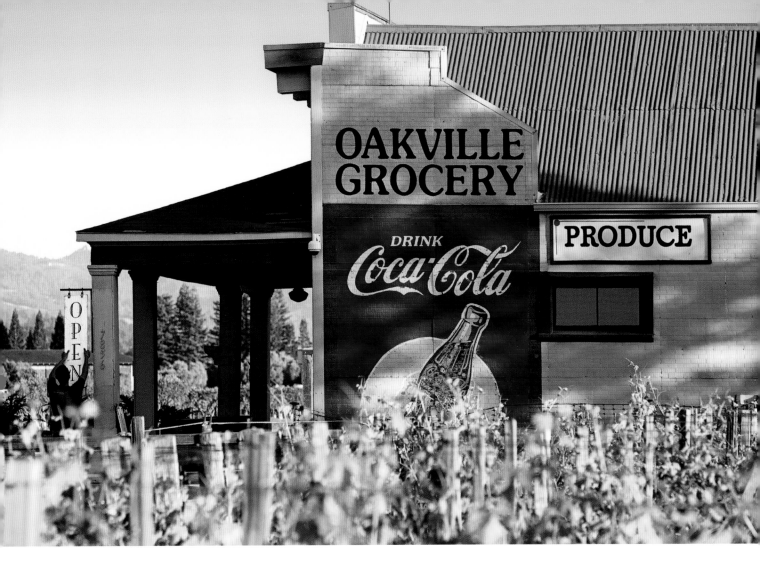

Now, did Joe do all this with his chest puffed out and the PR trumpets blaring? No. Just the opposite. For all his achievements, and for all of the accolades that he and his teams earned over the years, Joe never lost his quiet, self-effacing Midwestern manner; he was a man who shunned the limelight and steadfastly waved away anything that smacked of horn tooting or self-aggrandizement. Do the work, get it exactly right, make it beautiful, and build it to last; in the world of wine, as in the world of construction, that was Joe's unwavering mission and purpose; in the end, he believed the results would speak for themselves, and eloquently so.

Still, at the age of 87, with his health slipping, and his winery putting the finishing touches on an exquisite new venue for enjoying and appreciating his illustrious portfolio of fine wines, Joe decided the time had finally come to begin one last project: a book that would draw together the many chapters of his pioneering life and the most important lessons he had learned along the way. For years, I had wanted to do just such a book with Joe, but he always had other priorities. Then, in January of 2015, his son Bill called me, with a note of urgency in his voice: Joe's ready now. How soon can we start?

Joe, I quickly learned, was a methodical man and he held to a simple, time-tested formula for success: whatever the project you undertake, first define your audience, then set clearly defined goals, then develop detailed plans to achieve those goals, and then execute those plans with uncompromising rigor and precision. And so it was with this book. Even before we set to work, Joe made clear to me, via his daughter Lynn, exactly what he wanted this book to achieve: he wanted it to "Teach and Inspire." And he made clear to me the primary audience he wanted to reach out and touch: Young people, the builders and creators of tomorrow. They are our future, he said; they are the ones we need to encourage and help on their way.

Joe gave me another clear instruction: while he was ready to share his life story, he did not want this book to be some sort of constant exercise in self-promotion. Just the opposite. He hoped that through his experiences, readers would be able to see something much larger than himself, namely the ideals and values and practices that young people and others could use to build their own lives and dreams—and help build America in the process.

With these understandings locked into place, one bright, crisp morning in February of 2015 I drove up the Silverado Trail, turned off onto Taplin Road, and then I turned into Joseph Phelps Vineyards. What I came upon was a sanctuary of extraordinary beauty and grace, with rows of vines artfully planted and reaching up the hillside to the redwood and glass of the winery itself. If you are looking for a Taste of Paradise, this is about as close as you might ever come.

By this time, I had lived in the Napa Valley for almost a dozen years, enjoying the special spirit of the place and writing about its leading winemakers, chefs, and creative pioneers, but I had yet to meet Joe in person. Still, as I drove up the hill past the winery and made my way up to his gracious home nestled in the trees, I knew I was in for a very special treat. What I didn't expect was the sumptuous feast that meeting Joe turned out to be.

In a small driveway just below the house, I parked my car alongside a piece of pure Americana, a 1955 Ford Thunderbird, in pristine condition, freshly washed and in robin's egg blue, and I couldn't help thinking, "Wow! A classic '55 T-bird, full of style and panache; this is a man I have to meet!"

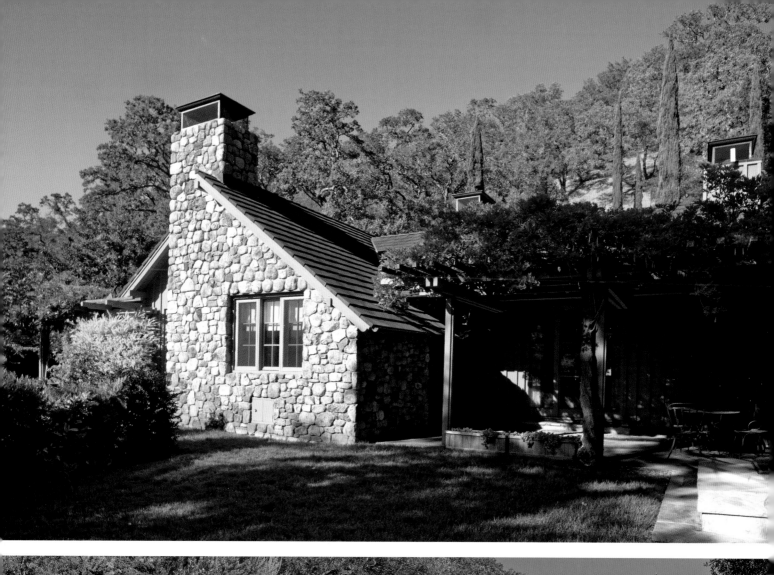

Joe's home spoke of a man of taste and refinement, and of rare feeling too. Above the front door there was a huge spray of bougainvillea in bloom, and in the center of the house there was a lovely interior courtyard with a tree rising in the middle. On one wall of the courtyard there was an elegant metal sculpture of a cluster of grapes, almost bursting with flavor and spirit. In Joe's dining room there was a bright, cheerful mural showing a festive moment at an outdoor café in the French countryside. In the back of the house there was a spacious sunroom, with glorious views out across Joe's vineyards and his special corner of the Napa Valley. In the sunroom there stood a grand piano and, as I soon learned, Joe's son Bill often sat there with his father in the late afternoon and played one of Joe's favorite pieces of music, Claude Debussy's "Clair de Lune". Those were moments and memories that both men cherished.

Finally, I met the man. I found Joe sitting at his kitchen table, enjoying eggs benedict and a big mug of hot coffee. And he was surrounded by love and attention. At the table with him was his oldest daughter Leslie; when Joe's health had started to slip, Leslie stepped in to manage his life, from his doctor's visits and his travel arrangements, to his rotating teams of caregivers. Ruben Contreras, Joe's longtime friend and personal helper, was in and out of the kitchen; in the mornings he always brought Joe warm croissants, pastries, or fresh breads from Bouchon Bakery, while in the late afternoons he often wheeled in his special margarita cart, ready to enliven the spirits of Joe and his friends and family and carry them into the night with loads of humor and good cheer. This, I soon learned, was pure Joe: work hard, take care of business, but also live life to the hilt and make every day a moveable feast.

"Come," Joe said, motioning me to a seat beside him. "Would you like some coffee? Eggs? A croissant?"

A few minutes later, I took out a notebook, turned on a tape recorder, and we set to work. Joe's job was to remember and talk, mine was to listen, understand, and then to write. And the formula felt exactly right. At this stage, Joe was physically frail; he relied on an oxygen tank to help his breathing, and his team of caregivers had to wheel him to and from the kitchen table. Still, on that first morning, as on most of the later days we worked together, Joe's mind was sharp, his memory vivid, and even at the age of 87, and even with a breathing tube fixed in his nostrils, his thirst for life remained undiminished. Over the weeks and

months that followed, Joe and I met regularly and we always worked right there at his kitchen table. Ours was an easy bond, and the more we worked together, the more I admired his humor and his natural humility, and when he got tired but kept right on going, the more I admired his unshakeable spirit too.

And what a story he had to tell. As I quickly came to see, Joe's life was a star-spangled American odyssey, and it had moved in almost perfect tandem with the larger evolution of America itself, from the wrenching upheavals of Prohibition, The Great Depression, and the Dust Bowl era to the economic, cultural, and agricultural wealth that we enjoy today. And there was more. As I learned of Joe's many innovations in the Napa Valley, and of his interactions with people like Joe Heitz, Robert Mondavi, Bob Trinchero, and Alice Waters, I came to see the profound impact that Joe had on the modern history of American wine and food. And as we worked, I also came to see that Joe's was far more than a story of wine, food, and business; it was a story of values, ingenuity, and the strength of character and spirit that had built this country and made it great.

Growing up on the family farm in Missouri, at the height of The Depression, and seeing his parents struggle to make a living and feed their four children, Joe was intent on helping out and proving his worth. By the age of seven, he was raising pigs and selling them at the local market. At seven! Active, restless, always on the go, young Joe was frustrated by his battered old bike, so he located a motor from a rusted out Maytag washer and somehow rigged it up to create a speedy, time-saving motorbike. Problem solved. As a teenager, after the family had moved to Colorado, Joe loved to fish in the local rivers, and his next step was a natural for a budding entrepreneur: he started a fly-tying business, enlisted a few pals to help with the labor, and then he sold their creations to local anglers, at a healthy profit too. The kid was on his way.

Chatting there at his kitchen table, these and other stories poured easily out of Joe, and I could see he was getting enormous pleasure from digging out the memories and sharing them with me. Together, too, we began to see how those stories fit into the larger arc of his life and everything he had been able to accomplish.

Soon, too, I came to see the qualities that made the man so special. His ferocious drive. His clarity of purpose. His command of process. His relentless perfectionism. And his instinct for hiring just the right people. Joe never hired conventionally from

diplomas or resumes; he hired from character and potential, not from what a man or woman was today but from what he believed they could grow into tomorrow. As our work progressed, I also saw that Joe's sharp analytical mind was harnessed to an insatiable curiosity and a constant craving for new skills to master. In his forties, he took up the piano. In his fifties, he took up French. And when he turned 60, Joe took up flying and quickly earned his pilot's license and bought a small plane. Then, as his skills expanded, and he passed his instrument training, Joe bought a more sophisticated plane, and when two of his top managers at Joseph Phelps Vineyards took up flying, Joe happily lent them his own planes to use. That was Joe. He loved to learn. He loved to grow. He loved to share.

Our talks were not always easy. As we dug deeper into his life and work, I asked Joe some very difficult questions, about his successes, yes, but also about his mistakes and disappointments, marital and otherwise, and we also delved into an episode that Joe viewed as a brutal and very costly betrayal. No matter what I asked, Joe never flinched or shied away from the harshest truth. Confronted by a difficult question, Joe would just sit there silently, thoughtfully, and then he would deliver an answer that was so apt and concise it almost made me shiver.

There at his kitchen table Joe shared with me a wealth of memories and insights, and also a wealth of wisdom about wine, business, and life. I would often leave his kitchen wondering how I would ever assimilate all this rich material and turn it into a clear, coherent narrative. Then I traveled to Greeley, Colorado, to learn about Joe's formative years and how he had built Hensel Phelps Construction into an industry giant. I also learned about how, as he left the world of construction to pursue a whole new life in wine, Joe had used a deft strategy to hand the entire company to his staff on a silver platter. Enjoy, he told them. You've earned it. In nearby Ft. Collins, I learned about the many far-sighted educational programs that Joe had started and endowed at Colorado State University, his alma mater. For more insight and stories, I interviewed Joe's four children—Leslie, Bill, Laurie, and Lynn— plus dozens of Joe's friends and colleagues, both in Greeley and in the Napa Valley, and while all this greatly enriched the material I had at hand, it also made the task I faced all the more daunting.

Soon, though, I was able to see and distill out the themes and values that guided and were most important to Joe: Family. Loyalty. Trust. Truth. Leadership. Community. Generosity. And first, last,

and always, Hard Work. As I came to see, these themes and values, when stitched together, formed Joe's personal formula for success in business and in life, and it all boiled down to this: "Work hard, play hard, and share. We're all in this together."

In helping me understand all this, Joe was extraordinarily generous with his time and his heart. And so were his children and others close to him. But what I have described up to here was only our foundation, the granite on which our book would rest. And as we kept moving forward, examining his amazing life journey—and America's journey right along with it—Joe never let me forget his guiding purpose: he wanted to create something truly special, a book that would be a lasting gift for his grandchildren and for ours, and for all the young people who are determined to follow their dreams and strive to make this world of ours a far better place. With Joe's wisdom and spirit guiding our way, we have crafted this book to serve that noble goal.

CHARACTER & SPIRIT

CHARACTER & SPIRIT

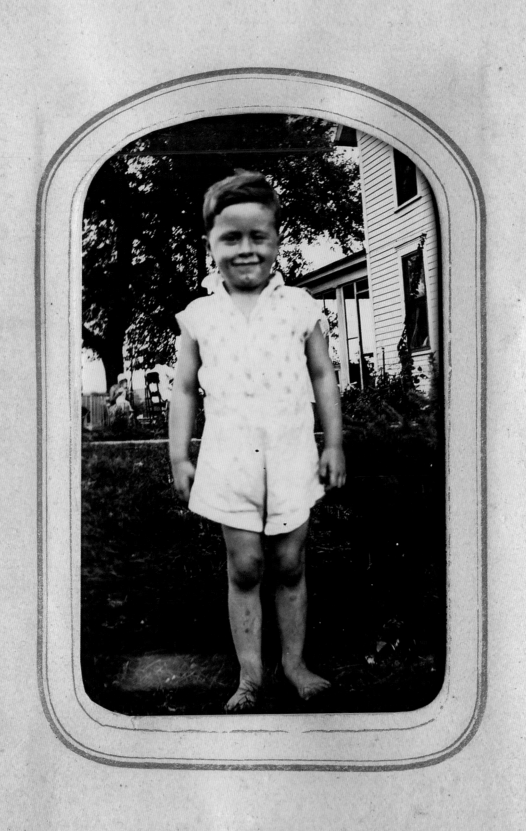

THE GOLD BUTTON

Some amazing things happened at Joe's kitchen table.

We'd be sitting there, sipping coffee, tracing the flow of his life and work, when suddenly, on the wings of an ignited memory or a cherished family photo, Joe would take me back in time, back to an important and revealing moment in his life.

One morning, for instance, looking at a photo of Joe at about the age of 5, we were suddenly back on the family farm in Maysville, Missouri. It was a hot, sweltering Midwestern day, with the thermometer registering way up in the 90s, and there was little Joe, barefoot and happy, playing amongst the horses and pigs and chickens, his knees filthy with dirt, his shins covered with bruises from all his running and tumbling, and then, to cool off, Joe went into the family's ice house, out back by the barn, and there among the sacks of pinto beans and kaffir corn that his father had grown, and there among the canned peaches and tomatoes and peppers his mother and sisters had put up during the winter, Joe climbed up those huge blocks of ice, their tops smothered in hay to help keep them from melting, and once at the top, with his fist thrust in the air, little Joe proudly proclaimed himself king of the castle.

On another day Joe's oldest daughter Leslie brought a true treasure to the table: an old postcard of a U.S. Navy battleship, the USS Helena, and two breaths later we were right there onboard, in the thick of the fighting off the coast of Korea, at the height of the Korean War. Joe was down in the communications well, with his big headphones on, transmitting vital coded messages between fleet commanders and the ship's captain, then relaying instructions to our gunners and pilots zeroing in on their targets. The

air and sea battles were intense, Joe was at his post day and night, but one freezing cold morning, with Christmas fast approaching, the USS Helena quietly slipped away from the fighting and made its way to a secluded port. Joe was totally in the dark, he had no idea what was coming next. A short time later, he was out on deck, watching as the ship refueled and as fresh supplies were hoisted onto the deck, and then there was a sudden commotion, and as Joe looked on in disbelief, who climbed aboard? General Dwight D. Eisenhower.

"Ike," as he was known to everyone throughout the military and across the nation, was the man of the hour. He was the hero of World War II, one of the chief architects of the D-Day invasion that had turned the tide against Adolf Hitler and his Nazi forces, and just a few weeks before, Ike had been elected President of our United States. He would take office in just a few short weeks. And here was the revered man now, come to the Korean front to assess for himself the course of the war and to show his total support for the men doing the fighting and putting their lives on the line every single day. Joe was more than impressed; he was deeply moved. And he was stunned by the man's demeanor. General Eisenhower, war hero, soon to be Commander in Chief, and with all those stars gleaming across the bill of his cap, came aboard with only a very modest nod and salute, and he made a point of warmly shaking hands with everyone he could, officers and crew alike, Joe included, and in so doing he made clear that he felt deeply honored and humbled to be among men so bravely serving their country. Joe too felt humbled: this was a golden lesson in leadership—and personal character—and a lesson that he would forever hold dear.

On another day at his kitchen table, high above his winery and his lush expanse of vineyards, Joe and I were talking about his many years in heavy construction, a world of concrete and steel, and a world that had brought him so much personal and financial success. And I couldn't help but wonder: had there been a specific moment, or some transformative experience that had changed the course of his life? That had led him into the world of fine wine and food and to this enchanted spot here in the Napa Valley?

Joe sat back in his chair for a long moment, reflecting, and then suddenly we were in Florence, walking alongside the River Arno, seeing and feeling the enduring spirit of the Renaissance. As we walked, Joe told me that as a young man his great dream had been to become an architect, to design beautiful buildings,

but the obligations of life had gotten in the way, and so had the Korean War, and when he got home from the war, he saw that his father's general contracting company was in desperate need of help, and his dreams of becoming an architect were pushed to the side. But in 1970, he and his wife Barbara made their first trip to Europe, they traveled all through Italy, from Sicily to Lake Como, but it was right here in Florence that something profound had happened...

Moments later Joe and I were standing in a lovely piazza, gazing up at Michelangelo's David, that enduring and uplifting symbol of the Renaissance spirit and the highest reaches of artistic achievement. For a long while, Joe stood there in deep reflection, trying to grasp the full measure of what one man, burning with inspiration and a ferocious drive to succeed, could one day achieve.

Then, a short walk later, we stood in front of the bronze doors of The Duomo, doors that Michelangelo had called "The Gates of Paradise." Joe stood there in awe. The Duomo was Florence's main cathedral and one of the true jewels of the Renaissance. Built entirely of white marble with a pinkish hue, and crowned by Filippo Brunelleschi's fabled Dome, The Duomo represents an artistic and an engineering achievement that has few rivals anywhere in the history of the world. And just imagine how it struck Joe.

Joe was a man who had built his reputation and his fortune in the construction industry, on the ability of his teams to construct massive structures on time and on budget. But building The Duomo was beyond his comprehension. The work had begun in 1296—and it had taken the next 140 years to complete! Imagine the effort! Imagine the investment! Imagine the commitment! Joe walked all the way around the complex, trying to take it all in, and trying to do so with his own experience as a builder now welled up in his throat. The sheer scale of The Duomo, the harmony of its proportions, the sheer majesty of Giotto's tower rising quietly alongside—how in the world had they done it? And how had they done it with tools that were closer to those of the Stone Age than to the tools that Joe and his teams had today? Joe could only shake his head in wonder.

Then we were inside, admiring the mosaics on the floors, feeling the upward thrust of the marble arches, the deep blues of the stained glass windows carrying us forward, and soon we were making our way up The Duomo's ancient steps, all 463 of them,

Joe in great pain now, hobbling along on a right foot left gimpy from a fall on a construction site. But he was determined to reach the top. And when he finally did reach the top, when, his heart racing, he finally came up into Filippo Brunelleschi's sacred dome—its ascending arms and covering artwork feeling like a taste of Heaven itself—Joe felt something inside of him burst wide open, and he felt a sudden rush of new energy and excitement sweep into his being.

Back at his kitchen table, Joe had trouble finding the exact words to describe the moment to me, but I understood what he was trying to say: he did not yet know how it would happen, or where, but right there in The Duomo, up in Brunelleschi's dome, Joe knew that his life would be forever changed. The world of construction, a life of building other people's projects, according to their needs and their vision and their blueprints, was no longer enough. Soon he had to create something that was truly and uniquely his own.

Yes, all these flights of memory, from Maysville to Korea to Florence, happened right there at Joe's kitchen table. "I'm not articulate," Joe often insisted to me. "I'll tell you what I remember, and I'll leave it to you to fill in the blanks and find the right words."

Yes, that was how we worked, and what a feast it was for both of us. Joe's intelligence was so acute, and on his good days his memory was so vivid, and his family's photo collection was so rich that Joe and I were able to sit right there at his kitchen table and build this book together, memory by memory, chapter by chapter, theme by theme. But where should we begin our book? And how in the world would we ever be able to lay in all the layers of story and significance that Joe's flights of memory were bringing to the fore?

For a long time, I simply assumed we would start our story back on the family farm in Maysville, around the time of Joe's birth, in 1927, when America was deep in the clutches of Prohibition and about to enter the tortuous years of The Great Depression and World War II. But when I actually sat down to write, a man named Thomas Jefferson kept elbowing his way in, reminding me of his guiding dream for American wine and all that Joe had done to help turn that dream into a golden reality. "Okay, Mr. President, I will be sure to give you and your dream for American wine proper attention, somewhat later in the story." Still, the more immediate question remained: where to begin the personal side of Joe's story?

One small button provided the answer.

The story of that button, the story of Joe's family here in America, actually begins in the era of Thomas Jefferson, and it begins with a young couple named John and Rachel Hensel. We don't know much about John and Rachel, beyond the fact that they began their journey in America in Pennsylvania and later settled on a farm in rural Ohio, in Tuscarawas County, in the eastern part of the state. John and Rachel had only one child, a son they named Abel, and he was born in 1832, just six years after President Jefferson passed away. Abel was raised on the family farm there in Ohio, and he matured into a strong, resourceful young man, especially skilled with tools and horses, and like his father he was intent on devoting his life to farming, with his fingers working happily in the soil. In 1860, though, something disrupted his plan: the South's secession from the Union and the outbreak of America's Civil War.

In the early stages of the war, Abel enlisted in the Union Army, eager to fight on the side of President Abraham Lincoln and those hell-bent on abolishing slavery and re-unifying our young country. Abel adapted well to the army and soon proved himself to be a very capable soldier. Before long, he was recruited into the elite troops of the legendary General William Tecumseh Sherman, one of Lincoln's most ferocious—and most successful—generals. In 1864, as the war entered its decisive phase, General Sherman and his troops, then some 100,000 strong, stormed into the Confederate stronghold of Georgia. The fighting was brutal, almost every step of the way. As Sherman was famously quoted as saying, "War is the remedy that our enemies have chosen, and I say let us give them all they want!"

In November of 1864, Sherman and his forces captured the city of Atlanta and burned it almost to the ground. From there, he and his troops began what became an epic chapter of the Civil War: "Sherman's March to the Sea," a scorched earth campaign that saw them burn plantations, destroy railroad lines, kill off livestock, and free thousands of slaves as they advanced. The aim of Sherman's plan was brutally clear: to devastate and demoralize the civilian population and convince them to abandon the Confederate cause.

In pursuit of that goal, Sherman took a drastic step: before leaving Atlanta, he severed all telegraph links to the outside world, to keep Confederate leaders in the dark about his next moves—and

to keep the Union high command in the dark as well. When asked about his general's plans, President Lincoln famously responded, "We know what hole he went in, but we don't know what hole he will come out of." Sherman finally reappeared on December 22, 1864, having slashed his way through the heart of Georgia. Once he reached the sea, in triumph, he sent a cable to President Lincoln: "I beg to present you as a Christmas gift the city of Savannah."

And where was Joe's great grandfather in all this? Right in the thick of it. No one today knows the precise details, but during some part of Sherman's march through Georgia, Abel Hensel was gravely wounded. His injuries were so serious that he was left for dead, right there on the battlefield. With next to no medical care coming from any direction, Abel seemed destined to become one of the 110,000 Union soldiers who ultimately gave their lives fighting for President Lincoln and the Union cause. But Abel Hensel did not die. Somehow he managed to bandage his wounds and make his way to safety. And once he had sufficiently healed, he returned to duty in the Union Army; there was no quit in the man or his cause.

On June 2nd, 1865, at the end of four bloody years of conflict, General Edmund Kirby Smith, the commander of all the Confederate Army forces west of the Mississippi, formally signed the terms of surrender offered by Union negotiators. With General Smith's surrender, the Confederate army was disbanded and our wrenching national trauma was finally brought to a close— thanks to President Lincoln's steadfast leadership and ideals, thanks to the fierce determination of William Tecumseh Sherman and Lincoln's other generals, and thanks, too, to the skill, commitment, and quiet courage of Union soldiers like Abel Hensel.

In our conversations, Joe made light of his great grandfather's Civil War exploits and heroism. But as his son Bill later confided to me, all his life Joe cherished a little something that had been handed down to him from his father: one gold button from Abel Hensel's Union Army uniform, a button filled with American history and with hallowed family lore, a button that spoke loud and proud about the character and spirit that Joe and his family had running through their veins.

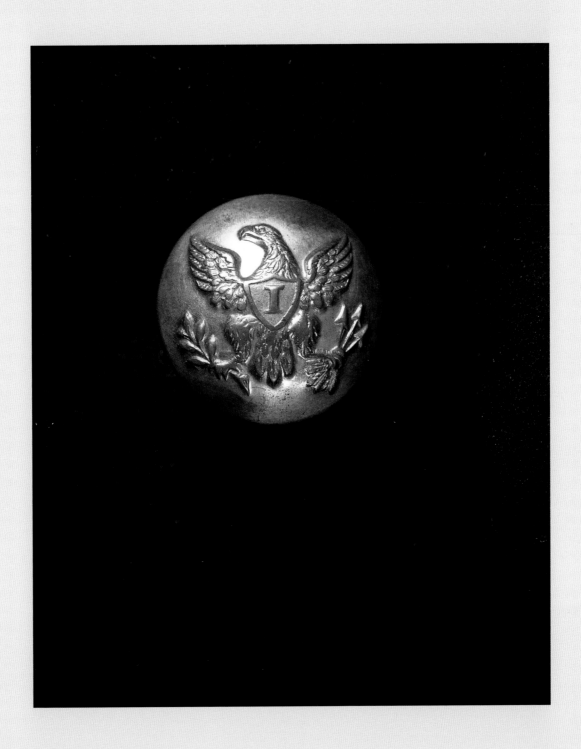

A GOLD BUTTON
FROM ABEL
HENSEL'S UNION
ARMY UNIFORM
BECAME A
CHERISHED
FAMILY HEIRLOOM.
THIS BUTTON
IS SIMILAR.

*Courtesy of
the Spurlock
Museum.*

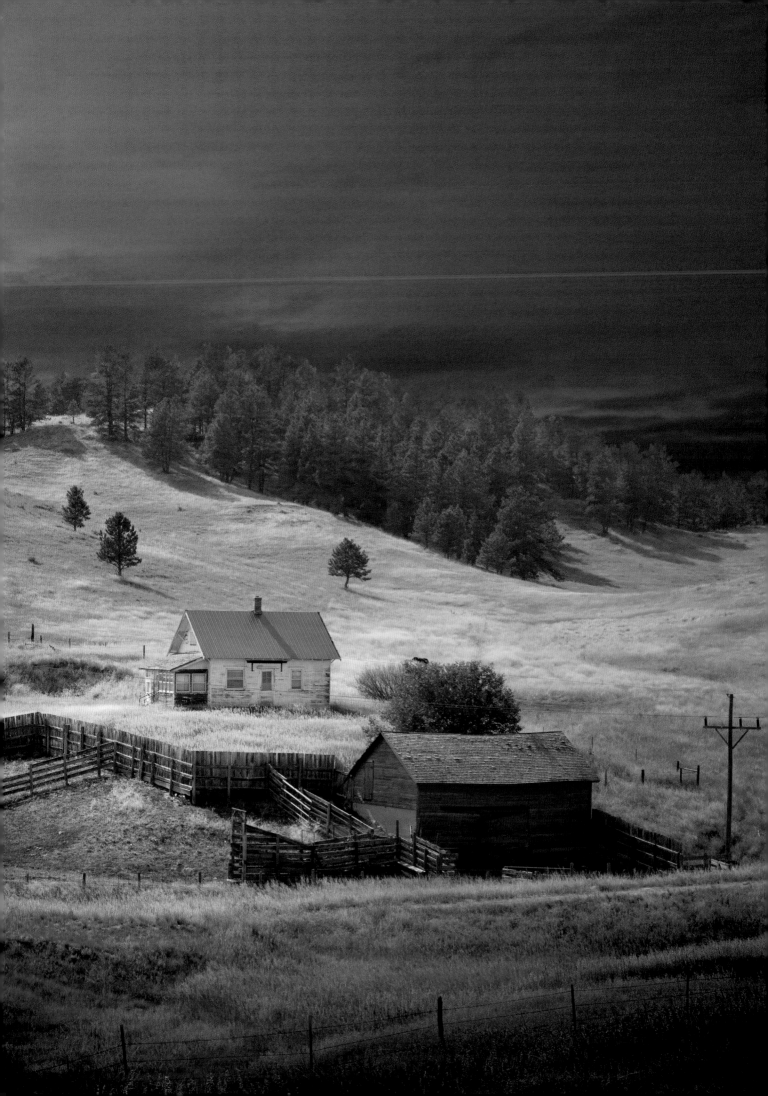

BEDROCK AMERICA

Following the Union victory in 1865, Abel Hensel was honorably discharged from the army and then he returned home to the family farm in Ohio to pick up the pieces of his life.

It wasn't easy. By then he had married a young woman named Katherine Fribley, and by the time Abel returned home from the war, their daughter, formally named Rachel but known by one and all as Maggie, was no longer the cuddly baby he remembered. A different man might have been content to settle down right there on the family farm in eastern Ohio, as he had originally planned, but the war had changed Abel. Now he was determined to leave the past behind and find someplace new, someplace to start over fresh.

So it was that Abel and Katherine soon packed up their lives in Ohio and began heading West. That was where he felt the future lay, for himself and for America, out toward the untamed fields and the wild, expansive landscapes of the Great Plains. The first place they stopped and tried to put down roots was Dover, Illinois, a tiny speck of a farm and ranching community west of Chicago. In Dover, Abel set up shop as a blacksmith, an honorable trade where he could put his expertise with tools and horses to profitable use.

Life in Dover was agreeable enough, but Abel felt no real connection to the land or to the people, and soon he became restless again, and he was consumed by an almost irresistible urge to keep pushing West. Abel was also eager to get back to farming, to living off the land. So one day in late 1878 or early 1879, Abel kissed Katherine and Maggie good-bye and set out searching again. By then, Abel was past the age of 50, but he was strong and

full of energy and he was determined to find just the right spot to start all over and build a better life for Katherine and their family.

From Dover, Abel made his way south and west through the belly of Illinois, and then he cut due west across the top of Missouri and then into the largely undeveloped farmlands of DeKalb County, in the northwest corner of Missouri. When Abel reached the little town of Maysville, Missouri, the county seat of DeKalb County, he immediately liked what he saw and felt. Maysville was a charming little town, true bedrock America, filled with honest, hard-working people, a strong sense of community, and the rock-solid, practical, no-nonsense values of the American heartland.

As Abel quickly discovered, Maysville and DeKalb County also had a rich history, reaching all the way back to the American Revolution and even across the Atlantic to France. The county was named for Baron Johann de Kalb, a Bavarian-born nobleman who had served in the French army and then as a major general in George Washington's Continental Army. Baron de Kalb was killed in action while fighting in our War of Independence, making him a true hero of the American Revolution—just the kind of soldier, adventurer, and patriot whose story would appeal to Abel Hensel, given his own spirit and his own experience in America's Civil War.

Abel was impressed by what he found in Maysville, and he felt the place had real potential for his family. Still, Abel was a methodical man, and very careful with his money, so he was not about to rush into anything. Instead, he began exploring the fields and hills on the outskirts of town, on horseback, seeing if he truly liked the area and, if so, if he could find just the right spot to buy some land and begin building a whole new life.

Abel took his time, scouting for property, talking with the local farmers and ranchers, and then one day he found it, sitting high on a hill four miles north of town: 320 acres of very promising farmland, with good topsoil, abundant water supplies, and a solid plateau on which to build a house, a barn, and the other necessary outbuildings. And the property had something else as well...

As DeKalb County historians later recounted, from the top of the hill where he envisioned building the family home, Abel Hensel could look back toward Maysville and see an entire sea of church steeples rising gracefully in the distance. Yes, as practical as he was, Abel Hensel was also a man of faith, and on that hill he was

MAYSVILLE, MISSOURI, CIRCA 1880. JUST ABOUT THE TIME ABEL HENSEL ARRIVED IN TOWN.

Lithograph, courtesy of the DeKalb County Historical Society.

taken by "the spirit of the place"—the exact same feeling that Joe Phelps would cite, nearly a century later, when he finally found his own chosen place in the world, high on a hill in the Napa Valley.

Thrilled, Abel rushed back to Dover, Illinois, worked out a trade for his property there, and then he and Katherine and their daughter Maggie packed up their belongings and made their way to their new lives in Maysville. The year was 1879, some 14 years after Abel had been left for dead on the battlefields of Georgia, and now he was eager to build a house for the family and return to his roots in farming, all right there on that hillside looking back toward Maysville and its sea of steeples floating gently on the horizon.

Now, did Abel hire a crew to build his new house? No. Even in his 50s, Abel was determined to do all the heavy construction by himself; such was the character and spirit of the man. To start, he purchased several loads of lumber and had them hauled in by wagon. Then, following his own design, Abel set to work and built their new family home, a large house with two bedrooms upstairs, two bedrooms downstairs, and later Abel added a big front porch, ideal for sitting out with Katherine and their kids on hot summer nights and relaxing after a hard day's work in the fields.

Abel's resourcefulness and can-do spirit were by no means the exception in and around Maysville. Just the opposite: they were the rule. The good folks of Maysville perfectly embodied the ethos that in those days reigned supreme across the Midwest and much of

the rest of bedrock America: Self-reliance. Do it yourself. Build the strongest, safest future you can for your children and their children—and always lend a hand to your neighbors as well. As that sea of steeples could attest, the guiding ethos in Maysville boiled down to this: "Work hard and share. We're all in this together."

Abel lived that ethos in both word and deed. On one corner of his property, with his own hands he built something else: a one-room schoolhouse, to serve his children and grandchildren and also the children of the other farm families living nearby. The school became an anchor of community life in Maysville, and after Abel passed away, it was renamed in his honor: The Hensel School. And through that school Abel's vision and generous spirit lived on: two generations later, Joe Phelps began his own schooling right there in the one-room schoolhouse that his great grandfather had built.

There is a distinct foreshadowing here. As you will see in the chapters ahead, when Joe finally found his chosen place in the world, high on his hill in the Napa Valley, in one corner of the farm property that Joe bought there was a dilapidated one-room schoolhouse, a place that Joe immediately brought back to life and used as his home and personal headquarters for the next eight years. And Abel's far-sighted commitment to education and helping his neighbors foreshadowed something else: Joe's own generous support for community and educational projects in Colorado and the Napa Valley. As the farmers of DeKalb County might well have put it: in Joe's case, the apple did not fall far from the tree.

Abel and Katherine prospered there on the hill outside of Maysville. In addition to their first child Maggie, they had five more children as well: David, Henry, Emma, Enos, and Ethel. It is Maggie, though, who carries our story forward. When she was a young woman, Maggie met a man of good values, strong character, and a very promising future. His name was John Quincy Phelps.

John Quincy Phelps also came from a family with a rugged frontier spirit. Indeed, he was born on June 17th, 1861 in Fort Bridger, Wyoming, as his parents were making their way west to start a new life in California. John Quincy's father was a doctor, and he was soon drawn to the same profession. John Quincy Phelps studied medicine at the Rush Medical College in Chicago and then at the Kentucky School of Medicine in Louisville. During this time, he met and married Maggie Hensel and the couple chose to settle in DeKalb County, near her parents. There, Dr.

John Quincy Phelps began practicing medicine—and Maggie began having babies.

On August 11th, 1890, Maggie gave birth to their first child, a boy, and to honor their combined family lineages, they named him Abel Hensel Phelps. He would later become Joe's father. Maggie then gave birth to another son, George, and he would become a doctor like his father and his grandfather. John and Maggie then had two more children: Ruth and John.

As he and Maggie built their family, Dr. Phelps built his medical practice in DeKalb County. He started out seeing patients in the outlying towns of Fairport and Weatherby, and then in 1898 he and Maggie and their four children moved to Maysville proper. There Dr. Phelps served for many years as the official DeKalb County Physician and as the County Coroner. The Phelps family, like the Hensels before them, were now prominent members of the town of Maysville and of the wider DeKalb County community.

Their son, Abel Hensel Phelps, soon to become Joe's father, came of age during a very exciting period in American history. In 1903, when he turned 13, the Wright brothers, Orville and Wilbur, were just about to rock the world: that year they successfully tested their experimental flyer, a double-winged craft they hoped would help man soar like an eagle and one day command the heavens. That first trial of the Wright flyer was held at Kill Devil Hills, a small town on the Outer Banks of North Carolina.

Just two years later, a visionary inventor in Detroit named Henry Ford would watch his first Model T Ford roll off something entirely new in the world of manufacturing: an assembly line, an ingenious tool for maximizing production and ensuring consistency of quality. Yes, thanks to its ingenuity and can-do spirit, America was on the move, promising increased prosperity across the country.

A NEW ERA IS BORN: THE WRIGHT BROTHERS RECORD THEIR FIRST SUCCESSFUL FLIGHT.

Kill Devil Hills, North Carolina, 1903. Photo courtesy of the U.S. Library of Congress.

But then came war.

In 1914, a young Serbian nationalist named Gavrilo Princip assassinated Franz Ferdinand, the Archduke of Austria and heir to the throne of the Austro-Hungarian empire. Within a month, that assassination set off a chain of events that led to the start of World War I, a global conflict of horrendous bloodshed and death—and that soon involved America as well.

Woodrow Wilson was President at the time, and for more than two years he worked to keep the United States neutral and out of the fighting. But the war was pitting Germany and its allies in the Austro-Hungarian empire against our close allies Britain and France. As the war progressed, the British and the French were in desperate need of supplies to fight the war, and their currencies were in serious trouble too. While President Wilson declined to intervene, several private U.S. banks stepped in to help. According to historians, this triggered a serious conflict between Wall Street and the White House, with strong passions on both sides.

Finally, as the fighting and the death toll mounted, and as reports came in of atrocities against civilians in Belgium and other parts of Europe, President Wilson at last reversed his position, and on April 6th, 1917, the U.S. Congress formally declared war on both Germany and the Austro-Hungarian empire. There were hard-eyed economic and political interests on the line, but President Wilson chose to cast the conflict in terms of American values and ideals. This war, he asserted, was designed "to make the world safe for democracy," and later he maintained this was "a war to end all wars."

By 1918, American troops and resources were pouring into Europe's western front, and that proved key in tipping the scales in the Allies' favor. On November 11th, 1918, with its war machine in shambles, Germany agreed to an armistice, effectively ending the war—but not before seven million civilians had died and more than nine million soldiers had lost their lives as well, many of them in trench warfare of a brutality far beyond anything seen in General Sherman's storied "March to The Sea."

By the time a formal peace accord was signed in Versailles, France, in 1919, "The Great War," as it became known, had proved to be one of the deadliest conflicts in human history, and it had triggered major political upheavals across the European continent, including revolutions in several of the nations involved. The impact here in America was profound and painful as well. According to official U.S. records, 53,402 American soldiers died in combat during the war, and another 204,000 were wounded, many of the dead and wounded coming from small towns just like Maysville.

When the war started, Abel Hensel Phelps, at age 24, was helping run his family farm high on the hill in Maysville, and in 1916, before America entered the war, he fell in love and got

married. His bride was an exceptional young woman named Juanita Cundiff, known to her friends and family simply as "Nita." When they married, Nita was 29 years old, and she was an ideal partner for Abel. She was smart, competent, and the kind of salt-of-the-earth woman who could handle just about anything that life tossed her way. The bride and groom both came from well-respected families in town, and their marriage in August of 1916 received fulsome attention in the *Maysville Pilot*, the local paper.

Abel Hensel and Nita started their married life in a small house in Maysville proper, but once they started their family, they moved to the Hensel family farm, high on that hill outside of town. Soon they had four children: Mary, Margaret, John, and the last to arrive, on November 12th, 1927, was an energetic, bright-eyed little rascal they named Joseph. Our Joe. As was the custom in farm families across the Midwest, Joe was born right in his mother's bed, and he arrived in the world weighing a sturdy 10 pounds. And talk about keeping it all in the family: Joe was delivered by Hensel's younger brother, Dr. George Phelps, and he was born right in the house that his great grandfather had built.

By nature and by necessity, Abel Hensel and Nita were both very hard workers. Life on the farm was late to bed and very early to rise, whatever the season. Out in the fields, Abel Hensel raised pigs and chickens and he grew oats, pinto beans, and kaffir corn—a variety of corn they used for home meals and for animal feed. Joe's father did most of the planting and field work himself, and he also held down a second job, at the Farmers Store, a local general store in Maysville. At home, Nita did it all: she nursed the kids, cooked, cleaned, and helped manage the farm. At harvest time, she helped out in the fields and, with her daughters, she then did the canning, putting up enough fruits and vegetables to last the family through the cold winter months. And at Christmas time, Joe told me, she baked Christmas cookies that Joe looked forward to all year long. Nita did all of that and she held down a second full-time job too: as a stenographer in an office in Maysville.

If that sounds like a heavy workload for Abel and Nita, on top of raising four kids, consider this: in their farmhouse, there was no running water. No indoor plumbing, just an outhouse out back, to serve all six of them. And there was no refrigerator inside either; summer and winter the family kept their milk, eggs, meats, and produce cold in their walk-in icehouse back by the barn. Needless to add, there was no TV, no cell phones, no laptops, and no Xboxes or Gameboys either. Joe's house was typical of many

NITA CUNDIFF PHELPS

Shown here with her brother Claire.

A. L. Brown
CAMERON, MO.

farms across the Midwest in the 1920s, and it made for tightly knit families—a golden virtue that no amount of fancy technology can ever provide.

And Nita had exceptional inner strength. Growing up in the Cundiff family, she was the first born of nine children, and when both her parents passed away, far too young, Nita stepped up and took care of her eight sisters and brothers. She never complained; she just did whatever it took to keep her family safe and well. And her faith and spiritual anchoring always kept her on a very even keel. Then, when she married Abel Hensel Phelps, and they had four children of their own, Nita again took it all in stride: in her eyes, this was just another of God's blessings, a new set of children to raise and properly groom for the challenges ahead.

Nita loved reading, writing, and learning in general, and she had a special fondness for poetry. Accordingly, Nita was in charge of her kids' education—a responsibility she took very seriously. As she had with her three older children, Nita took little Joe in hand and personally taught him how to read and write—long before she and Abel Hensel sent him along to that one-room schoolhouse in the corner of the family property. Through much of her life, Nita kept a personal diary, and there she often quoted passages from one of her favorite poets, Alfred Lord Tennyson. These lines from Tennyson's "The Golden Year" were among her favorites, saluting as they do both God and the virtues of honesty and hard work:

Ah, when shall all men's good,
Be each man's rule, and universal peace
Lie like a shaft of light across the land,
And like a lane of beams athwart the sea,
Thro' all the circle of the golden year?
...Live on, God love us, as if the seedsman, rapt
Upon the teeming harvest, should not dip
His hand into the bag: but well I know
That unto him who works, and feels he works,
This same grand year is ever at the doors.

Hensel and Nita were serious churchgoers, as were most of their friends and neighbors in Maysville. Every Sunday they took their four kids to services, and to the communal lunch afterwards, and as they grew up, Nita worked hard to pass along her faith and values to all of her kids. But it was not always easy with little Joe. Even as a boy, he was a handful: restless, high-spirited, stubborn, and at times he could be an impish little devil. Still, Nita left an

indelible mark on her son: throughout his life, and especially in running his businesses, Joe always demanded the unvarnished truth, with no phony gloss or inflated PR hype, just as Nita urged in this inscription that we found on the front page of her personal Bible, a quote from George Herbert, a Welsh poet from the 1600s:

"Dare to be true,
 Nothing can need a lie,
 A fault which needs it most,
 Grows two thereby."

"Dare to be true, nothing can need a lie." Powerful words. Enough, in fact, to build a life on. And, as it turned out, Abel Hensel and Nita and their four kids needed all the spiritual anchoring they could muster, given the storms that were about to smack them in the face. In October of 1929, just two years after little Joe was born, the U.S. stock market crashed, plunging America into The Great Depression and sending half of America's banks reeling into failure, taking many of their investors straight down with them, and taking countless towns like Maysville straight down too.

Farm families like Joe's were among the hardest hit. Almost overnight, prices for crops like corn and wheat collapsed, and tens of thousands of farm workers were laid off across the Midwest, while countless small shops and businesses were forced to shut their doors. In the months and years that followed, the crisis only deepened, triggering mass unemployment, bread lines, and food shortages across the country. In bedrock America, families like Joe's pulled even closer together; there was simply no other choice.

For all of the hardships, though, and in part because of them, Joe told me that his was an extremely happy childhood. He adored his two older sisters, Mary and Margaret, and he positively idolized his older brother John. And he made the farm his own personal playground. In summer, he loved to run around barefoot and play in the hay loft, and on those sweltering summer days so typical of the Great Plains, he would play hard, get filthy, and then go into the ice house to cool down and play make believe or king of the castle. What Joe loved most on the farm, he told me, was his family's feeling of sharing and closeness. With their mom and dad often working long hours in town, he and his brother and sisters were often left to fend for themselves and take care of each other. "We were all very close," Joe told me. "And we always helped each other. We had to; that's just the way it was."

Amidst the gloom and the heavy strains of The Depression, Joe was especially eager to help his parents and to prove his worth. At the age of 7, as I mentioned in the Introduction, he was raising pigs and selling them in the local market. "I could get $14 for a whole pig," Joe told me at his kitchen table. "That was good money back then. But I didn't really care about the money. What I loved and cherished was the sense of accomplishment it brought me."

"The sense of accomplishment."

Remember those four words; they tell us a lot about Joe's character and spirit—and about what motivated him throughout the course of his amazing journey. As you will see, Joe made a lot of money through his different endeavors, from construction to fine wine, and he definitely enjoyed the freedom and independence that money afforded him. And Joe always felt gratified, too, that in making good money he was ensuring the financial security of his family. That said, making money was not, down deep, what drove the man. No. What drove Joe Phelps was a constant thirst for new challenges, for new skills to master, for new realms to conquer, and for new ways to feel that exhilarating "sense of accomplishment."

But something else also drove Joe throughout the course of his life: Fear. And in the pages just ahead, you will see exactly why.

◆

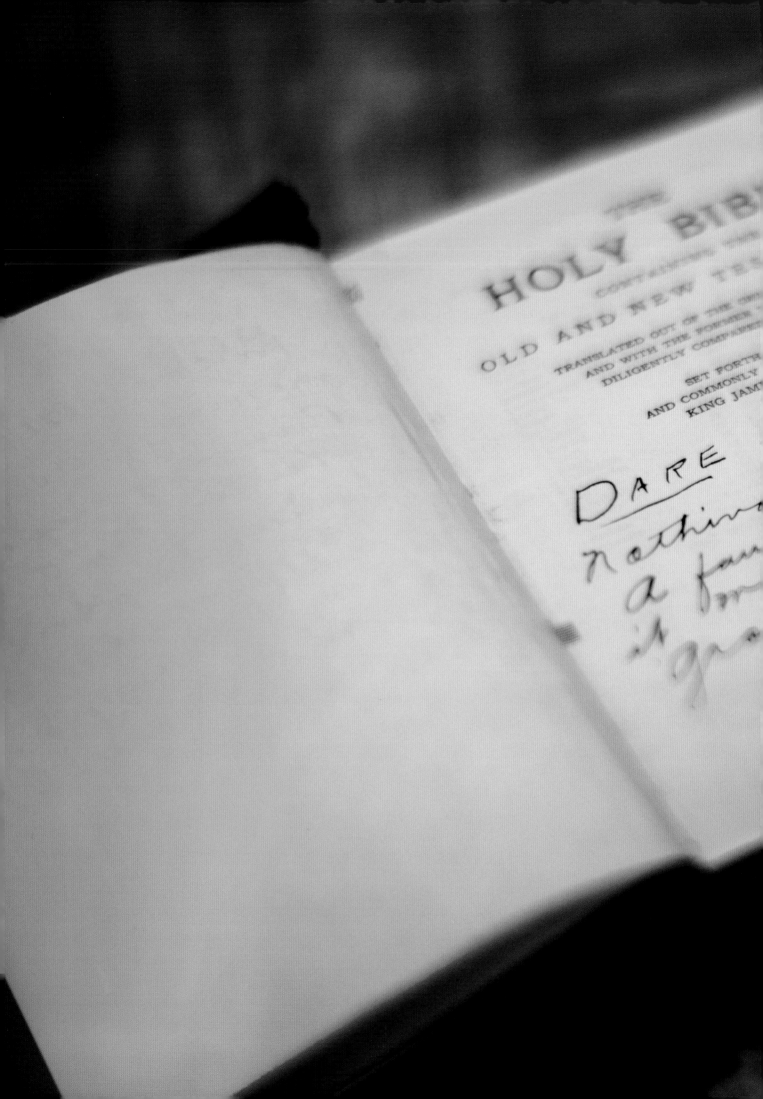

THE
HOLY BIBLE
CONTAINING THE
OLD AND NEW TESTAMENTS
TRANSLATED OUT OF THE ORIGINAL TONGUES
AND WITH THE FORMER
DILIGENTLY COMPARED

SET FORTH
AND COMMONLY
KING JAMES

DARE

nothing
a few
it gra

be true;
can need a lie.
which needs
two thereby.
Mather

AMERICAN BIBLE SOCIETY

NEW YORK

THE GRAPES OF WRATH

They seemed to come out of nowhere, dark, choking blizzards of dust rolling across America's heartland, spreading mayhem from the flatlands of Oklahoma and Texas, to the prairies of Kansas and Missouri, and even on up to North Dakota and Minnesota. And everywhere they struck, these rolling blizzards of dust left countless farms in ruins and countless American families homeless and uprooted, and often in the depths of despair.

The causes were several: years and years of punishing drought. Years and years of indiscriminate plowing. A total ignorance of sustainable farming and proper soil protection. And, too, there was a new arrival in American farming, a promising new tool of the Industrial Revolution: gasoline-powered tractors, their motors and swirling iron blades replacing horses and plows and enabling our farmers to churn across their fields and landscapes and rip into their precious topsoils in stretches as far as the eye could see.

All that churning was done, of course, in the name of Productivity and Progress, but the results were anything but. Soils and natural ecosystems were disrupted, as were plant and animal life, leaving them all painfully vulnerable when the droughts set in and those dust storms came rolling through. As Woody Guthrie came to sing: "You could see that dust storm comin', the cloud looked deathlike black, and through our mighty nation, it left a dreadful track..."

No words, no matter how vivid or how artfully put to rhyme, could capture the full breadth of the devastation. As those blizzards of dust swept across the Great Plains, trucks, cars, and wagons were instantly buried, thousands of acres of life-sustaining corn, wheat, and oats were soon laid to waste, and where once they

had happily roamed, thousands of cattle, pigs, sheep, goats, and chickens either scattered with the winds or were left to simply wither and die.

In April of 1935, Robert E. Geiger, a reporter from the Kansas City bureau of the Associated Press, witnessed first-hand one such deadly blizzard as it tore through the fields and farms of Boise City, Oklahoma. Good AP man that he was, Geiger immediately filed a sober, fact-based story back to the bureau in Kansas City. There, as he polished Geiger's copy, news editor Edward Stanley added two words that he felt crystallized what Geiger was trying to describe: "Dust Bowl." Although they were meant to describe only the situation in Boise City, those two words came to define and pin into our consciousness an entire benighted era, America in the 1930s.

Painfully aware of the limitations of words, Roy Stryker, the head of the U.S. Resettlement Administration, recruited a team of gifted photographers to fan out across the affected states and document the devastation and what the federal government was doing to help. Over the ensuing seven years, Stryker's team amassed more than 200,000 images, many were published in leading magazines like *Life* and *Look,* and those helped sensitize the nation to the plight of the afflicted farmers and their families. The images of Dorothea Lange and Walker Evans, in particular, put lumps in the national throat and iron and steel in our national resolve.

The crisis called for leadership of the highest order, and President Franklin D. Roosevelt rose to the challenge. Calm and reassuring, never divisive, FDR traveled through nine different states to see for himself the dimensions of the disaster and to listen to the farmers and hear their needs. And the President didn't dart here and there for quick, self-serving photo ops. No, with his wheelchair discreetly hidden in the trunk, President Roosevelt made his way by open car across the Great Plains, and as he went he promised our farmers and their families that they had his unwavering personal support and that of our government as well. And in so doing, FDR brought hope and smiles to people in desperate need of both.

During the Dust Bowl crisis, President Roosevelt used the radio and his signature Fireside Chats to inform us, lift our spirits, and call forth the very best we had inside. What he told the nation about his Dust Bowl trip stands today as a poignant lesson on the art of leadership: he brought us together in common cause

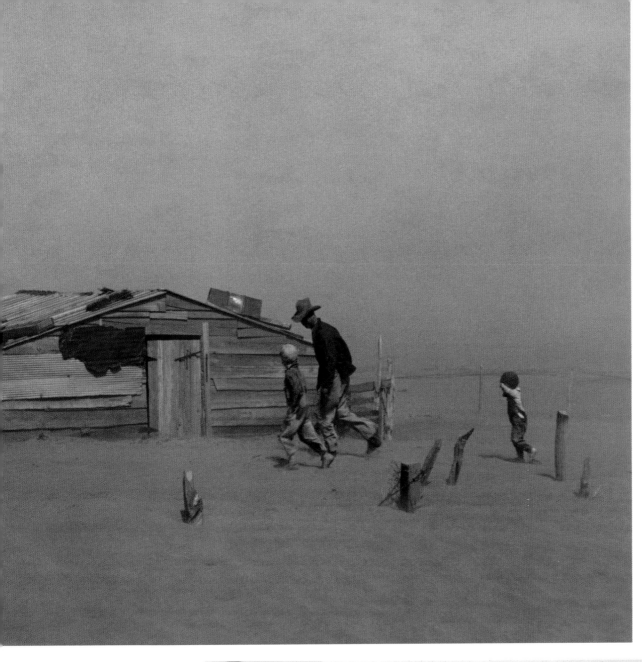

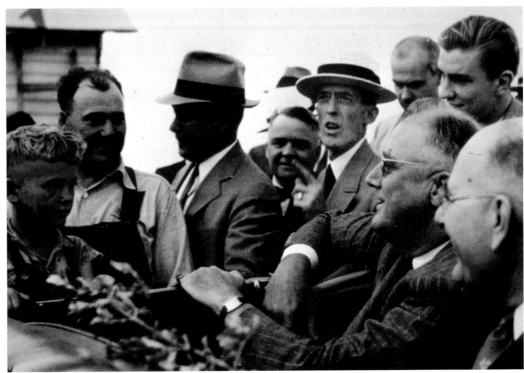

and a common spirit and he thanked the farmers and their families for inspiring us with "their self-reliance, their tenacity, and their courage."

Through those years of crisis, author John Steinbeck saw what President Roosevelt saw, he saw what Dorothea Lange and Walker Evans saw, and then he put his own unique gifts to work, creating the enduring American classic, *The Grapes of Wrath*.

By then, through his acclaimed novel *Tortilla Flat*, Steinbeck had already proved himself to be a champion of fishermen, farmers, and other hard-working families, men and women with calluses on their hands, scars on their heart, and wrenching stories to tell. And in 1936 he was drawn almost irresistibly into the lives of the many families who had lost their farms in those raging blizzards of dust.

Like so many serious writers, Steinbeck insisted on starting with in-depth, up-close reporting. As a first step, he made friends with a number of migrant workers who had made their way to California from the drought-stricken states of the Great Plains. For a time, he even camped right beside them and immersed himself in their lives, their conflicts, and their daily struggles to put food on the table and keep their families together. Shocked by their plight—and even more so by their courage and resilience—Steinbeck wrote a series of seven articles about the migrants for the old *San Francisco News*. The series, "The Harvest Gypsies," ran from October 5th to 12th in 1936. But for Steinbeck the series was simply not enough to convey the full drama of what he had seen and what he had come to feel.

To effectively tell the story of these migrant families, to get down into the sinew and marrow of their character and spirit, Steinbeck created a memorable set of characters, Tom Joad and his family first among them. Tom and his family were poor tenant farmers, working the land in Oklahoma—until those dust storms rolled in and destroyed most everything they had. As Steinbeck portrayed it, those dust storms provided the ultimate test of what Tom Joad and the other farmers and their families had in their veins. As he came to write in *The Grapes of Wrath*, when those choking blizzards of dust came rolling in, be it in on a farm in Oklahoma, or on a farm on the outskirts of a small town like Maysville, Missouri, this was it, the moment of truth, the moment of make or break:

"The people came out of their houses and smelled the hot stinging air and covered their noses from it," Steinbeck wrote. "The children came out of the houses, but they did not run or shout as they would have done after a rain. Men stood by their fences and looked at the ruined corn, drying fast now, only a little green showing through the film of dust. The men were silent and they did not move often. And the women came out of the houses to stand beside their men—to feel whether this time the men would break…"

Right there, John Steinbeck could easily have been writing not about Tom Joad and his family, but about Joe Phelps and his.

Yes, sitting with me at his kitchen table in the Napa Valley, exactly 80 years later, Joe remembered it all: the many years of drought. The punishing dust storms rolling through. The ruined crops. The farm animals they lost. And, above all, the palpable, inescapable sense of fear and helplessness that those dust storms washed into the heart of Joe and everyone else in his family. Yes, one minute his family was living happily there on the farm outside of Maysville, in the house that Joe's great grandfather had built with his own two hands, Joe and his brother and sisters enjoying their special sense of closeness, and two blinks later it was gone. Damn near all of it.

Joe's father was hardest hit. Even in the best of times, Abel Hensel was constantly at it, working dawn-to-dusk in the fields and even later at his job in town, and those dust storms had made it all the worse. As Joe told me, when his father was young, he had been a good-sized man, strong and tall, but when those dust storms hit, in the mid-1930s, Abel Hensel was in his mid-40s, and all the extra work he had to do on the farm had left him with a damaged spine, in layman's terms a broken back. And the many surgeries that had followed had cut his father's height down by a full six inches. That's quite a blow for any man. Worse, Joe told me, his father was left with a nasty twist in his spine, crimping his posture and severely limiting his ability to do physical labor. His dad bravely continued to farm his land as best he could, but in the end there was no escaping the cold, hard truth: "He was essentially disabled, physically," Joe said. "It finally became apparent that his health and physical condition just wouldn't permit him to farm."

As we sat there at Joe's kitchen table, looking back, I tried to grasp how all this must have hit a whip-smart boy of 7. Seeing his father struggle with a broken back. Seeing those dust storms rip through the family farm and all the destruction they left in their wake. That farm had been the anchor of his family for three generations. And that farm was Joe's private playground, the ice house out back was his personal fort, and that one-room schoolhouse in a corner of the family property was where he and his brother John and his two sisters, Mary and Margaret, had taken their first steps out into the wider world. And now it was all covered in rubble.

"It was hard to watch," was all Joe would say, but it must have seemed as if his whole world had been split open at the core.

The end came in the winter of 1935. In a wrenching chapter that John Steinbeck could well have written, Abel Hensel and Nita no longer had the physical strength or the financial means to keep the family farm out of bankruptcy. By then, too, Joe's uncle George had moved his medical practice to Cheyenne, Wyoming, and he was urging Joe's parents to pack up and come west too.

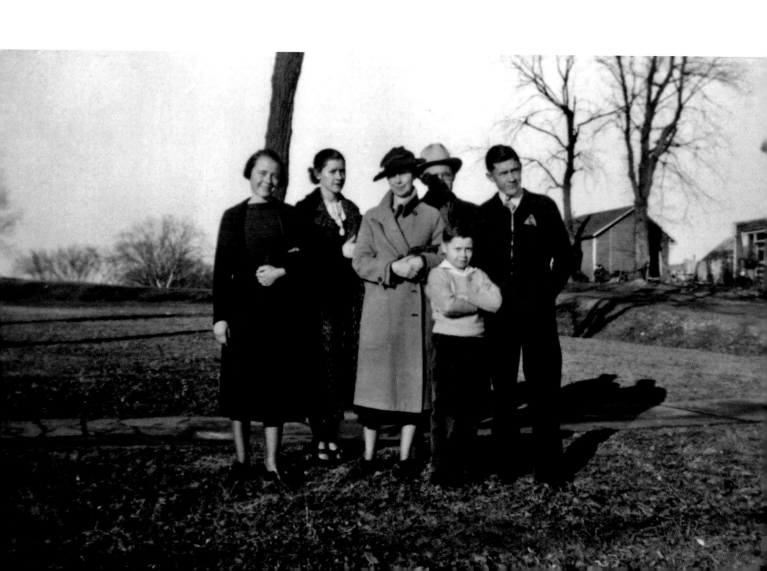

What a wretched moment this was for Joe's family. Abel Hensel and Nita had deep family roots in Maysville, they were established in the community, their friends were there, their church was there, and of course they longed to stay right there on their hill outside of Maysville, with that reassuring sea of steeples rising majestically in the distance. But now they simply had no choice: as Uncle George urged, they sold the farm, packed up all their belongings, and got ready to head west, to Colorado, to try to start their lives all over from scratch. An article in the *Maysville Pilot* that winter told of their plans and bid them a very sad farewell.

And what was little Joe's reaction to this wrenching moment? I had no need to guess. Thanks to his daughters Leslie, Laurie, and Lynn, right there on the mantle in Joe's kitchen, mounted on a big wide poster board, was the blow-up of a revealing family photo, taken in that dismal winter of 1935. Joe's family is standing outside in their Sunday best, their bags packed and ready to go. This was a family portrait obviously taken for posterity, and today that photo tells the story of that moment far more eloquently than I ever could:

On that stark winter day, Nita, no doubt buoyed by her iron-like faith and trust in God, is standing resolutely in the center of her family, with Abel Hensel standing in her shadow and withdrawn a bit to the rear. Their older son John stands alongside his father, and their daughters Mary and Margaret are right there close to their mom. And who's that stubborn little guy out front? It's our Joe, just turned 8, standing with his arms crossed defiantly across his chest as if to say, "Nothing will break me! I'll show you!"

And show them he would, of course. Over and over and over again.

◆

JOE AND
HIS FAMILY

Mary, Margaret,
Nita, Abel
Hensel, Joe,
and John (L–R)
in Maysville,
Missouri, 1935.

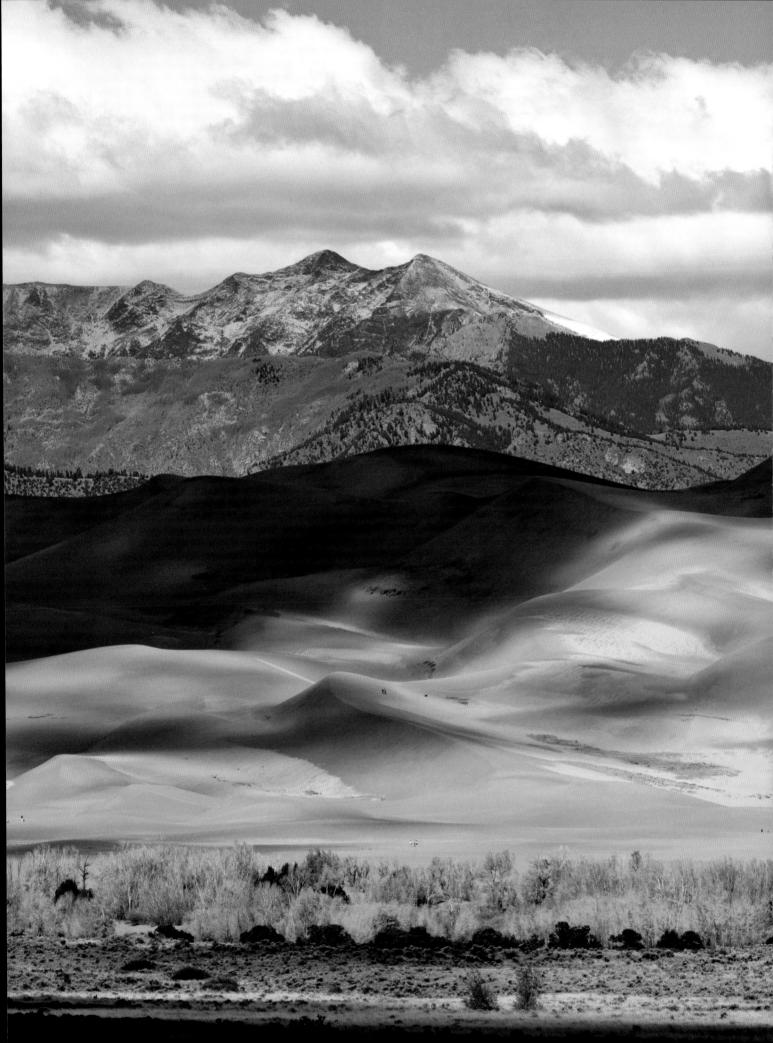

GO WEST, YOUNG MAN

The Civil War and General Sherman's "March to the Sea."

The Great Depression and the multiple hardships it brought to millions of families all across America.

The Dust Bowl years, the droughts, the agricultural and ecological ignorance, so many families uprooted, the era of *Grapes of Wrath*.

These were seismic upheavals in American life and history, and as Joe and I worked at his kitchen table, we both marveled at how his family's story ran like a golden thread through the heart of each of those upheavals. And after Abel Hensel and Nita lost the family farm in Maysville to those blizzards of dust, Joe and I settled in to explore where that golden thread led us next: to Greeley, Colorado.

By then, in 1935 and early 1936, thousands of Dust Bowl families were migrating West, many with their eyes on California, as in John Steinbeck's novel, but many farm families, including Joe's, were eager to remain closer to their roots in the Great Plains. Abel Hensel and Nita had no direct family ties to Greeley, but it is fairly easy to understand why they decided to start over in Greeley. Like Maysville, Greeley was farm country and pure bedrock America, and small though it was, Greeley enjoyed considerable status at the national level, thanks to its spiritual godfather, Horace Greeley.

At that stage, Horace Greeley commanded great respect in many corners of our young nation; indeed to many people his life story seemed to be cut straight from the cloth of The American Dream. Greeley was born back in 1811, the son of poor farmers in Amherst, New Hampshire, but poverty was no hindrance to young Horace;

in fact, it was a healthy kick in the rear. Even as a boy he was smart, ambitious, and resourceful, and at the tender age of 14 he landed himself a job as a printer's apprentice at a newspaper in Vermont. There, Horace learned everything he could about newspapers and he saw first-hand the essential role that serious newspapers played in American life and democracy. For Greeley, reporting the news, fairly and accurately, was more than a job; it was a calling of the highest order and one essential to the future of America. To put that conviction into practice, Greeley moved to New York City, the financial, intellectual, and cultural capital of the country. There he founded *The New York Tribune*, and under his guiding hand it became one of the most influential newspapers in American history.

Via his platform at *The New York Tribune*, in the 1850s Greeley became, like Abraham Lincoln, a fervent advocate for the abolition of slavery. When the Civil War erupted, Greeley actively supported President Lincoln and the Union cause. For Greeley, this was about far more than politics or power; it was about morality. And it was about what ideals and values should guide the future of our nation.

By background, Greeley was a morally upright New Englander and a fierce opponent of liquor, tobacco, gambling, prostitution, and capital punishment. That said, he firmly believed that the future of America would not be forged in New England, New York City, or anywhere else on the East Coast; it would be forged out West, and it would be forged by the coming generations of dreamers, idealists, and creators, by the young men and women who had the courage to break free and blaze their own trails. With that conviction, Greeley authored a single sentence that became an enduring rallying cry for legions of his followers and for millions of other Americans as well: "Go West, young man, and grow up with the country."

Embracing that spirit, in 1869 a group of Greeley's followers went west to Colorado and settled in an agriculturally promising part of the state, due north of Denver and with the Rocky Mountains rising majestically in the distance. They named their new town Greeley, to honor Horace Greeley and his guiding ideals and moral values. The town was to be a utopian, agrarian-based community, a place driven by faith, farming, community-wide cooperation, and a shared opposition to alcohol, gambling, exploitation of women, laziness, and other manifestations of moral turpitude. To set the right tone, Greeley was to be "dry"—

wine, beer, and all liquor were strictly banned from sale or public consumption. Even in 1933, when the U.S. Congress formally lifted national Prohibition, the town fathers in Greeley were having none of it: their community would remain dry. Horace Greeley himself had passed away back in 1872, but his followers believed that he too would have kept their town dry.

This, then, was the community that attracted Abel Hensel and Nita Phelps; to them this would be an ideal place to settle in, find work, and continue to raise their four children and put them on the right path in life. And as they very quickly discovered, in Greeley's homes and churches there was a guiding ethos that was a perfect match for their own: "Work hard and share. We're all in this together."

In Greeley, Joe's father soon got a new lease on life; his back may have been broken, but his spirit definitely was not. With help from his brother George, the doctor who had delivered Joe, Abel Hensel purchased an 88-acre farm just west of town. But the property had no house for the family to live in. So, just like his grandfather and namesake, Abel Hensel, had done when he arrived in Maysville, Joe's father decided to roll up his sleeves and build a house himself.

To start the process, Abel Hensel went to King Lumber, a respected Greeley institution, to look for guidance, supplies, and manpower. Like most American farmers, Abel Hensel was handy with tools—he had to be—but he had never constructed a house before, and he was not sure how to go about it. At King Lumber, though, Earl King, the owner, took Abel Hensel in hand. He set up the newcomer with a purchasing account, plus a skilled handyman who could help with the building, and he advised Joe's father on the tools, lumber, and other supplies he would need to get the job done—and done right. Welcome to Greeley, Mr. Phelps!

Abel Hensel got the job done, successfully, and he enjoyed the process too. So the next step was a natural: Joe's father, realizing that his farming days were now essentially over, decided to set himself up in business as a general contractor in Greeley. And to facilitate the launch of his new venture, he dropped the "Abel" from his name and set up shop as "Hensel Phelps, General Contractor."

Soon, thanks to recommendations from Earl King and others in the community, Joe's father had lots of clients knocking on his door, mainly businesses, schools, and families who needed help with repair work or remodeling projects. Soon, too, Hensel had his own building on the edge of downtown Greeley. Yes, thanks in large measure to the cooperative spirit in Greeley, and thanks to his own resourcefulness and can-do spirit, Hensel was right back on his feet, building a whole new life for himself and his family—and setting a sterling example for his children to follow.

One of Hensel's early clients was Warren Monfort, a prominent figure in Greeley life and an early pioneer in the American cattle business. At the time, most cattle in Colorado were raised out on the range and then brought to central points for slaughter, meat packing, and shipment. But Warren Monfort raised his cattle in feed lots just outside of Greeley, and by centralizing his operations there he held down costs, maximized profits, and built his company, then named Monfort Feedlots, into a local powerhouse. And Warren Monfort's growing success was good news for many others in Greeley, including Joe's father and his start-up operation.

In 1939, Monfort hired Hensel's company to build a truck repair center for Monfort Feedlots. Hensel and his crews did a good job, they finished the work on time and on budget, and then Warren and his wife Edith hired Hensel and his team to do some remodeling work at their home. Do the work, get it right, satisfy the client, and then parlay that job success into another and another; that was bedrock America and that was the way Hensel built his business—and provided another sterling example for Joe to follow.

Growing up, Joe loved to go help the crews on his father's job sites, after school or on weekends. Much of the work Joe did was basic sawing and hammering—and this was before the arrival of power saws and air guns for nailing. It was great training, and it gave Joe a first-hand look into the necessary skills and the demands of the construction business. Even then, in his grammar school years, Joe was eager to work, to learn, and to feel that exhilarating "sense of accomplishment" that comes with a job well done.

Many parents today would not want their young sons hanging around a construction site, with all the dangers looming there. But just as Nita worked hard to pass along her faith and values to her children, Hensel worked hard to pass along to them his

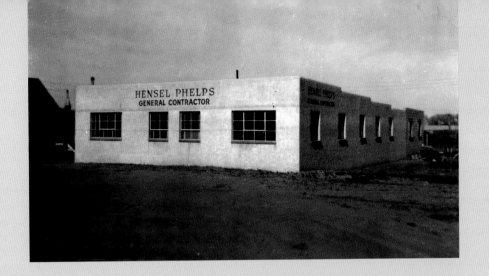

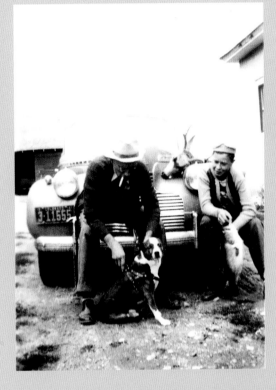

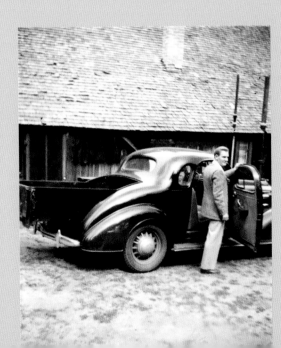

work ethic and a wealth of diverse, practical skills as well. In the fields and streams around Greeley, for instance, Hensel taught John and little Joe how to hunt and fish—and how to properly handle the responsibilities that come with both. The three of them often went hunting for rabbits, pheasants, ducks, geese, and deer too. During these outings, John always helped mentor his kid brother; despite their age difference, the two were very close. Also, by nature John was a caring, stalwart young man. In Greeley, he was widely known as "Deacon Phelps," because of his deep faith, his church work, and his strong sense of both family and community. Joe adored him.

As a father, Hensel passed along something else to Joe, something that would serve his son well his entire life: an eagerness to think creatively, to be inventive, to see how things work, and then figure out effective ways to make them work better, often using the least expensive materials at hand. Here is an illuminating case in point:

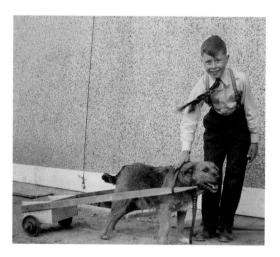

When Hensel first set up his contracting business, one of the things he needed most was a truck. How else to transport the tools and materials he needed at his job sites? But when he formally created his company, in 1937, Hensel was strapped for cash, and the U.S. economy was still in the grip of The Great Depression. Economic growth was flat, and unemployment was high: 15%— and even higher in farming areas like Greeley. No one had money to spare, including Hensel. Still, he needed a truck. So what did he do? He took his 1936 Chevrolet coupe and outfitted it with a long wooden box that he could jam into the trunk to carry tools and materials. Presto, a truck! Presto, problem solved! At very little cost too.

Little Joe quickly absorbed the lesson. Early on, with discarded scraps of lumber, he crafted a snazzy little cart for the family dog to pull. A short while later, and eager to ride his bike all over Greeley, Joe became frustrated with his old, hand-me-down set of wheels. So what did he do? In the spirit of his father, Joe located a motor from an old, rusted out Maytag washer and somehow managed to rig it up to his bike. Presto! A motorbike! Presto! Problem solved! And very cleverly, too, with not a single dime out of his pocket.

Now, how does a kid of 12 or 13 learn how to outfit his bike with the motor from an old Maytag washer? In *Popular Mechanics*, of course! The magazine, founded in 1902, was the bible for do-it-yourselfers of every stripe. In Joe's house, as in countless other farmhouses across America, *Popular Mechanics* held a place

JOE AND THE CART HE BUILT FOR THE FAMILY DOG

THE GREELEY CO-OP

Photo courtesy of the Greeley History Museum.

of pride on family bookshelves, right alongside the annual *Farmers' Almanac*. Later, the book *The Way Things Work* also enjoyed a place of pride in Joe's house, and you can easily understand why: in the Phelps home, necessity was the mother of invention. In those Depression days, with money always in short supply, there was simply no other way.

This same do-it-yourself ethos pervaded life in Greeley. Like most of their friends and neighbors, Joe's family went to church every Sunday, and Joe regularly attended Sunday school. He was not always attentive to Pastor Wood's sermons on the virtues of faith, family, and community, but Joe did his work at Sunday school and learned his lessons. Still, Joe's real treat each Sunday was the food.

After services, the church always hosted a big communal lunch, with families bringing home-cooked dishes and pies to share. Good food, good cheer, families celebrating together—these were values that Joe would cherish his entire life. Indeed, even 80 years later, Joe was still crowing about how much he loved those Sunday feasts, especially the fried chicken his mother usually contributed. Still, one thing was never to be enjoyed at those Sunday lunches: alcohol. No wine, no beer, no whiskey or gin. In Greeley, those were still akin to the Devil's brew, and no change was immediately in sight.

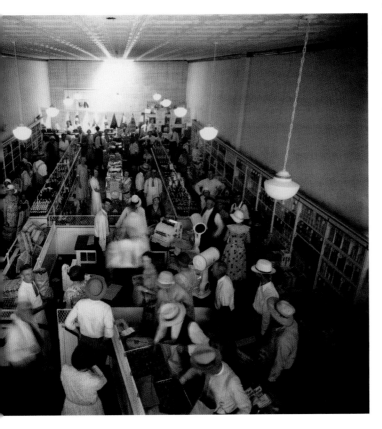

That same prevailing ethos of "work hard and share; we're all in this together" was also an anchoring principle of Greeley's shops and businesses. We saw that already with King Lumber, and how Earl King had helped Hensel get started in business and find new clients. Another example was the local food co-op in Greeley, a clear forerunner of today's Whole Foods and farmers' markets. Back in Maysville, Joe's family lived off their land as much as they could. But winters were tough. For meals, they drew on what they kept stored in their ice house, but they had little fresh meat or produce.

Life in Greeley was a little easier in this regard, thanks to the local farmers' co-op. There, with a single stop, families could stock up on fresh fruits and vegetables, as well as meats, eggs, flour, corn meal, spices and more. At that juncture in our history, America was still worlds away from the culinary wealth that we enjoy today, but I can see a distinct golden thread running from the Greeley co-op to what Joe would later create when he bought into the Oakville Grocery in the Napa Valley and turned it into a convenient gathering place for local farmers, artisans, and winemakers

to share their products and to serve the needs of their neighbors and the wider community.

As we saw, Joe's father was a resourceful man and very clever in finding innovative ways to solve problems. But very early on, Joe proved that in these same regards he was in a class all by himself.

By the age of 12 or 13, Joe had already become a skilled fisherman. Then, out on the streams, talking with his fellow fishermen, Joe spotted both a need and an opportunity: artfully tied flies were not in generous supply. Local anglers needed their Elk Hair Caddis, their Parachute Adams, their Pheasant Tail Nymphs, their Blue Winged Olives, their Muddler Minnows, their Woolly Buggers, and the other dry and wet flies and streamers they needed to attract and land the many varieties of trout to be found in the Cache La Poudre River and in the other local rivers and streams. And beyond trout, there were the salmon, mountain white fish, catfish, bass, blue gills, walleye, and other varieties of fish that anglers went after in the nearby lakes and ponds. Yes, Joe saw an opportunity, a big one, and he grabbed it.

In short order, he started his own fly-tying business, the Rocky Mountain Tackle Shop. At that time, fish hooks were in short supply, but Joe found a supplier out in Wisconsin and bought up all he could. Then he invented a fly that was entirely his own creation: the "Croppy Killer." To make it, he got chicken feathers from a local hatchery, and then he gave the feathers and the hooks to some pals—his first "subcontractors"—who did the fly tying. The venture was a success, and before long Joe had his own sales counter at Jones Sporting Goods, the leading sports shop in Greeley. By then, there was no mistaking the obvious: Joe Phelps was a born entrepreneur, and before he was even old enough to sprout whiskers and shave, the kid was well on his way.

Now, with his innate gifts and his rapidly evolving skills and instincts, Joe could have chosen several different paths to follow next. But out of fate, or perhaps it was even destiny, Joe was soon following in the footsteps of a number of true giants of American history, including the great Horace Greeley himself.

◆

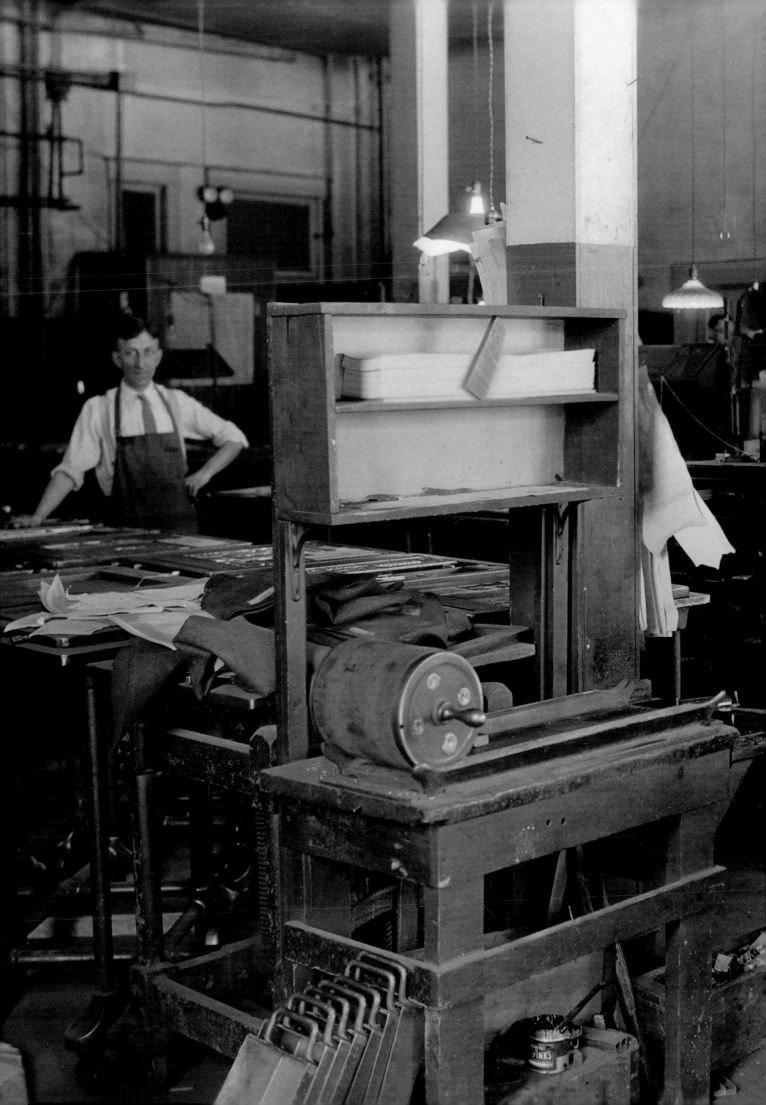

THE PRINTER'S DEVIL

Joe had a very special form of intelligence.

One minute at his kitchen table he would be telling me about the art of tying flies, the next he would be taking me into the art of pouring concrete: how working with concrete in the summer was so different from working with concrete in winter, and the special way concrete had to be poured in constructing a parking lot, to ensure proper drainage during rain storms and when the snow finally melted in the spring. As I soon came to see, Joe loved to study and master the intricacies of process; in his chosen realms he was like a walking edition of *Popular Mechanics* or *The Way Things Work*.

At the same time, Joe's was not an intelligence geared to abstract theory or patient, scholarly reflection. No. What Joe loved was practical knowledge, something he could put to use right away, and do so with his own hands and ingenuity. So it came as no surprise to me that in his early schooling, both in Maysville and in Greeley, Joe was a disinterested student. He wanted to build! He wanted to create! He wanted to look far beyond any classroom and learn how the wider world worked. And as Joe entered his teenage years, he found a smart, very practical way to do just that.

In the town of Greeley, as in so many cities and towns across the American heartland, the local newspaper was far more than a business; in many ways it was the heart and lifeblood of the entire community. *The Greeley Tribune*, founded back in 1870, was where everyone in town got their local and national news, their looks at local issues and politicians, their sports, their weather forecasts, their job listings, and their notices of the latest bargains and sales. *The Tribune* office itself was the nerve center of down-

THE PRINT SHOP
AT THE GREELEY
TRIBUNE

town Greeley; its imposing façade, and its bustling activity in and out, conveyed a feeling of solidity, importance, and community service—an ideal place for a kid like Joe to find out how the world actually worked.

And so it was that at the tender age of 13, even before he started high school, Joe marched into *The Greeley Tribune* and asked for a job. And as Joe recounted to me, he was hired right on the spot. I was not surprised. I had begun my own career at *The Baltimore Sun*, and I knew that newspapers back then—before the digital age—had a constant need for ambitious young kids: as paperboys, delivering the paper to subscribers throughout the city. As copy boys, running freshly typed stories from the reporters to the copy editors and then down to the typesetters. As errand boys, fetching coffee or sandwiches, and at the end of the day helping sweep out the newsroom and clean up the daily mess down in the print shop, left from handling type and big barrels of ink. Back in the day, this was all part of the romance and the grueling work of putting out a daily paper, and Joe told me he loved every minute of it.

And there was more. Joe was hired the way many young boys were in those days: as a "printer's devil." In title, that meant he was an apprentice printer, learning the craft; in reality it meant he did the grunt work for the printers: hauling ink barrels, helping mix the ink, wiping clean the used type, and mopping up at the end of the day's press run. After school every day, Joe went to *The Tribune* and worked a four-hour shift, and when he arrived the bosses had already posted, on the wall in the men's room, the checklist of that day's chores to be done. Unlike school, this was practical, hands-on work, with an immediate "sense of accomplishment." And he got paid for it too! Joe also took special pleasure in that term "printer's devil." It appealed to the touch of rascal he kept hidden inside.

For Joe, this began as a job, as a way to make some money and help out his family. But as he soon learned, a "printer's devil" enjoyed a respected place in the long history of American newspapers. In fact, some of our most celebrated presidents and writers had begun their working lives as a printer's devil, including Thomas Jefferson and Benjamin Franklin and Mark Twain and Walt Whitman. And as I mentioned earlier, Horace Greeley had begun that way too.

Mark Twain and Walt Whitman were drawn to the printers' back shop because they loved the romance of newspapers and the

Photos courtesy of the Greeley History Museum.

smell of the ink, and they wanted to become writers. Horace Greeley was drawn to newspapers because he wanted to help shape the future of America and he understood the special power—and the special responsibilities—that newspapers carry in a democratic system of government. Joe Phelps had no such ambitions. By nature and by passion, he was a budding entrepreneur, eager for practical skills and experience, and *The Greeley Tribune* gave him all he could handle. And Joe added a few entrepreneurial flourishes that were uniquely his own.

After his stint as a printer's devil, Joe was promoted to paper boy, delivering papers by bike to his assigned sections of Greeley. Every afternoon when the papers came hot off the press, Joe and the other paperboys gathered outside, next to a chute that ran down the side of the building. When the finished papers came sliding down the chute, the boys would roll them, fix them with a rubber band, and then stuff the papers into their bicycle baskets and set off on their appointed routes. And right there, just as he had with his fly-tying activities, Joe spotted a very sweet business opportunity: he bought up all the rubber bands in town and then sold them to the other paperboys, at a tidy little profit of course.

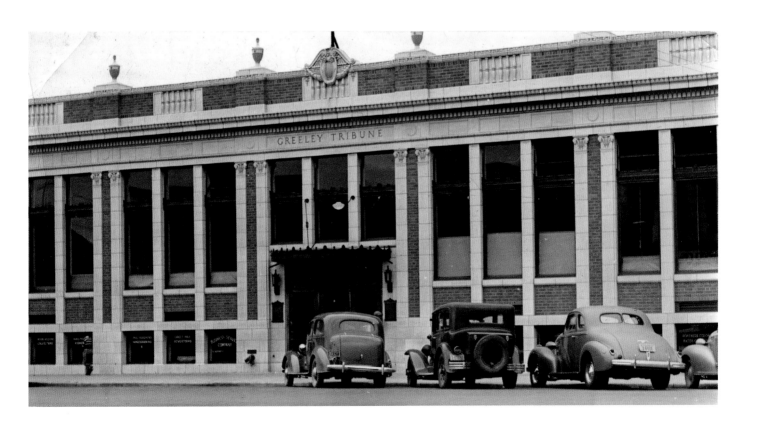

Clark Page, the plant manager and driving force of *The Greeley Tribune*, knew potential when he saw it, and soon he put Joe in charge of one of the paper's most important side-ventures: selling and printing wedding announcements and invitations. In that role, Joe did it all: he met with customers, listened to their needs, then created the designs, chose the paper, oversaw the printing, and made sure his customers were totally satisfied. Impressed by the kid's talents and initiative, Clark Page then gave Joe another job on top of that one: he made him a deputy circulation manager. Here Joe's job was to make sure every subscriber in Greeley got their paper, and if they didn't, it was Joe's job to fix it. Fast! This was a big job and a lot of responsibility, especially for a young boy just starting high school.

All this work at the paper, on top of his school work, left little time for girls or for sports. Joe was a pretty fair athlete, and at Greeley High, later called Greeley Central, he tried out for the football team. But it didn't work out as he hoped. Joe was strong and determined, but he was not a natural athlete, and the practices were a real ordeal for him. So Joe left football aside and poured his energy into fulfilling his different responsibilities at *The Greeley Tribune*—ideal opportunities for Joe to learn how the real world worked and to earn his prized "sense of accomplishment."

At home too, Joe was carrying a heavy load of responsibility—and a heavy load of pain as well. On May 21st, 1940, when Joe was only 12, his older brother John, that stalwart young man widely known and admired as "The Deacon," was killed in a tragic auto accident.

It happened seven miles west of Greeley, as John and a pal of his, Bill Williams, were driving home on a break from their classes at Colorado A. & M., in nearby Ft. Collins. On the drive home, with John at the wheel, they ran into a torrential downpour, and at one point their car skidded and slammed head-on into an oncoming vehicle. John was killed instantly and Bill was seriously injured.

The whole family was devastated, of course, and left to cope with a gaping wound that would never fully heal. "He was my hero," Joe told me, his voice shaking as if it had happened only yesterday. "It changed my life. It changed all of our lives."

From that point forward, Hensel and Nita, and Joe and his two sisters, Mary and Maggie, drew even closer together as a family. It was the only way to cope. And as Joe told me, from that point on, he felt a deep and enduring responsibility to help care for his

mom and dad and to help provide for the family; he was only 12, but now Joe was, as he put it, the only other "man in the house."

For any parent, there is no event in life more horrifying, or more traumatizing, than losing a child, and in all the photos I saw of Nita and Hensel later in their lives, you can see it plainly in their faces and their postures: there was something broken deep inside. Joe being Joe, he didn't want to talk too much more about John and his passing, so young, so unbearably tragic. But I think that one event helps explain how Joe conducted the rest of his life, and it helps explain too his steel-like work ethic and his ferocious, unrelenting drive to succeed and to always provide for his family and the other people closest to him. And on the heels of all this, the golden thread of Joe's life led straight into the heart of another national upheaval:

Pearl Harbor.

Just before 8 a.m. on December 7th, 1941, in a stunning sneak attack, hundreds of Japanese aircraft swept in and hammered the U.S. Navy's arrayed fleet and shipyards at Pearl Harbor, close to Honolulu, Hawaii. The Japanese planes pounded their targets for a full two hours and the losses they inflicted were massive, in both men and materiel: 2,000 American soldiers and sailors were killed, and another 1,000 were wounded. Some 20 U.S. vessels, including eight of our most powerful battleships, were destroyed, and so were more than 300 airplanes surprised while still on the ground. Just as bad, the attack cut deep into the American psyche: December 7th, 1941, would forever be known as "The Day of Infamy."

The following day, President Franklin D. Roosevelt asked the U.S. Congress to declare war on Japan; Congress approved, with just one dissenting vote. Three days later, Japan's key allies, Germany and Italy, declared war on the United States. Again President Roosevelt and Congress responded in kind, formally bringing America into the heat, fury, and massive death and destruction of World War II. Indeed, much of the world was already in flames, and the whole of America was now being put to the test, from sea to shining sea.

Joe had turned 14 just a month before.

For those of us who came of age during the Vietnam War or much later during the wars in Iraq and Afghanistan, it is hard to

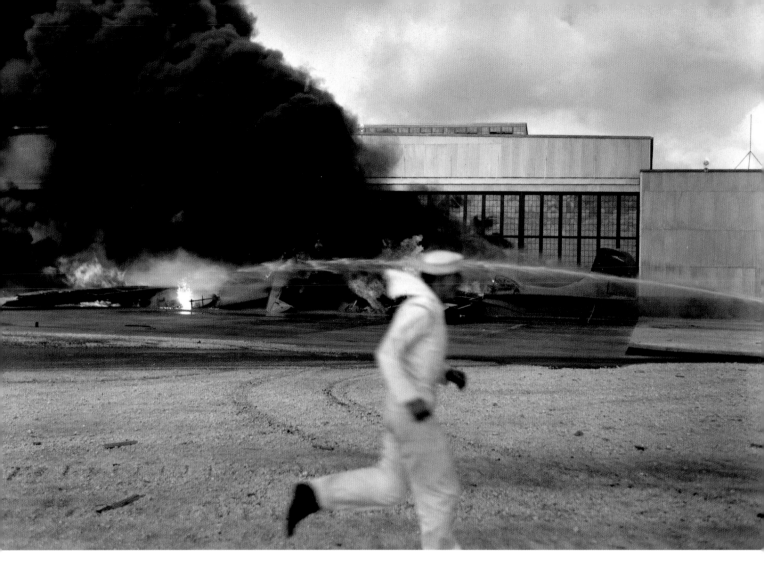

imagine how dramatically everyday life in America changed in
the wake of the attack on Pearl Harbor. In 1917, at the height of
World War I, the U.S. Congress had passed the Selective Service
Act, requiring young men to sign up for military service. After that
war, the act was cancelled. But in 1940, as ominous war clouds
again gathered over Europe, the U.S. Congress again imposed
a draft, requiring men between the ages of 21 and 36 to register
for military service. After Pearl Harbor and the ensuing years of
World War II, some 34 million men enlisted in the armed forces,
and 10 million men went into battle. But the American response
went far beyond that.

Here on the home front, President Roosevelt, as he had done
during the Dust Bowl crisis, again took to the airwaves each week
to keep us informed, to rally the country, and to again summon
the very best we had inside. In response, legions of civilian men
and women joined the war effort, in particular by working in facto-
ries and hospitals across the country. In short order, "Rosie The
Riveter," muscles bulging, became a galvanizing symbol of the
war effort and of America's bedrock character and can-do spirit.

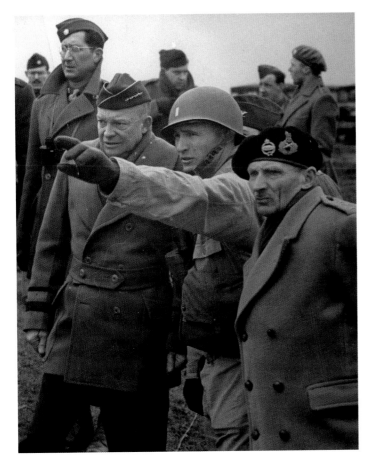

During the long years of wartime and hardship, Joe continued on at Greeley High, and he continued to work at *The Greeley Tribune*. During this period, Hensel was often working away from home, mostly on job sites up in Wyoming, while Joe's sisters, Mary and Margaret, continued their studies and helped Nita at home with the cooking and cleaning. That often left Joe as the only "man in the house," and he was constantly looking for new ways to bring in money and help the family. And given all the wartime restrictions and shortages in and around Greeley, he did not have far to look.

From Pearl Harbor forward, military planners faced a potential disaster: any shortage of rubber for tires or gasoline for military vehicles could gravely threaten America's war effort. Accordingly, the U.S. government discouraged private travel and imposed gas rationing nationwide. That meant that to buy gas, you had to have government-issued gas coupons. Soon, too, people in Greeley and across the country faced severe shortages of other essential goods: rubber, cement, and steel. All these had to be rationed too, and the overall message to the American people was clear: "Work hard and share; we're all in this together."

To help amplify the war effort, on January 1st, 1942, just three weeks after the Pearl Harbor attacks, President Roosevelt and his advisors took another dramatic step: they banned the production of new cars. From there, the nation's automakers rapidly converted their assembly lines to churn out Jeeps, trucks, tanks, fighter planes, and bombers—as fast as they could. That same year, a "Victory Speed" of 35 miles per hour was imposed throughout the nation, and instead of driving cars Americans were urged to ride "Victory Bikes." Joe's Maytag-powered bike would certainly qualify. But where to find the gasoline he needed to keep it running?

Yes, Joe needed gas for his motorbike, to get back and forth to his job, and Joe's father needed gasoline to keep his trucks rolling to and from their job sites. And now there was no escaping the brutal realities that war had imposed on Joe and his family: the future of Hensel Phelps General Contractor was now on the line—as was the financial future of the Phelps family. After all, how do you survive in business as a general contractor when gasoline, concrete, steel, and other essential building materials are under government rationing and very difficult to obtain? Yes, tell me: How do you survive?

The answer? Improvise! Wangle! Can-do!

According to Joe, his father may not have been the best farmer in the world, but during the war Hensel found almost magical ways to locate the concrete, steel, and rebar he needed to keep his business up and running. But what about gasoline? Where could he get that?

Well, by hook and by crook, and on top of his schoolwork and his duties at *The Tribune*, Joe managed to wangle himself a part-time job at a local gas station. There, he was able to put a few dollars in his pocket—and gas in his motorbike. Much more importantly, the job gave Joe access to something far more valuable: gas coupons. And not just the ordinary class "B" coupons that most citizens were able to obtain. No, by working at the gas station Joe was able to secure a steady supply of "E" coupons, those reserved for emergency vehicles such as police cars, fire trucks, ambulances, and civilian vehicles in service to the military. In sum, those "E" coupons were pure gold: they took their holders right to the front of the gas lines.

Those coupons were certainly gold for Joe's father and the family. Throughout the war, they enabled Hensel to keep his trucks and most of his equipment up and running—and keep his business running too. And with those highly coveted "E" coupons in hand, did Joe ever wheel and deal and make a little extra profit on the side? When I asked him that across his kitchen table in the Napa Valley, Joe just gave me a playful little wink.

On June 6th, 1944, U.S. General Dwight D. Eisenhower, and British Field Marshal Bernard Montgomery, launched the Allied invasion of Normandy. The D-Day operation, planned in the strictest secrecy and with several ingenious layers of deception, had one overriding objective: to thrust a huge Allied landing force onto European soil in order to begin the final push to defeat Adolf Hitler and the forces of his Third Reich.

In the history of warfare, no one had ever mounted an operation of such magnitude. Indeed, D-Day represented the largest amphibious invasion ever contemplated, and it demanded exceptional levels of leadership, planning, team building and training, logistical support, resource procurement and deployment, hard-eyed risk assessment, precision coordination, and then, of course, brilliant execution. And it required plenty of luck too. And the stakes could not have been higher: the fate of America, Britain,

Canada, Australia, and all of our other allies—plus the lives of tens of millions of people around the world—now hung precariously in the balance.

On the crucial Day One of the landings, while the Germans were expecting an attack much further to the north of France, General Eisenhower and his fellow Allied commanders hit the beaches of Normandy with waves of landing craft carrying 156,000 soldiers, supported from the air by a force of 11,000 Allied warplanes either on the attack or ready to go. The Allied fleet they had assembled was massive too. According to official U.S. naval records, the fleet supporting the landings included 1,213 combat ships, 4,126 landing craft, 736 ancillary craft, and another 864 merchant vessels.

The fighting was brutal and relentless, as the Allied soldiers waded ashore and fought their way in, almost inch by inch, under constant enemy fire from the ridges and the gun emplacements above. The casualties were dreadful on both sides: over 425,000 Allied and German troops would be killed, wounded, or listed as missing in action. And even today you can glimpse the full measure of what was lost: visit the Normandy coast and you will find cemeteries lined to the horizon with white crosses and Jewish stars. And for generations of Americans and their families, the names of those beaches will forever remain engraved in their consciousness: Omaha. Utah. Gold. Juno. And Sword.

Still, despite all the bloodshed, and in part because of it, General Eisenhower and his fellow Allied commanders were able to achieve their objective: the Normandy landings set in motion the ultimate defeat of Adolf Hitler and his forces of evil—and soon the defeat of Imperial Japan as well. "Freedom is never free," became the pained lesson for all of us to learn, and when Hitler's death camps and gas chambers were fully uncovered and shown to the world, along with the stories of the six million Jews and others who had been put to their death, two more words were burned into the hearts and souls of millions of people here in America and far beyond: "Never again."

On August 6th, 1945, as ordered by President Harry S. Truman, President Roosevelt's successor, U.S. forces detonated an atomic bomb over the Japanese city of Hiroshima. Three days later, the U.S. detonated a second atomic bomb over the city of Nagasaki. The carnage was horrible, but it served its intended purpose. Stunned, and their will now broken, the Japanese formally surrendered on September 2nd, 1945, in a solemn ceremony aboard the

USS Missouri, named after Joe's home state. With the stroke of a pen, all the horrors of World War II were finally brought to a close.

No one came through that war unmarked, including Joe. Once the war was over, and once he had graduated from Greeley High, Joe remained high-spirited and restless, still loving his job at *The Greeley Tribune*, and he still had plenty of boyish charm in his smile, as you can see in his formal graduation photo.

Still, Joe had now experienced terrible hardships right up close: the death of his beloved brother John. His father's business struggles. The sacrifices imposed by war on his family, on his town, and on his country. Through those hardships, Joe had learned a whole series of essential lessons: Work hard. Watch. Learn. Be vigilant. Be smart. Be inventive. Seize opportunity wherever you see it. And always do whatever it takes to protect your family and those you love.

There was more. From his mother, Joe had learned the power of faith. And from his father, from seeing him soldier on with a broken back, from seeing him suffer the loss of the family farm back in Maysville, and from seeing him come to Greeley and then bravely start his life all over from scratch, Joe had learned something else: Never give up. Never, ever give up. Never stop adapting to the core needs of the day, never shirk your responsibilities, and never let the woes of the moment sap your spirit or cripple your future.

There was more still. From working at *The Greeley Tribune*, Joe learned first-hand that businesses grow and prosper by serving the needs of their customers and their wider communities, and the best thrive, year after year, by believing in their people and treating them right, and by faithfully upholding their highest ideals and values, just as Horace Greeley had preached decades before.

Yes, as he moved into manhood, these were essential lessons for Joe, and more would soon be coming. And thanks to that golden thread that so intimately bound Joe's journey to that of America itself, some of the most crucial and inspiring lessons would come from a modest, self-effacing farmboy from Texas and Kansas, the man soon to be elected President of these United States: Dwight David Eisenhower. Destiny, I believe, would have it no other way.

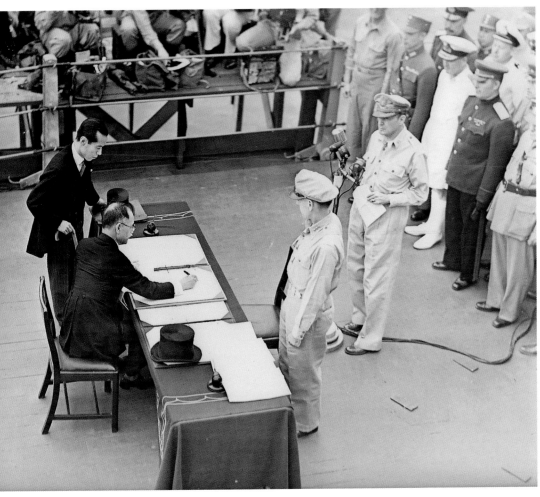

JAPAN
SURRENDERED,
ON BOARD THE
USS MISSOURI

*Photo courtesy of
Paul Chutkow.*

JOE'S HIGH
SCHOOL
GRADUATION
PHOTO

CONCRETE & STEEL

CONCRETE & STEEL

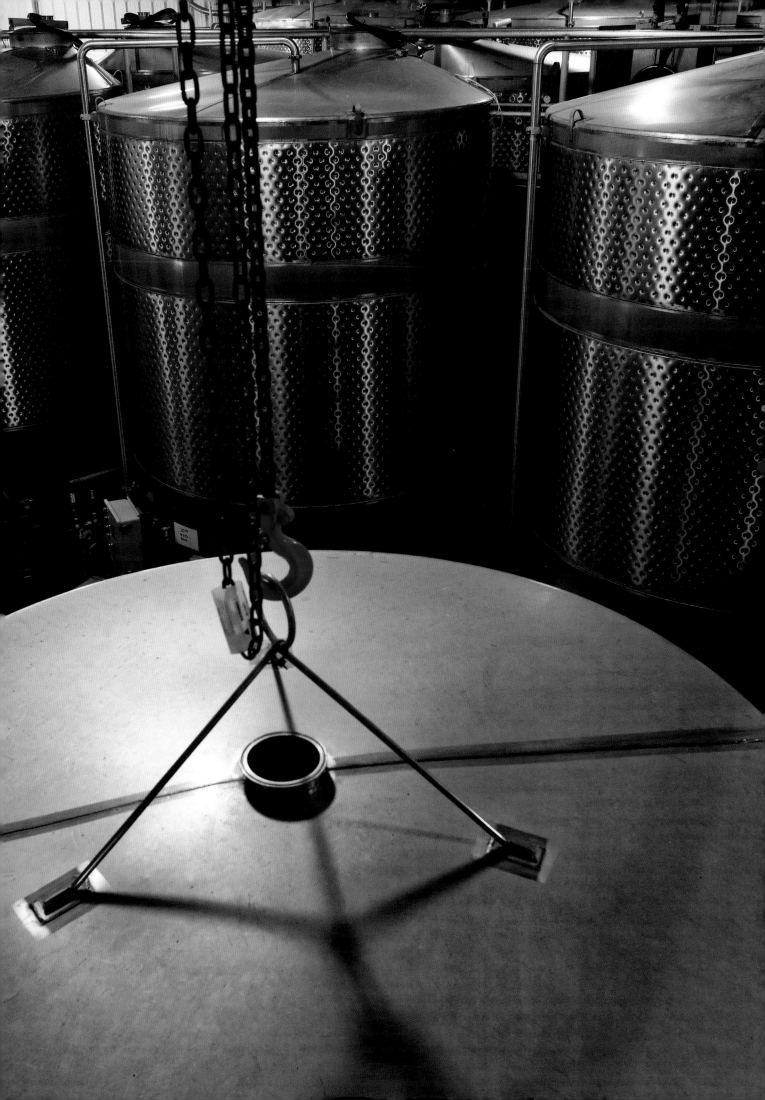

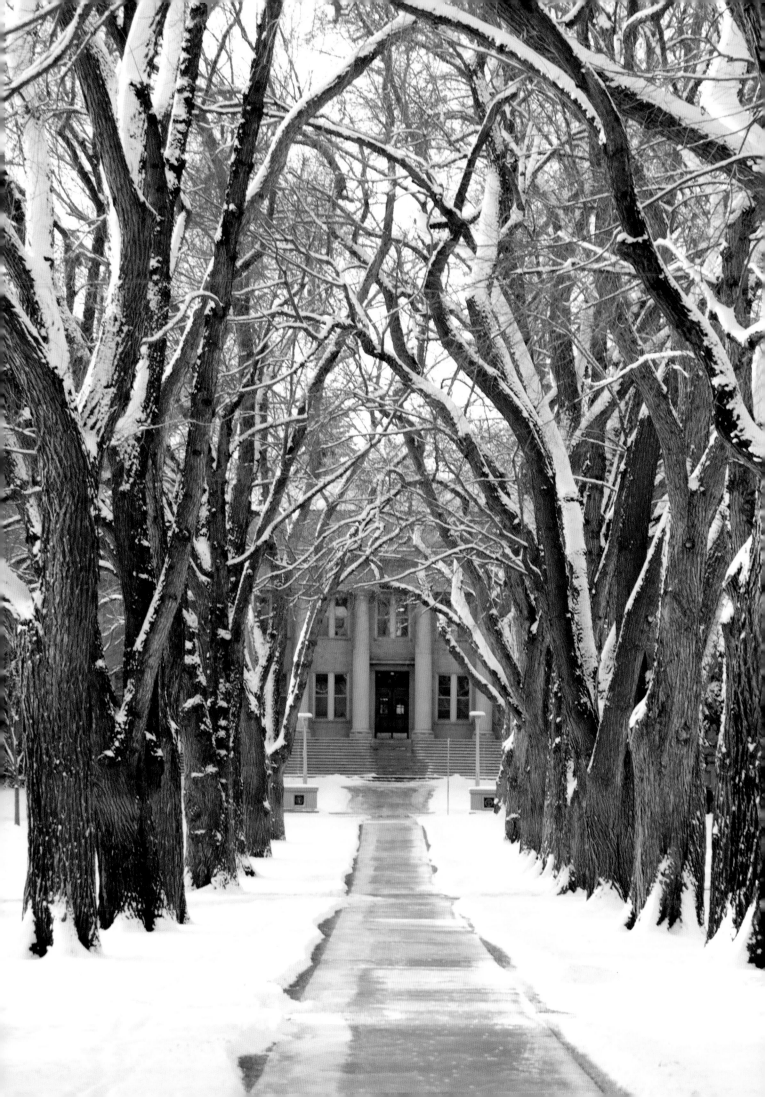

THE WILL TO SUCCEED

Hardship is a magnificent teacher.

And Joe's teenage years were a perfect case in point.

Given the hardships of war and his father's business struggles, Joe put aside the usual joys and growing pains of being a teenager and did what had to be done. On top of all his schoolwork, he worked nights at *The Greeley Tribune*, he worked several hours a week at the gas station—to secure those critical gas coupons—and when he could, he also helped out the crews at Hensel's construction sites. And what did all that commitment and hard work bring him?

I posed that question to Joe one morning as we sipped coffee at his kitchen table. As he often did, Joe just sat back quietly, reflecting, collecting his thoughts, and then he cut right to the marrow of it:

"One day I arrived at *The Tribune* and found I was being given a new assignment," Joe told me. "Clark Page was moving me into the circulation department. I was only about 14 or 15, but I was being given enormous responsibility. Each night the circulation manager would sit down at his desk at 6 p.m. and over the next two hours he would get calls from people complaining that they had not received their paper. And every night it was my job to set that right."

Yes, around 8 p.m. Joe would be handed a list of the callers and their addresses, then he would load up his motorbike with papers and personally deliver them right to the door of the people who had called in to complain. "It was usually a very cold night, with snow on the streets, but I had to make that delivery, snow or no snow. Our business depended on it. And so did my job."

COLORADO STATE
UNIVERSITY

The Oval,
leading up to the
administration
building. Photo
courtesy of
Colorado State
University.

79

As Joe explained, delivering those papers, night after night, rain or snow, brought him lessons that would motivate and guide him for the rest of his life: "Do what you're being paid to do. No whining. No excuses. Just do the work and do it right." At *The Tribune*, Joe did exactly that—and it paid off handsomely. His bosses were so impressed by his work and his work ethic that they promoted him to Circulation Manager —while he was still a teenager. "That was probably the most important promotion I ever received," Joe told me. "It burned into me the will to succeed."

"The Will To Succeed."

For Joe, everything he achieved later in life—in construction, in wine, in community building, in philanthropy—everything began with those four words. At different stages, other factors would also drive him: Fear. The fear of failure. The fear of seeing his family hit a bad patch and lose it all, as they had during the Dust Bowl. And he was often driven too by the sheer thrill of tackling something entirely new, like buying land and starting a winery totally from scratch, or taking up flying at the age of 60. Succeeding in those different realms required other skills, of course, but in Joe's mind the first essential quality was always the same: The will to succeed.

For Joe, that was a fundamental realization. And after World War II was finally brought to a close, with the Allied victory over Nazi Germany and Imperial Japan, he began wrestling with The Big Questions, the ones every young person faces, now as then: What path to follow in life? What college or university will best set me on my way? When he graduated from Greeley High in 1945, Joe had no firm answers to those questions. But this much he knew: he did not want to spend his life in the newspaper business. Yes, he still wanted to do things of real value for his customers and his community. But each day the staff at *The Greeley Tribune* poured their collective hearts, soul, and talents into putting out the paper, and a day later the results of their combined efforts would be used to wrap the trash or line the birdcage. No, that was not for Joe.

What about construction? Joe, of course, had grown up around his father's construction sites, watching and sometimes helping the crews build grain elevators, refurbish homes, or add new wings to local schools and churches. That was appealing work, yes, and it provided something of lasting value to your customers and your communities. And of course Joe loved to build: soon he would be taking another page from *Popular Mechanics* and build-

JOE, WITH
THE SAILBOAT
HE BUILT ONE
SUMMER DURING
COLLEGE.

ing his own sailboat. Still, Joe just couldn't see himself following his father into the world of construction, not at this stage anyway. There would be no fresh challenge, no new mountain to climb, no new trail to blaze.

What about architecture? That idea really appealed to Joe. He'd be coming to his passion for building from another angle. He'd be designing houses and buildings, he'd be innovating, and he'd be free to create something according to his own vision and desires. Yes, that intrigued Joe. The freedom to create. His way. But Joe had no idea what it would take to become an architect. And where best to start the process? He had no clue. None.

So Joe was in a quandary: where to go to college? Greeley was home to Colorado State College, later named the University of Northern Colorado, a highly respected teachers' college, but going there held no appeal for Joe. He had never really liked school or being cooped up in a stuffy classroom; there was no way he would make a career in education. And there was a much more attractive option not far away: the Colorado State College of Agriculture and Mechanic Arts—Colorado A&M for short.

Colorado A&M was located in Ft. Collins, a lively frontier town located 60 miles due north of Denver and 32 miles northwest of Greeley, making it an easy bus ride or hitchhike from Greeley. And Ft. Collins had a colorful history, one very much aligned with Joe's family history. The town was founded in 1864, near the end of the Civil War. It began as a western outpost of the U.S. Army but it quickly grew into a bustling farm community, thanks mainly to its robust production of sugar beets and lamb. To serve the needs of farm families in the region and beyond, in 1870 state authorities created the Colorado Agricultural College, and in 1879 the school opened its doors in Ft. Collins—welcoming all of five students.

But as more and more Americans pushed West into Colorado, just as Joe's family had, the college grew in size and in its areas of training. In 1935, the school was renamed Colorado A&M, to better describe its broader reach, and by then the school had earned a rising reputation for providing top-level, practical coursework in engineering, veterinary medicine, botany, horticulture, entomology, irrigation science, and more. The school also provided courses in the liberal arts, but its bread and butter remained technical training, giving students the practical skills they needed to grow crops, build businesses, and help build the future of the American West. From high above, Horace Greeley was no doubt smiling upon them.

For Joe, Colorado A&M became a relatively easy choice. His older brother John had been enrolled at Colorado A&M when he was killed in that tragic car crash, and he had thoroughly enjoyed his coursework there. Moreover, the in-state tuition was manageable, and Joe had several friends who had chosen to go to A&M as well. Joe also liked the location; he was intent on coming home on the weekends. In all, to Joe it seemed like a good fit, and he would have a wealth of subjects to explore. So Joe enrolled, and started out in the department of engineering.

Still, Joe faced one serious issue: Money. Financially, he was all on his own. Nita and Hensel were insistent that Joe and his two sisters go to college, firmly convinced that a good education was the royal road to success. And while they did help Mary and Maggie with tuition and room and board at their schools, they relied on Joe to make his own way at A&M. Indeed, the first time Joe packed a bag and left for Ft. Collins, his parents didn't drive him the 32 miles; they plunked him down alongside the road to Ft. Collins and wished him good luck. Another hard-nosed lesson in self-reliance.

From there, to pay his tuition and room and board, Joe needed a job. And where did he land the job he needed? At Gamma Phi Beta, one of the most popular sororities on campus. Sweet! For Joe, the work at the sorority was a joy and so were the perks: at meal times, Joe and a fellow "hasher" set the tables, served the meals, cleaned up, washed the dishes, and in the process he got to meet some of the prettiest and smartest girls on campus. Talk about landing in clover! Talk about a dashing young man destined for success! And there was more still...

Joe was soon invited to join one of the most prestigious fraternities on campus: Sigma Phi Epsilon. "Sig Ep" was not for the shy or the nerdy. This was for "the BMOC's, The Big Men on Campus," the leaders and titans of tomorrow. Indeed, through Sig Ep, Joe soon became friends with two young men who would become major forces in Colorado business, politics, and much more: Kenny Monfort and Roy Romer, a future governor of Colorado.

Kenny Monfort was the son of Warren Monfort, a pioneering figure in the American cattle business and, if you recall, an early client of Hensel and his contracting business. Kenny and Joe shared a deep, unspoken bond: they both had lost older brothers they cherished. As we saw, Joe's older brother John had been killed in that tragic auto accident driving home from A&M. And

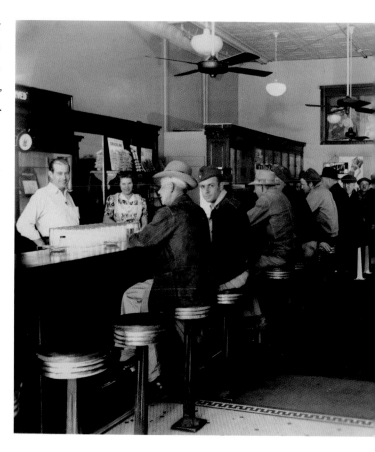

INTERIOR OF SPORTSMAN CAFE, 1946–52.

BARBARA PLUMB AND HELEN GEORGE WORKING IN THE FINANCE DEPARTMENT OF POW CAMP 202 IN GREELEY, 1943–1946.

Photos courtesy of the Greeley History Museum.

Kenny's older brother Dick had been killed during World War II, while serving in the U.S. Air Force. In January of 1944, Dick Monfort was serving on the crew of a big B-17 bomber when it was shot down during an Allied bombing mission over Frankfurt, Germany. Joe and Kenny remained close throughout their lives, and their wives and children did as well.

For Joe, his early years at A&M were a time of hard work, but they were also a time to cut loose. Back in Greeley, Nita and Hensel were stalwart members of the Methodist Church, and they lived quiet, modest lives and they expected Joe and his two sisters to do the same. Mary and Maggie did as their parents expected, but Joe was a very different story. "He was a total hell-raiser," his son Bill told me, with a generous laugh. "The stories are endless."

Indeed they are. And not surprisingly, beer and whisky often fueled the campus hijinks. Alcohol-wise, Greeley was "dry," and officially Ft. Collins was too. But there were several bars and taverns around town where Joe and his pals would go to enjoy beer, whisky, and music. And as on most college campuses, boisterous beer parties were a staple of sorority and fraternity life at A&M. Fine wine and the Napa Valley were still a million miles from Joe's field of interest—and from America's too—but at Colorado A&M he developed a love of beer, and he developed a reputation for being able to guzzle huge quantities at a single go. Party time? Our Joe was there! He was working hard, playing hard, and having an absolute ball.

By the end of his first two years in engineering, though, Joe was getting restless. His work in engineering, he told me, was far too much math and slide rules; there was no kick, no creative juice. And by now a compelling new figure had come into Joe's life: Dewey Luster, known far and wide as "Snorter" Luster. In the world of college football, especially in the Midwest, Snorter Luster was something of a legend. He had played football at the University of Oklahoma—he was a star defensive back—and during the war Snorter became head coach of the Oklahoma Sooners. Snorter was a charismatic figure, a natural leader and motivator, and he and his wife took an immediate interest in Joe. And with good reason: Joe had a little twinkle in his eye for their daughter Pat.

Well, one thing led to the next and soon Joe was down in Norman, Oklahoma, moving into a converted barracks and enrolling at the University of Oklahoma, planning now to switch to architecture. That plan lasted all of a week. "It just didn't feel right," Joe told me. Things with Pat didn't work out either. The two remained close friends for many years—later Joe even took Pat to a Super Bowl game—but it was not a romance destined to last. So Joe returned to Colorado A & M, in time to resume classes there.

By then, though, something new and exciting was happening across America. You could feel it in the offices and the lunch counters of Greeley. You could feel it on the avenues of Ft. Collins, and you could read about it in the pages of *The Greeley Tribune*: the country was on the move. The economy was starting to surge. The wartime blues were behind us now, and America as a whole was about to sweep into a period of unprecedented growth and prosperity. And few states were being affected as dramatically as Colorado.

Indeed, during the war years the federal government had poured tens of millions of dollars into Colorado, for the building of military installations, research labs, and various civilian projects too. The result was an immediate surge in new jobs and new people coming into the state. Now, on top of that, thousands of military men who had done their basic training in Colorado were coming home from the war and returning to the state and its wide open spaces to finish their studies, settle in, and start their families. By 1949, the state was already seeing the start of an economic and population boom, and that boom was bringing with it an escalating demand for expertise and skilled manpower in a crucial industry: Construction.

How to meet that escalating demand? Colorado A&M was eager to help lead the way. As a first step, it carried out a comprehensive evaluation of the coming needs of the building industry throughout the state. Then, based on their findings, the leadership at A&M created something that few universities or colleges in America had: an innovative, interdisciplinary program to give students hands-on, real-world training in how to plan, manage, and build construction projects, big and small. With great intelligence and foresight, the school launched the program with financial and technical support from leading construction companies in Colorado, helping ensure that their students would receive top-quality training as well as top-quality job opportunities when they graduated and went out into the workplace. This pioneering program

opened in 1946 with only ten students. But soon would come another: young Joe Phelps.

As we chatted at his kitchen table in the Napa Valley some 70 years later, Joe made no bones about it: his years at Colorado A&M—now Colorado State University—had been a major turning point in his life. And the training he had received in that pioneering program—called "Light Construction and Marketing" at the outset—laid the foundation for his later success in the construction business. Joe already had "the will to succeed." A&M took him from there.

As Joe explained it to me, his coursework was a happy mix of book learning and hands-on training, all of it taking him far beyond what he had learned at his father's construction sites. Now, from the ground up, Joe learned how to survey a given site and manage its special needs. He learned how to pour concrete. How to work with steel and rebar. How to plan for plumbing, electricity, roads, and water. Joe also learned the fundamentals of project management: How to assess the materials and manpower necessary for a given project, how to establish a sound financial plan, and how to get a project done, on time and on budget. As at *The Greeley Tribune*, this was stimulating, hands-on training, giving Joe the kind of real-world skills and expertise he would need in construction and most other businesses as well. Yes, for Joe this training was pure gold, and he poured himself into it—but he still had time to play.

Perhaps too much time. One day there was a small explosion in a campus chemistry lab, courtesy of Joe's experimenting. And one night, in very high spirits, Joe and some of his pals drove over to the town of Boulder, home of the A&M Aggies' arch rivals, the University of Colorado. At Kappa Kappa Theta, a popular U. of C. sorority house, someone burned a huge "A"—for Aggies—onto the front lawn. That did not go down well with university authorities; Joe and a few of the others were suspended from A&M. I asked Joe about that episode, and in his typically wry manner, he said, "Oh, you know about that?" He wouldn't confirm the story, but that sly little smile on his lips told me all I needed to know.

Still, with his relentless drive and will to succeed, Joe managed to turn his suspension to his advantage. He landed himself a job as a project estimator with one of the leading construction companies in Denver. At F. J. Kirchoff Construction, now defunct, Joe's job took him deep into the dollars and cents of how to put together a

major construction project—and do it in the most cost-effective way. This was challenging work, with high stakes too. As usual, though, Joe made light of it all: "Basically, I was just counting bricks, and figuring out how many bricks we needed to complete the project."

Modesty aside, Joe's job was to evaluate the needs of a given project—in terms of time, materials, and manpower—and then he had to develop a financial plan to get that job done, on time and on budget. At the end of this process, he had to give his bosses a number—the number from which they would make their bid on the given project. Everything rode on that final number: if the company's bid was too high, Joe's firm might not win the construct. But if the bid was too low, Joe's company might get the job—and then lose a ton of money from cost over-runs. A mistake like that could drive a company into bankruptcy. That was a lot of responsibility on the shoulders of a young man not even old enough to vote. But what fabulous training!

After that year in the field, Joe returned to Colorado A&M in the fall of 1948 to finish his studies and earn his degree. But he was still doing his share of beer drinking and hell-raising. And poor Nita; her son could be so exasperating! Would he ever settle down? On February 23rd, 1949, Nita noted in her diary that she had done Joe's laundry and mailed it back to Ft. Collins. In fact, her diary reveals that she was doing his laundry almost every week. As I read those entries, each done in Nita's very careful handwriting, I often thought, "What the heck is going on here?" By then, Joe was 21 years old, he was out in the world, and in every other aspect of his life, he was Mr. Independent. Mr. Self-reliant. And he couldn't manage to do his own laundry?

One day, though, Joe's son Bill told me something that struck a chord. "I think Nita was deeply depressed," Bill said. "The sudden death of her son John, so handsome, so caring, obviously destined for great things, I think that took a much deeper toll on Nita than she ever let on." As Bill and his sisters could see from family photos, when Nita was young, her eyes were brilliant—and piercingly so. But in her later years, Nita's eyes had lost their shine, as if John's death had dulled her inner light.

There was something else. Joe was the "baby" in the family; when he left for A&M Mary and Margaret were already gone, living their own lives, having their own families. That left Nita with an empty nest. Imagine it. Early on, when her parents died, Nita

had stepped in and raised her eight brothers and sisters. And then came the four kids she had given birth to and raised with Hensel. And now here she was with an empty house, with no one to teach to read and no young noses to wipe clean. In a diary entry on Sunday, February 5th, 1949, Nita clearly reveals her feelings. Joe had just come in for the weekend, she wrote, but after church he had left to go back to school. "Always lonesome when Joe goes back," she wrote.

When I read those words, I finally understood about Joe and his laundry. Of course he could have done his own laundry. But with each load of laundry he brought home, he was showing his mom she was still needed, she was still integral to his existence—and from her diary it becomes clear that her daughters were doing the very same thing. Nita's entries also reveal something sad about Hensel. He was still going to work, still marshaling on with his bad back, but his inner light had been dulled as well. As Nita wrote on May 30th of 1950, "Hensel worked in the yard. It is such a satisfaction to me to see Hensel take an interest in the yard. For so many years he was so indifferent to it."

Joe, good son that he was, always shouldering his responsibilities, always caring for those closest to him, would soon bring a flood of light back into his parents' lives. And in a diary entry on Saturday, June 24th, 1950, Nita clearly expressed her rising excitement: "Joe bought the diamond. So now we hope he is going to settle down."

Yes, Joe Phelps was now in love, with a woman of character and heart to match his own, and a whole new chapter in his amazing journey was now set to begin.

THE SIG EP
HOUSE IN THE
EARLY 1950S

*Photo courtesy
of the Colorado
State University.*

LOVE & WAR

It happened fast.

Joe met Barbara Ann Babcock in the spring of 1950, when they were both students at Colorado A&M, and for Joe there was an immediate click: she's the one. And there was no mystery as to why: Barbara was a lovely, gracious, and highly intelligent young woman, coming from a good family in Denver, and she had plenty of spirit too. As Joe told me, Barbara often hitchhiked to and from school, and she liked going to taverns and parties with Joe as well. Almost immediately Joe brought her home to meet mom and dad; this was no fleeting romance, this was for keeps.

Joe, always a young man in a hurry, was now going triple speed; he was head over heels. By May 14th of that year, Mother's Day, big things were already brewing. As Nita reported in her diary, Joe's sister Margaret hosted a festive dinner for the entire family. Joe brought Barbara, and guess who else came to dinner? Barbara's parents. They drove up from Denver. "We like the Babcocks," Nita confided to her diary. And two weeks later, Nita made another telling entry: "Barbara in infirmary—with cold and bad tooth." Yes, almost overnight Barbara had become a member of the family.

Just a few weeks later, Joe presented Barbara with a diamond ring and asked her to marry him. Barbara accepted. Joe was handsome, bright, sweetly caring, and clearly headed for success; she couldn't resist. Nita and Hensel thoroughly approved of Barbara, but they were still a little wary about their high-spirited, headstrong son. "We are pleased that Joe and Barbara are to be married," Nita confided to her diary. "So now we hope he is going to settle down."

JOE AND BARBARA
ON THEIR
HONEYMOON

*The Broadmoor
Hotel, Colorado
Springs, 1950.*

On the A&M campus, which was still relatively small, Joe and Barbara's engagement was cause for celebration. By then, Joe was a prominent member of his fraternity, Sigma Phi Epsilon, and Barbara was very popular at her sorority, Gamma Phi Beta; you can imagine the partying among their friends on campus. Indeed, when *The Greeley Tribune* later ran a story about their wedding, the headline read: "A&M Romance Culminated by Phelps-Babcock Wedding in Denver."

And what a wedding it was. The ceremony was held on September 1st, 1950, at the Calvary Baptist Church in Denver. And that was followed by a lovely reception and dinner at the church, with friends and family gathered around the happy couple. Everything about their wedding was traditional—as their marriage would be. "The bride's white satin gown featured a lace inset in the front panel, small standing collar and a cathedral train," *The Tribune* reported. "A Juliet cap, dotted with pearls, held her fingertip veil of white illusion." Among the ushers was Joe's close friend and fraternity brother Kenny Monfort, and several of Barbara's sorority sisters served as attendants to the bride and fought for the bouquet.

For Joe and Barbara, their future path now seemed to be paved with roses. As *The Tribune* reported, after the honeymoon Joe was to go back to A&M for one more semester to finish his degree and then he would join his father in the construction business. For her part, Barbara would leave A&M right away, before finishing her degree, to devote herself to Joe and to being a full-time wife. Yes, it was to be a traditional marriage, 1950s style.

Joe and Barbara culminated their whirlwind romance and wedding with a relaxing honeymoon at the Broadmoor Hotel in Colorado Springs. It was a smart choice, especially for a September getaway. The Broadmoor was a place of European luxury and style, known for its fine food, its nature hikes and fly fishing close by, and all the amenities of a top-quality resort. In sum, a beautiful way to start their married life together. And Joe and Barbara had plans to start a family soon as well. Indeed, by then America was already seeing a population surge—the fabled "baby boom"—fueled in large part by by soldiers and sailors coming home from the war, getting married, and starting their families. Joe, as usual, was moving in tandem with the larger flow of American life, and very happily so, as their honeymoon photo at The Broadmoor makes perfectly clear.

But their marriage and their happiness were soon to be tested. After their honeymoon, Joe and Barb returned to Ft. Collins and Joe finished his degree at A&M in the early part of 1951. From there, though, they did not move to Greeley as planned, and Joe did not join his father in business. And the reason was not pretty:

War. Again. This time in Korea.

Yes, on June 25th, 1950, nine weeks before Joe and Barbara got married in Denver, North Korea sent 75,000 troops smashing into South Korea, and it did so with the support of its allies China and the Soviet Union. This was the first armed conflict of the Cold War, and it sent shock waves around the world and across America. In response to the North Korean attack, President Harry Truman, a no-nonsense, tough-minded leader from Joe's own home state of Missouri, ordered U.S. troops to the Pacific in support of the South Korean military, and he convinced the United Nations to dispatch troops as well. The war was on—and Joe was soon in the thick of it.

Joe graduated from Colorado A&M in the spring of 1951, and he immediately enlisted in the U.S. Navy. By then, he was 23 years old, and while he yearned to settle in with Barbara in Greeley, as they had planned, Joe was also eager to serve his country. As soon as he enlisted, the Navy sent Joe to Officers' Candidate School in Newport, Rhode Island. Barbara was allowed to go with him. While Joe took courses in naval operations and basic naval engineering, Barbara managed to find work as a librarian at the officers' school. A resourceful young woman. Joe had every other weekend off, and he and Barbara used the time to travel around New England. That said, Joe's training was no picnic. To graduate from officers' school, he had to be tough, disciplined, and close-mouthed. "Loose lips sink ships" had been a popular refrain during World War II and it still was. Joe passed all the requirements and graduated from officers' school as Joseph F. Phelps, Lt. J.G., Lieutenant, Junior Grade.

From there, Joe wanted, and requested, admission to the Navy's construction corps, "The Seabees." That would have been perfectly in line with his training at A&M and with his future plans as well. But it was not to be. The Navy had more urgent needs in the fields of military security and cryptology—how to encode, transmit, and receive coded military communications. And Joe, with his gift for learning new skills and mastering process, was an ideal choice.

"The enemy was constantly trying to gain access to our security system and transmissions," Joe told me. "We had to stop them."

Next Joe was sent to the U.S. Navy base in San Diego, for a total immersion in military security and cryptography. There, the Navy arranged an apartment for Joe and Barbara, and in his spare time Joe started a new project, again straight out of *Popular Mechanics*: ham radio. During his high school years, Joe had built his own radio, using lead crystals, and he would spend long nights listening to broadcasts from Chicago. But now Joe built a more sophisticated radio, able to receive and transmit messages—a perfect adjunct to his training in cryptology. This was one smart, dedicated man, always driven by that relentless "will to succeed."

And succeed he did. Within three months, Joe was an accomplished—and trusted—cryptographer and he received a plum assignment: the USS Helena, a heavy cruiser assigned to Task Force 77, a group of aircraft carriers and battleships in the U.S. Seventh Fleet. The USS Helena was also the command ship of Rear Admiral Herbert Hopwood, one of the top commanders of the Pacific fleet. In early 1952, the USS Helena left its home port of Long Beach and headed for the Korean peninsula—with Lt. Phelps aboard. During Joe's deployment, Barbara shuttled between an apartment they had taken in Long Beach and her family back in Denver, with frequent visits to Nita and Hensel too. Love and war—never an easy mix.

On board the USS Helena, Joe spent most of his time in the ship's communications center, with headphones on, relaying coded messages from allied commanders and helping the fleet's gunners and fighter aircraft zero in on their appointed targets. He would then relay damage assessments back to the fleet's central command. In sum, Joe was constantly in the hotseat, making sure that the ship's captain and the fleet commanders were up to date about the ongoing action in the theater of operations.

This was challenging, high-pressure work, and Joe told me that his time aboard the USS Helena was an education unto itself, one that brought him valuable lessons that he would later apply in his life in both construction and fine wine. "I never told my children this," Joe told me at his kitchen table, "but the Navy changed my life and taught me things that I never could have learned any other way."

U. S. S. HELENA CA75

Like so many sailors and soldiers of his generation, Joe was very reluctant to talk in detail about his wartime experiences. But U.S. Navy records about the USS Helena tell a very vivid story about the heavy cruiser and what its crew faced during the fighting in Korea.

As those records show, the USS Helena was one of the first ships rushed to the Korean peninsula in the summer of 1950, just after hostilities erupted. This was while Joe was still at A&M. And the Helena immediately went into battle, On August 7th of 1950, its gunners struck their first enemy targets: a North Korean military depot, a train yard, and a critical power plant. From there, the Helena served as the flagship of the Bombardment Task Group, constantly pounding enemy targets. The ship also provided crucial air and artillery cover to U.N. forces during a massive amphibious assault to recapture the South's strategic port of Inchon. The result was one of the most crucial victories of the war.

By the fall of 1950, the USS Helena was long overdue for a major overhaul, and it was ordered back to its home port in Long Beach. Once the overhaul was done, the ship returned to the Korean front, as part of Task Force 77, a fleet of aircraft carriers and supporting battleships and other craft. The Helena's gunners proved to be deadly accurate in a number of key battles, so accurate in fact, that in September of 1951—as Joe was deep in training back in Long Beach—Syngman Rhee, the President of South Korea, boarded the USS Helena to present the ship and its Task Force the first Korean Presidential Unit Citation ever to be awarded to a naval unit.

Joe joined the USS Helena crew at the end of 1951, when the ship was back in Long Beach having its entire battery of guns replaced and upgraded. This was strict Navy philosophy and practice: make sure your equipment and your personnel are properly maintained and upgraded as frequently as possible. To that same end, as soon as Joe came aboard, the Helena left on a massive training exercise, code-named "Lex Baker One." This training exercise involved 70 ships, 15,000 sailors, and a large contingent of U.S. Marines. The goal: get them ready for the climactic push against North Korea, and assess their strengths and weaknesses before the battles ahead.

With that training under their belt, on June 8th, 1952, the USS Helena and its crew returned to the Korean front and soon found themselves in the thick of the fighting. For the next five months,

with Joe serving in the communications control room—night and day—the Helena's gunners pounded enemy supply depots, gun positions, rail lines, and other transportation facilities. The ship's helicopter force and specialized units also rescued downed pilots, two of whom were rescued from deep in enemy territory.

To hear Joe tell it, though, all this was just routine. Routine thanks to the months of rigorous training he and the crew had received. Routine thanks to the crystal clear chain of command and lines of authority. And routine thanks to the values and work ethic that the Navy had instilled in each and every officer and enlisted man. As Joe saw first-hand, everyone aboard the USS Helena knew their job and did it well, and the result was a tough, skilled, well-oiled team, built for success. And built for performance under pressure.

Joe was deeply impressed. "The Navy took a group of college kids, most of whom had never been on a sailboat, let alone a battleship, and through discipline and the heritage of the Navy taught college kids how to operate big, complicated, heavy artillery and eventually win a war," Joe told me. "No, not eventually. They won from the beginning. Because they had studied hard and learned the lessons of the fighting in the Pacific during World War II. The lessons from Pearl Harbor. From the Battle of Midway. And from Guadalcanal."

Discipline. Heritage. Learning the core lessons of history. As Joe explained all this, and as I listened intently at his kitchen table in the Napa Valley, whole new dimensions of the man suddenly came into view. Joe, I was now learning, may have been an indifferent student in his early schoolboy days, but in college and in his naval training he had become a voracious reader and an avid student of both history and process. To conduct a successful war, as in building a sailboat or a ham radio set, you had to understand all the essential parts, and then you had to master the process of welding those essential parts into a successfully functioning unit.

"What won the war in Korea," Joe went on, "was what had won the earlier fighting in the Pacific, in World War II: being adaptable on the ground and in the air, and using small, flexible, moveable fighting units." Yes, those were the keys: being adaptable, being flexible, forging well-trained small units into an efficient, well-coordinated, collective force. I didn't realize it yet, but Joe was helping me understand how he had taken over his father's small general contracting business in Greeley and built it into Hensel

Phelps Construction, one of the most dynamic and successful construction companies in the whole of America.

And there was something else that Joe now brought to the fore, a steel-like ethic that the Navy had cemented into Joe's hierarchy of values: "Get it right—and get it right the first time," as Joe put it. "Mistakes will happen. Acknowledge them. Don't cover them up. Fix them." Spot on! And advice that should be engraved on the front door of every school, company, and government office in the land.

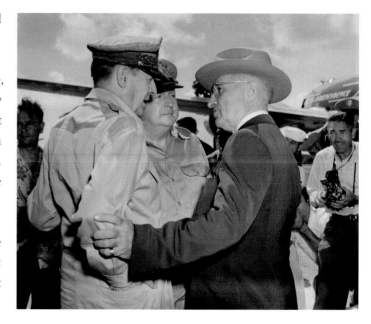

Being flexible, being adaptable, acknowledging mistakes—these were all critical elements in mounting a successful operation. But then Joe led me to what he saw as the most important element of all: Leadership.

And during his time in the Pacific, Joe had seen first-hand the qualities that the most effective leaders embody. For a time, Joe served on the personal staff of Admiral Hopwood, and he saw, up close, the way the admiral, a graduate of the U.S. Naval Academy and a decorated war hero, conducted himself, both on the bridge of the USS Helena and in private with his staff. Joe described the admiral's way as "quiet composure," a close cousin to Ernest Hemingway's famous definition of courage: "Grace under pressure." And Joe got crucial lessons from other leaders as well.

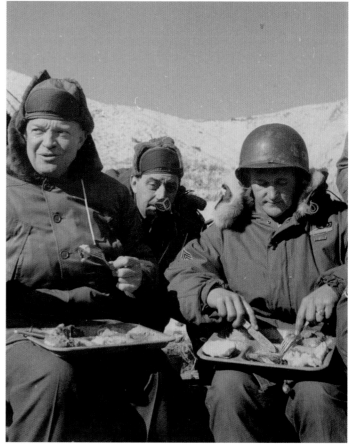

One came from President Harry S. Truman. Like Joe, Truman was born and raised in a small town in Missouri. His dad was a farmer. After high school, Truman worked on a railroad construction crew, and then he worked as a clerk in two banks in Kansas City. At the outbreak of World War I, Truman enlisted and served in the U.S. Army. After the war, he returned to Missouri, entered state politics and soon was elected to the U.S. Senate. In the 1944 presidential election, the already ailing President Franklin D. Roosevelt chose Truman to be his running mate. When FDR passed away in 1945, Truman became President and Commander in Chief. Truman was a firm believer in accountability; his motto was "The buck stops here"—meaning with him. In April of 1951, when the headstrong and often unruly General Douglas MacArthur made a series of poor decisions about conducting the war in Korea, Truman very publicly fired him, delivering the entire nation—and Joe included—a stark lesson in what I call "the dangers of swagger" and in the kind of tough, but necessary decisions that true leadership often demands.

Up against MacArthur's example, Joe got a very different lesson in leadership, and it came to him right on the deck of the USS Helena. And the lesson came directly from General Dwight Eisenhower, the hero of World War II and the architect of the tide-turning D-Day operation that led to the defeat of Hitler and his Nazi forces. "Ike," as he was known by the troops and far beyond, also came from a family of farmers. He was born in Texas and then raised in Abilene, Kansas, where he learned to hunt, shoot, and love the outdoors. Ike was raised in a religious home, and then attended West Point. As he rose through the ranks of the U.S. Army he became well-known and highly respected for his self-effacing ways and his plain-spoken Midwestern modesty. In November of 1952, Ike was elected to be President of the United States, and even that high honor produced no airs or swagger in the man. Just the opposite: he was humbled by the responsibility and the chance to again serve his country.

A few weeks after his election, and before taking office, Ike made a surprise visit to the Korean front to see for himself the progress of the war effort and to personally assure our troops of his unwavering support. At the front, Ike didn't lord over the soldiers under his command; to the contrary, he took his meals right alongside them. For this display of humility, depicted in a photo that was widely published throughout the world, General Eisenhower was cheered by the U.S. and allied forces serving in Korea, including Joe.

For Joe, there was another dimension to Eisenhower's lesson in Leadership. On December 1st, 1952, the USS Helena left the front and quietly slipped away to Iwo Jima, an island south of mainland Japan and the site of a crucial battle during World War II. Like all the junior officers onboard, Joe knew something special was up but he had no idea what. Soon, though, Admiral Arthur W. Radford, the Commander in Chief of the U.S. Pacific Fleet, came aboard for a secret meeting and inspection of the ship and its quarters. The admiral's visit only heightened the sense of mystery onboard.

Two days later, the USS Helena sailed on and quietly put into port on the island of Guam, a U.S. territory in the Pacific. Then Admiral Radford came aboard again. And who was with him now? General Eisenhower, the President elect, plus some of Ike's closest advisors. Joe was stunned, and honored, as was everyone else onboard. From there, as the ship steamed back to Pearl Harbor, Eisenhower and his advisors spent long days

THE DANGERS
OF SWAGGER

*General
MacArthur
running up
against Harry
Truman.*

THE VIRTUES
OF HUMILITY

*General
Eisenhower
eating with
his troops,
South Korea,
December, 1952.*

meeting in private to evaluate the course of the war and to help Eisenhower choose the members of his cabinet. He would be sworn into office just seven weeks later.

These were critical meetings. America was again at war, and the stakes were frighteningly high: in 1949, the Soviet Union, one of North Korea's chief backers, had successfully tested an atomic bomb, meaning the war in Korea could quickly spiral into a global holocaust. Yes, tensions throughout the world—and on the USS Helena—were running high. But whenever Ike emerged from his top-level meetings, he made it clear that he had not lost his quiet, reassuring manner or his innate Midwestern humility: he always went out of his way to shake the hands of the officers onboard, including Joe, and many of the crewmen onboard as well. In doing so, Ike always thanked the men for their service, letting them know that in his eyes they were the true heroes of the war effort. And in Joe's eyes, this was Leadership of the highest order, and it was a display of respect and graciousness that Joe would never forget.

As Joe told me that story, I could draw a straight line from the way Ike conducted himself aboard ship to the quiet, modest man sitting beside me in the Napa Valley. Let other captains of industry strut and swagger, let other winemakers blare their PR trumpets about this new review or ranking of their wines; Joe wanted none of that. Do the work, get it right, and let the results speak for themselves—that was Joe's way. And it was Ike's way too, as Joe saw first-hand.

At the end of each long working day aboard the USS Helena, as the sun was lowering in the West, the future President of the United States would emerge from those critical meetings and come up on deck. Then he would walk to the rear of the ship, shotgun in hand, and then he would take careful aim as a sailor flung clay pigeons out over the back of the boat. Again Joe was deeply impressed: along with everything else, that modest farm boy from Kansas was one heckuva shot!

On July 27th, 1953, under sustained pressure from U.S. and U.N. forces, the North Koreans agreed to an armistice; three years of brutal fighting were brought to an end. For President Eisenhower and his leadership, it was a major victory, but it had come at a very high cost. All told, more than 36,000 sailors and soldiers in the U.S. Navy and Army had given their lives in Korea, and another 103,000 had come away wounded, many of them for life. Our

BY THE END OF THE KOREAN WAR, JOE WAS A CONFIDENT, BATTLE-TESTED NAVY OFFICER.

South Korean allies paid an even dearer price: they lost 217,000 soldiers in battle, and one million South Korean civilians had lost their lives as well.

The war took its toll on Joe as well. He had spent a year and a half aboard the USS Helena at or near the Korean front, and by the time it was over you could see how much he had changed: it was written on his face. The touches of boyishness that were still there in Joe's high school graduation picture, and in his honeymoon photo, those were all long gone now, wiped away by everything he had witnessed and done. In conversations with Barbara, and later with their four kids, Joe preferred to never look back, and to never talk about it, but people who had been in combat—or those who had seen the traumas of war up close—they knew what Joe had gone through.

Joe came back from the war a strong, confident, battle-tested man. And the cold, uncompromising realities of war had taught him the meaning of those two words "Service" and "Sacrifice." And the war had also helped Joe understand why the cherished watchwords of the men and women who had served in World War II were "Honor, Duty, Country." Those who served in World War II and the Korean War were men and women of the rarest sort, true American heroes, but always too modest and self-effacing to say so. To my mind, the newsman Tom Brokaw had it exactly right when he wrote a book telling their stories and calling them "The Greatest Generation."

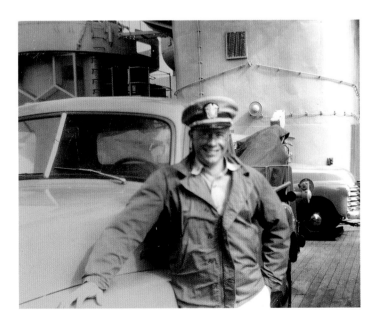

TAKING CHARGE

During the 1940s and the 1950s, many American families like Joe's endured the hardships of war and the inevitable storms of life by relying on one rock-solid, uplifting belief, a belief you would hear expressed in houses of worship and at countless dinner tables across the country: "From the hottest fires comes the finest steel."

Nita Phelps, Joe's mom, held to that belief with every fiber of her being, and she often expressed it in the pages of her diaries. In her eyes, wars and droughts and economic downturns, as lamentable as they might be, were also learning opportunities, a time for men and women to mature and grow wiser, and ultimately to put more steel in their character and more compassion in their heart.

"Years go and come," Nita wrote in one entry of 1952. "Some are rain, some are sunshine, we cannot have all the days sunny and bright. For into each life and year some rain must fall."

It was with precisely this spirit that Nita watched her son Joe, the youngest of her four children, go off to war. She looked past the dangers that Joe would face and focused instead on his strength of character, his growing maturity, and his eagerness to serve his country. "Joe looks wonderful in his uniform and we are so proud of him," Nita confided to her diary. "And I think he has changed. It does something to us when we see how our children made good."

In Nita's eyes, Barbara was also proving her character and making good. When Joe arrived off the coast of Korea and was thrust into the heat of battle, with the USS Helena often coming under attack, Barbara bravely kept her composure—and not under the easiest of circumstances: she was pregnant. And her new husband

was 6,000 miles away. Still, like so many Navy and Army wives, Barbara very capably managed their lives on the home front and she remained attentive to her parents in Denver and to Nita and Hensel as well. And during her visits, Barbara did her best not to worry them.

Still, one day in March of 1952 Barbara decided to confide in Nita. "Barbara and I took Hensel to his Rotary meeting," Nita told her diary, "and on the way Barb told me of her questionable pregnancy. Was not prepared for it and have some fears. But hope all is well."

Yes, Barbara was having complications with her pregnancy, and she would right to the end. On November 14th, with Barbara in her ninth month, Nita wrote in her diary: "Called Barbara and she had been to the doctor. At present the baby is breach and may turn. We are worried but know all will be fine as the doctors now can manage these things." Joe, of course, was worried sick, especially because he was so far away and he had only intermittent reports from Barbara. Indeed, for both of them this was a trial by some of the hottest fire.

At 7:15 on the morning of November 20th, 1952, Jim Babcock, Barbara's father, called Nita and Hensel with the news: Barbara had been rushed to the hospital in Denver five hours before. She was now in labor. And at 9 a.m. Jim called again: Barbara had delivered a baby girl! Named Leslie Ann. And mother and daughter were both doing fine. Great news! Still, the very next day, Nita and Hensel drove to Denver to see for themselves—and to send a full report on to Joe. "Saw Barb," Nita told her diary that same night. "She is looking fine. And oh that sweet baby girl! 8 pounds, 3 ounces and a roly-poly. Raised her head and looked around. Wrote to Joe..."

Joe, of course, was over the moon, and as soon as the news reached him aboard the USS Helena, he sent Barbara a telegram expressing his congratulations, his love, and no small measure of relief:

"Am thankful proud and yours forever," he told his young bride. He and Barbara were half a world apart but they had never felt closer.

The birth of Leslie Ann was the culmination of a year of profound upheaval for Joe—and a year of profound personal growth as well. As we saw in the previous chapter, the demands of the Navy and the cold realities of war had erased the last traces of boyhood from Joe's face and his being, and becoming a father had only deepened

the process. As Joe told me at his kitchen table in the Napa Valley, the birth of Leslie filled him with an almost unfathomable joy— but it had also filled him with a heightened sense of responsibility with regard to his family and his country. As Joe saw it now, his highest priority in life was this: Defend and Protect. And how he longed to hold that vulnerable little baby in his arms!

And soon he had the chance. In December of 1952, after more than six months at the Korean front and a few weeks after Leslie was born, Joe returned to Pearl Harbor aboard the USS Helena— with President-elect Eisenhower and his top aides onboard as well. From Pearl, Joe was to fly home to reunite with Barbara and see their new baby for the very first time. Barbara was beside herself with joy, and so was Nita. As Nita wrote on December 16th, "This is the day. Joe lands in Long Beach at 10 a.m. and will fly to Denver, arriving at 2 a.m. Thank God. He is so near home. Barbara leaves this morning to meet him and I will keep Leslie Ann—all night."

To give a proper welcome to the returning war vet and first-time daddy, Nita pulled out all the stops: she hurriedly finished writing all of her Christmas cards, and then she and Hensel put up the

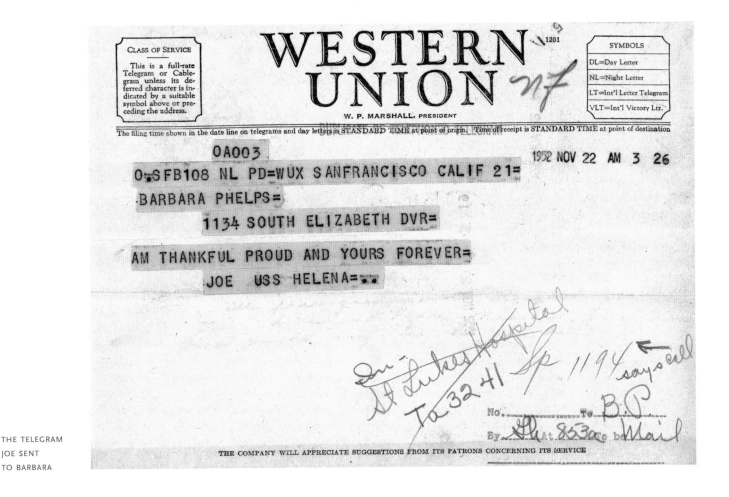

THE TELEGRAM
JOE SENT
TO BARBARA

Christmas tree. For the Sunday before Christmas, Nita prepared a dinner fit for a king and queen: roast duck and a pheasant too. She even learned a new way to roast duck, cutting the birds in half for roasting and serving everyone a full half. Yes, her Joe was home.

After Christmas with Nita and Hensel, and with visits from Joe's sisters Mary and Margaret and their families, Joe and Barbara went back to the Broadmoor, where they had honeymooned, for a few days by themselves. Nita took care of Leslie Ann. And Nita was thrilled to see how happy Joe and Barbara were. "We thank the Lord for bringing Joe safely back to his loved ones," she wrote in her diary. "Joe looks wonderful and it's been a long year for us..."

A long year indeed. Love and War—it hadn't been easy on Joe and Barbara, or on Nita and Hensel. By this time, Hensel was 62 years old, and while he was still running his contracting company, he was tired and struggling with a few health issues, and on doctor's orders he was trying to quit smoking. Nita was very worried about him. And she prayed that once Joe had finished his tour with the Navy, he would come home and help Hensel with the business. Still, Nita would never say that openly—she would never dream of intruding on Joe's personal life or his decisions. That was simply not her way.

With Joe home for Christmas, and with both Barbara and Leslie doing so well, Nita, ever the spiritual anchor of her family, was able to close out her diary of 1952 with great joy and a few poignant reflections: "We have come to the last day of a year, and it was a year that was both happy and sad... Joe has completed half of his naval service and Leslie was born—a beautiful, happy baby. Barbara is fine. And Hensel has almost quit smoking..."

As was her habit, in closing out her diary for 1952, Nita recorded the best books she had read over the course of the year. Among them, along with three books on gardening, were Edna Ferber's *Giant*, James A. Michener's *Return To Paradise*, and Ernest Hemingway's *The Old Man and The Sea*, which helped him earn the Nobel Prize for Literature two years later. In this same entry, though, Nita signaled a major shift that was coming to her family and to America's cultural and technological landscape: Television.

By this time, her daughter Mary and Mary's husband, Bob Runnells, had four children (soon they would have five), and this Christmas they had become the first in the extended Phelps family to own one of those magical new boxes, the kind that

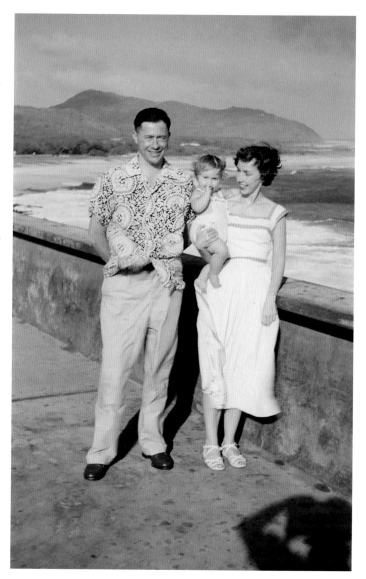

streamed all sorts of exciting images and programs right into their living room. "They have the first TV in the family," Nita reported. "Watched the year end with Leslie Ann..."

Other changes were coming too. Three weeks later, as Joe returned to the USS Helena and the Korean front, General Eisenhower, that humble farm boy from Kansas, was sworn in as the 34th President of the United States, and the outgoing President Harry Truman, having admirably served his country, quietly packed his bags and returned home to Independence, Missouri—and he did so without an ounce of swagger. Eighteen months later, the U.S. and its allies forced the North Koreans to give up the fight, and a year later, in 1954, Joe was discharged from the U.S. Navy, honorably of course.

Now what?

At that stage, Joe had the world at his feet; he could have joined any number of major companies across America, and earn top dollar too. After all, from his training in construction management at Colorado A&M, and his work as an estimator at F.J. Kirchoff, Joe could have easily landed a top job in the world of construction. And thanks to his time as an officer on the USS Helena, Joe had hands-on, battle-tested experience in the realms of leadership, team building and motivation, strategic planning, resource management, logistics, integrating new technology and more— credentials that every big corporation craves, and often has difficulty finding.

Still, Joe had made up his mind: he and Barbara would settle down in Greeley and Joe would go to work with his father. His reasons were sound. For starters, Greeley was home. It was family. And it was comfortable. And he and Barbara both felt that Greeley, with its good people, its strong sense of community, and its bedrock values, was a fine place to raise Leslie and the other kids they were eager to have. Just as importantly, and perhaps even more so, Joe could see that Nita and Hensel were aging and needed help. And they had been through so much—The Depression, the Dust Bowl, losing the farm, losing their son John—and they had taken such good care of their children every step of the way. So in Joe's eyes, there was no issue: he had to step in—and soon take charge. His hierarchy of values would have it no other way. As Joe expressed it to me: "Family first."

Alas, things did not work out quite as Joe had hoped.

JOE, BARBARA, AND LITTLE LESLIE, TOGETHER AT LAST.

Indeed, when Joe arrived for his first days of work at Hensel Phelps General Contractor, the company offices were still located in that same squat, cramped building a few blocks from downtown, and Joe immediately saw that not much else had changed either. Hensel and his crews had done a few jobs up in Wyoming and in nearby Ft. Collins, but most of their jobs were small and showed no signs of leading to anything bigger. Also, during Greeley's frozen winter months, Hensel had the habit of closing down completely; his crews simply did not have the expertise or the wherewithal to work in the ice and snow. The upshot: during most of the winter, Hensel and Nita were left with next to no income, and so were his crews. That, of course, was not a formula for sustained business success, and how could Joe support Barbara and Leslie operating like that?

As Joe also discovered, his father had taken no steps to modernize his equipment or the way he ran his company. None. In fact, Hensel was still working up his cost calculations and his project bids—the lifeblood of his business—with the same old hand-cranked adding machine he had used for decades—a clear sign to Joe that his dad was miserably stuck in the past, and with no pathway out. As you can imagine, Joe was shocked when he saw all this. After all, he had just spent nearly three years in the communications cockpit of one of the Navy's most sophisticated battleships, with the latest technology at his fingertips and a huge support staff helping him too. And here was his poor father still using that outmoded adding machine and still managing every aspect of his business by himself, without even a secretary to answer the phone!

Digging deeper, Joe found something else: financially, Hensel was getting by, but little more than that. Indeed, Hensel was failing to properly structure the bids he made on new projects; basically, he was just adding up his projected costs in material and labor and then adding a small percentage on top of that, for his take-home profit. The result was lost revenue—and lots of it. On top of all this, Joe found that his father had failed to keep up with the rapidly changing technical demands of the construction industry. A simple case in point: no one inside the company knew how to pour concrete, meaning that countless construction projects remained far beyond the company's reach. Seeing all this, Joe was deeply shaken. Still, it remained his father's company; Hensel's name was on the door.

What to do?

Joe now found himself in a very awkward position. He could see that his father was over-worked, tired, struggling, and in running his company he was woefully behind the times. At the same time, Joe had enormous respect for his father, and especially for the way he had totally reinvented himself in Greeley after losing the family farm back in Maysville. That took guts and ingenuity and more resilience than most men have. And Hensel had something else that Joe deeply admired: Honor and Integrity.

"Dad put a lot of stock in a handshake and an oral agreement," Joe told me. "That was one of the best things about his generation: the way people did business and worked together. People trusted him and he was good at making friends and establishing relationships."

For a time, Joe just kept his mouth shut and helped out his father as best he could. Still, by nature and by training, Joe was a take-charge guy, and one day, in a fit of frustration, he simply went out and bought a modern calculator—and he hired a secretary too. And all hell broke loose with his father. Hensel accused Joe of going behind his back, of recklessly spending money, of making too many waves, and, of course, of undermining Hensel's authority. There was, no doubt, some truth in all of that. Still, for Joe there was no turning back now, and what ensued were several weeks of cold war between father and son. It was agony for both of them.

Finally, one morning Hensel came into the office and invited Joe to join him for a coffee—away from the staff. That was the essential first step: a gesture of peace. From there, it took some graceful diplomacy and compromise from both men, but soon they were able to work out a buyout agreement that worked well for both of them.

Under the agreement, the company provided Hensel and Nita the financial means to comfortably retire and spend their winters in Palm Springs, California, while still enjoying their summers back in Greeley, close to their children and grandchildren. In exchange, Hensel accorded a $40,000 loan to Joe and a car, plus the freedom to build the company as he saw fit. To seal the transition of power, and to give the company a fresh look, father and son agreed to rename the business Hensel Phelps Construction. All that done, a new, much happier era was born for both of them.

HENSEL'S
ANTIQUATED
ADDING MACHINE

Now fully in charge, Joe aggressively sought new projects to build, and with his keen nose for opportunity Joe was soon knocking on the door of his alma mater, Colorado A&M. A shrewd move. With the post-war boom, the state of Colorado was rapidly expanding, and so was the school. Under President Bill Morgan, A&M was boosting enrollment, diversifying its curriculum, and offering advanced degrees for the first time too. Yes, A&M was entering a period of major expansion, and that meant more classrooms to build. More labs. More dorms. More married housing too. And who better to lead the building spurt than a brilliant graduate of A&M's own School of Construction Management? Talk about a win-win!

Yes, thanks to his training at A&M and his work at F.J. Kirchoff, Joe was able to win a whole series of highly competitive bids to build new buildings on the A&M campus, and in the process he put his company on a whole new footing, in terms of its finances, its technical capacities, and in terms of its reputation too. To handle the mushrooming workload, Joe expanded his staff, developed a strong, reliable network of subcontractors, and he upgraded the company's equipment and management practices. practices. To mark the change, Hensel's old adding machine would later be put on display in the entryway of the building, signaling to every visitor that a new era had opened at Hensel Phelps Construction.

And as Joe made clear, this would be an era defined by enlightened leadership and management, with strong discipline up and down the company, and with a constant effort to hire the best people and earn their loyalty and support. To achieve that, Joe would institute a system of generous rewards for years served in the company and for meeting pre-set performance targets for every company project. Very early on, Joe also offered his most trusted people shares in the company, long before that became a common practice in the upper echelons of American business. In the pages ahead, you will see how Joe's initiatives worked in practice. But right here you can see his guiding ethos: "Work hard and share. We're all in this together." And in Joe's eyes, there was really no other way, not if you wanted to rise to the top and become the very best you could possibly be.

"The writing was on the wall," Joe said of the many changes he set into motion. "We had to learn to do things differently, and that included not shutting the job down in the middle of November and going on vacation until the first of April. Learning how to pour concrete, how to pour winter concrete, learning how to

Behavioral Sciences Building and Engineering Building at Colorado State University. Photos courtesy of Hensel Phelps Construction.

estimate crafts and trades, and how to put prices on work that we previously relied on subcontractors to do for us. We made those changes and we got everything turned around in less than a year." Yes, Joe turned everything around in less than a year. General Eisenhower himself would have been deeply impressed.

As would become usual with Joe, the results spoke for themselves, as you will see in the photos of the many buildings that Joe's crews built for Colorado A&M. The key word here is "transform." In less than a year, Joe transformed his father's company. And in a few short years, Joe and his crews transformed the campus of Colorado A&M. To signal the university's transformation and its broadening horizons, in 1957 the Colorado State Assembly approved a name change: Colorado A&M now became Colorado State University. In Joe's eyes, all this represented business at its very best: grow your company and improve the lives of your people by serving the needs of your customers and your communities. That way everybody wins.

Classrooms, dorms, research labs, student health centers—Joe and his teams were helping build far more than a campus; they were building the future of a great university, one that would serve our daughters and sons for generations to come, and in no small way they were laying the foundation for the future of Colorado and the future of America itself. And that future was going to be defined, in large measure, by the coming advances in science and technology.

The advent of television and national broadcasting was only one part of it. In 1955, Dr. Jonas Salk invented and brought forth the first vaccine to prevent polio, one of the most devastating diseases on the planet. Antihistamines to relieve allergies, and tranquilizers to ease anxiety and depression were also invented in the 1950s, as were new open-heart surgery techniques and artificial valves and pacemakers, each of them offering hope and longer lives for millions of people contending with debilitating or deadly heart ailments.

Yes, in the mid-1950s the future looked bright for America, and it looked bright for Joe and Barbara as well. Soon, in addition to little Leslie, they had three other young children running around their home in Greeley: Bill, Laurie, and Lynn, who was born seven years after Leslie. In the style of the day, Barbara was driving a Chevrolet station wagon, and on TV, the top shows were "Perry Mason," "Maverick," and "Father Knows Best." In the world of

pop music, Elvis Presley was becoming a sensation, and for kids like Joe and Barbara's the must-have toys were Slinkys and Hula Hoops. Gas cost just 24 cents a gallon, and the average purchase price of a new house was $12,200. Yes, life was good in the Phelps household and across most of America too.

Still, as Nita reminded us at the beginning of this chapter, "Into each life and year some rain must fall," and on October 4th, 1957, some very heavy rain did begin to fall, in the form of an 84-pound, beach ball-sized scientific and technological breakthrough called "Sputnik." This was the world's first man-made satellite, and it was engineered and launched by the Soviet Union, our Cold War rival and by then a nuclear power too. It was small in size—tiny next to the satellites of today—but the launch of Sputnik 1 immediately thrust the United States and the Soviet Union into a tense, jaw-to-jaw "space race," a battle of missiles, satellites, and national brain power, with enormous international clout and prestige on the line.

In ways that are difficult to imagine today, the launch of Sputnik 1 sent waves of fear straight into American homes, schools, churches, and businesses. Communities and schools held practice air raids, urging families to stay inside and having school-children duck under their desks. For his part, President Dwight Eisenhower maintained his signature grace under pressure, but he also took several crucial steps. First, he ordered the creation of the National Aeronautics and Space Administration, NASA, a new government agency that was to urgently develop the material resources and the scientific and technological experts necessary to meet the Soviet challenge. The President also accelerated the development of our own missile systems, both for defending the country and attacking any enemy.

Many ordinary American families were also moved to action by the launch of Sputnik 1. Specifically, many families hired construction crews to build heavily fortified bomb and fallout shelters in their backyards or their basements, to protect their families in the event of a nuclear attack. Joe Phelps was one of them.

Chemistry Biologial Sciences Building and Morgan Library at Colorado State University. Photos courtesy of Hensel Phelps Construction.

At the new home Joe was building for Barbara and their children on 23rd Avenue, what is now Glenfair Drive, in a quiet residential neighborhood of Greeley, Joe had his crews from Hensel Phelps construct a concrete fallout shelter in one corner of the basement. The shelter was small and could be quickly sealed off from the world outside. The result was startling. Outside the new family home were swings for the kids to play on, plus a fun little tree

house that Joe had personally built for his kids, while right there in the basement was that fallout shelter, specially fortified against nuclear attack. The dichotomy was stark, almost surreal, but such was life in America in the late 1950s.

On January 31ˢᵗ, 1958, four months after the launch of Sputnik 1, the United States landed an important punch. From the U.S. military launch pad in Cape Canaveral, Florida, facing straight across the Atlantic, America successfully launched Explorer I, our first satellite put into orbit. Explorer 1 weighed only 18 pounds, but it gave the entire nation a huge psychological lift.

Over the ensuing months, the U.S. military and its NASA advisors would test-launch a series of powerful Atlas rockets, announcing to the world—and to our Soviet adversaries in particular—that we were determined to rise to the challenge and to meet any threat. In parallel with the Atlas program, the U.S. Air Force was developing the more advanced Titan missile program, with launch sites spread across the country. The Titan was a fearsome weapon: a large, two-stage missile able to reach distant continents and deliver a deadly payload. It could also serve as a booster for future space launches.

By 1960, just five years after Joe took over his father's company, the United States of America was entering a dynamic and turbulent new era, an era of missiles and satellites, of accelerating computer technology, of space launches and moonwalks, and of astounding scientific and technological breakthroughs. And in 1960, Joe and Hensel Phelps Construction were also entering a dynamic new era, an era of incredible growth and innovation, and in ways that no one in Greeley could possibly foresee, our man Joe would soon join hands with a gifted engineer from the Titan program, and later he would get a tremendous boost from the brain trust at NASA too.

Yes, my friends, buckle your seatbelts. We're ready for liftoff!

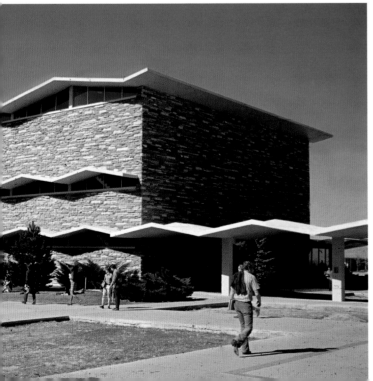

BUILDING AMERICA

BUILDING AMERICA

THE GALVANIZING MISSION

His words still electrify and inspire, all these years later:

"Let the word go forth," President John F. Kennedy told the world in his inaugural address, "from this time and place, to friend and foe alike, that the torch has been passed to a new generation of Americans—born in this century, tempered by war, disciplined by a hard and bitter peace, proud of our ancient heritage—and unwilling to witness or permit the slow undoing of those human rights to which this nation has always been committed, and to which we are committed today at home and around the world."

Yes, the torch had been passed, from strong, battle-weary Dwight Eisenhower to the young senator from Massachusetts, a brilliant, Harvard-trained, Navy-hardened inspirational leader, a man who called on young Americans to come serve their country, to explore exciting "New Frontiers," and who, with unshakeable ideals and soaring eloquence, was able to summon so many of us to the cause.

For young readers today, I'm sure it's difficult, if not impossible, to grasp the full power of what John Kennedy set into motion. By the tens of thousands, college graduates volunteered for the Peace Corps, a Kennedy initiative that sent idealistic young Americans to the far corners of the globe, to provide education, health services, and technical assistance to disadvantaged peoples and to promote peace and greater understanding wherever they went. "Ask not what your country can do for you. Ask what you can do for your country," the President urged, and those words quickly became a clarion call for many in the post-war "Baby Boomer" generation.

Then, on May 25th, 1961, just four months after his inauguration, President Kennedy set before this country a noble dream and a galvanizing mission: to put a man on the moon and then bring him safely home—and do so by the end of the decade. With their launch of Sputnik 1 and their subsequent launches of missiles and men into space, the Soviet Union had laid down a dangerous challenge, with perilous stakes, and President Kennedy was eager to respond. As he framed it, the very future of the world was now at stake:

"If we are to win the battle that is now going on around the world between freedom and tyranny, the dramatic achievements in space which occurred in recent weeks should have made clear to us all, as did the launch of Sputnik in 1957, the impact of this adventure on the minds of men everywhere, who are attempting to make a determination of which road they should take. Since early in my term, our efforts in space have been under review… We have examined where we are strong and where we are not, where we may succeed and where we may not. Now it is time to take longer strides—time for a great new American enterprise—time for this nation to take a clearly leading role in space achievement, which in many ways may hold the key to our future on Earth."

In embarking our nation on this "great new American enterprise," President Kennedy defined and made clear his guiding ethos:

"No single space project in this period will be more impressive to mankind, or more important for the long-range exploration of space; and none will be so difficult or expensive to accomplish… But in a very real sense, it will not be one man going to the moon—if we make this judgment affirmatively, it will be an entire nation. For all of us must work to put him there." If I may paraphrase: Work hard and reach for the moon; we're all in this together.

Americans of every age and political stripe felt the power of the President's words and vision: he was issuing a call to greatness, he was challenging America to reach for the moon and launch a bold new era of scientific and technological progress—and uplift all of mankind in the process. It was a noble dream, and the response to the President's call was swift. On both the political left and right, the Congress approved the President's plan to accelerate our efforts to develop the human talent and material resources necessary to put a man on the moon and bring him safely back to Earth by the end of the decade. NASA anchored the effort, but

PRESIDENT JOHN F. KENNEDY DELIVERING HIS INAUGURAL ADDRESS

Capital Hill in Washington D.C., January 1961. Photo courtesy of the Associated Press.

many leading universities and private companies also joined in, accelerating their research into missile and satellite technologies, and computer technology as well. And the national response ran deeper still.

In several communities around the country, a number of public and private schools were encouraged to identify, via rigorous testing, students with an unusual aptitude for math and science. A select few, some no older than 10 or 12, were then rushed into accelerated courses in algebra, chemistry, and other sciences, with the idea that they would excel and one day go to work for NASA or Bell Labs or on the strategic missile sites being built by the U.S. government and its partner contractors in engineering and construction. This effort was not done as a formal national program, but many of those young students chosen referred to themselves as "Sputnik kids," and they longed to help President Kennedy protect the nation and fulfill his higher dreams for America. I know. I was one of them.

And Joe Phelps?

Joe did not have the same eloquence or background as President Kennedy, and he did not have the same weight on his shoulders. But Joe and President Kennedy were both Navy men, they both had been tested in war, and they shared a common wisdom and spirit, a common approach to leadership, and they shared common dreams for America too.

Let me prove that point. As we saw in the previous chapter, after the torch had been passed at Hensel Phelps Construction, Joe's first priority was to examine where the company was strong and where it was not, and then upgrade its capacities accordingly—specifically by expanding his staff and modernizing their equipment and range of operations. His next priority was putting the company on a much stronger financial foundation, which he achieved through his many building projects at Colorado State University and beyond.

By 1960, that landmark year, Joe was thriving and eager for more, as much of the country was. At home, he and Barbara and their kids were happy in their new home on 23rd Avenue. In 1960, Leslie turned 8 years old. Her brother Bill, who had been born on the island of Oahu as Joe finished up his tour in the Navy, turned 6, and their sisters, Laurie and Lynn, turned 4 and 1 respectively. Needless to say, Barbara had her hands full with the four little

ones, and she was busy with community events in Greeley as well. According to her children, Barbara was the day-to-day anchor of their daily lives as they grew up. She managed their homework and their doctors' appointments and did almost all the shopping, cooking, and housekeeping. When they were big enough, Barbara often took the kids to Denver to shop, see her parents, and attend museums and concerts. Bill told me his mom was more culturally attuned than Joe was, and it was Barbara who encouraged Bill to take up the piano. His sisters took piano lessons too, but it was Bill who had the most passion for it, and he became a very accomplished pianist, all thanks, he says, to his mother.

And where was Joe in all this?

At the office. Or on the road for Hensel Phelps Construction. Even as a boy he had relentless drive, as we saw, but that was even more true now, and by 1960 his work ethic was already legendary. The HP office opened every day at 7:30 a.m., and as he was building the company Joe liked to be the very first one there—and he was often the last to leave as well. But that was just the beginning.

Joe insisted on working Saturdays and Sundays and almost every holiday too, including Christmas, and he made it clear to his top managers that if they wanted to succeed and rise in the company, he expected them to show the same level of commitment. As he was fond of telling them, "Monday through Friday, you work for Hensel Phelps. On Saturdays you work for me!" His staff got the message loud and clear.

According to his children, at the end of a long day at the office, Joe would finally go home. There he would have a relaxing bath and a gin and tonic, and then he would have dinner with Barbara and the kids and get caught up on their lives. And then what? After dinner, instead of staying home, Joe often went straight back to the office, where often he would work deep into the night. This was hard on his family, but you can understand his compulsion: in those early years at Hensel Phelps, Joe was not just managing his staff and their projects, he was personally putting together every new bid and he was constantly pursuing new ventures and new ways to build the business. With that aim, along with everything else he did, Joe served on the board of the First National Bank of Greeley.

This workload was punishing, but it was paying off. According to his son Bill, by 1960 Joe was on his way to becoming a millionaire,

a star-spangled plateau that he would reach by the age of 35, just two years later. And after all the financial hardships that Joe and his family had endured, from The Great Depression, to losing the family farm in Maysville, to all their wartime struggles in Greeley, to achieve a measure of financial security was a great relief to Joe and a great source of pride as well.

But in his role as provider-in-chief, Joe went far beyond that. In line with his guiding ethos of "Work hard and share; we're all in this together," in 1957 Joe began offering company stock to his most trusted employees. And where did he start doing so? With his top managers? With his longest serving craftsmen? With someone who had brought in a major new piece of business? None of the above.

Instead, Joe offered the first shares to Edna Schneider, the woman he had hired to be his secretary and also the company's chief phone answerer and part-time bookkeeper. Edna also served as Joe's personal gatekeeper and schedule protector—a role that Evelyne Deis would later serve when Joe went into the wine business. In exchange for all her hard work, Joe treated Edna and her husband "Dutch" like members of his own family, and by giving her company stock he was sending a powerful message to his entire staff: "Take good care of me, and I will take good care of you!"

There was more. In 1957, Joe launched a company newsletter called "The Batterboard," a name derived from the device, made of two stakes and a horizontal wooden cross-piece, that builders use to lay out the boundaries and topography of a construction site. In his first edition of The Batterboard, Joe noted that, depending on the work flow, his team now ranged from 40 to 60 full-time people. But Joe did not view his staff solely in terms of his immediate payroll. As he noted in The Batterboard, his staff, adding in their spouses and children, represented an extended family of 171 people—and Joe made clear that he felt a strong responsibility to all of them. How many employers think that way?

In my eyes, Joe's concern for his staff and their families speaks volumes about the man and his character and values. In so many caricatures of American capitalism, corporate bosses are portrayed as cheap money grubbers out for short-term profit at the expense of their workers—and oftentimes at the expense of the quality of their work product too. But as Joe well knew, from his experience in the Navy and beyond, his long-term success

depended on his ability to build a skilled, highly motivated—and highly loyal—team of specialists, all of them eager to work hard for the common good—and to consistently produce a work product of the highest possible quality. No compromises. So in Joe's eyes, that meant that loyalty and quality of work had to be properly and generously rewarded.

But how to do that?

For Joe, offering stock options to his employees was only one part of a much broader approach. Another part was built on performance goals and bonuses. For instance, in 1959 Hensel Phelps won a $1.5 million contract to construct student housing at the University of Wyoming in Laramie. Joe put together a small crew, with four job superintendents, and he gave them a clear workplan, with dates to finish specific portions of the project—and he built into the plan generous bonuses for meeting those target dates. The result?

With a clear blueprint for success, and pushed by those promised bonuses, the work crews slept in trailers right at the job site, they cooked their meals right there too, and after a long day of work, they would finish their dinner and then go right back to it, hanging doors and doing whatever else needed to be done to get the job done on time—and on budget. They were following Joe's lead and emulating his own relentless work regime. And it paid off, quite handsomely too. The superintendents were making only about $8,000 a year, but they brought the Laramie project in at $150,000 below budget—and Joe gave them big bonuses drawn from that sum. Hensel Phelps got the job done, and done right, the client was thrilled, and the work crews were generously rewarded. Everybody won. And from that project forward, Joe's system of benchmarks and bonuses became a central feature of all Hensel Phelps projects.

Later Joe built other incentives and rewards into his system as well, including offering staffers profit-sharing, health care, and in many cases even college scholarships for loyal staffers and their children. Such benefits are standard in many corporations today, but at the time they were anything but. To further build team loyalty and solidarity, Joe began issuing special hard hats—bright yellow in color and adorned with the HP logo and the name of the staffer—to workers who reached five years' service to the company. And those workers wore them with pride, as you can see in the following pages of photos from HP worksites.

JOE AND
HIS STAFF

Joe also found other ways to reward loyalty to the company. On one wall of the HP office, he created a mural listing the names of people who had long served the company, complete with their years of service. The message was clear: Joe was not just offering his people a job; he was offering them security, benefits, and a life-long place in his extended family. In this same spirit, at the annual company party Joe always paid special tribute to the outstanding performers and to all the hard hat honorees. That was his way of saluting them and saying, "You are the true heroes of Hensel Phelps, the men and women who get the job done and done right, every day of the year." When Joe told me about those respectful salutes, I immediately thought of President-elect Eisenhower aboard the USS Helena, shaking hands with Joe and all of his shipmates, thus letting them know that in his eyes they were the true heroes of the mission.

What drove all this? Why did Joe work such punishing hours? Why was he so intent on building lasting loyalty to his company? Was this just sound, effective business leadership and management? Or was there something else at work here, something deeper?

As Joe and I talked at his kitchen table, and as I kept probing for answers, I soon saw that for Joe hard work and being generous were simply the right way to live, the right way to lead, and the right way to build a community and a country. As Joe expressed it to me: "Share what you've got, and you will get back a thousand fold"—words that could have come straight from Nita and her most cherished beliefs about how to live and lift up those around you. And those same words could have come from John Kennedy too.

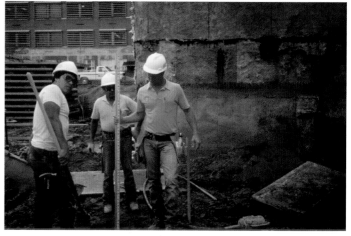

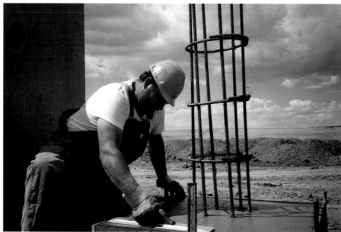

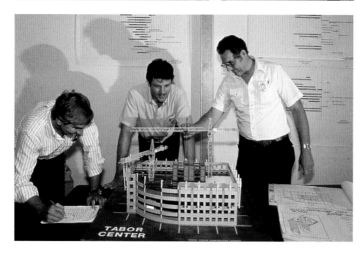

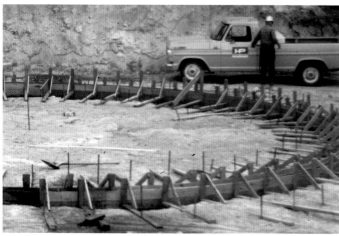

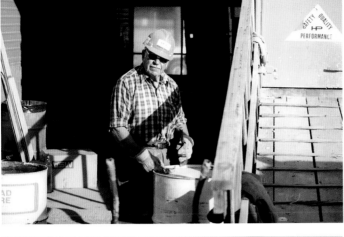

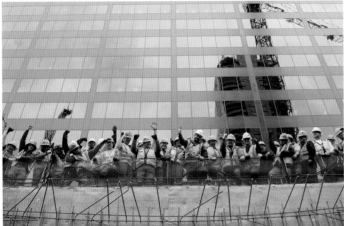

But something else drove Joe, something that he would never openly proclaim, modest as he was, but I finally came to see and understand it: inside his self-effacing manner, inside his nuts-and-bolts discussions of process, team-building, and financial workings, Joe Phelps had his own noble dream, his own galvanizing mission: he wanted to make his construction company the very best it could be, an industry and community leader, and an inspiring model for others to follow. And that very same sense of mission would also inspire his later initiatives at Colorado State University, his generous funding of breast cancer clinics for women, and also his commitment to providing housing for migrant farm workers in the Napa Valley.

Yes, Joe was a man with a dream, a man with a mission, and like President Kennedy he knew that he could not achieve his aims by himself; he had to recruit the best people he could find, earn their trust and loyalty, and make them feel they were part of "a great new American enterprise." As Joe led me to understand, building that team, realizing that dream, fulfilling that mission is what drove him, it's what made him work deep into the night, it's what called forth the very best he had inside, and it was also what gave him something he needed, something he craved: the constant jolts of creative juice that almost magically transformed unbridled work into unbridled joy and the highest forms of personal satisfaction.

"Did I love the work?" Joe said to me at his kitchen table. "Of course I did! For me, every day was a new day. Another opportunity to prove that I and my team could achieve whatever we set out to do."

Yes, there it is, my friends, directly from Joe's own lips: each day was a challenge, each day was a fresh opportunity to prove that he and his team could achieve whatever they set out to do. Thanks to John Kennedy, America was setting out for the moon. And thanks to Joe, Hensel Phelps was in launch mode too, and it would not be long before their galvanizing missions would beautifully intersect.

◆

**HENSEL PHELPS
CREWS AT WORK**

*Photos courtesy
of Hensel Phelps
Construction.*

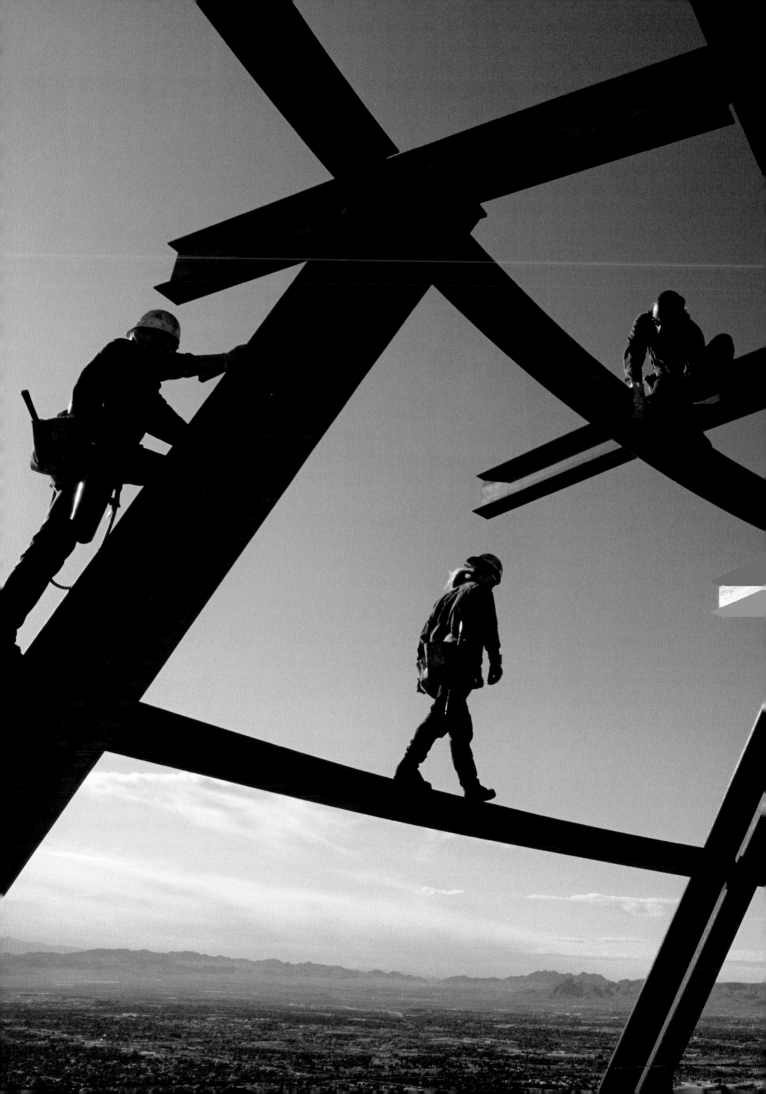

TOGETHER WE RISE

Now I was excited. Very excited.

At the outset of our conversations, Joe made clear why, at the age of 87, he was so determined to do this book: "To Teach and Inspire," to reach out to young people in particular and share with them the life lessons and guidance he felt they needed to grow and prosper. And now I knew that Joe, bless him, was making good on his promise.

Think about it: through these pages, Joe has led us through his family history, starting all the way back in the Civil War, and he has shared with us all the hardships and lessons of his early years, years of The Great Depression, the Dust Bowl, two wars and more. Then in the previous chapter he led us straight into the heart of his guiding spirit, that All-American can-do spirit that proclaims that we can achieve whatever we set out to do—even go to the moon!—provided we work hard and we work smart and we all pull together.

Yes, I was excited. I had spent decades traveling the globe and writing about exceptional men and women, including a vast array of artists, creators, and business pioneers, many of them true icons of our time. What qualities set them apart? What had they learned during the course of their life journeys? Those were the questions I always sought to answer, and with Joe it was the same. I knew that Joe was something truly special, a man with a wealth of wisdom and achievement behind his modest façade, and I was now eager to go deeper, to talk with his closest friends and colleagues, to hear their stories about Joe and to see first-hand what they had been able to achieve together. With all that in mind, I packed a bag and went to Greeley, Colorado, the roots of so much of his success.

Early in my years as a foreign correspondent, traveling extensively throughout Asia, Europe, and Africa, I learned a valuable lesson: never make lasting judgments about a place, a people, or a culture based on your first impressions. Whether you are entering a big, bustling city like New Delhi, or a quiet village in Burgundy or on the coast of Senegal, the realities are never as simple as they might first appear. And that was certainly true of Greeley. As I drove due north from the Denver Airport, across those wide open spaces, I had the feeling that I was going back in time, back to a simpler time in American life, and that feeling only increased as I drove into town.

There are no skyscrapers in Greeley, no fancy hotels or restaurants that I could see, and no chic coffee shops either. I had a meal at a steakhouse just off the road leading into town, and the place was packed with cattlemen from the Monfort feed lots outside of town and with sun-darkened men who spend their days working on the oil rigs that dot the landscape for miles around. Most of them were eating huge slabs of beef with all the trimmings and washing it down with pitchers of beer, and as with the other people I met in Greeley, in these men and women and their families I never saw or even sensed an ounce of big-city haughtiness or pretension. Not one ounce. This was bedrock America at its best—proud, hard-working men and women, devoted to their families—and to me the whole town felt like it was stuck back in the 1950s, and very happily so.

It was the same when I made my way to 6th Avenue and pulled up in front of the offices of Hensel Phelps Construction. I had to smile. Today Hensel Phelps is one of the leading construction companies in the whole of America, a $3 billion colossus with a dozen regional offices across the country, and yet its home office is located today in the exact same spot it was back in 1937, when Joe's father opened the business. And while the façade has been freshened, and the work space has been vastly expanded, the building itself still has the same low-slung, no-frills structure and the same cluttered lot alongside, filled with cranes, backhoes, forklifts, and other out-of-use construction equipment. Frankly, I had to laugh. Joe had left for California 50 years before, but that building to me was still pure Joe: modest, self-effacing, no PR gloss, and absolutely no bull crap.

Beware those first impressions though. What I found inside was very different: it was modern, high-tech, and dazzling, albeit in a low-key way. Right in the entryway, enclosed in a glass case, was a

relic of the distant past: the antiquated adding machine that Joe's father used to use. But on the facing walls of the entryway, and on the walls of the company boardroom, were stunning photos of many of the buildings and facilities that Hensel Phelps has built over the years, working hand-in-hand with many of the largest and most respected institutions in American business and American life:

IBM. Kodak. Disney. State Farm. Nokia. Samsung. Sheraton. The airports in Denver, Dallas, Tulsa, Los Angeles, San Francisco, and San Jose, California. The Rev. Martin Luther King Library in San Jose. The American Art and Portrait Gallery at the Smithsonian in Washington D.C. The National Air and Space Museum in Chantilly, Virginia. The M.D. Anderson Cancer Center in Houston. The U.S. Embassies in Berlin and South Africa. The FBI. The Pentagon. NASA launch pads. And many more too, as you will see in the photo portfolio coming ahead.

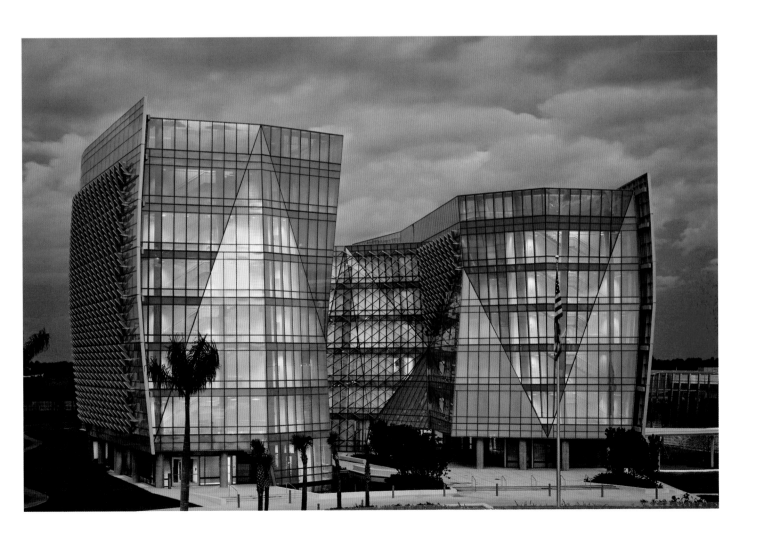

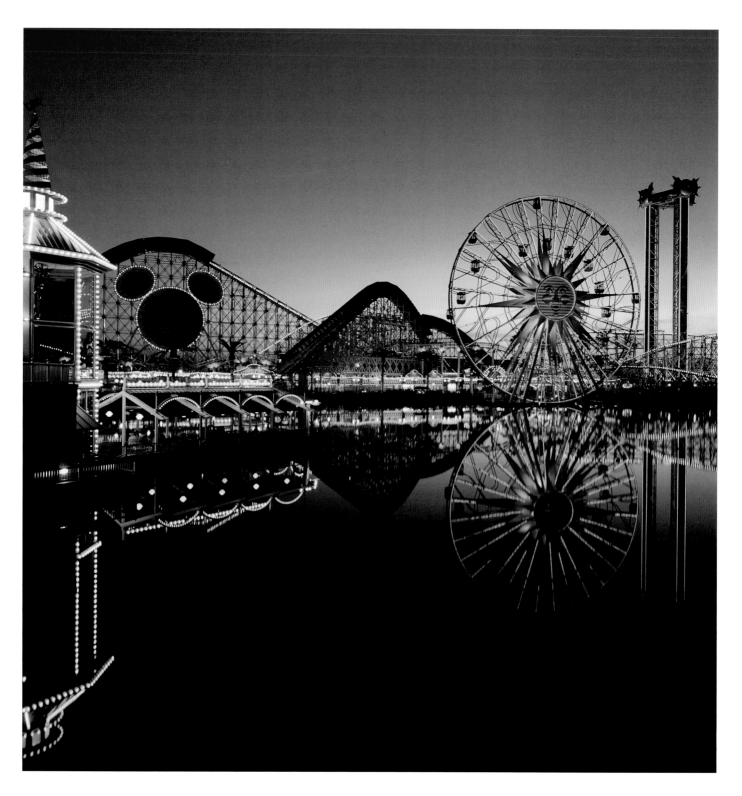

I was more than impressed; I was shocked. Joe and I had talked at length about what he had launched at Hensel Phelps. And before coming to Greeley, I had done some research on HP, of course, but seeing up close the range and quality of what they had built was far beyond what I had imagined. And then Jeff Wenaas, the current President and CEO of Hensel Phelps, took me in hand and gave me a taste of cutting-edge, high-tech construction in America today.

On his computer keyboard, Jeff made a few clicks and suddenly I was watching workers and visitors moving through the halls and offices of a new building still in the planning stages. Thanks to this computer animation technology, Hensel Phelps and its clients can now adjust every aspect of a new project, thus elevating the quality, beauty, and efficiency of the building they want to build and have last for generations. As Jeff was helping me understand, the era of wooden batter boards and of giant blueprints on paper was now ancient history; everything was digitized and revolutionized now. Yes, outside Hensel Phelps was the 1950s, but inside was the new world created by visionaries like Bill Gates, Steve Jobs, and the animation geniuses of Pixar, the creators of "Toy Story," "Finding Nemo," and so much more. It was, frankly, awesome to see.

The spirit inside HP was awesome too. I met with Muriel Reitz and Nancy Upchurch, two staffers who had prepared for me a thumb drive with the detailed Hensel Phelps history on it, plus a wealth of photos of HP projects. Muriel and Nancy were integral parts of the extended HP family, and they had served Hensel Phelps faithfully for a combined 70 years. Again, this was beyond impressive. How many companies today inspire such loyalty and lifelong devotion?

BUILT BY
HENSEL PHELPS
CONSTRUCTION

Pentagon Metro Entrance, FDA Laboratory in Irvine, California, Pentagon Remote Delivery Generators, and Evolved Expendable Launch Vehicle launch pad in Cape Canaveral, (clockwise).

Now I could fully understand something that Joe had told me at his kitchen table. One day, thinking in big picture terms, I asked Joe what had been the key to his success in the wine business. Without even a blink Joe said, "Our success in the construction business."

I would later come back to Hensel Phelps, to learn more and to see the fabled "Golden Goose," but first I had to go meet Bob Tointon. Before I left for Greeley, Joe had given me a list of people to see and Bob was at the very top of the list. As Joe explained it, "In 1963, as we were rapidly growing the company, I needed an operations man. A trusted right arm. Bob Tointon was it. All the way through."

I found Bob at his office in the center of town, on 8th Street, a short walk from *The Greeley Tribune*, where Joe had worked during his teenage years. Bob was a tall, gracious man, with a razor-like mind and the kind of bearing that immediately inspires confidence and trust. I could see why he and Joe had worked so well together and later became partners in a number of related ventures. Indeed, the name on Bob's front door spoke volumes: Phelps-Tointon, Inc.

Bob and I settled in at a table in his office, and then, with a tape recorder running, Bob told me about his background and about how he had come to meet Joe, an encounter that profoundly impacted both of their lives, all across their friendship of 50-plus years. If anyone had the straight scoop on Joe, I knew it was Bob Tointon.

"I was born on a 160-acre farm northwest of Smith Center, Kansas," Bob began. "That is in the north tier of Kansas counties, and it is the geographic center of the lower 48 states." He was born in 1933, six years after Joe, during the worst of The Great Depression. "My dad was working the farm with four horses. No tractors!" Bob said. But then came the Dust Bowl, and all the ruin that came with it, and by 1934 Bob's father was unable to raise enough crop to feed his horses. So Bob's family, like Joe's, had no choice: they had to move. And they chose to move West, to Oregon, 35 miles west of Portland. Yes, Bob's family had to start all over... from scratch.

"In Oregon is where I went to grades one and two," Bob said. "Then in 1941 we moved back to Kansas. We had to. Because my father had had pneumonia the last two winters we were in Oregon. This was before penicillin, and the doctor said that if you want to live, you have to get back to a drier climate We had only one place to go, so we went back to Smith County, Kansas."

Back in Smith County, Bob went to three different schools, as did his two younger brothers, and one of those was a tiny one-room schoolhouse. "There were four of us in my 5th grade class in that one-room school. And we were the biggest class!" Bob laughed. Soon, by necessity, the Tointons moved on to the town of Kensington, Kansas. There, his father found work in a foundry, but then the foundry closed and his father, with a family to feed, took what he could get: a job as a fireman at a state hospital, a tuberculosis sanitarium. The family lived about ten miles away, and there Bob went to high school. And just like his dad—and Joe growing up—Bob worked hard and did whatever needed to be

BUILT BY
HENSEL PHELPS
CONSTRUCTION

The American Art and Portrait Gallery at the Smithsonian in Washington D.C. and conference room at the U.S. Embassy in Berlin.

done. And it paid off: Bob earned himself admission to Kansas State University.

At Kansas State, Bob studied civil engineering and graduated in 1955. He met his wife Betty there as well, and she too graduated in 1955. From there, like Joe and millions of other young American men, Bob enlisted in the armed forces. "In college I was in advanced ROTC," he explained, "and after the Korean war, the draft was still on. With the advanced ROTC, I was allowed to finish college. But six months after graduation, I joined the Air Force and began pilot training. I didn't know why, but I just wanted to be a pilot."

From there, the U.S. Air Force took Bob in hand and taught him everything he needed to know about being a pilot. After a year of intensive flight training in Arizona and Texas, he earned his wings and was assigned to Pope Air Force Base in North Carolina, which flew missions in support of the big U.S. Army base at nearby Ft. Bragg—one of the largest military installations in the world and one of the U.S. military's most esteemed bases. In sum, The Top of The Top.

After his three-year tour with the Air Force, and eager to make use of his training as a civil engineer, Bob went into the construction industry. It was an easy transition. During the summer between his junior and senior years in college he had worked for the Eby Construction Company, based in Wichita, and he had worked for Eby for six months after graduation too. After the Air Force, Bob had a standing offer to go back to work for Eby, and he soon found himself back out West with Eby, helping build Atlas and then Titan missile sites in Colorado, Wyoming, and Nebraska. Bob was smart and an eager learner, and soon he was made a job superintendent—a post that Bob said was way beyond his level of expertise.

"I was 26 years old and I really didn't know what I was doing," Bob said, in his usual modest, self-effacing way. "But it was a great learning experience." Soon, at a missile construction site south of Denver, he was promoted to "operations manager." At that stage, the Atlas and Titan missile programs were part of the front line in America's Cold War confrontation with the Soviet Union, and every missile construction site was part of our larger system of national security. So the stakes were incredibly high, as was the pressure.

At the construction site that Bob was managing, the crews had to build the silos where the missiles were kept at the ready, and they had to construct and install all the equipment and support systems necessary for a safe, successful launch. With so much on the line, there was simply no room for error or a breach in standards; every step in the construction process had to be executed with precision, meaning done right—and done right the first time. No mistakes.

From the Titan I project, Bob moved on to Eby's office in Englewood, Colorado, where he worked as an estimator. Rumor had it, though, that Bob was going to be transferred to the Eby home office in Wichita, but he and Betty were not eager to go. They loved Colorado. Also, during this period in the early 1960s, the state of Colorado was booming, and Bob wanted to stay put. Life was good. Why move to Wichita?

There was something else. During an earlier assignment with Eby, Bob and Betty had lived in Greeley and they had liked it very much. In fact, they had become active members of the Congregational Church in Greeley, and Bob even taught Sunday school there. As those rumors about a transfer to Wichita persisted, Bob remembered how one of his fellow Sunday school teachers was often singing the praises of some guy named Joe Phelps. A real dynamo, the man said. You ought to look him up. That man was Kenny Monfort, Joe's old fraternity brother at CSU. The pastor of the church also spoke highly of Joe. The stars, you might say, were now moving into alignment, and Bob decided to reach out.

"I wrote Joe a letter, unsolicited," Bob explained. "The night he got the letter Joe called to tell me he and Barbara were going to Denver for the weekend and were planning to go out on Saturday night. Could we meet in Denver on that Saturday afternoon?"

Meet they did, over coffee on that cold Saturday afternoon in late January of 1963. And right away these two can-do farm boys from the Midwest clicked, at a professional level and a personal level too: "The conversation just flowed. I apparently triggered something in him, because he started telling me stories about experiences he had had, and I shared some that I had had, and we just kept going."

Poor Barbara. Joe and Bob were jabbering away at a coffee shop on an enclosed bridge near the Hilton Hotel, leaving Barbara almost literally out in the cold. After awhile, though, she got

impatient and eager to go have a quiet dinner with her husband. "Barbara walked by, very quietly," Bob recalled, "and Joe introduced us. They were headed to Trader Vic's for dinner, one of Joe's favorite places in Denver, and I'm sure Barbara wanted to know when we'd be done. But we just kept on talking—for three hours! Right away we found we had great mutual respect for one another." Three weeks later, Bob went to work for Joe, and the rest, as they say, was history.

But it was never easy. Working with Joe, Bob quickly discovered, was a constant challenge. Joe was driven, stubborn, and his temper could be volatile, though Bob said he was never on the receiving end. Also, in those early years as he was building the business, Joe was not a delegator; he insisted on being personally involved in every aspect of every project the company took on. "He was a very hard worker," Bob said. "He was sharp. Quick on the uptake. And I was a quick learner and a hard worker." But Joe set an example that was very hard for anyone to match, including Bob:

"It was not unusual for me to work 12 hours on a construction site, but we normally didn't go back to work in the evenings," Bob said. "But at Hensel Phelps, that was Standard Operating Procedure. After dinner you were expected to go back to work, for a couple of hours anyway. Then, depending on what you were working on, it could get longer than that."

Joe's pace may have been punishing, but Bob found it exciting; he and Joe were learning and building together, and loving almost every minute of it. "There'd be three or four of us working, and then around 10 o'clock the others would go home. But Joe and I would stay on by ourselves and it would end up being a three-hour bull session. We worked hard, and we certainly made a few mistakes along the way. We had a few disasters here and there too. But we learned so much along the way."

Some of their most valuable lessons, Bob said, came from a huge, multi-faceted production plant they built in Colorado for Kodak, to produce film, x-ray plates for medical use, and more. "That was a very key job for us," Bob said. "It was a large quantity of work, all on one site. And we had the right people: a known project manager, a known general superintendent, and several known crafts foremen too. We controlled all that, and we performed very well for Kodak. We had to bid the first two jobs, and after we were low bidder on the second job, they negotiated the rest directly with us." In sum, they had earned the full trust of Kodak—a bankable asset!

BOB TOINTON

During his Air Force years.

The lessons: Hire the right people. Give them the training they need, plus the necessary tools and resources, and make sure that each person on the team knows exactly what they are expected to do. Total clarity, total accountability. From there, do the work, get it right, totally satisfy the client, and in the process establish your credibility throughout your industry. That will attract new clients, new revenue streams, new profits, and crucial new lessons to learn. And there was one more important lesson here, one that Bob and Joe relentlessly hammered home to the crews working with Kodak:

"Don't lose it! Don't screw it up!" Bob said. "We were going to do whatever it took to satisfy that customer."

The Kodak project, Bob said, helped them establish a template for future HP projects, often with equally prominent clients. "One, we made money on the Kodak project, so it increased our working capital," Bob said. "Two, which was ultimately more important, was that it was a great training ground for us. That's where we started a lot of people in careers at Hensel Phelps. And we had people on site they could learn from and we could learn what the newcomers were all about." In other words, HP's managers could evaluate the new staffers' potential and see where they were strong and where they were not. That helped fuel a constant process of training and improvement of staff, operations, and outcomes.

Master of process that he was, Joe tried his best to institutionalize the lessons they were learning. In the spirit of *Popular Mechanics* and those blueprints he used to follow, Joe developed Field Office Guides and distinctive red notebooks, filled with mimeographed memos and how-to advice. "Nobody read them," Bob said. "They were all too busy on the job." So they launched something else: intensive training programs, like Joe's undergrad classes at CSU.

"We brought every salaried employee to Greeley for three days and we didn't do anything but cover every section of The Field Guide," Bob said. "Then things began to get better."

To further the learning process, during summers Joe brought in professors from CSU to train and coach their staff. This quickly proved to be a win-win: staff performance improved, and with help from the professors they were able to spot and recruit the very best students from CSU's School of Construction Management. Always thinking long-term, Joe later turned this initiative into a formal partnership with CSU, an apprenticeship program giving

BOB TOINTON
AT WORK

*Bob Gilbert,
Joe Phelps, Bob
Tointon, and
Paul Bassett
(L–R).*

students a six-month stint with leading construction companies —and giving those companies the chance to test and hire the very best students.

"Joe was a true leader," says Dr. Mostafa Kattab, who now serves as head of the CSU program in construction management. "And it is the responsibility of leaders to see the future. Joe did. He was ahead of his time in understanding that industry cannot thrive without a solid partnership with education. Our apprenticeship program has really changed our department, and it has changed the construction industry as well. Our students always hit the ground running. And according to our industry advisory board, our program at CSU is the top such program in the country."

There is an essential theme at work here, whether it is located at an Atlas missile construction site, a Kodak manufacturing plant, a university program, or a national effort to put a man on the moon:

"Together we rise."

And as it turns out, this was also favorite theme of President John F. Kennedy. In a speech he gave in Heber Springs, Arkansas, on October 3rd, 1963, to commemorate the opening of a major new dam in the region, Kennedy said that the genius of America's free enterprise system was built on one foundational belief: that in a dynamic, expanding economy "a rising tide will lift all boats." According to Ted Sorenson, one of Kennedy's lead speech writers, that "rising tide" phrase did not originate with President Kennedy; he borrowed it from another source. But coming from Kennedy's lips, that phrase had both poetry and power, and the economic creed that it embodied dovetailed perfectly with the economic creed and can-do spirit of a rising American entrepreneur named Joseph Phelps. Let's pause here for a moment and think about how Joe saw that "rising tide" metaphor in action almost every single day.

Now, when we see or drive past a construction site, most of us see only concrete and steel and heavy equipment. And thus we fail to consider what that new facility or building truly represents, for its immediate occupants or for the wider community it serves. But Joe saw every construction site through a different lens. He knew that when his company builds a bridge, or a hotel, or a new plant for Kodak, or an animal science center or hydraulics lab at CSU, or a new wing of an airport in Dallas or San Jose, his crews are building far more than a building; they are building

an economic and social asset that can help lift countless families and entire communities. And inside that economic asset is a powerful multiplier effect.

As an example, think about all those buildings that Joe's crews built on the campus of Colorado State University. At one level, all those contracts helped fuel the rising success of Hensel Phelps and that, in turn, brought them more projects to build, more people to hire, and more subcontractors and skilled craftsmen to bring onto projects as well. Moreover, in building classrooms and new housing for students, Joe and his crews were enabling the university to extend its reach, increase enrollment, and provide more jobs for teachers, administrators, support staff, and more—jobs that would provide good wages and benefits for hundreds or even thousands of staff members and their families. And what did that mean, in turn, for the town, the businesses, and the people of Ft. Collins? It meant growth and prosperity, with more new businesses coming in, more job openings, and more housing to be built for the newcomers. Yes, in Joe's eyes, President Kennedy had it exactly right: in a dynamic, expanding economy, "a rising tide lifts all boats."

For Joe, though, there was an added component: Sharing. In Joe's eyes, if you want to motivate your people, and earn their loyalty and trust, sharing must be an essential part of your plan. Sharing responsibilities, and sharing the rewards too. In that spirit, in February of 1965, marking the completion of Bob Tointon's second full year with Hensel Phelps, Joe decided to do something special.

"He invited Betty and me to dinner," Bob recalled. "Then at the table he handed me a brown envelope. Then Joe said, 'Inside that envelope is a stock certificate for 50 shares of HP stock. Go to the bank and take out a loan for $15,000. To help you buy those shares, the company has already guaranteed the loan.'"

That envelope delighted Bob and it typified Joe's philosophy of "Work hard and share; we're all in this together." There was an unwritten rule at HP, Bob explained, that no one would get stock options until he or she had been on staff for a full two years. In other words, show us your loyalty, and we'll show you ours. To sweeten the arrangement, stock options were made available in direct proportion to an employee's years of service. In addition, Joe included in this program a repurchase agreement, whereby at any point the company would agree to buy

back the stock at its book value—provided there was no run on the company's liquidity.

Joe's system worked beautifully. His team worked hard, and smart, and as they turned their success with Kodak into projects for other blue-ribbon companies and institutions, Hensel Phelps saw its fortunes rise—and its stock price rise right along with it. "Over 20 years," Bob said, "our earnings grew an average of 23 percent a year—after taxes. Everyone holding stock did extremely well."

In subsequent conversations, Bob and I would dig deeper into the qualities that made Joe and Hensel Phelps so successful. And Bob would explain too how Joe's granting of stock options, plus his employees' own ingenuity and hard work, later enabled them to take over the entire company. For now, though, I had only one thing on my mind: I wanted to go back to the Hensel Phelps boardroom and take a close look at that "Golden Goose," an enduring symbol of Joe's guiding wisdom.

A few minutes later, I walked into the boardroom and there it was: the Golden Goose, sitting regally atop a long glass case extending the length of an entire wall of the boardroom. Lined up inside that glass case were 240 golden eggs, shining in the light, and each representing one man or woman at Hensel Phelps who had become a millionaire by working for the company, working days, nights, weekends, and often holidays too, year after year, all in an effort to make their company the very best it could possibly be.

As I admired that goose and all those golden eggs, the message to me was brilliantly clear: John Kennedy had it right, and so did Joe: Together we rise. Indeed, in a dynamic, expanding economy, with freedom of opportunity, a can-do spirit, and plenty of hard work, individual initiative, and a relentless effort to learn, grow, and improve, a rising tide really does lift all boats.

In today's trendy business parlance, some folks might call that a "win-win." But I think that goose and those golden eggs speak with an eloquence that no words can possibly match.

GOLDEN GOOSE

The Golden Goose and its Golden Eggs, over 240 of them, each representing one man or woman at Hensel Phelps who had become a millionaire by working for the company.

THE GOLD STANDARD

This gold shield was designed to protect the Voyager 1 and 2 satellites during their Earth orbits. But it had another purpose too: it explained how to play the system's in-flight recorder.

Bob Tointon often made me laugh, just as Joe always did.

After our first conversation in his office in Greeley, I often went back to Bob to deepen my understanding of Joe and how together with their teams of specialists they built Hensel Phelps into the industry leader that it is today. And just like Joe, Bob's answers often had the ring of "Aw shucks, mate, it was nothing really..."

Let me give you an amusing case in point. In the previous chapter, Bob told us about how building that big manufacturing plant for Kodak had brought forth crucial lessons for Joe and Bob as they planned and carried out future projects. Again, process. Joe was a master at it, and, clearly, so was Bob. They both had razor-like minds, able to master the nuts and bolts of any building project, plus the planning, resource allocation, team building, and the steady accrual of working capital that enabled them to expand the business—and see HP shares rise more than 20 percent a year.

Impressive, to say the least. But I wanted to dig deeper with Bob, to see if I could learn more about what he and Joe brought to Hensel Phelps. I thought his time in the Air Force might offer clues. And when I asked him about it, Bob said he really didn't learn all that much in the Air Force. All he did was learn to fly. Yeah, that's all.

So I pressed him further, and soon it became clear that the U.S. Air Force had taken Bob in hand and very methodically taught him everything he needed to know to become a top-notch Air Force pilot. That meant mastering not just the cockpit skills of flying very high-powered and complicated planes, but also mastering navigation, and flying in all sorts of weather.

Bob began his training at the Air Force base in Marana, Arizona. "I first flew a T-34," Bob said, a single-engine, propeller-driven plane that the Air Force uses for the first steps of their training process. Once he had mastered that, he moved to a T-28—a more advanced single-prop trainer craft. From there, the Air Force assigned him to its Big Spring Air Force base in West Texas. There, Bob moved on up to the T-33, a jet trainer built by Lockheed and capable of flying at 600 miles per hour. That earned him his wings as a certified Air Force pilot. And he did it all in one year. Simple really, easy as pie.

Then it was on to Pope Air Force Base, a partner operation to the U.S. Army base at Ft. Bragg, the largest military installation in the world and one of the sharpest points in the U.S. military's spear. There Bob learned to fly C-123s, a burly, two-engine, medium-sized workhorse of a plane that from the mid-1950's to the late 1960's played a vital role in U.S. operations during the Vietnam War. "It flew low and slow," Bob told me. "It could operate from a 1500-foot airstrip made of pierced steel planking."

Yes, that was Bob's mind at work. Fifty years later, he still knew the airstrip specs required for the C-123. And it was the same with Joe. He had fallen in love with wine and the Napa Valley, so one day, without one hour's experience in the wine industry, he buys a 600-acre cattle ranch, hires a winemaker, and in about two blinks of an eye they're producing Insignia, a Bordeaux-style blend that Robert Parker and other wine writers view as a seminal event in the history of American wine. No big deal. Piece of cake, really.

I imagine it was the same inside NASA in the mid to late 1960s. At that point, NASA's teams of scientists, engineers, technicians, and its partner contractors were working day and night—and weekends and holidays too—to develop America's missile capacity and reliability, all in pursuit of President Kennedy's goal of putting a man on the moon before the end of the decade and returning him safely to Earth. Imagine the process! Imagine the drive! Imagine bringing all those disparate elements together into one cohesive, high-performance unit. And just imagine the pressure—and the potential consequences of a failure with the whole world watching.

And so it was with Joe and Bob and their teams at Hensel Phelps. Build a new control tower at San Francisco Airport? Ho-hum. Build a new cancer center in Houston? Or a new launchpad for NASA at Vandenburg Air Force Base in Southern California?

Routine. A new museum in Washington D.C.? Rebuild The Pentagon after 9/11? Easy! I'm exaggerating a bit, of course, to drive home the point: under the values and process and uncompromising performance standards that Joe and Bob had built into their company and instilled in their teams, the phenomenal had become routine. Business as usual.

Still, wasn't there a touch of genius in all this?

After all, back in 1955 Joe had taken charge of his dad's struggling general contracting company and within just ten years he had built it into an industry giant, well on its way to working with NASA and some of the most respected names in American business. Weren't there some key innovations that drove that transformation?

Back in the Napa Valley, I had put that question to Joe. He thought about it for a moment or two and then he said, yes, there was one key innovation: his Standardized Subcontractor Agreement. As Joe explained it, that agreement established a comprehensive system of management practices, with clearly defined performance targets and generous, pre-set incentives and rewards for getting any given job done and done right, meaning on budget and on time, and also conforming to the highest standards in the construction industry.

And two other assets were built into the Subcontractor Agreement: Total Transparency and Total Accountability. "What made it work," Joe explained, "were daily reports from work sites to management. So at the end of every day, management knew exactly where the job stood in terms of being on budget and ready for inspection."

This agreement was key, Joe said, because using subcontractors was "the mother's milk" of the construction industry and it had to be handled just right. So Joe and Bob maintained a core staff in Greeley, but for the scores of projects they built across America and beyond, they had to rely on outside talent. It would be financial suicide for any company to permanently hire enough staff to handle all those projects. The answer: subcontractors. As Joe explained it:

"We joined forces with engineering companies, electrical companies, and plumbing companies that had outstanding records. And with our Subcontractor Agreement in place, with its performance

goals and its generous reward system, that enabled us to bring to our jobs the best talent in the industry."

That was Joe's formula in a nutshell: performance goals, a generous reward system, and attracting the best talent in the industry. As I now saw, Joe's Standardized Subcontractor Agreement was his detailed blueprint for how to succeed in the construction business. And now I could see why Joe considered it to be his most important innovation, a true stroke of brilliance. But what did Bob Tointon think?

For Bob, with his disciplined, nuts and bolts engineer's mind, Joe's Subcontractor Agreement was not some stroke of genius; it was the natural product of Joe's ability to take disparate elements of a task and then stitch them together in a highly effective way. "I wouldn't say that we were particularly creative or innovative," Bob told me. "What we did was just highly refined blocking and tackling. And it was the product of a lot of thought and a lot of very hard work."

Hard work indeed—and something else. "Joe was a perfectionist," Bob said. "If he chose to do something, he was all in. And he was all in with the Subcontractor Agreement. He would go to King's Café and sit there for hours and hours, drinking coffee and working on that agreement. Once he got it fully laid out, we took it to a law firm in Denver to make it into a legally binding document for our subcontractors. Then Bob Ruyle, our in-house attorney, stepped in and put on the final touches." And the principle undergirding the Agreement was simple: if the subcontractors performed at optimum levels, Hensel Phelps would continue to expand its business and its reach—and that would bring the subcontractors more work and more profit as well. Work hard and share. Together we rise. Perfect!

There are important lessons here for all of us. About hard work. About focus. About sharing. About maintaining uncompromising standards. And, perhaps above all, there's this: whatever you set out to do, in life, in business, or in anything you dream of doing, reach for the moon! Go for the gold! And once you define your goal, give it every ounce of strength and intelligence you have inside.

"In all the time I knew him," Bob told me, "I never saw Joe settle for second best. Not in construction or in wine. Joe never wanted

to do anything half-assed. Be the very best you can be. For Joe and for all of us, that was the gold standard. In everything we did."

Did Joe and Bob and their teams at Hensel Phelps—and those who later carried on the work—succeed in their galvanizing mission? Well, my friends, see what they built across America, from sea to shining sea, and then you be the judge.

◆

BOB TOINTON
AND JOE PHELPS

BUILT BY
HENSEL PHELPS
CONSTRUCTION

*Dallas/
Fort Worth
International
Airport and
North Colorado
Medical Center
in Denver.*

*Pennybacker
Bridge in Austin
and Houston
Astros' baseball
stadium.*

The Steven F. Udvar-Hazy Center in Chantilly, Virginia, a companion facility to The Smithsonian's National Air and Space Museum in Washington, D.C.

THE AWAKENING

THE AWAKENING

CALIFORNIA DREAMING

How did he do it?

How did Joe Phelps move so seamlessly from the construction industry, a world of concrete and steel, into the world of taste and culture, the world of fine wine, fine food, and their related arts?

This, to me, was always one of the most fascinating aspects of Joe's amazing journey. And this was one of the first questions I posed to Joe as we worked together on this book: How did you move into fine wine, and do it so successfully? His response was classic Joe:

"Sip by sip."

The truth, of course, was a little more complicated. And once again Joe's personal journey was moving in almost perfect tandem with the larger flow of American history and culture. And Joe was able to pinpoint the moment that for him it all began: March of 1967.

That was the month and year when Joe and Bob Tointon and their management team launched something new for Hensel Phelps Construction: a branch office in the San Francisco Bay Area. For convenience and centrality, they opened the office in the town of Burlingame, located 18 miles south of San Francisco and just a few minutes' drive from San Francisco International Airport. Their primary goal was to secure new work in the lucrative field of heavy construction in California, focusing mainly on public works projects like highways and bridges. But their larger, longer-term goal was to extend the reach of Hensel Phelps up and down the West Coast.

"We were in a growth mode," Bob Tointon explained to me, "and by then we had a good system for handling projects and we had good people onboard." People like Dennis Gustafson, John and Doris Jensen, Herb Marr, Russ Culbertson, Fritz Rohn, Paul Bassett, and others. As Bob put it, "We were willing, able, and ready for more."

Opening the new office, in a territory they did not know well, was an ambitious, high-stakes move, and with so much on the line Joe decided to personally take charge of establishing the new office and putting it onto a solid footing. Again, typical hands-on Joe. But Joe, too, was ready for more, ready for a fresh challenge. "By this time," Joe told me, "Bob was really running our day-to-day operations and doing so with great skill. I wanted to go out and build the business."

To do that, Joe rented office space in Burlingame and set up an apartment close by, so he could spend all week hard at work, while still going home to Greeley on weekends. Soon he had a routine. To start his work week, Joe would drive from Greeley to Denver, then fly into SFO either late Sunday night or at the crack of dawn on Monday morning. Then he would work out of the new Burlingame office all week long, and then catch a flight back to Denver late on Friday. To save time coming and going, Joe kept his car at a Hensel Phelps facility right at the Denver airport, so he could get it quickly and speed home to Greeley. To be with his family? Well, sort of. As was his routine, first thing the next morning Joe would go to King's Café to anchor the weekly Saturday meeting of his top management team. The pace was punishing, but that was Joe. Driven, to the hilt.

For you to understand what happened next, with Joe shuttling back and forth every week from Greeley, I need to step back and describe the social, cultural, and political turmoil that was then erupting across America, with the Bay Area being a major epicenter of it all.

As anyone who lived through it knows, the latter years of the 1960s were a time of profound upheaval across the whole of the country. The assassination in 1963 of President John F. Kennedy, so young, so full of promise, had been wrenching enough. Then, in April of 1968, less than five years later, the revered civil rights leader Dr. Martin Luther King Jr., so eloquent, so uplifting in his vision and spirit, was shot and killed as he stood out on the balcony of a hotel in Memphis, Tennessee. In the shock of it all,

riots immediately erupted in several cities across America, and understandably so.

And more violence and tragedy were soon to come. In June of 1968, as the war in Vietnam raged and continued to bitterly divide the nation, President Kennedy's younger brother Robert was shot and killed one night in Los Angeles, as he campaigned to become the nominee of the Democrat Party for the crucial presidential election coming that November. First JFK, now his brother "Bobby," again so young, so full of promise—and again the victim of an assassin's bullet. Now there were more riots, and more anti-war protests on college campuses across the country, and there was even more anguish and confusion. What was happening to America?

No one was quite sure. And a thoughtful article in *U.S. News & World Report* delivered this chilling verdict: "The killing of Robert Kennedy, which followed the assassination of civil rights leader Martin Luther King Jr. by only two months, deepened America's self-doubt. Many concluded that violence had become a toxic and permanent virus infecting American society, that something had gone profoundly wrong in the country and that the road to peaceful change had become blocked by madmen, evildoers and fanatics. Optimism, that most American of virtues, plummeted."

That verdict was spot-on. As those of us who lived through it saw with our own eyes, some toxic virus did seem to have America by the throat, and few families escaped the resulting turmoil. At dining room tables across the country, the war in Vietnam and the military draft then in place stirred heated arguments and split many American families brutally in two, as fathers and mothers who had served their country in World War II or the Korean War saw their sons and daughters marching in the streets, carrying peace signs, and denouncing "American imperialism" in Vietnam, Latin America, and far beyond. Add to that the arrival of "The Pill" and changing sexual mores, the growing use of marijuana, LSD, and other drugs, and a pop music culture that eagerly celebrated the virtues of liberation, sexual freedom, and the credo of "turn on, tune in, drop out"—add all that together and you can understand the different forces that were shaking America to the core.

A young poet and folksinger named Bob Dylan quickly emerged as the voice of this new generation bent on rebellion, and many of his lyrics managed to capture and define the rising spirit of the time:

ON THE
CAMPAIGN TRAIL

*Robert F.
Kennedy
campaigns for
the Presidency,
Los Angeles,
California, 1968.*

POOR PEOPLE'S
CAMPAIGN

*Protestors carry a
picture of Martin
Luther King Jr.
on the 'Solidarity
Day' rally,
Washington
D.C., 1968.*

Come mothers and fathers
Throughout the land
And don't criticize
What you can't understand
Your sons and your daughters
Are beyond your command
Your old road is rapidly aging
Please get out of the new one
If you can't lend your hand
Cause the times they are a-changin'

Yes, the times they were a-changin'—and nowhere as vividly or
as provocatively as San Francisco. The city's Haight-Ashbury
district in particular, with its psychedelic street art, its drug-fueled
"happy buses," and its colorful array of tie-dyed hippies, peace
activists, pot shops, and long-haired "flower children," became
a national symbol of the rising "counter-culture" and the shift
in values it represented.

Now, let me be clear: Joe Phelps, Navy man, Korean War veteran,
business leader, father of four, solid citizen, was not about to drop

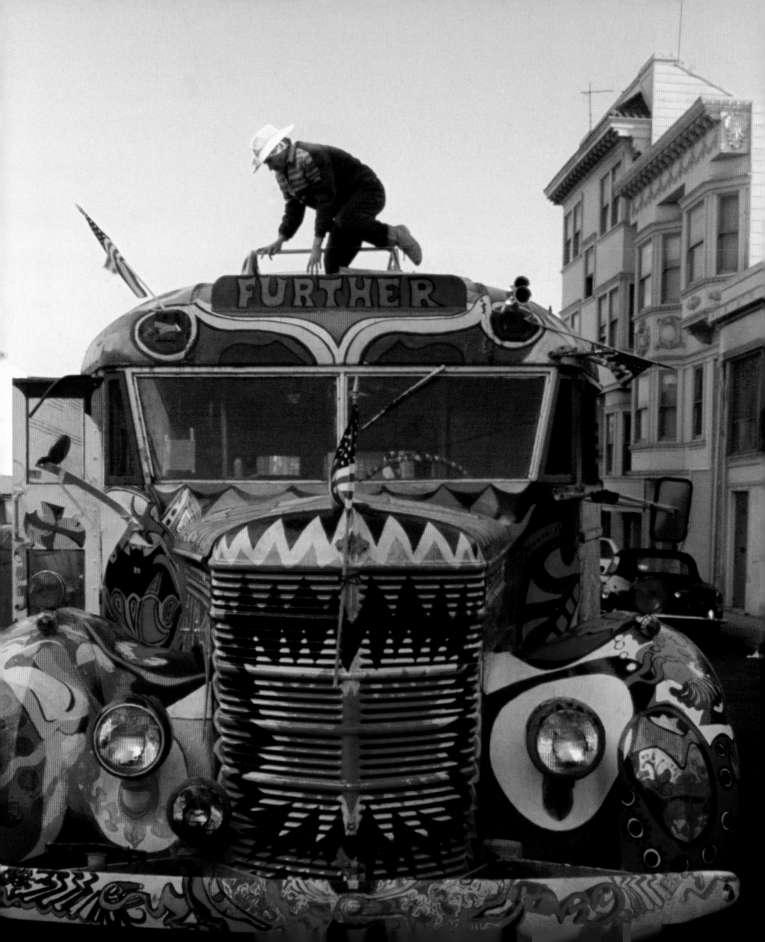

acid, smoke dope, carry a peace sign, or start wearing a pony tail. But when he came to the Bay Area, Joe was clearly intrigued by these new shifts in American life and culture; his daughter Lynn still remembers walking through Haight-Ashbury with her dad at the height of it all. Both were wide-eyed; Greeley this was not.

Still, in this same period another profound shift in American life and culture was also surging to the fore, and again San Francisco and the wider Bay Area were at its epicenter, and this shift would soon sweep up Joe, heart and soul, and never let him go:

I speak, of course, of the rise of fine wine and fine food.

Back in college, Joe loved to drink a good, cold beer with his pals—often many of them. And later, when he came home from a hard day's work at Hensel Phelps, he loved to have a bath and relax with a gin and tonic. Before he started coming to California, though, wine—and fine wines in particular—remained outside his field of interest. And Joe was not alone: few Americans at that time drank fine wine; we were still a nation of beer and whisky, vodka and gin. The best-selling wines in the marketplace at that juncture were "jug wines," big, hearty table wines sold in hefty jugs and offered at only a few dollars a pop.

At this juncture in our history too, wine, especially cheap wine, had about it a lowly, unsavory air. Indeed for many Americans, the word "wine" slid easily into the word "wino," conjuring up images of street drunks swilling cheap wines from flasks wrapped in filthy brown paper bags. The marketplace reflected that: the biggest sellers of that era were known as "bum wines," and those included such elevated brands as "Ripple" and "Night Train." In that era, the jug wines of Ernest and Julio Gallo reigned supreme, but one of their biggest sellers was "Thunderbird," sold in smaller flasks and carrying a kick that would make even a mule immensely proud.

Against that lowly image, the big wine companies and their ad men struggled mightily to make wine drinking publicly acceptable and even sophisticated, often with laughable results. At that stage, too, the American wine industry was run like the Wild West: there were few controls about labelling or the pilfering of names from the premier wine regions of France, Italy, or beyond.

Still, by the early 1960s many American wine houses were eager to move upmarket, away from those unsavory "bum wines". To

that end, the folks at California's Italian Swiss Colony came up with an ad campaign designed to give their wines a warm, endearing family feel. The campaign featured a lovable granddaddy winemaker and the kind of tagline that makes Madison Avenue executives stand up and cheer: "That Little Old Winemaker, Me!"

To heighten the appeal for their retailers and prospective buyers, the image makers at Italian Swiss turned to Austrian-born Ludwig Stossel to play their "Little Old Winemaker." Stossel was a veteran Hollywood character actor with one shining claim to fame: he had a brief but memorable scene in "Casablanca," with neither Humphrey Bogart nor Ingrid Bergman anywhere in sight. In that enduring piece of Hollywood lore, Stossel played Mr. Leuchtag, an elderly, fumbling European gentleman headed to America with his wife and having a farewell brandy with Carl, their favorite waiter at Rick's Cafe. As the ad men had hoped, Stossel's "Little Old Winemaker" brought both humor and a touch of class to the Italian Swiss Colony brand, and the campaign had a long and very productive run.

In traditional, upright, church-going Greeley, where all alcohol beverages had long been formally banned, no one was drinking "bum wines." But in private clubs or at home, in the early to mid 1960s, no one was reaching far beyond basic table wines either.

In this vein, Bob Tointon told me a revealing story. One night in Greeley Bob and his wife Betty were invited to a dinner party, and so were Joe and Barbara. As Bob tells it, when Joe arrived, he proudly presented the hostess with his idea of a very fine wine: Lancer's, a light, sweetish, rosé-like wine from Portugal. An elegant Burgundy or Bordeaux Lancer's was not. Lancer's most distinctive quality, indeed, was not its nose or its character, but its signature brown ceramic bottle: a bottle of Lancer's, empty and serving as an atmospheric candle holder, was a common sight in pizza joints and college dorm rooms across the country. Such was America's taste in wine in the mid 1960s—and such, too, was the taste of a man who would soon transform himself into one of the most discerning and sophisticated winemakers in the history of American wine.

By now, you know enough about Joe Phelps to accurately guess what happened next. When Joe got to San Francisco, he quickly developed a taste for fine wines, and fine Burgundies in particular. And as usual with Joe, tasting was not enough. He wanted to know how fine wines were made, he wanted to learn about their

countries and regions and cultures of origin, and he began reading everything he could get his hands on. Mr. Popular Mechanics at work. And, of course, he began searching for the finest wines he could find. The more he tasted—"sip by sip," of course—the more intent he was to understand the art of fine wine, and the qualities and nuances that make one wine more refined and satisfying than another, and how to discern their differences in nose, taste, feeling in the mouth, and how well they pair with different foods. As with everything else he chose to do, Joe plunged in right up to his neck, and soon he was becoming a passionate and very knowledgeable wine enthusiast.

With food, Joe's horizons were expanding as well. Joe loved good food, and he and Barbara often went into Denver for a special meal. But the Bay Area was a whole other story. When he began spending his work week around San Francisco, Joe told me he was like a kid in a candy store, and he was struck by the wealth and diversity of the restaurants, markets, and neighborhood eateries. There were steakhouses, seafood and sushi bars, French restaurants, Italian, Chinese, Thai, Korean, Russian, Mexican, Spanish, and more. In the whole of Greeley, you could count the interesting places to eat on a single hand; in San Francisco he could find as many within a single block or two. Joe, needless to say, was enthralled, and while he was not yet ready to take cooking lessons, those too soon would come.

Joe's life did not turn on a dime. Few lives do. But his immersion in the tastes, culture, and bursting creative energy of the Bay Area, and his happy awakening to the joys and artistry of fine wine and food, represent a pivotal period in Joe's life. He was clearly loving it—but his wife Barbara was having some reservations.

One night, one of Joe's new friends in California, a banker and wine enthusiast named Bud Mueller invited Joe and Barbara to dinner at his home in Belvedere, an exclusive Marin County enclave perched on the edge of the San Francisco Bay, just across from the city. As you will see in the pages ahead, Bud Mueller would play a major role in helping Joe find his dream property in the Napa Valley and also get his start in the wine business. But that night at dinner, Bud sensed trouble ahead.

"Joe was the prototype self-made man," Bud told me. "He was smart, confident, ambitious, and very opinionated. He was very relaxed over dinner, but Barbara was not. As I later learned, Barbara at that stage was feeling very conflicted. She loved Cali-

fornia but she also loved her life back in Greeley." Indeed, this was an unhappy omen of what was to come.

During my time in Greeley, I often thought of Joe at this point in his life, in the latter part of the 1960s, turning 40, and shuttling back and forth between his home in Greeley and his home away from home in the Bay Area. In essence, he was going back and forth between two radically different poles of American life. How did he handle it? And how did his time in the Bay Area help spur his decision to leave his roots in the construction industry—and his home in Greeley—and build a whole new life for himself in the Napa Valley? What, down at the roots, drove that huge, life-changing decision?

My conversations with Bob Tointon had helped explain the business side of Joe's decision, but now I wanted a different perspective, so I went to see Robert Ruyle, the No. 2 on Joe's must-see list of people for me to look up in Greeley. Bob was a lawyer by temperament and by training, and he had done some important legal work for Joe and Hensel Phelps Construction. "Good man," Joe had told me. "Very intelligent. And a mighty fine tennis player too!"

Apparently, Bob Ruyle was also a fine fisherman and outdoorsman, judging from several of the framed photos I saw on the walls of his law office. And when we sat down to talk, I quickly saw, too, that Bob came from the same farming roots as Joe and Bob Tointon.

"My grandparents were originally from Nebraska and they had a wheat ranch in Canada," Bob told me. "My grandparents came to Greeley shortly after World War I. My granddad had served in the Army during the war, and afterwards they came here to Greeley. My granddad opened a little grocery store over on 10th Street."

Why did they choose to settle in Greeley? As Bob explained, it was because of the agricultural richness of Greeley and the surrounding Weld County farmlands. "My grandparents," he said, "bought a small property west of town. And my dad's two uncles had a small family farm near there too. Joe's parents had an 80-acre farm just adjacent to my uncles' farms."

Yes, that was Greeley, pure bedrock America, where everyone knew each other and often worked close by too. "My grandmother was really a very independent woman," Bob went on. "She owned a creamery here in Greeley and they bought sour cream and sold

it to a cooperative in Denver. They also purchased eggs, candled them, and sold them to several grocery stores around town."

"Candling eggs," I soon learned, was an essential step in running an egg business. It required holding a light or a candle near an egg to examine its inner contents and determine whether the egg is fertile or not. From looking at the color, shape, and opacity of the egg's interior, a farmer could determine whether there was a chick inside or not. Oh, the layers of education I was getting in Greeley!

"When I was little, I used to work for my grandmother for a dollar a day," Bob said. "I had a Social Security number back in 1940, when I was five years old. She used to let me take her payroll and income to the bank on my bicycle when I was seven or eight years old. She lived to be a hundred and nine!"

What Bob was helping me understand was what I had sensed when I first drove into town: that life in Greeley, then and as now, really was like stepping back in time, back to a simpler, more innocent time in America, and well before all the turmoil and the political, cultural, and moral upheavals of the 1960s. "My wife Lydia and I went to kindergarten together," Bob continued. "She was born in Denver but her father, David J. Miller, moved to Greeley and was a prominent lawyer here. In fact, he was one of the top lawyers in the state. Growing up, Lydia and I lived in the same neighborhood."

When Bob graduated from Greeley High in 1953, the town had 17,000 people. "We had one high school, and our graduating class had 150 people," Bob said. "Greeley High was a power-house as far as athletics were concerned. We went to the state basketball tournament almost every year for 20 years. My senior year we took second in the state." It took some prodding, but modest, self-effacing Bob finally admitted that he had played a little basketball in high school—and had been named to the all-state team as well.

Like Joe, Bob worked for a time as a delivery boy for *The Greeley Tribune*: "As you've heard, we used to roll up the papers and put rubber bands around them, and Joe bought up all the rubber bands in town. Then as we made our rounds, we would toss them up onto the porch. You had to deliver the paper all the way to the porch; you couldn't leave it in the driveway or anything like that." Discipline! Service to your customers! Small town America at its very best.

Bob and I chatted along like this for more than an hour. He told me how he had gone to college—the first person in his family to leave farming and go to college. Then he went on to law school at the University of Colorado in Boulder. Then he came home to Greeley to marry Lydia and practice law with her father. Soon they had three kids, and to hear Bob tell it, life was as good as it gets:

"In the old days," Bob said, "the thought about Greeley was that we had two things: we had filling stations and we had churches. We are still a very religious-oriented community, though probably not as much as before. Beyond that, not much else has changed."

In his early years practicing law, Bob did not know Joe Phelps very well, but he did know Bob Tointon; they were both active members of the Congregational Church. "We were about the same age, and our children were about the same age. My wife started a pre-school at the church, and Bob's children attended the pre-school."

The two Bobs soon discovered they shared a common love of the outdoors and one particular passion: duck hunting. "I had a place out southwest of Greeley that I hunted on," Bob Ruyle said, "and I used to take Bob out there. In fact, the first time I took him out there I thought he was going to shoot me, he was so excited!" They often went fishing together too, on the nearby North Platte River.

On the strength of that bond, Bob Ruyle soon began handling legal matters for Bob Tointon. He managed the purchase of a house for Bob and his wife Betty, and he drew up a will for them too. As you might have guessed, before long Bob Tointon introduced him to Joe Phelps. And that was in a moment when Joe really needed help.

"It was the Thursday just before Labor Day weekend, in 1966 or 1967," Bob recalled. He and his wife Lydia and their three kids were about to leave for Sun Valley, Idaho, on a family vacation. They had their train tickets, their hotel reservation, everything. But duty called, and Bob didn't even hesitate:

"Hensel Phelps was having a problem with one of their roofing subcontractors. The subcontractor had filed for bankruptcy, and Joe wanted me to help out at the bankruptcy hearing the following Monday." Bob agreed to help, and he and Lydia promptly called off their long-anticipated family vacation. From there, Bob worked all through the weekend and then represented Hensel

ROBERT RUYLE

During his Hensel Phelps years (L).

Phelps at the hearing and throughout the rest of the case—earning Joe's trust and respect in the process. Bob then joined Hensel Phelps full time in 1970, and from there the two men became lifelong friends.

I tell Bob's stories here for several reasons. First, to show, again, what a brutal taskmaster Joe could be; he drove his people as hard as he drove himself, day, night, weekends, and holidays too. That said, once you earned Joe's trust and respect, he treated you like family and he offered you company stock as well: "Work hard and share; we're all in this together."

But I also relate Bob's stories for a larger reason: they tell us so much about small town life in Greeley and how business was done there—and in so doing they paint a stunning contrast between life in Greeley and the upheavals that were rocking San Francisco in the late 1960s. Yes, as Bob Ruyle was helping me understand, Joe was now caught between those radically different poles of American life. In the end, though, he chose California Dreaming, craziness and all.

Was there a deeper element that helped drive Joe's decision?

Yes, and it emerged a few minutes later.

After our chat, Bob invited me to lunch with his wife Lydia. And what a treat she was! Lydia had two big, bright eyes that were full of laughter and wisdom. She had style, she had flair, and she wore a big, exotic silver necklace that looked Navajo or maybe Egyptian, something to be worn by a goddess of sunshine and light.

At a glance you knew that Lydia was an artist, and you knew that she was spiritually awake, and that she had lived long enough and well enough to never suffer fools or shade her words simply to be polite. As I later learned, Lydia was a gifted painter, a fierce and very effective advocate for teaching art in public schools, and an equally fierce advocate for women's rights, from equal pay to marriage reform, and every possible freedom of choice. And Lydia, I could see, had great respect and affection for one Joe Phelps.

"His mind, his ability to understand the way things work—or should work—was amazing to see," Lydia said. At one stage, she was helping the Greeley Philharmonic Orchestra raise money; its very survival was at stake. And their fund-raising effort was

not going well. So she went to see Joe. He listened, learned, and promptly announced they were doing it all wrong. Then, with a few clear suggestions, he helped them transform their entire approach to fund-raising and, Lydia said, he may well have saved the symphony in the process.

Then I asked Lydia to help me understand something larger: Joe's journey in life, his dramatic shift from construction into fine wine and fine food. Bob Tointon and Joe's son Bill had both told me that Joe's move into the world of fine wine and fine food was a natural evolution, he had simply moved his multiple gifts for business from one arena to another. That made perfect sense to me—in part. But I wondered if Lydia might have a somewhat different take. She did indeed, and she expressed it in three words:

"The Artist Inside."

Those were her words for Joe's dramatic shift in life, for embracing what he had found in California. As Lydia explained it, Joe was certainly a brilliant businessman and a master of process, yes, but there was always deep inside him a frustrated artist struggling to break free, struggling to find his own proper medium of artistic expression. As she noted, in various stages of his life Joe had studied the piano, eager to play. He had tried his hand at painting. And, of course, he had put his innate creativity to work in his business. In construction, though, Joe was building according to other people's vision, other people's needs and blueprints—not his own. In building his own winery totally from scratch, and totally free from any outside constraints or demands, and creating his own family of wines, according to his own taste and his own gifts—that for Joe was a true liberation. It gave him, Lydia said, her big eyes dancing, what Joe needed most: essential tonic for his heart and essential nourishment for his soul.

I have no ability to see inside another man's soul. But to my ears, Lydia's words had the sweet ring of truth. And please keep them in mind as we now follow to where Joe leads us next, to Florence and the genius of Michelangelo and Brunelleschi, to Burgundy and its glorious chateaus and outdoor markets and manicured landscapes, and then on to Joe's own chosen corner of the Napa Valley, with its majestic views and sun-dappled vineyards, its feeling of sanctuary and repose, and, above all else, that very special uplifting spirit that had instantly captured Joe's heart and had never let it go.

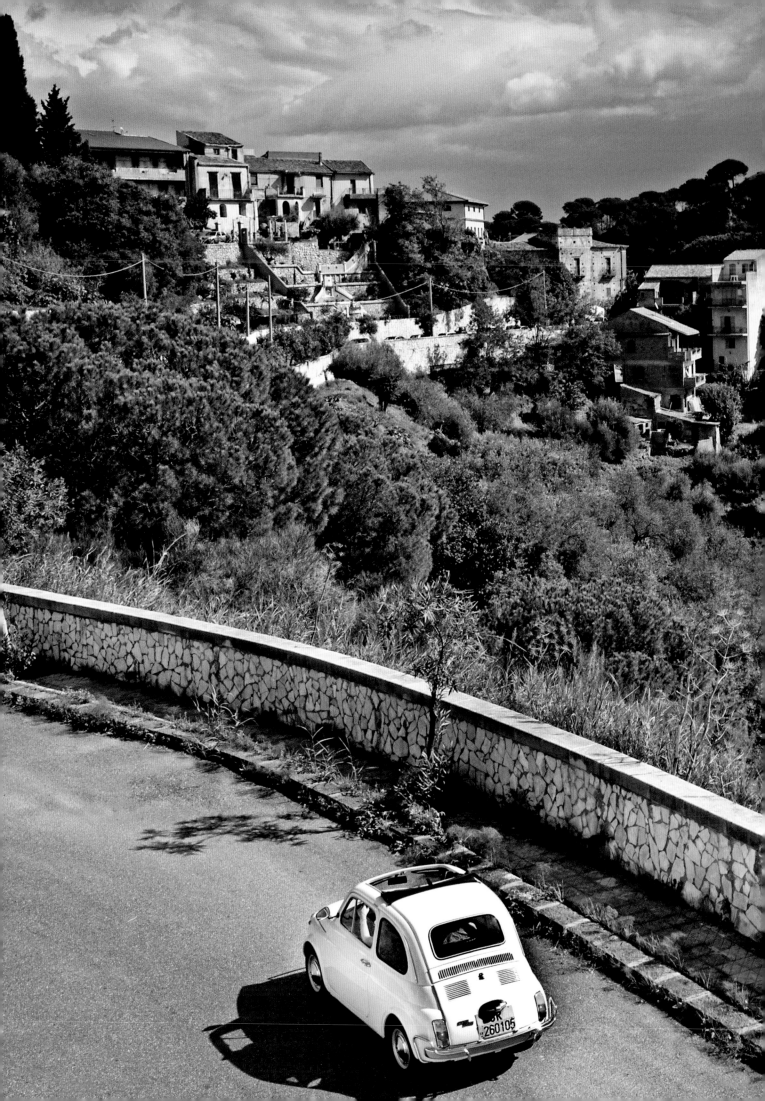

THE SPIRIT OF ITALY

Oh, that gleam in his eye!

During most of our chats, Joe remained his usual wry, witty, straight-to-the-point self. But on that lovely spring morning in the Napa Valley when we first started talking about the joys of Italy, Joe's face lit up and a playful gleam came dancing to his eye.

The wines! The pasta! The fresh morels! Those heavenly white truffles! Yes, Joe was carrying us back to the autumn of 1971, when he and Barbara were in a rented Fiat gallivanting up and down the boot of Italy, from the Lake Como region up north all the way down to Sicily and back, eating, drinking, immersing themselves in the very special spirit of Italy—and loving every minute of it.

"This was my first experience of Italy," Joe said, sipping coffee. "We were on vacation, for three full weeks, and my wife and I really took it all in." They had started in Germany, and then, after crossing the Alps, they made their way through some of the most enchanting spots in Italy, or anywhere else on the planet: Genoa. Portofino. Cinque Terre—"the five cities" along the Italian Riviera—and then into Tuscany and the city of Florence, the fabled birthplace of The Renaissance and home to so many of the enduring masterpieces of Michelangelo, Donatello, Botticelli, and Leonardo da Vinci.

"We simply fell in love with Florence," Joe said. "With the art, and especially the architecture."

Joe, as you will recall, considered studying architecture in college, but soon gravitated toward engineering and then construction. But the idea of designing his own buildings, his way, was never

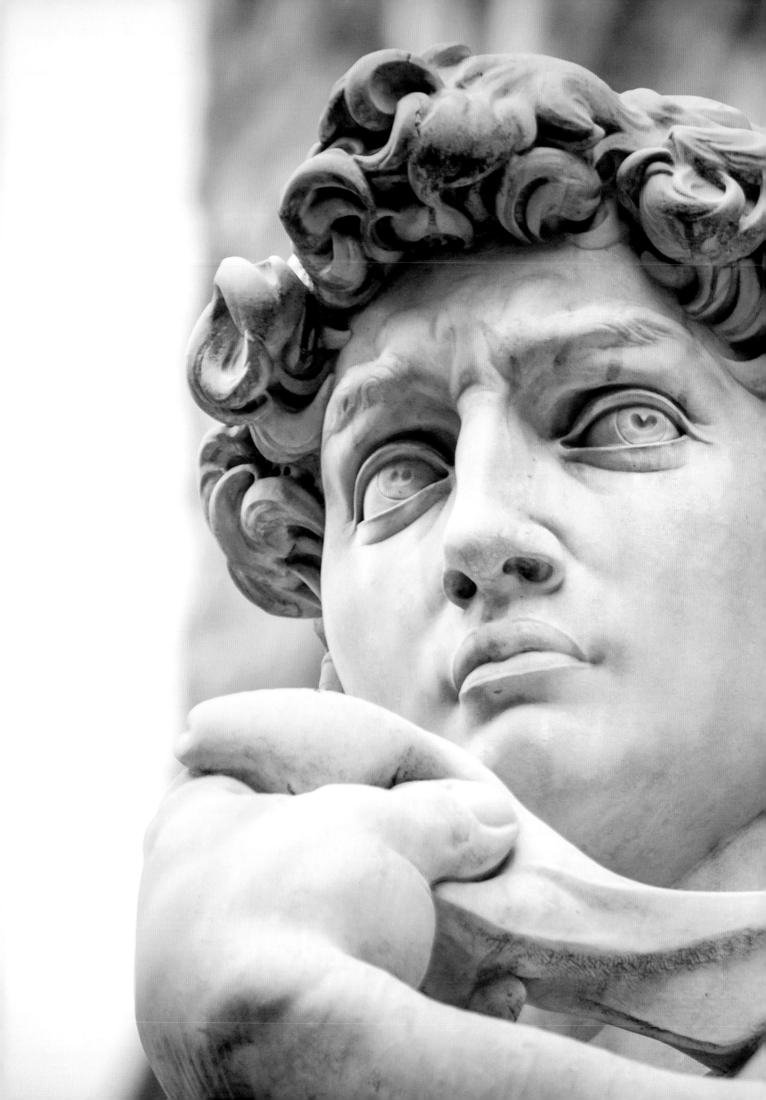

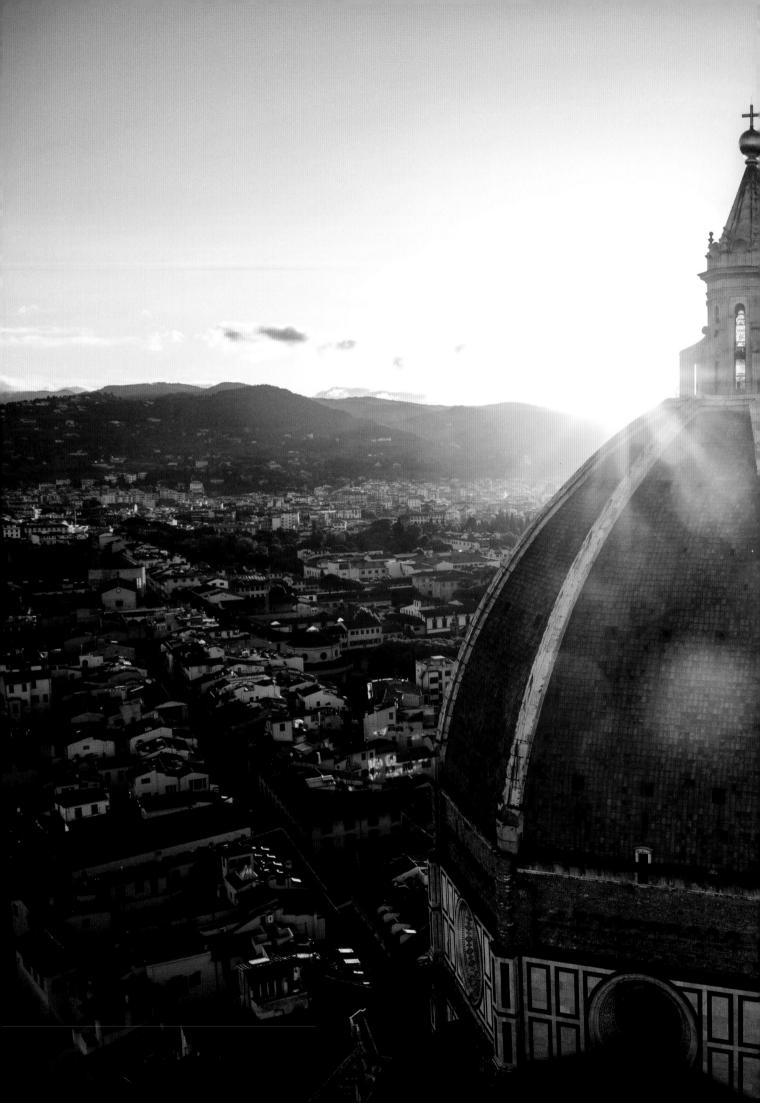

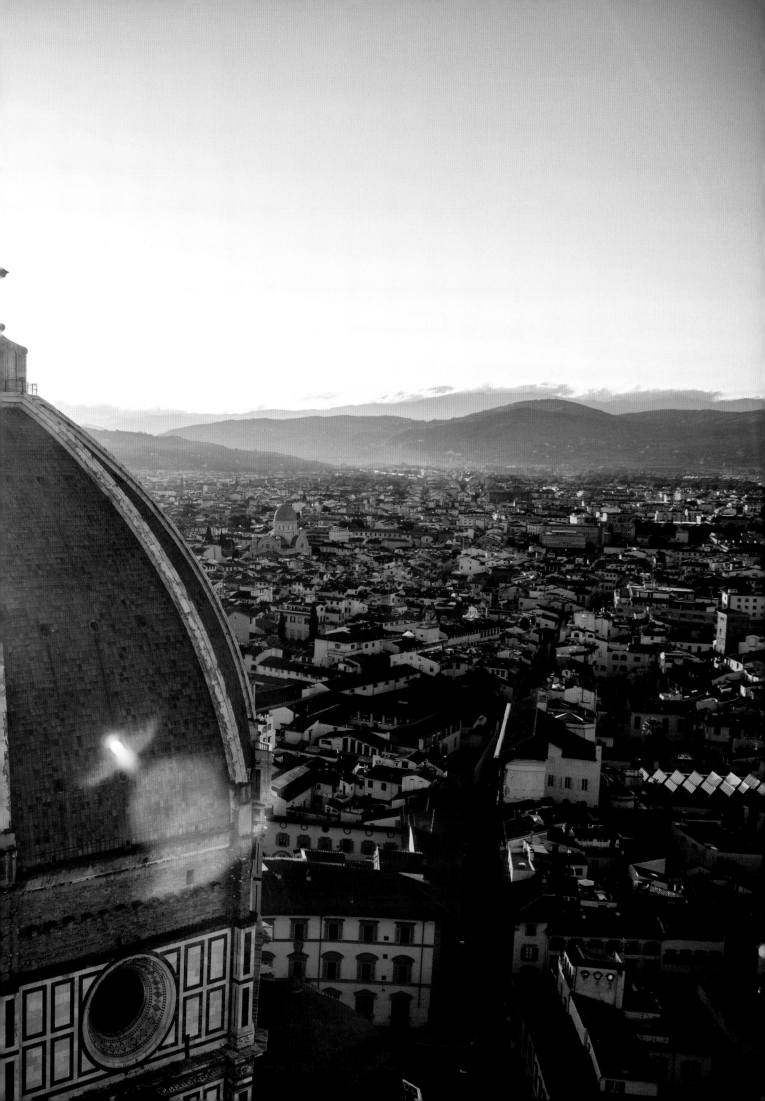

far from his heart, and Florence brought that desire roaring back to the fore.

"I had had an operation on my right foot," Joe explained, "and I was wearing a kind of crutch. Nevertheless, we managed to climb to the top of The Duomo, all 463 steps. That was not easy, especially for someone with one foot out of whack, but it proved to be one of the great experiences of my life."

Back in Chapter One, I described how important experiencing The Duomo had been to Joe's journey in life. And I described how its great halls, its marble floors, and its stained glass windows had so impressed him, with their blend of artistry and technical skill. And I also described how the genius of Filippo Brunelleschi and his magnificent dome had inspired Joe and encouraged him to reach higher in his own work as a builder. But what happened to Joe in his time in Florence and across Italy ran much deeper than that.

After Florence, Joe and Barbara spent time exploring and wine-tasting in the Chianti region of Tuscany, and right away both of them felt a warm and very uplifting connection to the place and its people. Tuscany, they found, was rich in wine, rich in heart, and it was rich in that special Renaissance spirit, and soon Joe and Barbara were dreaming of making a whole new life for themselves.

"Right there we began talking about buying property in Tuscany," Joe told me, "and having a house and a vineyard there too. At that stage, it seemed that much of that part of Italy was for sale, you could have land almost for the asking, and every piece of ground had a vineyard—and every piece of ground also had roaming bands of grape pickers, riding their bikes through the vineyards, stealing grapes, and then taking them home to make their own wines."

As Joe described it to me, what he discovered in Tuscany was an amiable mix of gentle anarchy and an unbridled passion for good wine, good food, and the joys of gathering together around the family table. Yes, Joe and Barbara were getting their first taste of La Dolce Vita—the sweet life, Italian style—and they loved it:

"In Chianti, and then at the Enoteca in Florence, and later when we were in Venice," Joe said, "we really enjoyed the wines and the food and the markets, and more than that, we thought, 'This is it. The romance, the art, the architecture... This is the way life can be.'"

For Joe, always so focused, always so driven, always so wrapped up in his work, this immersion in the spirit and values of Italy came as something of a shock. And it took "the awakening" that had begun in San Francisco to a whole different plateau. And this element was key: in Italy, Joe came to understand that good wine, consumed in moderation, was something more than a healthy practice and a joy to drink: it was an expression of an entirely different set of values.

"Those were such good days," Joe told me, rather wistfully. "I was seeing first-hand an entirely different system of values. And I think it changed my whole life. It definitely did. The Italians had so many things that we in America just didn't have."

And here was the real beauty of it: as Joe discovered in Italy, the essence of wine, down at its core, was about something that was already dear to his heart: Sharing. "Wine brings people together, at home, or at the corner café or trattoria," Joe said. "It was traveling in Italy that I first realized that."

While in Italy, Joe realized something else: how much he missed farming and the sensual pleasures of living close to the land, especially the symphony of aromas and flavors. "The wines, the cheeses, the fresh mushrooms, and those heavenly white truffles—everything in Italy smelled fresh and new to us. The seafood too. And I realized then how much I wanted to get back to growing things. I missed that in Greeley."

As you can clearly see, Joe's time in Italy sowed the seeds for what he chose to do just two years later: buy property in the Napa Valley, plant grapes, and begin making wine. But Joe being Joe, he was in no mood to be patient. As soon as he and Barbara returned home, he began transforming his house—and his life. And during my time in Greeley, I got to see first-hand exactly what he did.

With Joe's two youngest daughters, Laurie Phelps Anderson and Lynn Phelps Finch, as my personal guides, we went to their old house in Greeley, located on Glenfair Drive. To our surprise, the present owners of the house, Jack and Linda Schreiber, had left the house almost exactly as it had been when Joe's family lived there. Jack and Linda were old friends of Joe and Barbara's—Jack and Joe had been in the Rotary Club together—and they told us they loved the house just as it was; why change? To me, this was yet another indication of Greeley being anchored in the past— and quite happily so.

Linda and Jack let us roam through the house, and they let me take pictures as well. Down the hall where the kids' bedrooms used to be, Laurie was in amazement: everything was the same, including the knobs on the bathroom sink. But several things had changed in the house, and to my eye they stood as enduring signposts of the ideas and spirit that Joe had brought back with him from Italy.

In a sitting room in the back of the house, Joe already had an element inspired by Italy and the American churches he loved: stained glass windows. A whole band of them, bathing the room in a soft, almost reverential light. But after his trip to Florence, Joe had built an addition to the house, with a fireplace made of marble imported from Italy. And next to the fireplace were inlaid book shelves with a domed design, and crowning the room was an Italian-style ceiling, with stylish wooden edging. And right nearby was a quiet reading room, with lots of books on the shelves and paintings on the walls—a few breaths of The Renaissance spirit brought home to Greeley.

And there was something else: to create just the right feel for the new addition, Joe had designed and installed a special set of double doors, both adorned with lovely carvings in wood, obviously done by skilled Old World craftsmen. And it did not take a genius to see the roots of Joe's inspiration here: the celebrated bronze doors of The Duomo, the creation of Lorenzo Ghiberti, a Florentine artist and sculptor. The doors had originally been designed for The Baptistry adjoining The Duomo, but they were later brought to the Duomo itself. And it was Michelangelo himself who had given the doors the name that has endured across the ages: "The Gates of Paradise."

What a delicious revelation all this was! Joe the builder, Joe with a frustrated artist stirring inside him, had come home from Italy in a fervor, eager to enliven his house and his family with a generous touch of the Renaissance spirit and touches of Italian design as well. And the new entryway to their home was even a bow to The Gates of Paradise. Perfect! No wonder Linda and Jack Schreiber had left the house just as it had been!

And now comes the best part, the finishing touch: what Laurie, Lynn, and I found down in the lower level of the house, right beside the door of what had been the family's concrete fallout shelter. In that cozy little space we found a long wooden work bench, with a rack for tools just above it. That rack was now

carefully lined with screwdrivers, but in Joe's day it held cork-
screws, funnels, strainers, and a big clipboard where Joe carefully
recorded his tasting notes.

Seeing all this, Lynn simply lit up with excitement: "This was it!
Next to nothing has changed!"

As Lynn explained, this was Joe's first wine lab, the place where he
had begun learning how to make wine. To get started, Joe bought
a hand-cranked grape crusher, and then he had a load of fresh
grapes shipped in from California. There is a wonderful photo
of the day the crusher arrived, with Joe's mom Nita and a group
of workers standing beside it out in the driveway. You can almost
see Nita thinking, "Oh Joe, what sort of mischief have you got us
into now!" From there, of course, in his best Popular Mechanics,
do-it-yourself, can-do spirit, Joe began teaching himself the rudi-
ments of crushing, fermenting, blending, aging, and constant
learning, "sip by sip."

By 1971, when Joe and Barbara returned from Italy, their oldest
children, Leslie and Bill, had both left home for their respective
prep schools. In the fall of 1968, Leslie went off to the Katharine
Branson School in Marin County, north of San Francisco, and the
following year Bill went East to Phillips Exeter Academy, located
in New Hampshire. Laurie and Lynn remained at home, and soon
Lynn had a very serious new job: helping her dad in the wine cellar.

To guide his learning process, Joe would sample a wide variety
of wines, to study and evaluate their characteristics and the way
they were made. Then Joe would document his findings, bottle
by bottle, and then he would carefully soak off the labels. From
there, it was Lynn's job to dry the labels, smoothing them out
flat, and then paste the labels on a wall alongside the workbench
and cover them with a protective glaze. The idea was to create a
rough visual map of Joe's journey in wine. And just guess what
we found next...

"Oh my god, it's still here!" Lynn exclaimed. And there it was,
hidden behind a spare mattress: the wall of labels. The map of
her dad's journey in wine. And with a simple glance, you could
see that Joe had not built his knowledge and learned his craft
by sampling jug wines or the mule-like kicks of a Ripple or a
Night Train. Oh, no. Even at the beginning stages, Joe Phelps was
learning his craft from top-of-the-world Burgundies like Chas-
sagne-Montrachet and from some exquisite Bordeaux wines too,

DETAIL OF THE
CARVED DOOR

*Joe's Greeley
home.*

many of them imported by the eminent wine writer and connoisseur Alexis Lichine. In sum, Joe was intent on learning from The Best of The Best. As always with Joe, second best would never do.

Now it was all coming clear to me. In the eyes of Linda and Jack Schreiber, a lot of history—the personal history of Joe Phelps and the wider history of wine in America—had taken place right under their roof in Greeley, and they were intent on preserving it, waiting for someone like me to come along and help Joe tell his story. They even kept the original blueprints from which Joe had built the new addition to their house—a plan Joe then executed, of course, with construction crews from Hensel Phelps. Keep it all in the family.

We had tea with Linda and Jack, and then we left Glenfair Drive with a flood of warm family memories, and I left with a notebook full of observations. And as we drove off, I couldn't help but shake my head in wonder at the stunning juxtaposition that Laurie, Lynn and I had found right there in the basement: Joe's first wine lab just a few steps away from that chilling concrete fallout shelter—two revealing emblems of Joe's journey, and of America's as well.

◆

Beaulieu Vineyard
BV
ESTATE BOTTLED
NAPA VALLEY
BURGUNDY

PRODUCED & BOTTLED BY BEAULIEU VINEYARD
AT RUTHERFORD, NAPA COUNTY, CALIFORNIA

PRODUCED AND BOTTLED AT THE WINERY

VINTAGE 1970
Souverain
NAPA VALLEY
Pinot Chardonnay
ALCOHOL 12½% BY VOLUME
SOUVERAIN CELLARS · ST. HELENA, CALIFORNIA

ESTATE BOTTLED
Inglenook
Napa Valley
GAMAY
1967
PRODUCED AND BOTTLED BY INGLENOOK VINEYARDS, RUTHERFORD, CAL.

Imported by
DAVIS BROTHERS, INC.
Denver · Colorado

BOLLA
SOAVE
BOTTLED IN ITALY

Beaulieu BV Vineyard
NAPA VALLEY
BURGUNDY
ESTATE BOTTLED

Produced from Gamay
and Mondeuse Grapes

ESTATE BOTTLED is the rare designation permitted
for use only by the wine growing estates — the same
privilege enjoyed by the "chateau" wines of France.

TWO choice French grape varieties combine to pro-
duce this wine. From the Gamay grape it derives
more than the usual claim to the name of Burgundy.
The Mondeuse of Savoy contributes its character
and individual fruitiness.

The Napa Valley Burgundy of Beaulieu is a wine
of clear ruby color, fresh, light in body, pleasing in
fragrance and flavor.

NET CONTENTS
1 PINT 8 FL. OZS.

SOAVE
CLASSICO
DENOMINAZIONE DI ORIGINE CONTROLLATA
BOLLA
PRODUCED AND BOTTLED IN THE CLASSIC ZONE
SOAVE - ITALY
BY
FRATELLI BOLLA - PRODUTTORI
VERONA - ITALY

Heitz Cellar
NAPA VALLEY
CHABLIS
ALCOHOL 12½% BY VOLUME
PERFECTED AND BOTTLED IN OUR CELLAR BY
HEITZ WINE CELLARS
ST. HELENA, CALIFORNIA

This Inglenook table wine is Estate
Bottled. Almost unique as such in America,
every drop comes only from carefully selected
vines. It reflects more than 90 years of
Inglenook heritage, and craftsmanship pos-
sible only when every step of its development
is guided by our winemaker.

VINS D'ALSACE BOECKEL
APPELLATION ALSACE CONTRÔLÉE
GEWÜRZTRAMINER
ESTATE BOTTLED Produce of France

E. BOECKEL NÉGOCIANTS A MITTELBERGHEIM, B-RHIN

Shipped by: E. BOECKEL, NEGTS. A MITTELBERGHEIM, B.-RH ALSACE
Imported by: STUART IMPORTS LTD.
SAN FRANCISCO, 7 CALIFORNIA U.S.A. Importers Basic Permit SF 1-4o
Alcohol by volume 12%

Produced from Gamay
and Mondeuse Grapes

LOUIS M. MARTINI
ST. HELENA

Shipped by
ALEXIS
LICHINE & Cº

Beaujolais Villages
APPELLATION CONTRÔLÉE

Louis Latour
MAISON FONDÉE EN 1797
NÉGOCIANT A BEAUNE (CÔTE-D'OR)

EASTERN DISTRIBUTOR "21" Brands, Inc. NEW YORK
12½% ALCOHOL BY VOLUME

California
MOUNTAIN CHIANTI
Red Wine made from Napa & Sonoma County Grapes
Prepared and Bottled at the Winery by
LOUIS M. MARTINI

IVANCIE WINES

Our wines are produced from grapes
of the famous California Northcoast counties
of NAPA, SONOMA, and MENDOCINO.
The Ivancie family originated from Austria.
They have been making wine in the
Old World Tradition for many generations.

Ivancie Wines are cellared and aged under
the favorable conditions of low
humidity and the "Mile High" altitude of the
Colorado Rockies.

Only Varietal Grapes are used in the making
of Ivancie Wines. The result is a
distinctive bouquet, deep body, and a
lingering after-taste.

Heitz Cellar
NAPA VALLEY
CHABLIS
ALCOHOL 12½% BY VOLUME
PERFECTED AND BOTTLED IN OUR CELLAR BY
HEITZ WINE CELLARS
ST. HELENA, CALIFORNIA

Beaujolais Villages
APPELLATION CONTRÔLÉE

Louis Latour
MAISON FONDÉE EN 1797
NÉGOCIANT A BEAUNE (CÔTE-D'OR)

VINTAGE 1970
Souverain
NAPA VALLEY
Pinot Chardonnay
ALCOHOL 12½% BY VOLUME

PRODUCED AND BOTTLED AT THE WINE

EASTERN DISTRIBUTOR "21" Brands, Inc. NEW YORK
12½% ALCOHOL BY VOLUME

Vintage of
1969

California
MOUNTAIN PINOT CHARDONNAY
A Dry White Wine made from Pinot Chardonnay Grapes
Produced and Bottled at the Winery by
LOUIS M. MARTINI
ST. HELENA, NAPA COUNTY, CALIFORNIA, U. S.
WESTERN DISTRIBUTOR Parrott & Co. SAN FRA

BURGUNDY
RED WINE
FREDERICK
WILDMAN
ALCOHOL
13% BY VOLUME
MOUNTAIN PINOT CHARDONNAY

This excellent dry white wine
grapes of the sparse-producing
donnay variety grown on our v
Mayacamas Mountains just nort
Napa Bay and not far from the
County line.

NET CONTENTS
1 PINT 6 FL. OZS.

VINTAGE 1970
Souverain
NAPA VALLEY
Pinot Chardonnay
ALCOHOL 12½% BY VOLUME
BY
SOUVERAIN CELLARS · ST. HELENA, CALIFORN

1970
Napa Valley
GAMAY ROSÉ
ALCOHOL 13% BY VOLUME
PRODUCED AND BOTTLED BY
ROBERT MONDAVI WINERY
OAKVILLE, CALIFORNIA

Concannon
vineyard
PETITE SIRAH

Weibel GREEN HUNGARIAN
Serve well chilled—at about 50°

WEIBEL CHAMPAGNE VINEYARDS
Mission San Jose, California

THE HERITAGE OF MIRASSOU
The Mirassou family has been producing
some of the Santa Clara Valley's finest
varietal wines since 1854. It was at that
time that our founder, Pierre Pellier,
planted grape cuttings which he brought
from Bordeaux, France. His son-in-law,
Pierre Mirassou, succeeded him, follow-
ed in turn by his son Peter Mirassou and
his grandsons, Edmund and Norbert.
In 1961 the 5th and present generation
extended these fine varietal plantings
into the world famous Monterey County.

It is our desire to follow in the tradition
that has set Mirassou apart, family owned
and operated with an uncompromising
commitment to excellence.

GAMAY BEAUJOLAIS is a high-spir-
ited, light Burgundy with a delicate,
fruity aftertaste. This wine should be
consumed at an early age.

BOLLA
VALPOLICELLA is a delightful wine,
not too spiced, or with poultry, veal and lamb.
It is garnet red in color, dry, with a unique after-
taste and intense yet delicate bouquet.
13% alcohol.

BOTTLED IN ITALY

Heitz Cellar

SOAVE BOLLA
ITALIAN LIGHT DRY WHITE WINE
SUPERIOR QUALITY
PRODUCED AND BOTTLED IN
SOAVE - ITALY
BY
FRATELLI BOLLA
VERONA
ITALY

GREEN HUNGARIAN
by
Weibel

For three generations our family has made this
delicately sweet varietal wine. It has a unique
charm and versatility you will find most enjoyable
with all light foods.

GRAND VIN DE GRAVES

1969
CHÂTEAU CARBONNIEUX
GRAND CRU CLASSÉ
LÉOGNAN
MISE EN BOUTEILLES
AU CHÂTEAU APPELLATION GRAVES CONTROLÉE
Propriétaire : Société des Grandes Graves

Napa Valley
CHARDONNAY
187

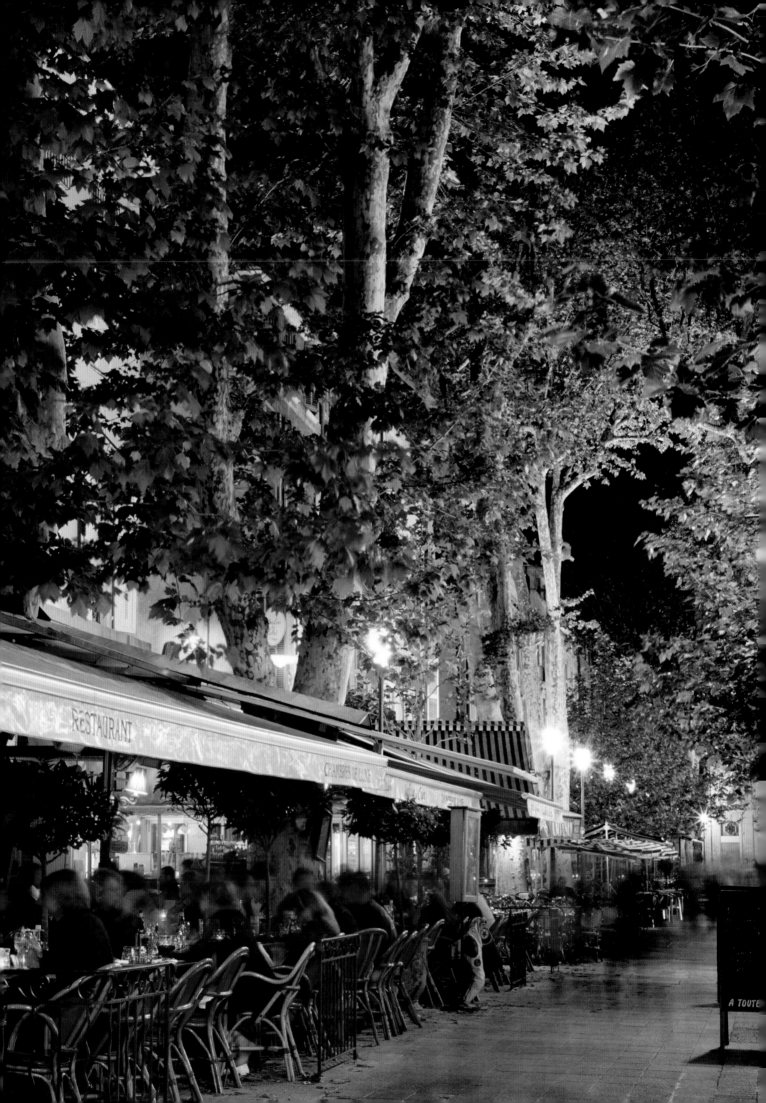

THE CULTURE OF FRANCE

"Bonjour, Monsieur Phelps," I said one morning as I walked into Joe's sun-filled country kitchen, and the old boy didn't miss a beat:

"Ah, bonjour, Paul. Asseyez-vous. Voulez vous un café?" Sit down. Would you like a coffee?

Joe's knowledge of French, I quickly saw, was quite solid, and his accent was pretty good too. And soon we were off and running, talking about his early trips to France, about how he had fallen in love with France and French culture, and about how what he had seen and learned in Burgundy, Aix-en-Provence, and Paris, of course, had helped inspire and define what he soon would be doing in his new home high on a hill in the Napa Valley.

"I loved Italy, I loved the spirit of the place," Joe said, "but on my first trip to France, I got very excited about the country, because it seemed a far more reasonable and rational place than Italy, and a much easier place to live. And it turned out I was right."

Joe told me his first real taste of France came in Aix-en-Provence, a lovely university town in the south of France, some 20 miles north of Marseilles. Aix-en-Provence was the birthplace of Paul Cezanne, and with its sun-dappled landscapes, its tree-lined boulevards, and its wealth of bistros and outdoor cafes, taking long, leisurely walks around Aix gave Joe an instant immersion in the aesthetics and all the rich sensory pleasures that make France France.

And for Joe, one of the most enchanting of those pleasures was the food. "Aix is where I really got excited about French food," Joe said, "because there I ran into a place called Les Deux Garçons."

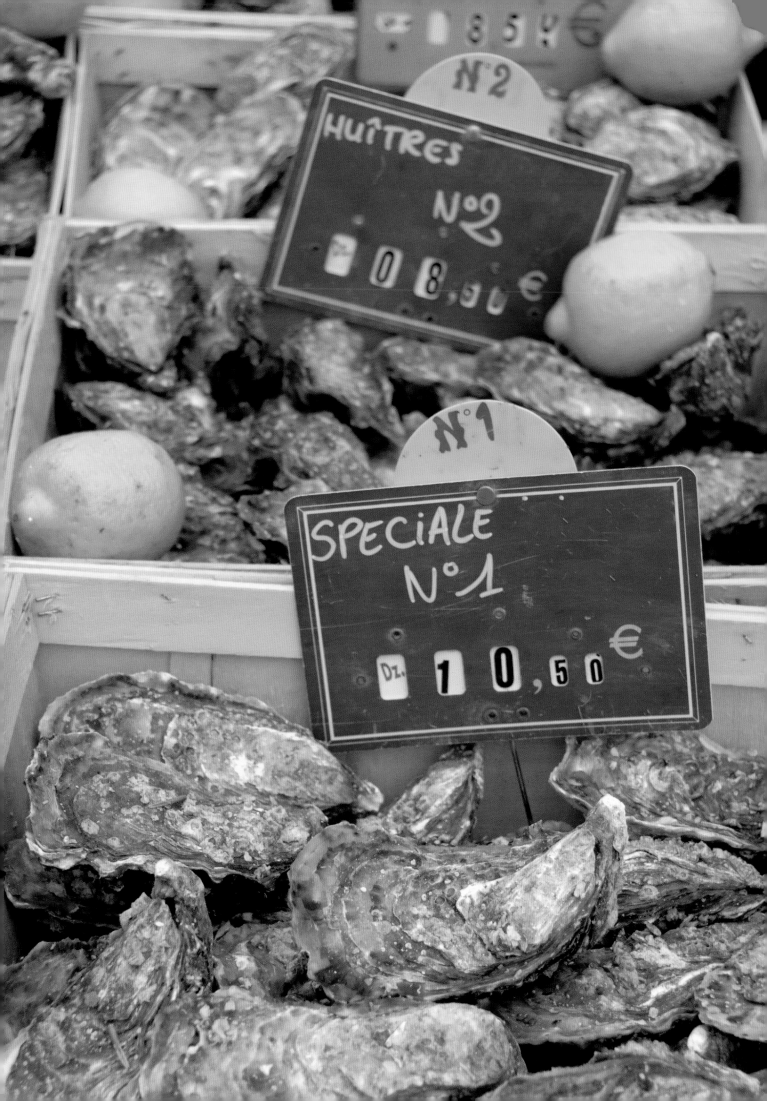

Now Joe leaned back in his chair, as he remembered feasting at this iconic bistro in Aix, facing the picturesque Cours Mirabeau. Oh, those oysters on the half-shell! The sumptuous bouillabaisse, the steak tartare, the seared magret de canard, the farm-fresh chicken, and the glorious fish and seafood platters, most of the catch coming straight from the Mediterranean Sea—as Joe remembered it all, our mouths were watering right there at his kitchen table. And, of course, the wines. The wines! The heavenly wines of Burgundy and Provence, of Bordeaux and the Loire Valley, and even the local wines you could find at the co-ops in almost every corner of France.

"For me, this was it, Heaven on Earth," Joe told me, with a touch of rapture in his voice, and right then and there I could see, I could feel, how France and its very special joie de vivre—its joy of living—had captured his heart. In his later years, Joe's grandchildren would call him "Seppi"—short for "Giuseppe," Joe in Italian—and that was entirely fitting, given his love for Italy. But the simplicity of his country kitchen in the Napa Valley, the stylish mural in his dining room, and, above all, the soaring quality and elegance of the wines that he and his winemakers had crafted over the years—the inspiration for all of that had come from only one place: France.

And Joe and Barbara always had Paris. In their first trips to the City of Light, Joe and Barbara would usually stay on the Left Bank, and they would spend their days savoring the art at The Louvre, the Rodin Museum, or the Jeu de Paumes, the small museum in the Tuileries Gardens that back then was home to many of the most celebrated Impressionist paintings in the world, the Monets and the Renoirs, the Pissaros and the Manets, and those of Edgar Degas and Mary Cassatt. By late afternoon, Joe and Barbara would be back on the Left Bank, strolling through the Luxembourg Gardens or exploring the shops and art galleries along the rue de Seine.

"We almost always ate dinner somewhere on the rue de Seine," Joe told me, and after dinner they would walk over to the Boulevard St. Germain, to have a coffee or a cognac and watch the passing parade from a table at an outdoor café. A perfect end to a perfect day.

Isak Dinesen, the Danish writer, once observed that "all the arts flow together"—wine, food, fashion, and the arts of architecture, painting, sculpture, design, music, and more—and nowhere do

CHAMPAGNE
JOSEPH PERRIER

*Poster by
Colette Stall.*

L'INSTANT TAIT-
TINGER POSTER

*Grace Kelly
standing behind
the champagne
flute.*

L'INSTANT
TAITTINGER

SACHEZ APPRÉCIER ET CONSOMMER AVEC MODÉRATION

you feel that truth more keenly than in Paris. Joe and Barbara felt it wherever they strolled and wherever they ate, and they even felt it when they traveled around the city via The Paris Metro: many of the great French houses of wine, spirits, and fashion promote their creations with brilliant poster art, strategically placed on the walls of the busiest Metro stations. And as you will see in the pages ahead, when Joe moved to the Napa Valley he wanted all the arts to flow happily together at his master creation, Joseph Phelps Vineyards.

But first came Burgundy, one of the most esteemed wine-growing regions in the world. During one of their trips to France, Joe and Barbara flew into London's Gatwick Airport, and from there they flew into Dijon, in the heart of Burgundy. Their youngest daughter Lynn was with them on the trip. Given his love for fine Burgundy wines, Joe's plan was to spend time in Dijon and in nearby Beaune, the wine capital of the region, with the intention of deepening his knowledge of Burgundy wines and learning first-hand how they were grown, aged, blended, and then brought out into the world.

As Joe told me, this was a fabulous education, a dream come true. After all, it is one thing to drink an exquisite Romanée-Conti or a memorable Chassagne-Montrachet at home in Greeley or at a fine restaurant in Denver or San Francisco. But it is quite another to see and smell the vineyards of Burgundy first-hand, to taste the wines they produce right where they were planted, and, of course, to immerse yourself in the culture that brings these wines to life and helps them sing. And for a budding wine connoisseur like Joe, what could be more exciting and informative than going to a chateau or to the Hospices de Beaune, the center of wine activity in Burgundy, and spending hours tasting and comparing, learning "sip by sip" how some of the world's finest wines come into being. Yes, for Joe this was indeed "Heaven on Earth," and an experience that would help carry him straight to his own personal corner of the Napa Valley.

For this trip, Joe again rented a Fiat and for a time he and Barbara and Lynn meandered through the back roads and hamlets of Burgundy. They were enchanted by the lushness of the vineyards and the landscapes, and by the many outdoor markets, with their bountiful arrays of fresh fruits, vegetables, and flowers. Joe and Barbara also loved their long lunches and their relaxing dinners, and they loved starting their day with steaming coffees and warm croissants fresh from the oven. For Joe, of course, all

this was worlds away from his hectic Saturday morning meetings at King's Café in Greeley and from those lunches bolted at his desk or gulped between meetings. Joe's guiding ethos remained "work hard and share," but now he wanted more balance in his life, and he wanted to make much more room for glorious wines, food, and fun too.

As Joe made clear to me, these early experiences in France stood out as a turning point in his amazing journey. During this period of the early 1970s, Joe was reaching his mid-40s, Hensel Phelps Construction was strong, growing rapidly, and virtually debt-free, and financially Joe and his family were totally secure. But now, with his relentless drive and his constant need for fresh creative juice, Joe was thirsting for more, and his travels across France had shown him where to head next and they had helped light the way. In time, too, Joe would have his own homes in the south of France, sanctuaries where he could cook, paint, read, relax, and enjoy all the other pleasures of life, with the same gusto the French do.

As I closed my notebook and turned off my tape recorder that afternoon, I asked Joe to summarize for me what these early travels in France meant to him, and how he felt about them now, looking back through the lens of everything he had gone on to live and create in the Napa Valley. Joe was quiet for a moment, and then, as only he could, he summed up his feelings in just a few words:

"France was a precious gift to me, and it was the origin of many very happy beginnings."

◆

THE VALLEY OF DREAMS

THE VALLEY OF DREAMS

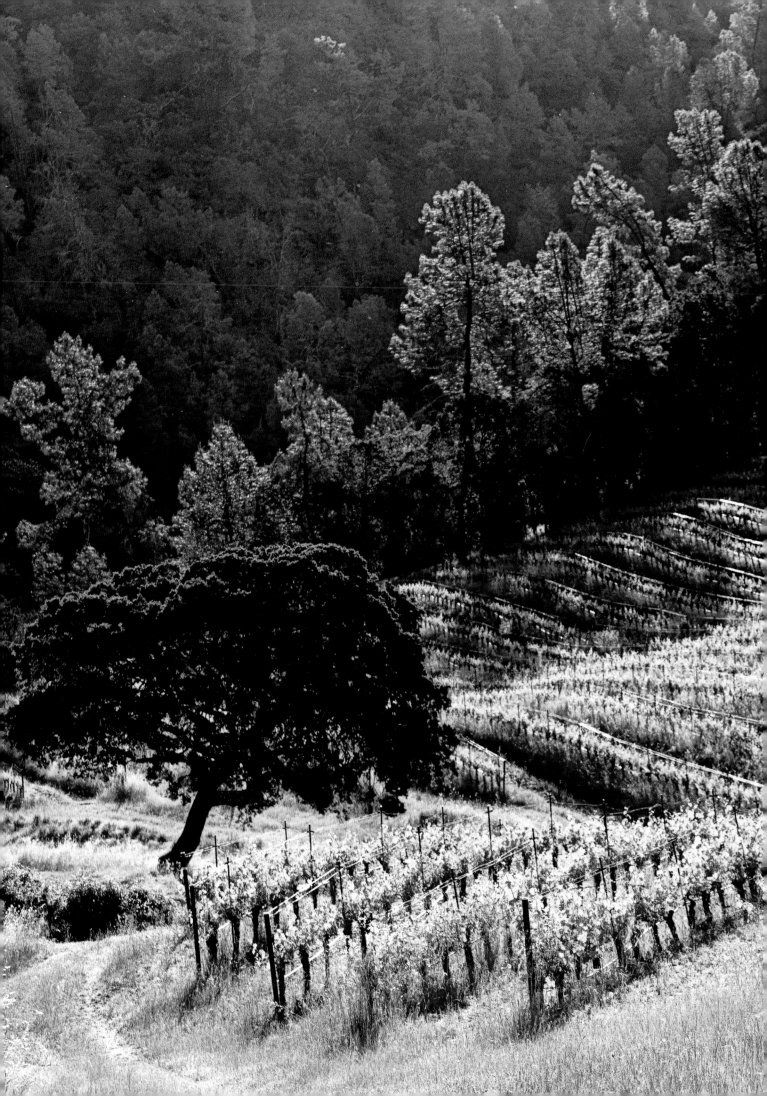

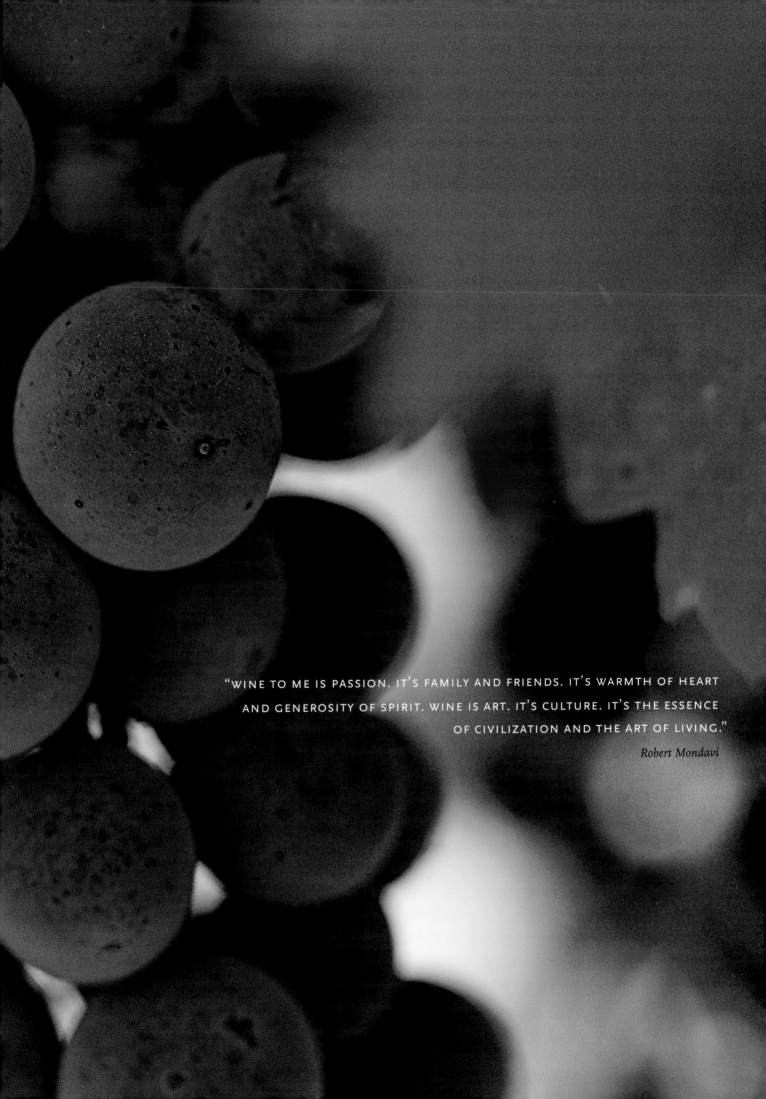

"WINE TO ME IS PASSION. IT'S FAMILY AND FRIENDS. IT'S WARMTH OF HEART AND GENEROSITY OF SPIRIT. WINE IS ART. IT'S CULTURE. IT'S THE ESSENCE OF CIVILIZATION AND THE ART OF LIVING."

Robert Mondavi

SUN, SOIL & SPIRIT

His timing was perfect.

Joe first came to the Napa Valley at a crucial juncture in its history: when the valley was just beginning its transformation from a sleepy, inward-looking California backwater into what it is today: one of the great winegrowing regions of the world and, of course, a dream destination for wine and food lovers from all over the globe.

In my eyes, this is one of the great American success stories of the past 50 years: how this quiet, unassuming 29-mile sliver of farm and ranch land, with only two dozen wineries, few restaurants, and almost no art or culture, turned into a star-spangled showcase of American artistry, ingenuity, and entrepreneurial flair, with more than 500 wineries—more than 500!—and a parade of high quality restaurants, bistros, galleries, markets, and festivals that can make even the folks in Burgundy and Tuscany green with envy.

And guess what? In his own modest, self-effacing way, Joe was right in the heart of it all, creating, innovating, and helping lead the parade. As Bob Trinchero said at the outset of this book, "Joe Phelps is the unsung hero of the Napa Valley and American wine."

To help you understand Joe's entryway into the valley, and also the importance of everything he built once he got here, let me present right here a capsule history of winemaking in the Napa Valley.

The history of grape growing in California begins more than 300 years ago. According to most accounts, the first grapes were planted here back in 1683, almost a full century before the Declaration of Independence and the start of the American Revolution. But those vines were not properly cared for and they soon perished.

In 1779, though, a group of resourceful Spanish missionaries led by Father Junipero Serra, a prominent figure in early California history, planted vineyards in the nine different missions they started across California, including one in Sonoma County. Father Serra and his followers had one objective: to make wines to use in their missions' religious services—and not for wider consumption. So the birth of commercial winemaking in California was still many years away.

In terms of the Napa Valley, one early trailblazer was a rugged farmer and fur trapper named George Calvert Yount. Yount was born in North Carolina but, like Joe Phelps, he spent most of his early boyhood years on farms in Missouri. During the War of 1812, Yount served in the fabled Kentucky Riflemen, battling the British and their local allies. After the war, Yount came west to California and settled in the Napa Valley. With a land grant from the Spanish government, he secured property near the geographic center of the valley, in an area that was later named Yountville, in his honor.

At that stage, several Indian tribes were living happily in the Napa Valley, but Yount is credited with being the first Euro-American to take up permanent residence. On his land, he built himself a cabin and then, in 1839, he planted the valley's first grapes—a landmark event in the history of the Napa Valley. George Yount died in 1865, just after the end of the Civil War. *The Napa Register*, then as now the most influential publication in the valley, reported his passing with an extensive and very respectful salute.

Even with Yount, though, something was missing: *vitis vinifera*, the species of grape that for centuries has been the grandfather of the finest wines of Europe. Would *vitis vinifera* grow in American soil? Many of our earliest settlers on the East Coast certainly hoped so. In fact, many of them came to our shores carrying cuttings of this ancient plant, whose origins trace back to the Mediterranean basin. But they had little success. The plants would last only two or three years and never long enough to produce grapes of a quality suitable for making wine. The climate and the soils up and down the East Coast were just not hospitable to *vitis vinifera*, and so all the hopes and dreams of those early settlers quite literally died on the vine.

But what about in California?

Two early settlers, John Patchett and Hamilton Walker Crabb, are credited with being the first to plant *vitis vinifera* in the Napa Valley. But like their counterparts on the East Coast, their hopes and dreams of making good wine in America also died on the vine.

Then along came a Prussian immigrant named Charles Krug. Krug arrived in the United States in 1847, and with the fabled Gold Rush of 1849 he came to California and worked for a time as an editor at a German-language newspaper in San Francisco. Then Charles Krug fell in love with wine and abruptly transformed his life—just as Joe Phelps would do 120 years later. To learn the ropes, Krug went to work for Agoston Haraszthy, a Hungarian immigrant who had come to California and founded the Buena Vista Winery over in Sonoma County. After his apprenticeship, Krug married a woman from a wealthy California family and moved to the Napa Valley.

With help from his wife's dowry, Charles Krug bought 540 acres of prime Napa Valley farmland, on the northern outskirts of the town of St. Helena. There he plant vineyards and in 1861 he opened the Charles Krug Winery, the very first winery established in the Napa Valley. The winery is still going strong today, over 150 years later.

Krug was the start. Soon other European immigrants with dreams of making wine in America settled in the valley. In 1875, Jacob and Frederick Beringer, two brothers from Germany, opened Beringer Brothers, on a site just to the south of Charles Krug.

CHARLES KRUG
VINEYARD

*Lithograph,
courtesy of the
Napa Valley
Museum.*

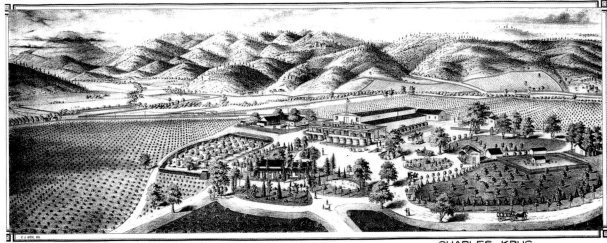

CHARLES KRUG.
RESIDENCE, VINEYARD AND CELLARS IN ST. HELENA, NAPA CO. CAL.

Then in 1879 Gustave Niebaum, an adventuring fur trader and sea captain from Finland, came and opened the Inglenook Winery, in the town of Rutherford, just a few miles further to the south, along what is now Highway 29. Inglenook has changed hands several times since, but it is now the fiefdom of another adventurous pioneer: Francis Ford Coppola, the legendary creator of "The Godfather" trilogy.

In creating Inglenook, Niebaum had one over-arching ambition: to make fine wines in the Bordeaux style—and with Bordeaux quality as well. And Niebaum made his mark. At the 1889 World's Fair in Paris, Niebaum's wines beat rivals from Bordeaux and beyond and came away with gold medals. Many traditionalists in the European wine world were shocked—just as they would be again 87 years later in the now-famous Paris Tasting of 1976. Niebaum, of course, was over the moon, as were the other early wine pioneers in the Napa Valley. In their eyes, the future could not be brighter.

For the next several years Gustave Niebaum, Charles Krug, the Beringer brothers, and the other European settlers rode a beautiful wave. For them, the Napa Valley had an array of natural riches that even the French had to envy. The soils were rich in minerals and nearby water sources. In the summer growing season, the days were filled with sunshine and heat, and yet the evenings were cool and soothing for the grapes, thanks to the marine breezes that flowed in from the top of the San Francisco Bay. Yes, for these early settlers, the Napa Valley was like a gift from heaven itself, an ideal place to put down roots, grow grapes, craft beautiful wines, and plant deep in the American soil the true essence of European wine and culture. And for them there was the sweetest cherry on top: their *vitis vinifera* grapes simply adored the warm California sun.

But then came phylloxera.

At the start of the 1900s, many of the wineries in the Napa Valley and elsewhere in California were crippled by the onset of that nasty little root louse called phylloxera. This tiny, microscopic beast feeds on the roots of grape plants, and an infestation can devastate an entire vineyard in just two to three years, or even less. Phylloxera had wreaked havoc in the vineyards of France in the mid-19th Century, and it wreaked plenty of havoc in the Napa Valley as well.

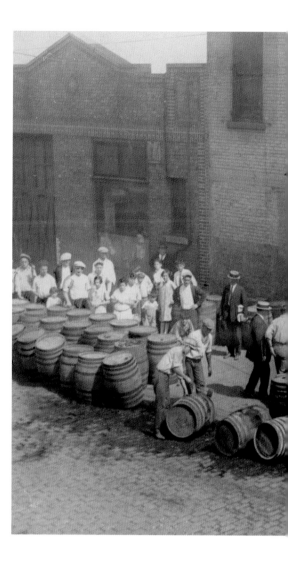

PROHIBITION

Prohibition agents confiscate barrels of wine on the streets of St. Helena, California.

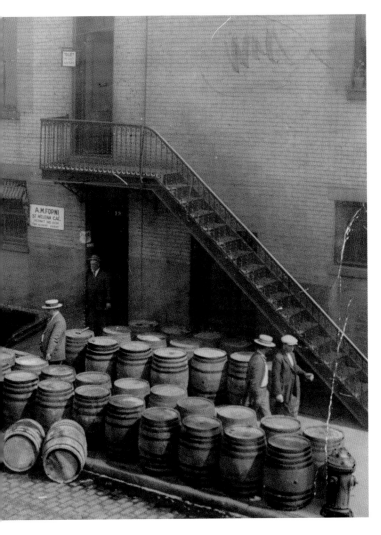

And soon thereafter came Prohibition.

Nature's havoc was bad enough; Man's havoc was even worse. In 1919, in response to a very vocal national Temperance Movement, the U.S. Congress passed the Volstead Act, which banned the sale of most alcoholic beverages. The act, implementing the 18th amendment to the Constitution, went into effect in 1920, and it forced most Napa Valley wineries to shut their doors. But there were exceptions. Due to the significance of wine in many religious traditions and ceremonies, the Volstead Act allowed for the making of sacramental wines—a proviso that allowed Christian Brothers Winery and Beaulieu Vineyards, both Napa Valley stalwarts, to make sacramental wines and thus stay in business. For the rest of the young wine industry, though, in the Napa Valley and in other winegrowing regions across America, Prohibition was almost a death blow, and one from which it would take decades to recover.

Prohibition was formally lifted in 1933, but The Great Depression dragged on, and for the next three decades not much changed in the Napa Valley. No new wineries were built anywhere in California, and by the early 1960s there was no change visible on the horizon.

And understandably so. At that juncture, the dominant forces in the American wine market were still those inexpensive jug wines and those cheap "bum wines" like Thunderbird, Ripple, and Night Train. On top of that, anyone who wanted a better wine could easily buy a good Burgundy or Bordeaux or a decent Chianti for $5 or $10 a bottle, or even less. With those stark market realities, most of the two dozen vintners remaining in the Napa Valley felt absolutely no urge or compunction to upgrade their equipment and vines and try to move upmarket. Try to compete with the French or the Italians? With their centuries of knowhow and experience? What would be the point of that? And what fool would take on that kind of risk?

Well, one fool named Robert Mondavi.

Robert stands today as one of the preeminent figures in the history of American wine, and I want to share with you some highlights of his family story, as they add many layers of flavor and character to the story of American wine and they take us directly to Joe's own doorway into the Napa Valley.

Robert's parents, Cesare and Rosa, were born in Le Marche, what was then a very backward farm and mining region of central Italy. Their parents were poor sharecroppers, meaning they were allowed to live and farm on a small plot of land—provided they gave a large portion of whatever crops and animals they raised to the wealthy landowner who lived in the big manor house just up the hill. This was one small step away from feudalism, and as teenagers Cesare Mondavi and Rosa Grassi had only one goal and one dream: to get out—and somehow get to America.

Cesare's older brother Giovanni was the first to make it here. In the early 1900s, he joined a wave of migrant workers and made his way to Hibbing, Minnesota—and then straight down into the region's iron ore mines. In 1906 Cesare followed him there—and straight down into the mines as well. Two years later, he brought Rosa to Hibbing, both of them eager to start a family and begin a whole new life in America. While Cesare worked in the mines, Rosa rented out rooms to other Italian immigrants and she fed them too. The family ethos was clear: "Work hard and share; we're all in this together."

Then tragedy struck. One day Giovanni was killed in a mining accident, leaving his wife and two small children behind. With that, Cesare said, "Basta! Enough! No more mining for me!" With Rosa and soon four of their own children to feed, plus Giovanni's widow and two children to look after, Cesare faced a serious crisis: what to do now? He had little money. Little English. And few skills outside of mining and farming. How was he going to provide for his family?

The answer: Roll up your sleeves! Improvise! Can-do!

And so it was that Cesare packed up and moved the family to the town of Virginia, Minnesota, 30 miles to the northeast. There, with a partner, Cesare managed to open a small Italian grocery store, aiming to serve poor immigrant Italian families just like his own.

Like most of their customers, the Mondavis enjoyed wine every day at the family table. Wine was an integral part of their culture and tradition, and a glass or two of good wine with meals was an essential part of their daily lives and of their overall sense of health and well-being. That was the way it was with many Italian immigrant families: they were eager to build new lives in America, yes, but they were also eager to hold onto their Italian way of life.

But then came Prohibition.

As we saw earlier, the Volstead Act had a provision that allowed wineries to make wines for sacramental purposes. But the act also had a provision that allowed private families, like the Mondavis and their neighbors, to make up to 200 gallons of wine a year, for family consumption at home. Great! But where to get the grapes?

California, of course!

To secure the grapes their members needed to make wine at home, the local Italian Club dispatched Cesare to California's rich Central Valley. And once he got there, and once he saw its warm sun, its rich soil, and the high quality of grapes it produced, there was no going back to Minnesota, except to pack up the family and come back to Lodi, a strategic locale in the Central Valley. There Cesare built a thriving wholesale grape business, shipping wine back to Italian markets in Minnesota and other parts of the Midwest. In 1933, as Prohibition was finally lifted, Cesare's son Robert was graduating from Stanford University, with a degree in business, and one day he turned to his father for advice and guidance:

"Dad, the very best grapes in California, where do they come from?"

His father didn't hesitate: "The Napa Valley! No question about it!"

And so it began. Through his father's connections, Robert landed an apprenticeship at Sunny St. Helena Winery, a bulk wine producer located in St. Helena. Then in 1943, during the ongoing hardships of World War II, Robert spotted a golden opportunity: the Charles Krug Winery was going up for sale. The Mondavi family grabbed it.

For the next two decades, Robert and his younger brother Peter ran Krug, with Robert in charge of sales and marketing and Peter in charge of winemaking. But then in 1962, something dramatic and life-changing happened: Robert made his very first trip to France.

With his first wife Marjorie and another couple, Robert made his way across Burgundy, Provence, and the picturesque chateaus of the Loire Valley. He also tasted the best wines of Tuscany and the Moselle region of Germany. But it was the wines of Bordeaux that made him reel in envy. In a kind of rapture, Robert tasted his

way through Bordeaux, carefully studying the wines and crafts-
manship of the fabled five "First Growth" chateaus of Bordeaux:
Château Mouton-Rothschild, Château Lafite, Château Margaux,
Château Haut-Brion, and Château Pétrus.

Across the world of wine, in France and far beyond, those were
The Gold Standard, the best of the best, the fine wines against
which all others were judged. And with each wine he tasted,
Robert was more and more enthralled. By their elegance. By
their symphony of flavors. And by the way they joyously danced
on his palate, igniting his senses and his spirit as well. For Robert,
this was entirely new: this was wine as High Art—and no one
in California or anywhere else in America was crafting anything
that even came close.

"Much of what I saw was a revelation," Robert later wrote in his
memoir, *Harvests of Joy*. "At the great chateaus, the way of grow-
ing grapes and making wine was far different from what we had
been doing for generations in California... We made wines in
bulk, using huge tanks; they kept their output small to maximize
quality, and they aged their wines in small oak barrels to create
gentleness, subtlety, and complex layers of flavor... The contrast
was stark: we were treating wine as a business; the great Euro-
pean chateaus were treating wine as high art."

What happened next stands as a pivotal moment in the history of
the Napa Valley and the history of American wine. As impressed
as he was by everything he tasted in France, Robert returned
home with a dream and a galvanizing mission: to make wines
that could stand proudly alongside the very best of Burgundy
and Bordeaux.

"We can do it!" Robert told everyone he met. "It will take time. And
research and investment. But one day we can make wines that are
every bit as good as the best of France—and maybe even better!"

Robert wanted the Charles Krug Winery to lead the campaign. He
was ready to spend whatever it took to upgrade their equipment
and their winemaking techniques. But his brother Peter did not
share Robert's dreams or ambitions. The tension between them
built, and then one day, at a big Italian family lunch, the broth-
ers came to blows. The fight split the entire Mondavi family in
two. But as destiny would have it, that fight enabled Robert to go
out on his own, in 1966, and create The Robert Mondavi Winery.

And here is where Joe Phelps comes into the story:

To start his own winery, and equip it properly to make world-class wines, Robert needed financial backing, and for that he turned to two friends in the Napa Valley: Fred Holmes and Ivan Schoch. And for advice on how best to structure and implement the deal, Fred and Ivan turned to Bud Mueller, an investment specialist with Wells Fargo Bank. "Fred was one of our best customers," Bud told me. "Our chairman told me to help Fred in any way we could."

With Bud guiding the process, Fred and Ivan agreed to provide the necessary seed capital for the launch of the Robert Mondavi Winery. But according to Bud, the arrangement soon ran into trouble. "While Bob was a great, great salesman, he was not a great businessman, and Fred and Ivan soon lost confidence in Bob's ability to create the winery within the financial framework they had established."

Soon thereafter, Bud Mueller became restless and went back east to work for Wachovia Bank. But Bud had been bitten, hard, by the wine bug, and soon he saw an opportunity that he simply could not resist: the esteemed Souverain winery was going up for sale. And the price was only $450,000. A golden opportunity. So Bud turned to his old pals Fred Holmes and Ivan Schoch and they closed the deal. "We got it for a pittance," Bud told me. And all they needed now was a top-quality builder. The old Souverain facility was painfully inadequate, and Bud and his partners wanted to build a brand new winery, something that would sit gracefully at the top of a hill in the Rutherford region of Napa Valley, making a visible statement of elegance and pride.

Enter Joe.

"I had met Joe in Greeley, back in 1966 or 67," Bud explained. "I was based in San Francisco at the time, but my territory for Wells Fargo covered nine states in the Midwest, including Colorado. My work at the bank often involved construction companies, and I found most of them to be unprofessional and unreliable. But not Joe's. I was very impressed with the efficiency of his company, and while we never did business together in Colorado, I immediately thought of him for what we wanted to do with Souverain."

Joe was thrilled. In dollar terms, especially when compared with public works projects, the fee was not enormous: $1 million. But in prestige terms, it would be hard to imagine a better gate-

way into the Napa Valley. Why? Because the Souverain winery had been founded and developed by a true pioneer, one of the Napa Valley's most esteemed winemakers and environmentalists: Lee Stewart.

Lee had come to the valley in 1943, and up on Howell Mountain, on the northeast side of the valley, Lee planted grapes and began making wine. His was essentially a one-man operation, with bare bones equipment, but he had something far more important: guidance from the dean of Napa Valley winemaking and the man many people called "The Maestro"—André Tchelistcheff. André was a Russian émigré with fabulous credentials: he had studied at two of France's most prestigious institutions: the Institut Pasteur and the Institut National Agronomique, the French national institute for agriculture. He then came to the Napa Valley and became the winemaker at the French-owned Beaulieu Vineyards.

André also shared his expertise with other leading winemakers in the Napa Valley, including Lee Stewart. Together André and Lee Stewart made wines of very high quality, and they also influenced many other winemakers throughout the valley. Indeed, Lee hosted regular get-togethers for fellow grape growers and winemakers to share their methods and their evolving body of experience and wisdom. You know the guiding spirit: "Together we rise."

Early on, Lee Stewart established himself as a strong advocate for healthy, environmentally clean grape growing and winemaking practices. He also was among the first in the industry to focus on crafting single-varietal, estate-grown wines. On top of all this, Lee had an eye for talent and a gift for mentoring. Indeed, two of the young winemakers he took under his wing were Mike Grgich and Warren Winiarski, two men who, as we will soon see, would stun the wine world by beating the best of Burgundy and Bordeaux and winning the celebrated Paris Tasting of 1976, a singular event in the rise of the Napa Valley and the history of American wine.

When he began building the Souverain facility, Joe, I'm sure, would have loved to learn the multiple arts and sciences of grape growing and winemaking directly from Lee Stewart, but it was not to be. By the early 1970s, Lee's wife had fallen ill and, according to Bud Mueller, Lee was eager to leave the wine business and take care of his wife full time. Indeed, when Joe and his crews from Hensel Phelps began preparing the site, Lee Stewart was already gone.

Constructing the new Souverain winery was no piece of cake. As I learned from the files of Hensel Phelps Construction, Joe and his crews began the work in March of 1972, exactly five years after he opened the HP branch office in Burlingame. And this job presented a whole series of difficult challenges. For one, the new facility was to be built at the top of a very steep hill—never a simple task. For another, in addition to the offices and reception areas, Joe and his teams had to build the adjoining facilities for winemaking and cellaring, plus the necessary roads and electrical and water supply lines. On top of all this, Joe had agreed to a killer deadline: to have the wine-making wings of the facility ready by early fall of that same year, 1972, in time to handle that year's harvest and crush.

And there was one other tiny, tiny factor: Joe and his crews had never built a winery before. Did that stop Joe? Heck no!

Now, step back a moment and consider the task at hand: build a five-star winery, from scratch, on treacherous terrain, put in the necessary roads, piping, electricity, plumbing, and water supplies, and then build the necessary rooms and platforms for making, aging, and storing the wine: the de-stemmers, the presses, the big fermenting tanks, the barrel rooms, the storage racks, and all the rest, and do all this and get the entire operation up and running in a period of seven short months. Seven! Yes, easy as can be.

For Joe this was a huge challenge, sure, but it was also a fabulous education—coming free of charge. He got to study, from the inside, and following in the footsteps of Lee Stewart, exactly what it takes to build a top-quality winery and everything that goes with it. That knowledge was priceless, and it led Joe to believe, just as Robert Mondavi did, that "We can do this! We can make great wines too!"

As always, Joe and his crews from Hensel Phelps got the job done on time and on budget. And by meeting that harvest-time deadline they earned a hefty bonus in the process. On top of that, the quality of the new Souverain facility made a powerful statement about the quality of their wines—and about the quality of Joe and his crews.

HENSEL PHELPS
CREWS AT WORK

Building Chateau Souverain winery, Geyserville.

Bud Mueller was again impressed. Deeply. "Joe came in under budget and in less time than we had agreed upon," Bud told me. "He did a great job on that project and on the one that followed. Indeed, I never worked with a contractor that was any better."

Success breeds success, and thanks to their work on the new Souverain facility in Rutherford, Joe and his team at Hensel Phelps Construction landed another golden opportunity. And here again Bud Mueller played a decisive role. As Bud explained it to me, when he and Fred and Ivan joined hands and bought Souverain, they had one primary goal: to quickly build the business and sell it within a few short years. And that is exactly what they did: they sold it to the food giant Pillsbury, at a handsome profit of course.

"At that stage, Pillsbury had a foot in the wine business, and they bought 100 percent of Souverain," Bud explained. "As part of the agreement, I was to stay on and help them run it." Eager to expand the wine portion of their business, Pillsbury then decided to build a much bigger winery in Geyserville, over in Sonoma County. And Bud quickly steered the job to Joe. The new Chateau Souverain facility was to have a production capacity of 500,000 cases of wine a year—far larger than the winery in Rutherford. Accordingly, the contract too was far bigger, indeed more than twice as large: $2.4 million. Not bad for a builder brand new to the wine business.

With the new job in Geyserville, Joe and his crews once again got it done on time and on budget, and they earned major accolades in the process. That, in turn, brought them a third major winery to build: the Cambiaso Winery, also located in Sonoma County. Through their work on these projects, Hensel Phelps Construction earned itself a glowing reputation throughout California Wine Country, and Joe earned himself a reputation as one of the wine industry's savviest and most trustworthy businessmen. Yes, new though he was to the area and the industry, Joe was already becoming a quiet, but very influential voice in the rising success of the Napa Valley.

But Joe's heart was already beginning to wander away from the construction industry. Even as he and his crews were building the first Souverain facility in Rutherford, Joe was already looking for his own special place in the Napa Valley, a place to settle in, grow grapes, and make his own fine wines—wines that could compete with the best in the world. Indeed, away from the construction site, Joe was spending long hours trekking through open fields and potential vineyard land, often up to his knees in mud, and often with a very knowledgeable guide leading the way: Ivan Schoch.

"Ivan knew the land," Joe told me. "And we often trudged through the mud together. I couldn't have done it without him."

By the close of 1972, Joe was hooked. For life. Come what may. And as Joe was telling me this part of his story, as always right there at his kitchen table, I leaned in and asked him the crucial question:

"Joe," I said, or words to this effect, "your roots were in Greeley. Your wife and kids were in Greeley. Your business too. So why did you decide to uproot yourself and move to the Napa Valley? What was the attraction? What drew you so powerfully to this valley?"

Joe thought for a long moment and then said:

"The spirit of the place."

I put down my pen. I knew I had struck gold. "The spirit of the place." Joe, I knew, was talking first and foremost about his idyllic corner of the Napa Valley, his 600 acres just off the Silverado Trail. But he also made clear that his feelings extended to the valley at large, this land so rich in history, this terrain so fertile for artists, creators, and intrepid pioneers. Yes, Joe now knew it for sure: this was the place for him, the place to build, the place to create, the place to follow his highest dreams wherever they might lead.

◆

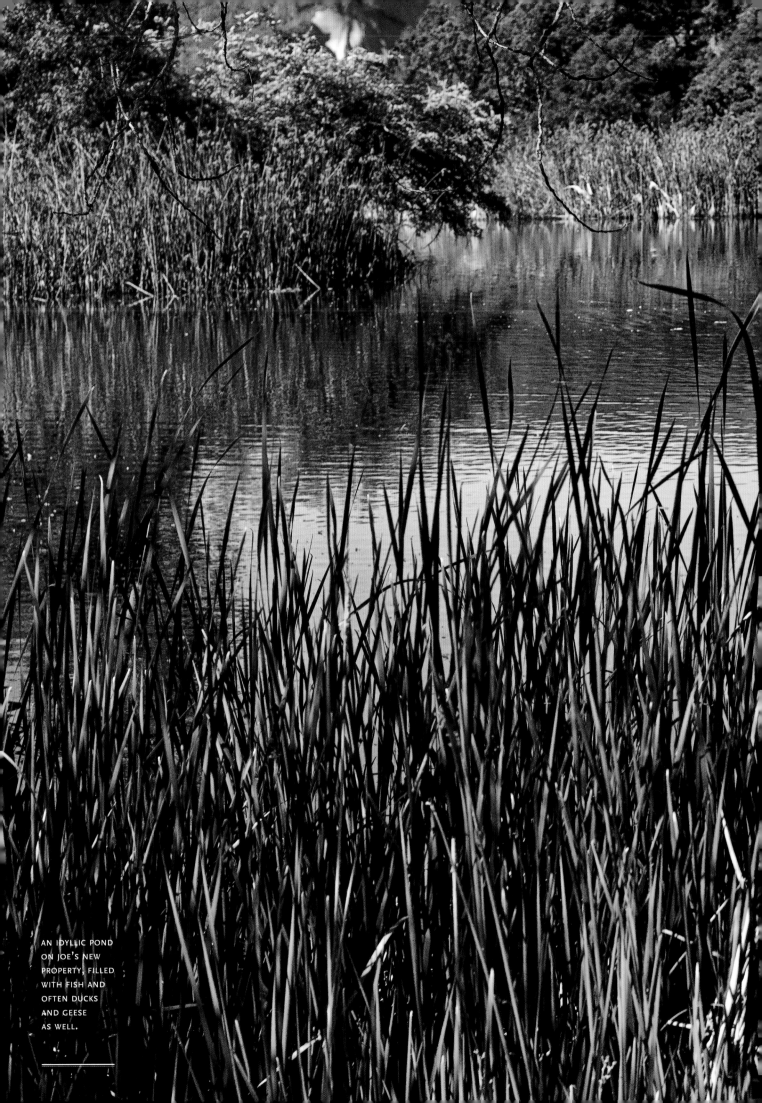

AN IDYLLIC POND
ON JOE'S NEW
PROPERTY, FILLED
WITH FISH AND
OFTEN DUCKS
AND GEESE
AS WELL.

A TASTE OF PARADISE

There is a joke you often hear in the Napa Valley:

"How do you make a small fortune in the wine business?"

"Start with a big one!"

No one had to drive that lesson home to Joe Phelps. In building the new facilities for the Minneapolis-based food giant Pillsbury, Joe saw first-hand the initial costs of building a winery, and he could easily estimate the annual costs—and risks—of running a quality wine business. Indeed, by 1975, just three years after they began dabbling in the wine business, Pillsbury's directors were reporting losses of $6 million a year in wine, and they bowed out of the wine industry soon thereafter, with their tail between their legs.

With his aversion to debt and unnecessary risk, Joe was intent on being both modest and prudent in his initial steps into the Napa Valley. So in looking at potential properties with Ivan Schoch, Joe kept his ambitions tightly in check. And soon he found a promising piece of land, located on the southwest corner of Zinfandel Lane and the Silverado Trail, southeast of the town of St. Helena. It was a small parcel, only 15 acres, and it included a charming landmark: an old stone bridge in the back of the property, where the Napa River curled gently by. To Joe, it looked like a good opportunity, at an affordable price, and he jumped on it—but not primarily as a wine-making venture. He considered building a winery there, but he saw the property mainly as a sound real estate investment.

As Joe explained it to me, by the close of 1972 he felt certain that the new waves of energy and money pouring into the Napa Valley would drive up land prices, and a choice spot right on the Silverado Trail would surely be increasing in value. Also, at that stage Hensel Phelps Construction had a strong cash position. So Joe came up with a formula that would work well on many levels: he created a new company, Stone Bridge Cellars, and he set it up as a wholly owned subsidiary of Hensel Phelps. Stone Bridge would purchase the property, and it would thus become a promising financial asset of the Hensel Phelps umbrella company—with little or no personal risk for Joe. In other words, this was a very smart, well-anchored business venture. And Joe went ahead and closed the deal.

But there was one thing missing: Joe's heart wasn't in it. And then it happened, as if Destiny herself had come smiling...

As he was putting together the deal for the property on Zinfandel Lane, Joe heard about another property that might be available: the Connolly Ranch, a family-owned cattle ranch located a little ways further north and tucked back off the Silverado Trail. And there was nothing modest or prudent about it: the ranch was over 600 acres, and it was far more expensive. Also, the Connolly Ranch had been a working cattle ranch for decades—the ranch was known for the quality of its Hereford cattle—and no grape vines had ever grown there. Not a single one. And no other crops had either.

Still, Joe went for a look and he was immediately enthralled. The landscape was enchanting, with steep hills and rolling contours, and from up on the hillsides the views were absolutely spectacular, especially in the glow of the late afternoon sun. Moreover, the ranch and its surroundings had a special self-contained feel, like some private sanctuary just waiting for a quiet, painterly hand to come bring it additional life and color.

Okay. But was this a place for growing top-quality wine grapes? At first, the answer seemed to be a thundering no. Ivan Schoch told Joe that while the soil up on the hillsides might be hospitable to growing grapes, the soil on the lower reaches of the ranch definitely was not. On top of that, Ivan believed the ranch would never be ideal for growing Cabernet Sauvignon, the varietal that was already the premier asset of the Napa Valley's ambitions in fine wine. So if growing Cabernet was to be any part of Joe's future plans, Ivan urged him to look further south, in proven Cab country.

CHAPTER 16: A TASTE OF PARADISE

And right there the story could have ended. But Joe was not swayed by Ivan's logic. Or anyone else's. The truth is he had fallen in love with the place, and down in his bones he felt this was an ideal spot to settle in, put down roots, and begin a whole new life in the Napa Valley. And part of the romance was this: the Connolly Ranch had wonderful echoes of Joe's past. Near the entryway to the ranch was the family farmhouse, and it was similar in feel to the home Joe had grown up in back in Maysville, plus it had a towering oak tree standing alongside, conveying a feeling of dignity and permanence.

And there was something else on the ranch that appealed to Joe: on the front side of the ranch, facing out onto the Silverado Trail, was a one-room schoolhouse, a bit dilapidated now, but still very similar in look and feel to the one-room schoolhouse where Joe had started his own schooling back on the family farm in Maysville. Perfect!

As Joe was telling me all this, sitting at his kitchen table as always, I could see that in many ways this ranch had brought Joe full circle, back to the family farm in Maysville and also back to the soil, back to planting, growing, and harvesting. And the more Joe talked, the more I realized that we had come to a golden moment in his life story, a true turning point. Joe had come to the Napa Valley as a builder, with a rising passion for fine wine, but what did he really know about the inner workings of the wine business, the winding, complicated road from the vineyard to the shelves at your neighborhood wine shop or supermarket?

Next to nothing.

And beyond shipping in grapes from California and trying to make wine in his basement back in Greeley, what did he really know about the multiple arts and sciences of growing grapes and making fine wine? Most serious grape growers spend years learning botany, biology, hydrology, geology, soil protection, water management, microclimates, wildlife conservation, and how to tend their vines throughout the year. Likewise, most dedicated winemakers would eagerly spend years working under the guidance of a Lee Stewart or an André Tchelistcheff, learning not just the basics but all the subtleties of crafting and nurturing fine wine and bringing it to full maturity. And what did Joe know of all that?

Next to nothing.

CHAPTER 16: A TASTE OF PARADISE

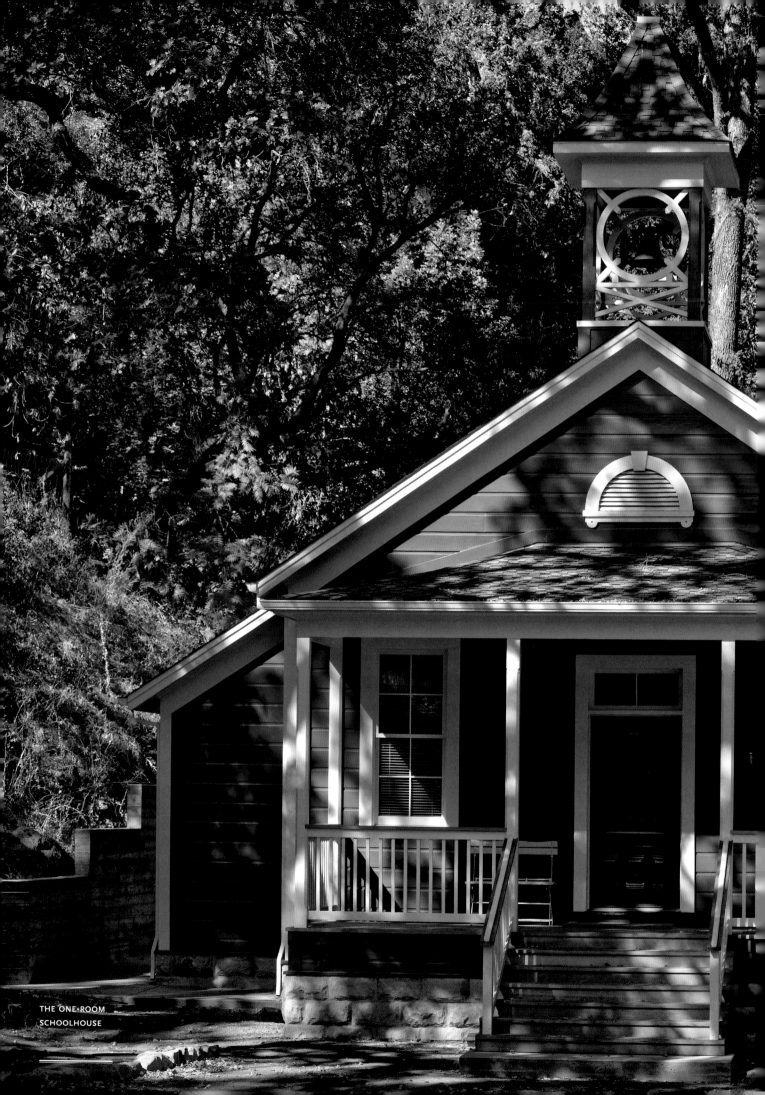

THE ONE-ROOM
SCHOOLHOUSE

Still, did his lack of training and expertise stop Joe? No! It didn't even slow him down. The romance of making wine, and the sheer beauty and potential that he saw in the Connolly Ranch only fueled his passion and his determination to succeed. And here he was now, sitting peacefully at his kitchen table in the Napa Valley, telling me about how it all began, about how he had been moved to make his blind and somewhat crazy leap into the great adventure of making fine wine. And as he was telling me about finding this property, his own Taste of Paradise in the Napa Valley, I now saw a new side of Joe coming into view. "Joe," I said, "this place was simply made for you! Right down to the one-room schoolhouse!"

Joe laughed. "It truly was made for me," he said. Then he paused for a long moment, and soon Joe was reaching back in time, back to one afternoon in Portofino, on his very first trip to Italy.

It was their first day in Portofino, and he and Barbara had enjoyed a glorious Italian lunch, fresh pasta with white truffles, a platter of oysters, mussels, and baby clams, plus a lovely white wine, and afterwards they had gone for a long walk looking out across the Mediterranean Sea. "It was so beautiful there," Joe said, his voice now filling with emotion. "And all at once I realized how special that place was: whatever the land didn't provide, the sea did."

Now Joe led me to the heart of it: "You know, Paul, I think that day changed my whole life. Right there in Portofino I began to think in terms of, Where can I find this? Where can I create this? Where can I get back to farming and to growing things? And on the very first day I arrived in the Napa Valley I knew this was the place..."

"Back in Missouri," Joe went on, "whole farms simply dried up and blew away. But here in Northern California it's the opposite: here the land is alive with trees and rocks and wild, unusual growth. And walking through the fields and vineyards of this valley, I could feel it: This was God's creation. And Barbara thought so too."

God's creation. Joe had never spoken to me like this before, and for me it was a very special moment, and even now, as I write, I can see and feel it still. Joe and I were there alone in his kitchen, and the afternoon light streaming in through the windows had softened and taken on a reddish hue. And beside me was this extraordinary man, confined to a wheelchair, an oxygen tube fixed in his nostrils, his health and his strength clearly in decline, and yet here he was, determined to keep his spirits high, determined

to take me right into the core of his life's journey, and determined, too, to show me the inner richness and the quiet courage that had propelled his daring leap into the emerging world of American wine.

"The Artist Inside."

Yes, as I now could see, Lydia Ruyle had it exactly right: Joe was a brilliant businessman. A born entrepreneur. A master of process. But just as Lydia had described to me that day back in Greeley, there was inside this man a frustrated artist struggling to cut free, struggling to find the terrain where he could learn and grow, where he could finally spread his wings and truly soar. And once I understood that, I also realized that what Joe had been looking for in the Napa Valley was far more than a simple piece of land; he was looking for a place of spirit and inspiration, he was looking for the right canvas on which to create, on which to paint his masterpiece.

Joe being Joe, though, business came first: he had to build his new adventure on a rock-solid financial foundation. That meant putting together enough capital to buy the Connolly Ranch and develop the property. Joe did that, shrewdly, via the newly created entity Stone Bridge Cellars. Under the arrangement, Stone Bridge put up the necessary capital—and Joe, in return, gave Stone Bridge some properties he owned in Colorado. As Joe explained it, "We worked out a sophisticated trade of several of my properties in Colorado for the one property here."

Still, there was a last minute wrinkle. Pat Connolly, the owner of the ranch, was in failing health and inclined to sell, but he was still struggling with the idea of giving up his beloved ranch. To ease his misgivings, Pat raised the final asking price. By a lot. Still, for Joe there was no turning back now: he paid Pat's asking price, the escrow formally closed on March 1st, 1973, and Joe never looked back: "We bought the property, first and foremost, as an investment. And it turned out to be a good one."

I should say it did. And one of the first benefits, Joe told me, had nothing to do with money or wine: it came from sharing this Taste of Paradise with Barbara and their four kids. "When my daughter Laurie was in high school, or maybe she was in college," Joe said, "she took a course in economics, and one day she came to me and said, 'Dad, don't ever regret making a huge investment in land. It's the best thing you could have done. We're all proud of you!'"

A daughter's love. Who could ever put a price on that? Not Joe:

"To be honest, I was affected more by my heart and my children than by any geology," Joe told me. "When I bought this property, my hope was that some day this place would make all of us proud—and it has fulfilled that promise."

At a personal level, there were other dividends as well. Joe had always been a caring and loving father, but his relentless drive and the long hours he spent at work meant he was often away from his children during much of their formative years. But now Joe hoped that buying the ranch, and spending time there with Barbara and the kids, would give him the chance to make amends. And to some extent he succeeded. Today, more than 40 years later, his daughters Laurie and Lynn still have warm memories of the hillside picnics and horseback rides they enjoyed with their dad on the ranch.

"Pat Connolly had built a tunnel beneath the Silverado Trail, and he used it to move cattle from one part of the ranch to the other," Lynn told me. "Dad and Laurie and I would ride our horses through the tunnel and then up the hill past where Dad's house is now. And up near the top we often stopped for picnics under the trees." When Joe's daughter Leslie and his son Bill came back from prep school or college, they too loved spending time on the ranch with Joe. Also, as you will see, Leslie and Bill later came to work with Joe.

With Barbara, it was more complicated. Once he had purchased the ranch, Joe planned to keep going back and forth to Greeley; he was, after all, still President of Hensel Phelps Construction. For his time in the valley, though, Joe turned the schoolhouse into his part-time home. And to make his family feel like they were an integral part of his new adventure, Joe designated a plot of land close to the schoolhouse as "Laurie's Chardonnay," and later he had it planted accordingly. With a similar aim, he planned to build a tennis court close to the schoolhouse, expressly for Barbara. She loved to play tennis, and Joe hoped the court would please her and help anchor her new life in California. But the court never got built.

"Barbara liked it here," Joe told me. "But she didn't stay very long."

As I explained before, Barbara felt very conflicted about the way her life was turning. She loved Joe and she loved California, but her roots and her entire life were back in Colorado. By then,

too, with Leslie, Bill, and Laurie off to college, Barbara still had Lynn, their youngest, at home in Greeley. Lynn was very happy in high school there, and Barbara did not want to uproot her. So Barbara felt deeply torn, and now her marriage with Joe entered a very difficult period, as the two of them tried to figure out what to do next.

For Joe, though, it was now full steam ahead. And in poker terms, he was "all in." Joe was now determined to pour every lesson he had learned in life and business into this new venture. And there was one thing more. Back in Greeley, when Joe was making wines in his basement, trying his amateur's hand with Zinfandel and Chenin Blanc, for instance, he bottled his wines under the label "Cache Valley," and his own name did not appear on the front of the label. But now, in that same "all in" spirit, he decided to name his new enterprise Joseph Phelps Vineyards, like a painter or a sculptor now confident enough to sign each creation.

But Joe knew he still had a long way to go in the art of crafting fine wines. So for ongoing technical guidance, in true Popular Mechanics style, he turned to a man named Bob Ellsworth. A former research chemist, Ellsworth had become passionate about winemaking, and with a partner, Davis Bynum, he had opened a small winery in the town of Albany, north of Berkeley. But amateur winemakers kept turning to Ellsworth for guidance, so he and Bynum opened a side venture called "The Compleat Winemaker," a small shop where they sold basic wine-making equipment and shared their expertise. It was Bob Ellsworth who had helped Joe get started, and he had arranged the shipments of grapes to Joe in Greeley. And now Joe went back to Bob for more advice and guidance. No more dabbling in his basement; Joe was now determined to dig in and master the process of making fine wine.

That would take time, though, so Joe began canvassing the valley for an experienced, top-quality winemaker, someone who had the art of wine running through his veins and would be willing to help mentor Joe as well. And through Ivan Schoch and Fred Holmes, and also Joe's new neighbor Joseph Heitz, one of the Napa Valley's most respected wine men, Joe found his way to a tall, soft-spoken, German-born winemaker named Walter Schug. You will meet Walter in the next chapter, and you will see how beautifully their talents complemented each other.

"I was so lucky," Joe told me. "I was instantly accepted into this valley. And before long, I knew or met all the right people."

Through Bud Mueller, Ivan Schoch, and Fred Holmes, Joe made yet another valuable connection: to the esteemed Bay Area architect John Marsh Davis. As impressed as Joe had been by the quality of the wines at the great chateaus of Burgundy and Bordeaux, he had no desire to build a winery with the pomp and pretense of a French chateau. To the contrary, he wanted something clean and elegant, with lots of natural wood and light. And for that, John Marsh Davis was perfect. And Joe admired his work: Davis had designed Bud Mueller's house in Belvedere, and he had designed the two wineries that Joe and his crew had built for Souverain, the one in Rutherford and then the much larger Chateau Souverain in Geyserville.

On a personal level, Joe and John Marsh Davis also had much in common. Davis had been born and raised in Oklahoma, and after graduating from the University of Oklahoma he had spent four years in the Navy. Aesthetically too, Joe and John were fully in tune. Like Frank Lloyd Wright and a few others, John Marsh Davis had a special feel for creating designs that melded harmoniously into the landscape of a given site. And that was exactly what Joe wanted for his new property: Harmony. Flow. Greenery. Uplift!

Perfect!

But Joe wanted something more, some special touch of character and distinction, and one day, with Destiny still at his side, he found it, unwanted and discarded on the side of a road. As Joe's son Bill tells the story, in 1972 Hensel Phelps had been commissioned by Caltrans, the California Department of Transportation, to build a new bridge for car and truck traffic in Annapolis, California, up in the northwest corner of Sonoma County. As part of the contract, the HP crews had to first remove the old bridge and its supporting trellis. From the HP office in Burlingame, Joe was overseeing the project, and one day he decided to go for a first-hand look at how the work was progressing.

While he was on site, Joe spotted a huge pile of lumber beside the road. What was that? It turned out to be the struts and beams from the dismantled trellis and, lo and behold, they were made of old growth redwood, timbers of remarkable beauty and structural stamina. Old growth redwood! Pure California! Instantly Joe was seized by an idea: reconstruct the trellis and use it as a signature element of his new winery. Perfect! But would Caltrans part with that supply of precious redwood? And if so, at what price? So Joe called Caltrans and very generously offered to "recycle" it—and

do it for free. "Take it," the Caltrans folks said, evidently relieved to have someone come and take on the costly labor of hauling it away.

And so it began. "In John Marsh Davis's earliest sketches for the winery, there was no trellis," Bill said. "But once Dad saw those redwood beams, the trellis became an integral part of the design. And Dad became intimately involved in developing the trellis idea."

From there, Joe and John Marsh Davis worked together to make the trellis harmonize with both the feel and the functioning of the new winery. And together they turned Joe's idea into the distinctive emblem of California history and tradition that it remains today.

Joe, The Inspired Artist at Work.

When Bill told me that story, I was immediately reminded of how Joe had come home from Florence and seeing The Duomo and had launched himself into remodeling his house in Greeley, with those carved wooden doors and that Italian ceiling and marble fireplace. And here was Joe now, creating on a much bigger canvas. And it made me wonder: Joe had studied the piano. How had that gone? What was the deeper nature of his creative talent and drive?

In search of answers, I phoned Phyllis Eaton, Joe's piano teacher back in Greeley. Phyllis told me she had known the family for years, and she had introduced all four of the Phelps kids to the joys and the demands of learning to play the piano. And then came Joe.

"One day Joe approached me about taking lessons," Phyllis said. "He was interested in learning what his children were learning."

As Phyllis explained, Joe would come see her at night, after a full day's work at the office. "Joe had an engineer's mind," she said. "He wanted to know how to read music, and how the notes on the page related to the different keys on the keyboard. He was not a natural, but he worked hard and did pretty well. He practiced a lot and he hated to make a mistake. That said, putting in feelings, using crescendos and the like, that did not come naturally to Joe."

Joe's son Bill, by contrast, had a real feel for the piano. "He was one of my best students," Phyllis said, "and Joe loved listening

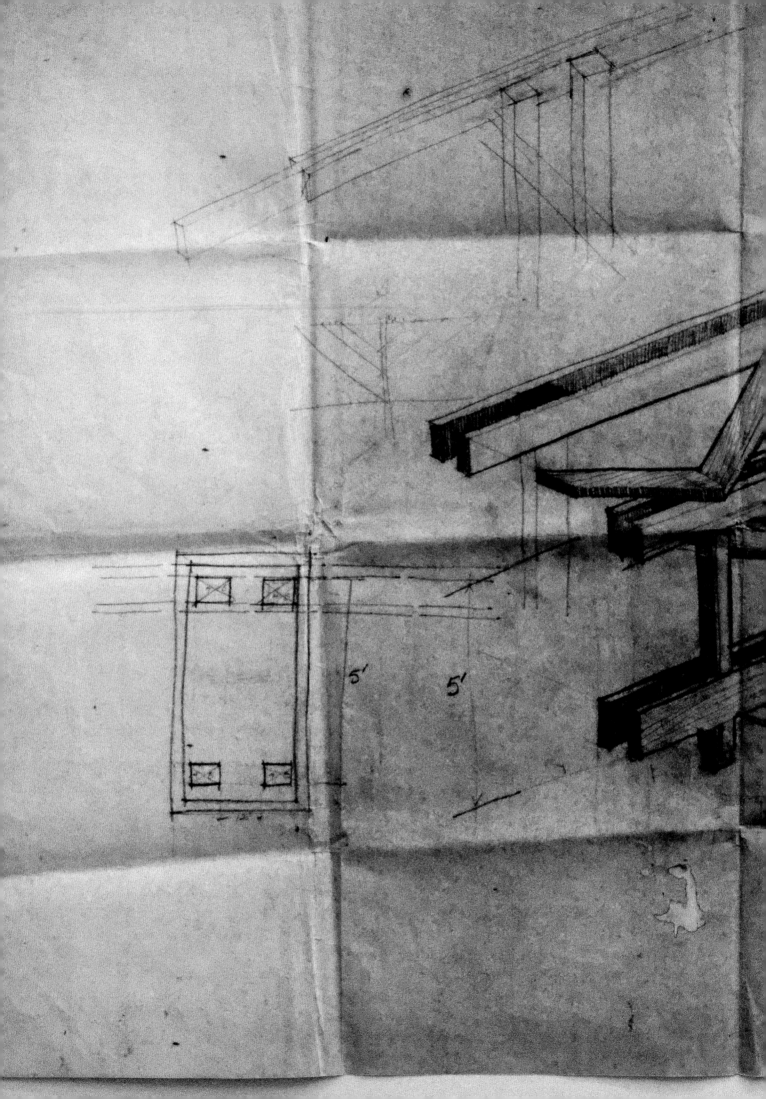

5' 5'

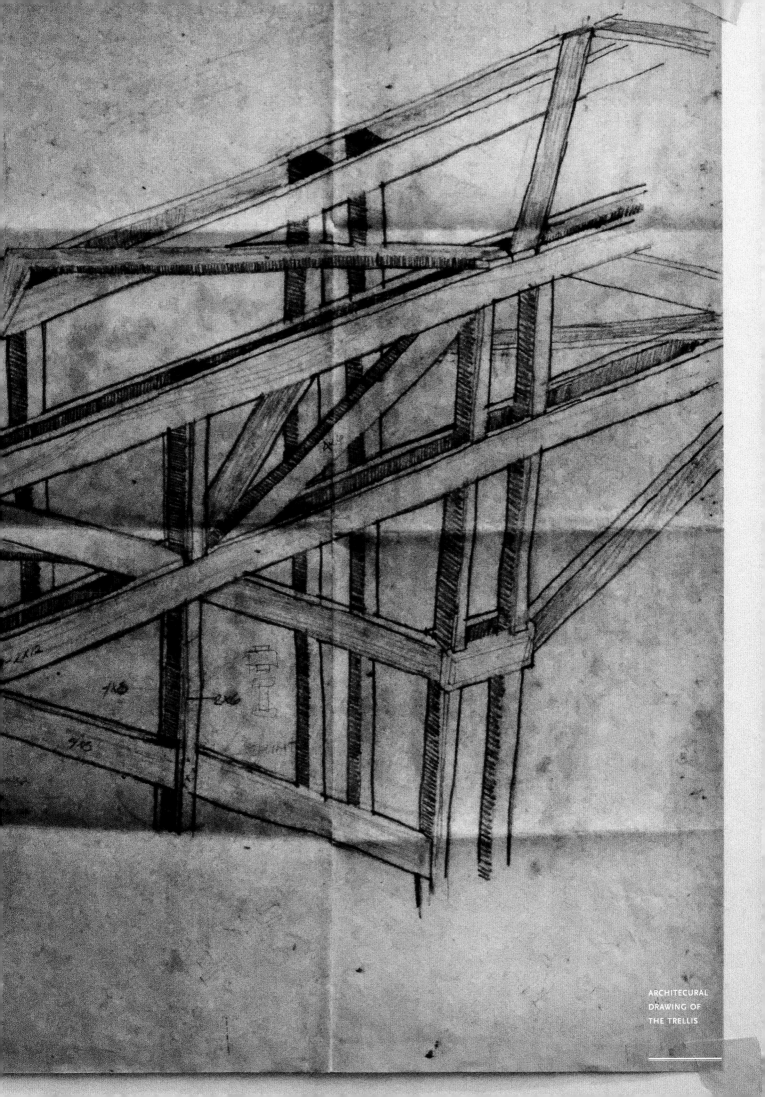

to him play. But Joe just didn't have that same natural talent. The truth is, he could not express himself through art until he found wine and food."

In my view, Phyllis nailed it: "He could not express himself through art until he found wine and food." As I immediately wrote in my notes, "Eureka!"

And now it all came clear. As artists themselves, Phyllis Eaton and Lydia Ruyle understood Joe, they understood the fire he had inside, and they understood how vital and life-changing it was for Joe to find his own special place to grow and create. And that, my friends, will help you understand everything that happened next.

◆

JOE AT WORK,
TRANSITIONING
FROM
CONSTRUCTION
TO FINE WINE.

GLORY IN A GLASS

By April of 1973, Joe was off and running.

He had his dream property.

He had his architect.

He had his winemaker.

And Joe had his ultimate goal:

To make beautiful wines, wines of quality and distinction, wines that artfully expressed the soil and spirit of the Napa Valley. And as with his life in the construction business, Joe had one golden rule guiding his new life in wine: In everything we do, be the very best we can be. No compromises. Second best will never do.

With all that in place, Joe moved into action on several fronts. Per the advice of winemaker Walter Schug, he had his vineyard team prepare large areas of the ranch for planting. This was a top priority, of course. It takes a good three or four years before a newly planted vineyard produces wine-quality grapes, and Joe wanted to make sure his vineyards were properly planted and taking root in the course of 1973, his first year in operation.

Second, with architect John Marsh Davis, Joe began planning the actual construction of his winery, to be located high on a hillside and facing west, with spectacular views across his sanctuary-like enclave in the Napa Valley, an area known as "Spring Valley." The plan was to begin readying the construction site in the late fall of 1973, and have the winery finished by the fall of the following year. This was a tight schedule, but Joe had a top-notch construction crew lined up: from Hensel Phelps, of course.

And then, of course, the wines. As he prepared to launch his own winery, Joe accelerated his "sip by sip" education into the finest wines of France and beyond. To help me understand his learning process, one afternoon Joe had his daughter Leslie take me down into his private wine cellar, located beneath his kitchen in the Napa Valley. It was enlightening, to say the least.

There I saw rack after rack of beautiful wines, all of them carefully organized and catalogued. And what treasures I found there: row upon row of many of the greatest wines of Bordeaux: Château Mouton Rothschild. Château Latour. Château Haut-Brion. Château Gruaud-Larose. There were also fine wines from the Rhône and Loire valleys, and many from California too. And Joe loved nothing more than opening those bottles with friends. Indeed, a few nights before, after a board meeting, Joe opened a 1961 Château Latour—a full magnum. "It was so good," board member Damian Parker told me, "it just brought you to your knees. One of the best wines I've ever tasted." That was Joe: share the wine, share the wealth.

As Joe explained to me, over the long term he planned to craft a wide array of fine wines, but his first concern was balancing the art of winemaking with smart business planning, specifically with regard to cash flow. And in building the Souverain winery, Joe had learned a valuable lesson from Ivan Schoch, Fred Holmes, and Bud Mueller: Don't dawdle. Start producing wines your very first year in operation. Start building your inventory. Start building your name.

With all that in mind, Joe planned to jump right into the process of crafting a high-quality Cabernet Sauvignon, one of the leading varietals in the Napa Valley and the American marketplace. But Joe knew that crafting a fine Cabernet and aging it properly in French oak barrels could take three years or more, so he was also intent on producing two German-inspired white wines, Riesling and Gewürztraminer. These were varietals with proven commercial appeal, plus they could be crafted and sold within a year or so of their harvest—making them a source of prompt cash flow. This was pure Joe. As he was fond of saying, the first need and responsibility of any business is to generate revenues and reliable profit streams. Their Riesling and Gewürztraminer were designed to do just that.

Joe very carefully laid all this out for me in big-picture terms, and then I set out to learn more about Walter Schug, the winemaker

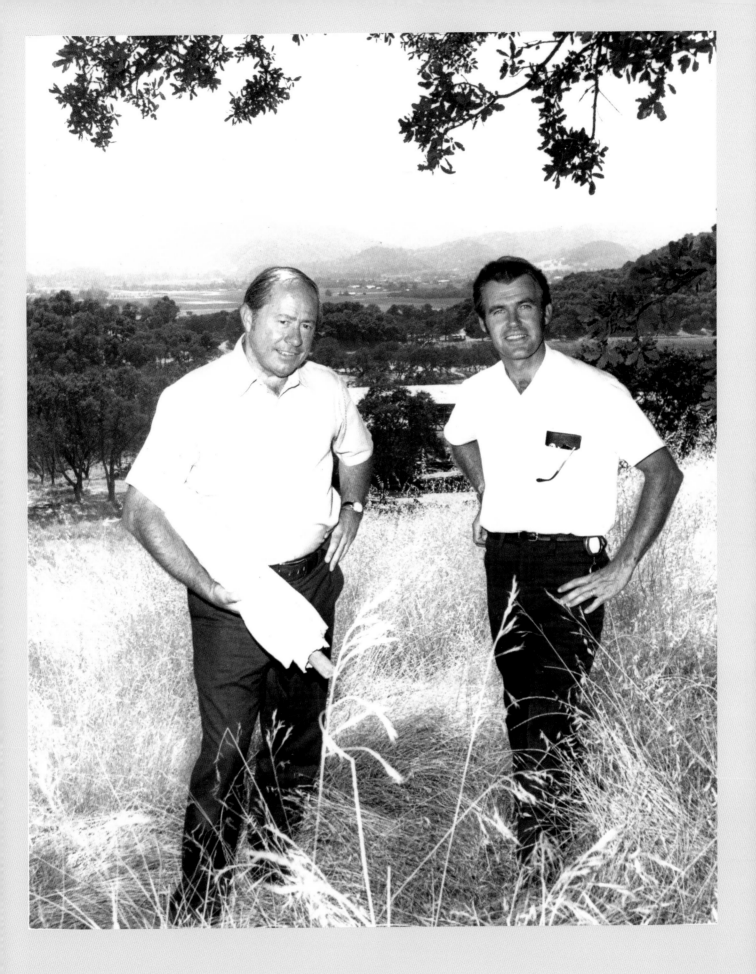

Joe had chosen to help him turn his dreams into a shining reality. Walter, I soon learned, was an unusual mix of Old World tradition and training and New World guts and can-do spirit. He was born and raised in the Rheingau wine-growing region of Germany, set along the banks of the Rhine River. And Walter had wine running in his veins: his father had managed a prominent winery in the region and Walter had grown up playing in the vineyards.

For his training in wine, Walter studied viticulture and enology at the prestigious university at Geisenheim, one of the premier wine institutes in the world. From there, Walter learned his craft in various wineries in Germany and England, and then he landed a one-year apprenticeship in California, just as America was beginning to awaken to the joys and artistry of fine wine. Walter loved California, and he saw plenty of opportunity for his talents in the emerging California wine industry. And so it was that in 1960, he returned to Germany, married his sweetheart Gertrud, who also came from a wine family in the Rheingau, and then the young couple packed up their lives in Germany and sailed for New York. From there, to feel the pulse of America and absorb its colors, they drove cross country in a Volkswagen Beetle, packed to the gills.

Following his years with Joe, Walter started his own highly respected winery, Schug Carneros Estate, located in the southern portion of Sonoma County. I was eager to meet him. So one morning I drove over from Napa and found his place, a lovely expanse of hills and vineyards swept by gentle breezes flowing in from the nearby San Francisco Bay. Walter's son Axel greeted me and led us into a room that was filled with memorabilia from Walter's life in wine in both Germany and California. We settled in and Axel told me that he had a deep respect for Joe and for how hard Joe and Walter had worked to create and launch Joseph Phelps Vineyards.

Walter and Joe had been a good fit for many reasons, Axel said, but first among them was his father's extensive knowledge of the vineyards of the Napa Valley and the surrounding areas. "Dad worked for Gallo for several years in the '60s," Axel explained, "when Gallo was the largest wine producer in the country, and with the largest presence in the Napa Valley and nearby regions. Dad was in charge of quality control and also relations with the growers, so he could guide Joe to the very best vineyards and growers."

With that, Walter came into the room. What a charming man! He was tall and gracious, with a wonderful twinkle in his eye.

And like all of the winemakers I had known in France, Walter viewed fine wine as something far more than a healthy, enjoyable beverage; in his eyes, fine wine was a pillar of European life and culture, and it was also a reliable measure of a nation's degree of advancement in art, viticulture, and the multiple sciences related to winemaking. And as Walter told me, when he first arrived in California in 1959, the American wine industry was in a very primitive condition.

"Prohibition was a big problem, with lasting consequences," Walter explained. "Even after Prohibition was lifted, there was no training. People in the vineyards and cellars didn't know what to do."

Still, Walter was deeply impressed by the potential he saw for fine wine in California, mainly due to what he called "the generosity" of the California soil and sun, both so essential for growing top-quality grapes and making beautiful wines. And like Joe, Robert Mondavi, and others, Walter believed that one day the Napa Valley could earn a place among the great wine-producing regions of the world.

That said, when Walter first arrived here, few American consumers were thinking in terms of varietals or any sort of fine wines. At that stage, many Americans thought there were only two kinds of wine, red and white, and as a consequence most major wine companies had only one focus: making wines in bulk, wines that were high in alcohol, cheap to produce, and cheap to buy. Indeed, Walter's first job in California was in quality control at a bulk wine company called California Grape Products, located in the town of Delano, near Bakersfield in central California. And the wines they were producing had little in common with the fine wines of Europe.

"We were producing five million gallons a year," Walter said, "and it was all shipped to the East Coast by railcar, by tank car. Because back then all the distributors were bottling their own wines and labelling them with whatever label they thought was necessary to sell them. In parts of New York state, for instance, they put on labels written in German, to sell in the local Germantowns." Back then too, there were few regulations regarding labeling, making clear to consumers a wine's content or its true place of origin. In contrast to the carefully regulated wine industries of Europe, ours seemed to Walter like the Wild West, but he loved its frontier spirit.

"I knew the material for success in wine was there, but there just weren't enough educated people," he said. "Even after Prohibition, few people went to university to study viticulture and enology, and the universities themselves were not very advanced. At that stage, the wine program at UC Davis was not very advanced either. We had a lot of work to do."

Then came Ernest and Julio Gallo, as positive agents of change, for Walter personally and for the industry at large. "Gallo decided to grow their own grapes and sell their own wines, under their own label," Walter said. "In doing that, the Gallos were very smart."

Walter spent five years as a superintendent of wine production at the plant in Delano. But then one day in 1966, when the Gallos were running short of wine, Julio Gallo himself reached out to Walter with an offer he couldn't refuse: Move to the Napa Valley. Help us build a network of high-quality growers throughout the region. And so it was that in 1966 Walter and Gertrud and their three kids, Axel and his twin sisters Claudia and Andrea, moved to the town of St. Helena, where soon Walter would be overseeing a network of 600 growers, and where soon he would meet a brilliant newcomer to the Napa Valley and American wine, one Joe Phelps.

"One day when I was still at Gallo I got a call saying, 'Mr. Phelps would like to talk with you,'" Walter recalled. "At that stage, he was building the Souverain winery and the future winemaker there was a buddy of mine who had started at Delano, Bill Bonnetti. One day Bill ran into Mr. Phelps at the construction site, and Joe said to him, 'You know, Bill, I am thinking about starting my own winery. If I do that, who should I talk to?' And Bill told him about me."

And so it began. The two men met, and Joe outlined his vision for what would become Joseph Phelps Vineyards. "Joe loved French wines, and he had many examples of the kinds of wines he liked," Walter said. "And I could see this was going to be more of a red wine venture than a white wine venture." Joe envisioned a day when most of their wines would be estate-grown, but in the early stages, as they were planting their own vineyards, they would need to buy grapes from other growers in the valley, and Joe made clear that Walter's vast expertise in this realm would be invaluable, as would Walter's expertise regarding what kind of equipment to buy for grape de-stemming, pressing, fermentation, and barrel aging.

Walter liked Joe's vision for his future winery and he foresaw a very comfortable fit. "We had a nice conversation," Walter told me, "and I said to myself, 'This is a wonderful opportunity.' It had nothing to do with what he was offering to pay me or anything like that. I just like to work on new opportunities."

Creative freedom was a big issue for Walter, and here he and Joe saw eye to eye. While Joe's first love was red wines, especially Cabernet blends from Bordeaux and varietals from the Rhône Valley, Walter was eager to craft German-style white wines like Riesling and certainly a Pinot Noir too. Those ran in his family. "The Rheingau," he explained, "was known for its Riesling. But the town of Assmannshausen, near the end of the Rheingau, was all Pinot Noir. The winery that my father managed was all Pinot Noir."

Another issue for Walter was quality. He had had enough of the bulk wine business; with the wines he wanted to craft now, Walter wanted to go for the gold; in his eyes, second best would never do. So he was delighted to find that Joe held himself to the exact same standard. "I felt that Joe was someone who had the money to let me do what I wanted to do," Walter told me. "And we had the exact same goal: he wanted to make beautiful wines, wines he liked to drink. And he wasn't going to say, 'No, we can't do that, we don't have the money.' In fact, we didn't even have a budget. We were just determined to make the very best wines we could."

There was something else that appealed to Walter. From his work in construction, Joe knew how to choose the right people, earn their trust, give them the freedom they needed, and build a loyal, closely knit team. And Walter felt those qualities were exactly what was needed to start a first-class winery from scratch and help it grow patiently to maturity. Vision. Organization. Planning. Building for the long-term. In wine, as in construction, those were must-have qualities, and here again Walter saw a very happy fit. "I was always good at organization, at thinking things through," Walter said, "even in my youth. Joe and I both knew that to succeed, we needed a very clear, carefully thought out plan. That was essential."

On Joe's side, he was impressed with Walter, but with so much at stake, he had to be sure. So as a test, Joe first hired Walter as a freelance vineyard consultant, to examine the property on Zinfandel Lane and assess its potential for growing top-quality grapes. Walter studied the property, evaluated the soil and the varietals that would grow best there, and he and Joe even sketched

out where a winery could go. Joe was now doubly impressed. And when Joe's realtor first showed him the Connolly Ranch, in early 1973, Joe formally hired Walter to be his winemaker, his wine mentor, and his vineyard scout and evaluator. By then, Joe had fallen in love with the Connolly Ranch, but he still needed Walter's counsel and professional advice: Did the Connolly Ranch have the right stuff? Did it have what it takes to produce fine wines, wines that could one day stand among the very best in the world?

Walter immediately set out to answer that question. "For four days," Walter said, "my wife and kids and I walked up and down the property. This was the early spring of 1973, the streams were flowing, everything was green, and the place was just beautiful."

That said, the property needed work. "The ranch was unmanaged, it had been up for sale, and so we were stumbling over wire fences that had fallen down and blackberry bushes that were growing out of control," Walter said. "With all that, we were trying to see where grapes could be planted and where we could put a winery. I saw 35 acres that I thought could be planted and three spots where I thought we could put a winery and offices."

Once he had completed his inspection, Walter gave Joe his verdict: Yes! This is the place. And thus it was settled: it was on this raw, rough canvas that Joe would now paint his masterpiece.

WALTER SCHUG,
JOE PHELPS, AND
JOSEPH HEITZ.

That said, Walter and Joe still needed help to get up and running—lots of help. They had no vineyards. No winery. No equipment. And no existing network of growers and suppliers either. But Walter and Joe had friends and neighbors they could count on to help. In short order, Ivan Schoch and Fred Holmes invited Walter and Joe to craft their first Cabernet and Riesling at their Souverain facility. Then Joe's neighbor Joseph Heitz invited them to make their first Pinot Noir in his shop. Joe was elated. As he was discovering, at heart the Napa Valley was a farm and ranching community with the same bedrock values and strong sense of community that he had treasured back in Greeley: "Work hard and share; we're all in this together."

In the pages ahead, as you follow the Napa Valley's stunning rise on the world stage, you will see many examples of the valley's spirit of sharing at work, often with Joe quietly at the center of initiatives for the betterment of all. And just as we saw with Lee Stewart and André Tchelistcheff sharing their deepening expertise with other growers and winemakers in the valley, these early pioneers didn't see themselves as rivals; they saw themselves as partners in a common and very noble cause: to lift the quality and prestige of Napa Valley wines. As a group, they were all convinced the Napa Valley had the sun, soil, and entrepreneurial flair to one day stand proudly beside Burgundy, Bordeaux, and Tuscany, but they knew that no single winery could achieve that goal all on its own. It had to be a collective effort. That thinking was a cornerstone of the rise of the Napa Valley.

Still, for Joe the risks were incredibly high. His initial outlay for the Connolly Ranch was substantial. His initial outlay for staff and equipment was substantial. It would take him at least a year to build his winery and get it up and fully functioning. And on top of all of that, Joe had absolutely no track record in the industry. And absolutely no clout with the regional or national distributors who talked with retailers and urged them to put the finished wines onto their shelves. Yes, for Joe the risks were incredibly high, and given all these hurdles, how, in the end, would it all work out?

The answer: Fabulously well!

And Walter's gifts were one primary reason why. In fact, Walter's very first Johannisberg Riesling, the 1973, proved to be a major success. And just two years later, Walter's Riesling and Joseph Phelps Vineyards itself earned the kind of ecstatic review that every winery—young or old—dreams of, but very few ever attain.

240

280

900

EXIST. DRIVEWAY

PARKING

SCALE

SEPTIC
SYSTEM
FIELD

NORTH
1" = 200'

TABLIN LANE

200

TO SILVERADO TRAIL

240 280 320 360

NOTE:
TOPOGRAPHY TAKEN
FROM MAP FURNISHED BY OWNER.

KEITH
ENGINEERS ·
4635 O
SANTA
TELEP

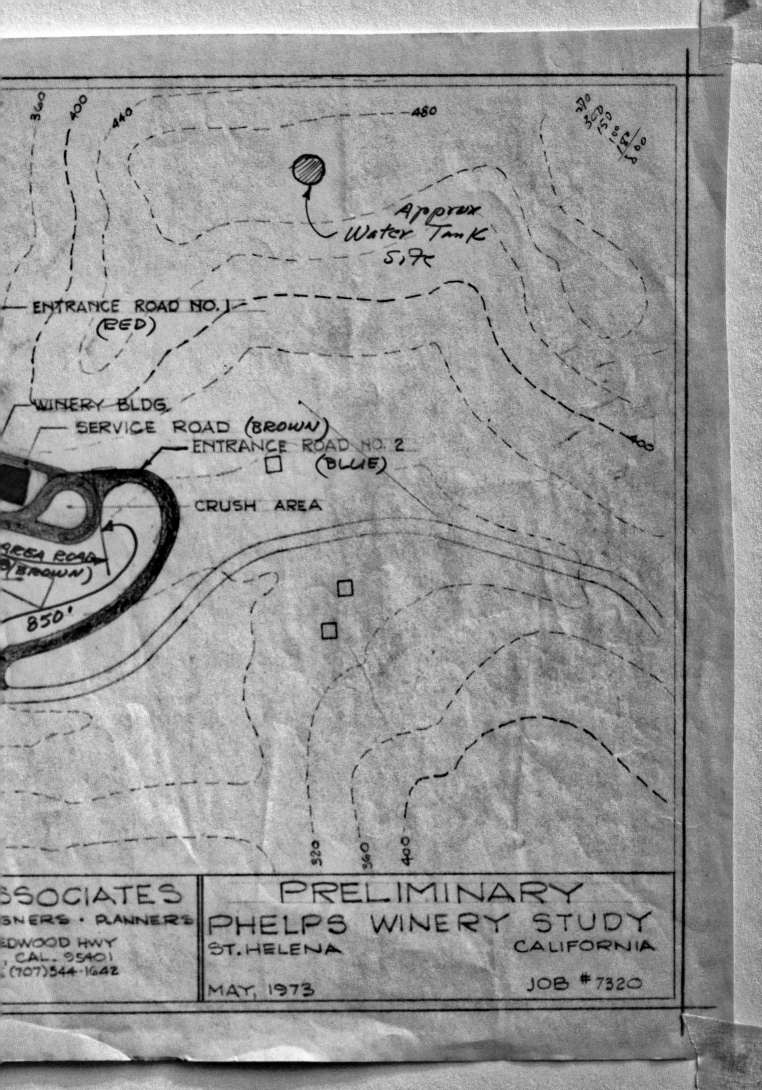

360 400 440 480 370 350 150 300 400

Approx
Water Tank
Site

ENTRANCE ROAD NO. 1
(RED)

WINERY BLDG.
SERVICE ROAD (BROWN)
ENTRANCE ROAD NO. 2
(BLUE)

CRUSH AREA

AREA ROAD
(BROWN)

850'

400

320 360 400

SSOCIATES
GNERS · PLANNERS
EDWOOD HWY
CAL. 95401
(707) 544-1642

PRELIMINARY
PHELPS WINERY STUDY
ST. HELENA CALIFORNIA

MAY, 1973 JOB # 7320

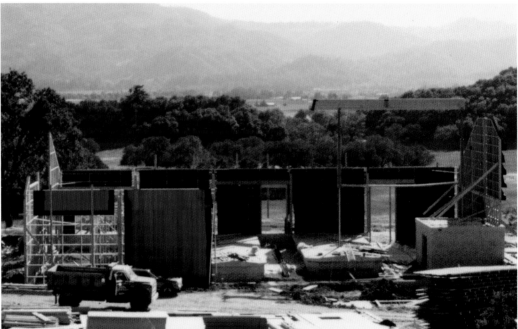

BUILDING
JOSEPH PHELPS
VINEYARDS, FALL
OF 1973 TO THE
FALL OF 1974.

*First four photos
courtesy of
Joseph Phelps
Vineyards. Last
photo, courtesy
of Walter Schug.*

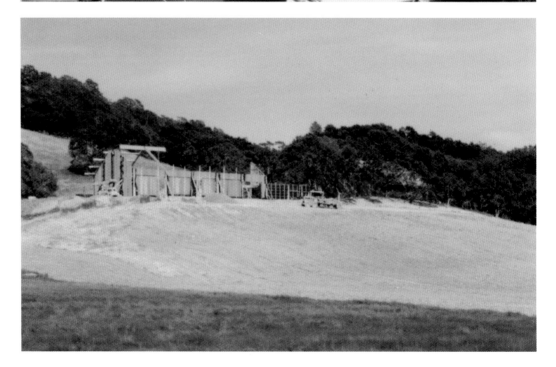

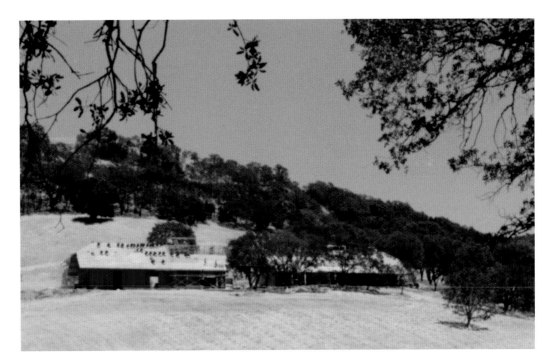

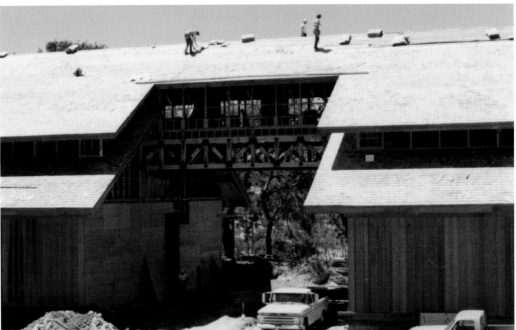

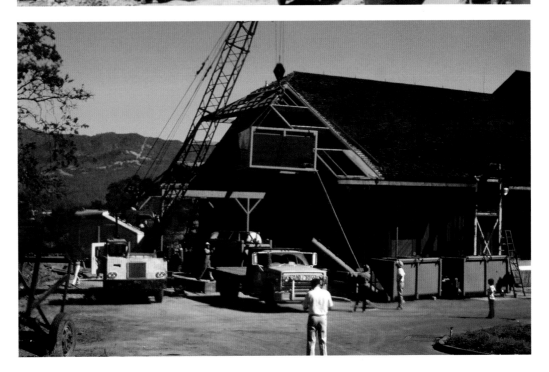

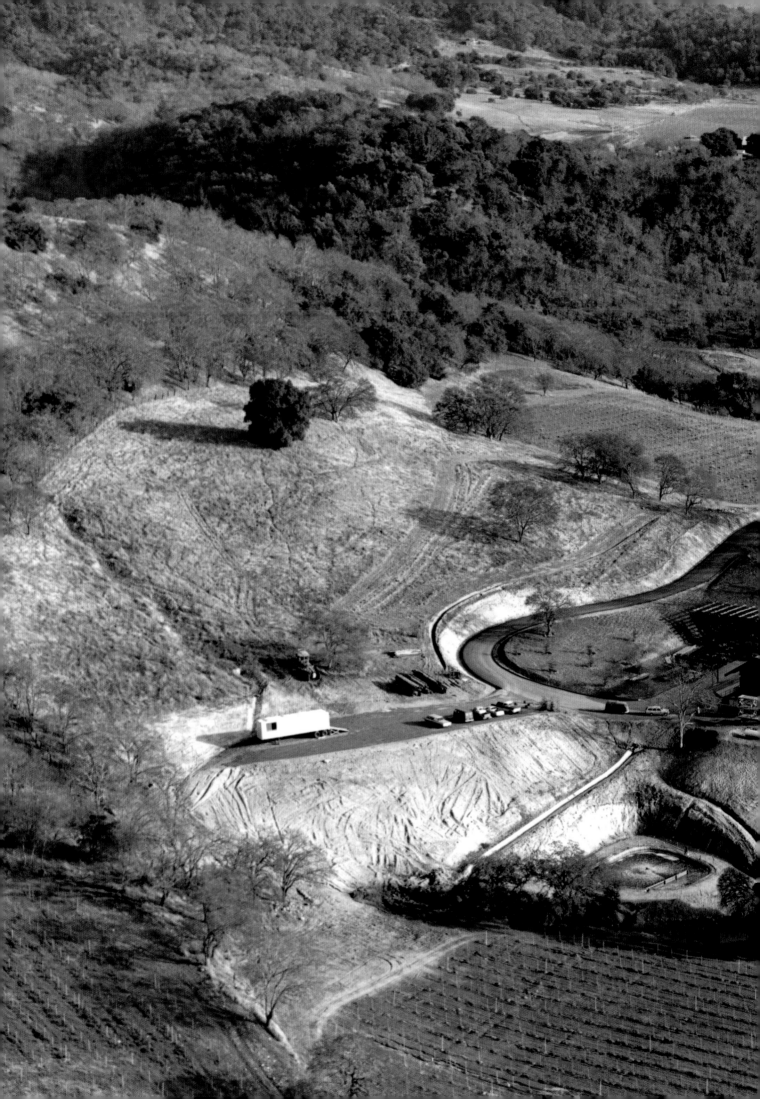

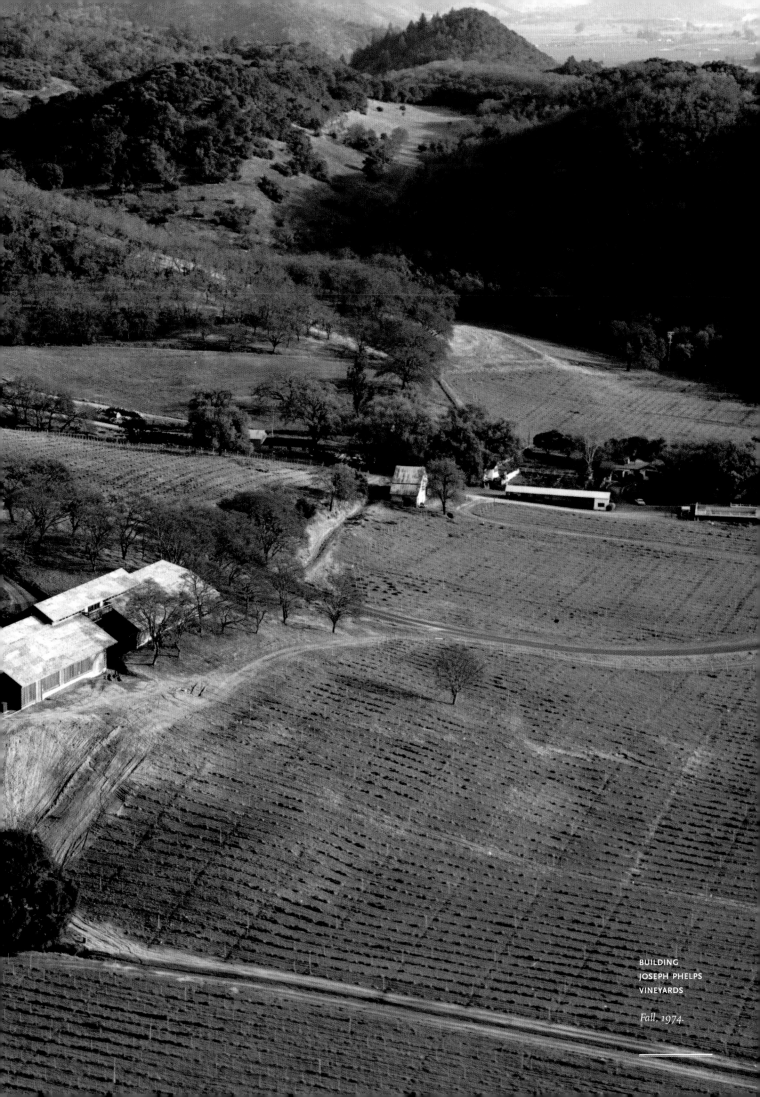

BUILDING
JOSEPH PHELPS
VINEYARDS

Fall, 1974.

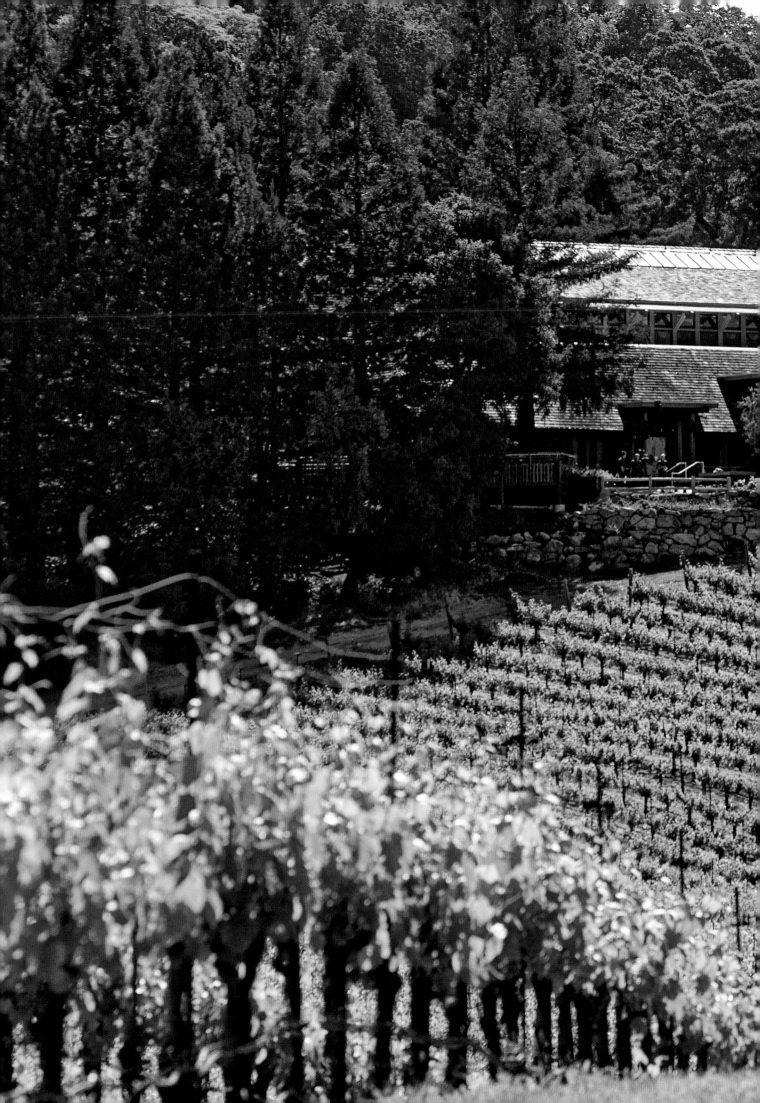

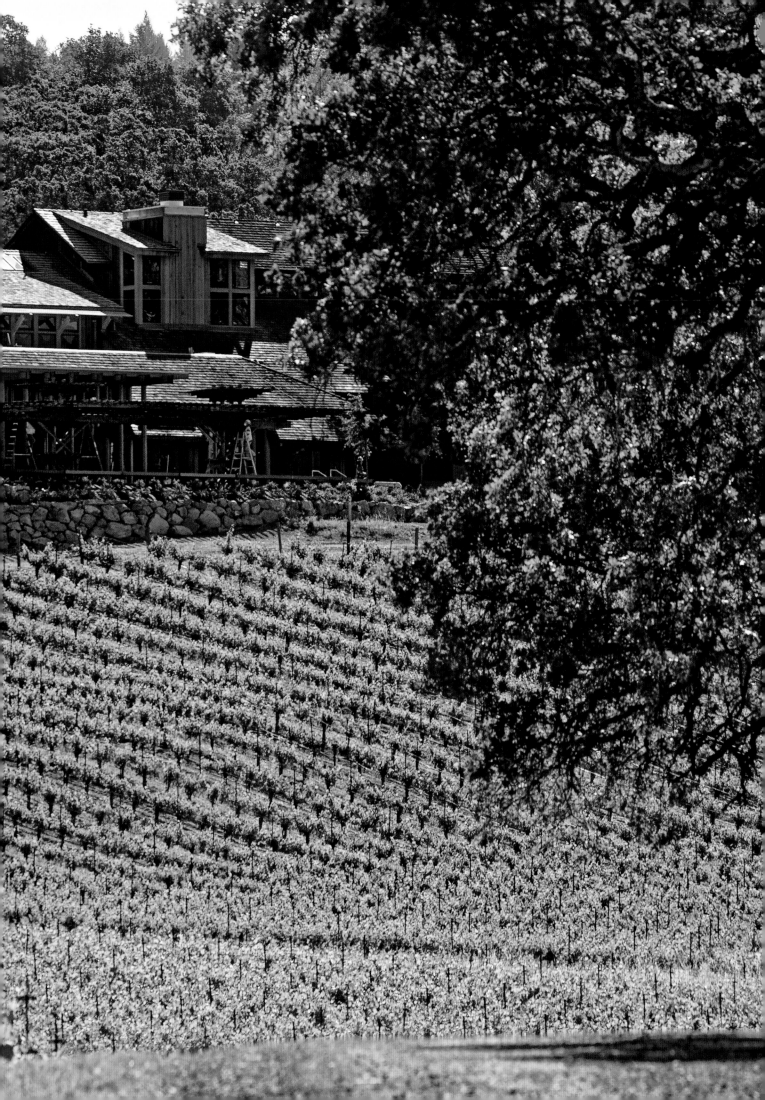

That review came courtesy of Robert Lawrence Balzer, who at that stage was one of America's most esteemed wine writers. And the man had clout all across the wine industry. Balzer had his own wine column in the *Los Angeles Times*, and for true wine aficionados he had his own private newsletter and buying guide as well. Beyond that, with the *L.A. Times* as co-sponsor, Balzer organized high-profile wine tastings and competitions, evaluating the top wines of California, and a gold or even a silver medal from a Robert Balzer tasting was widely viewed as an emblem of the highest distinction.

Just imagine, then, how the masters of the wine world snapped to attention when Balzer got a little giddy over Walter's 1975 Late Harvest Johannisberg Riesling, and over Joe's new winery as well, with its stylish architecture and its signature trellis. Even now Balzer's applause flies off the page:

"The words that follow in lyric praise of one wine are perhaps the most extravagant narrative in my wine-writing career," Balzer wrote in his newsletter. "On my first visit to the very handsome new winery just off the Silverado Trail, I stopped before the rustic, weathered timber gateway, the framed vista to rolling vineyards and an equally impressive monumental contemporary wooden winery striking some awe. Joseph Phelps' dominion has obvious dedication and determination to achieve a high-level ranking in the state's fine wine production. Half an hour later, with winemaster Walter Schug, that impression was confirmed in an impromptu sampling of current production."

Then Balzer waxed poetic about Walter's Johannisberg Riesling:

"It is perhaps one of the finest white wines I have ever tasted in my life," he wrote. "Flashing a lemon-gold brilliance, ribbing the glass with glycerin-crystal tears, a rich Riesling perfume heady with added pungency of Botrytis, it tells the most casual taster the quality of California achievement with the grape. Factually, there is 10 per cent residual sugar, .94 total acidity in a balanced harmony of elegant structure matching the artistic architecture of the wine's home... Wine lovers should write for their quota now."

Extravagant praise indeed! And for a start-up winery too!

And there were more rave reviews coming. In the following years, Walter made a series of Late Harvest Rieslings, in different styles

and with different flavors, depending on the degrees of residual sugar. With those creations, Joe and Walter earned reputations as free-thinking innovators, and Walter solidified that reputation by crafting highly praised German-style Gewürztraminer wines and Late Harvest Gewürztraminer wines too.

In crafting these elegant, small-production wines, Walter used different levels of botrytis, the "noble rot" that appears late in the harvest. The botrytis shrivels the grapes and leaves a distinctive and very agreeable musky accent—making for wines that are very appealing as semi-sweet dessert wines. To properly age these wines, Walter imported from Hungary several large, stately, oval-shaped oak casks, and those casks became another signature feature of Joseph Phelps Vineyards. Indeed, those same oval casks still enjoy a place of pride in the tasting areas of the winery today.

And then came Syrah.

In our conversations, Joe told me was this was one of his proudest achievements in wine: bringing Syrah to America. Joe loved Syrah wines and their place of origin: the northern reaches of the Valley of the Rhône in southeastern France. Syrah is a dark-skinned grape that produces rich, deeply concentrated red wines, often with sharp accents of fruit and spice. The history of Syrah traces back to the Roman era, and maybe even further back, and some of the early settlers in California had planted Syrah back in the 1800s. But it was never bottled and sold here as a single varietal; it was always blended with other grapes—until Joe and Walter came along.

"We brought Syrah into existence in the United States," Joe told me. "We rarely get credit for it, but that's the truth."

There is a fascinating background story here. Back in 1935, Harold Olmo, a professor in the wine program at UC Davis, launched an experimental program to cultivate Syrah in the Napa Valley, and he did so with well-established wineries like Christian Brothers. By 1974, though, all of Professor Olmo's experimental vineyards were gone, except one: the Wheeler Ranch, owned by Christian Brothers and located where? Near Joe's own property on Zinfandel Lane. Destiny, as usual, was smiling on Mr. Phelps.

"Christian Brothers had never done a varietal Syrah," Joe said, "and those grapes ended up in their red Burgundy program. So in 1974 we were able to buy ten tons of the fruit, and that's the year we started our Syrah program."

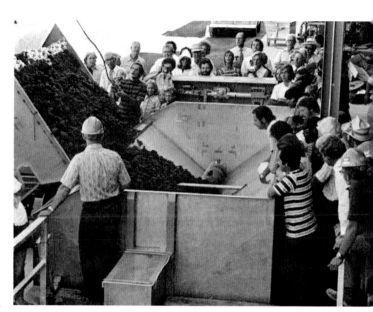

As with their German-inspired wines, their Syrah was a hit with reviewers and the buying public, and Joseph Phelps Vineyards has produced a quality Syrah every year since, helping Joe earn a place among the so-called "Rhône Rangers," the original pioneers who helped popularize Rhône-style wines here in America. And Joe's Syrah continues to earn rave reviews today. Indeed, the eminent critic Robert Parker gave the 2014 Phelps Syrah a 95-point salute:

"Possibly the best Syrah the Phelps winery has ever produced," Parker raved. "There are 1,600 cases of this sexy, endearing, dark purple wine, which has an incredibly intense bouquet of spring flowers, marmalade, honeysuckle, and blackcurrant and black raspberry fruit. This stunning wine, which is medium to full-bodied with silky tannins, would easily pass as a dead ringer for a Côte Rôtie in a blind tasting." High praise indeed! True glory in a glass.

Still, there was even more lavish praise to come.

Indeed, it is now time to share with you the story of Insignia, the wine that sealed Joe and Walter's reputations here and abroad, and the wine that has proudly stood as the standard bearer of Joseph Phelps Vineyards for the past 40 years. And what a story it is.

I had enjoyed Insignia long before I met Joe, and once we began work on this book, and once I saw his precision business mind at work, I naturally assumed that right from the beginning he and Walter had set out to create something truly unique, a signature wine that, like their trellis, would set Joseph Phelps Vineyards apart from all the other wineries in the Napa Valley. Yes, that was my assumption: that they had set out to create a blended red wine with Bordeaux-like character and elegance, a wine with cachet and a touch of swagger, something to announce to the world that a bold new force had come to the Napa Valley and American wine.

But my assumption was totally wrong. And Walter Schug set the record straight. As he explained:

"In the beginning, we did not set out to create a trophy red wine. At that point, we were trying to get Americans to understand varietals; most consumers were just thinking 'red wine.' And I kept saying to Joe. 'We need to educate people with regard to varietals.' So I wasn't too happy with making blended wines."

Still, the reality at hand—namely that they had no grapes of their own to work with—forced them to move away from pure varietals and be more flexible and creative. Walter: "We were getting all sorts of grapes from different growers, and we were not sure what to do with them. But our goal was to make the very best wine we could with the grapes we had. So as we worked and studied in the lab, with monthly tastings, we started playing."

"Playing" is indeed the right word. Walter would usually start with his best Cabernet Sauvignon grapes, and then, tasting as he went, he would add in small quantities of other varietals that he had at hand, Merlot in particular. "One guy working with me would try this blend, another would try that one. Joe came in on a monthly basis, away from his construction work, and he worked on blends too." In time, Walter said, this approach turned into a broader philosophy for their flagship red wine: "Let's just make the best wine we can every year, using the very best grapes we have."

Again, as with Syrah, Joe and Walter were way ahead of their time. At that stage, the preeminent winemakers in the Napa Valley were crafting and marketing their wines as pure varietals, prominently labeled as Chardonnay, Cabernet Sauvignon, Pinot Noir etc. But remember the fine wines that Joe kept in his cellar? The Château Mouton-Rothschild? The Château Latour? The Haut-Brion? For Joe, those were it, The Gold Standard, and those were not pure varietals; they were blended wines. So let the others hold to their reliance on pure varietals. Fine. Good for them. But for Joe and Walter, for their flagship red wine, there was only one standard to reach for: The Best of Bordeaux. And second best would never do.

Their inaugural 1974 Insignia was a telling case in point. The very best grapes they had that year were Cabernet Sauvignon grapes from a vineyard in the Stag's Leap region, further south along the Silverado Trail. While playing in the lab, Walter found that these grapes were producing exquisite juice, and when he blended it with just a small amount of Merlot, the result was even better. But one huge question remained in Walter's mind: "The blend was fine, but how in the heck are we going to sell it?"

THE FIRST
CRUSH AT
JOSEPH PHELPS
VINEYARDS

September 10, 1974.

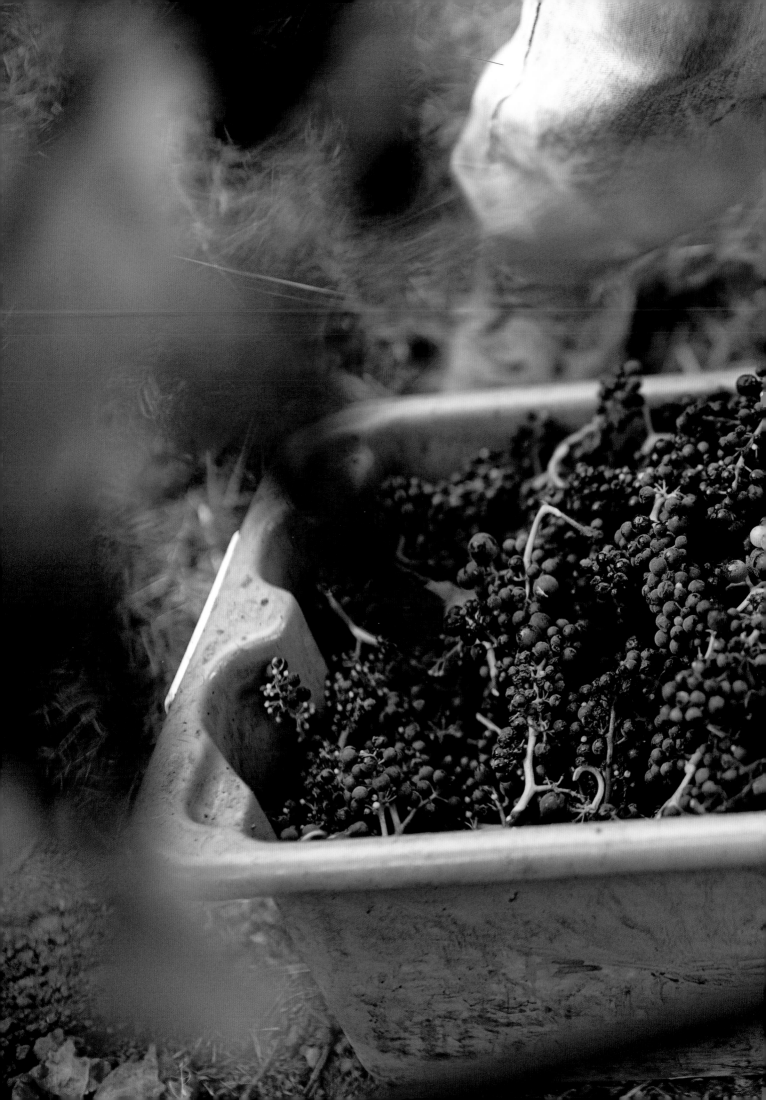

The main question mark was the name. As a rule, Joe was never thrilled about naming a wine after its predominant varietal. In his view, that practice led to names and labels that lacked distinction and panache, and there were legal restrictions governing such labeling as well. For instance, under regulations set forth by the federal Bureau of Alcohol, Firearms and Tobacco, the BATF, a wine labeled Cabernet Sauvignon had to contain 75 percent Cabernet Sauvignon grapes, at a minimum. For his flagship red wine, Joe wanted a much freer hand, not just in the name of the wine, but also in the different varietals they chose to use in any given year.

As Joe later told an interviewer from the Bancroft Library at UC Berkeley, for their series on pioneering winemakers, "We knew that we wanted a name for this wine that would give us the long-range ability to blend superior selections of Bordeaux grape varieties without regard to the BATF regulations. We decided that our label should refer to this wine simply as 'a red table wine' and that the perceived quality would ultimately speak for itself."

Still, Joe wanted a name that said something beyond "red table wine." But what name would have the flair and magic he sought? As Joe told me, he and Walter and several members of Joe's family brainstormed for months, even years, trying out this name and that. Finally, Joe told me, one morning while he was shaving, the name "Insignia" just popped into his head. *Voilà!* That's it! For Joe and Walter and the family and everyone else at their young winery, that name triggered a very satisfying "click," and it gave them the total freedom they sought going forward.

"The proprietary name Insignia was selected to represent the finest lots available for each vintage," Joe explained to the interviewer from the Bancroft Library, "and to emphasize the importance of blending over varietal designation as a determinate of quality. We are steadfast believers in varietal integrity whenever a varietal is shown on the label, but we are equally committed to the idea that blending, in certain cases, can truly enhance other wines, adding interest and value for the consumer."

Still, finding the right proprietary name was by no means the end of the Insignia story; indeed, it was just the beginning. And once Walter and Joe found the precise blend they liked—94% Cabernet Sauvignon and 6% Merlot—they put the wine into French oak barrels to be very patiently aged. Joe knew, in his bones, that this was a wine with enormous potential, and it was not to be rushed.

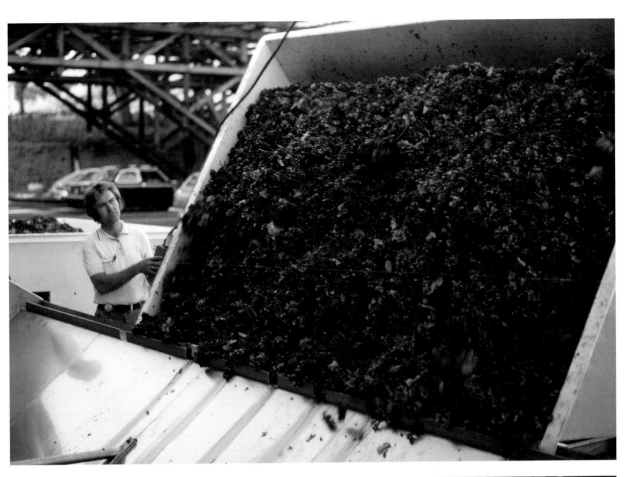

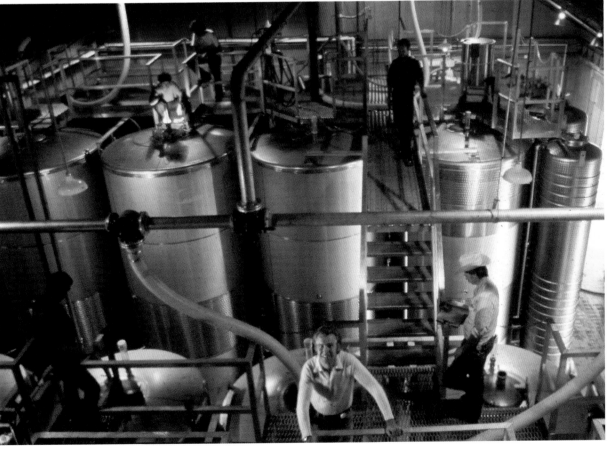

WALTER SCHUG
AT WORK

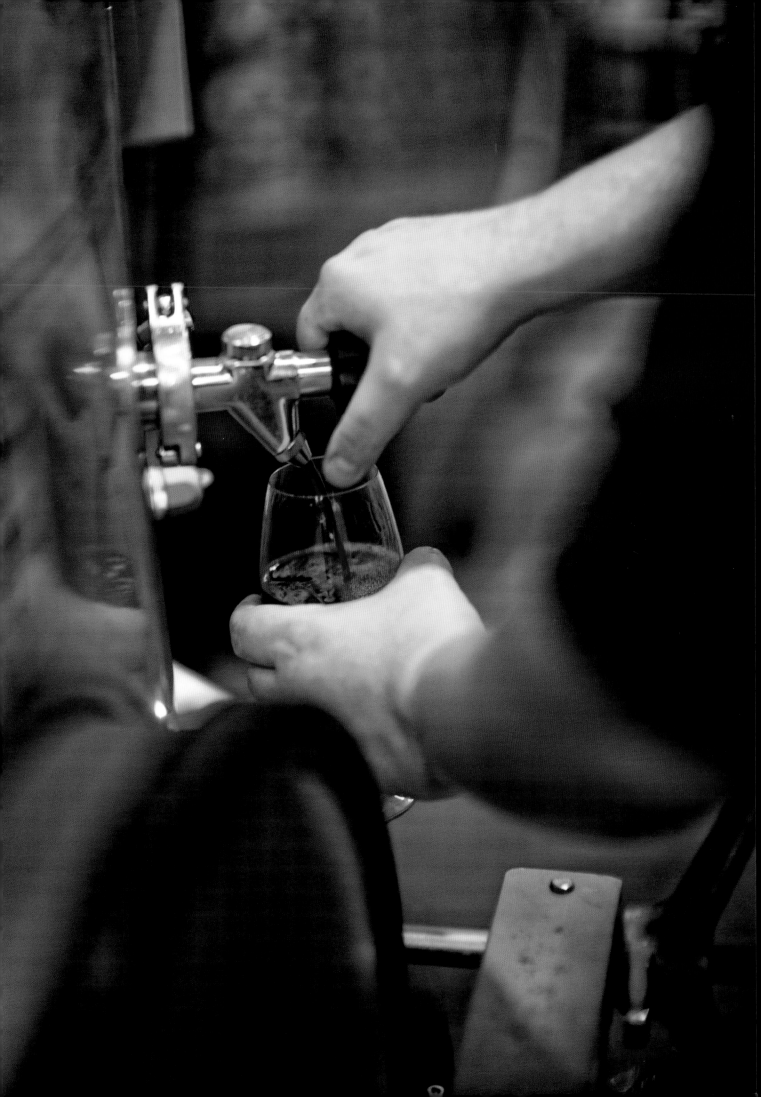

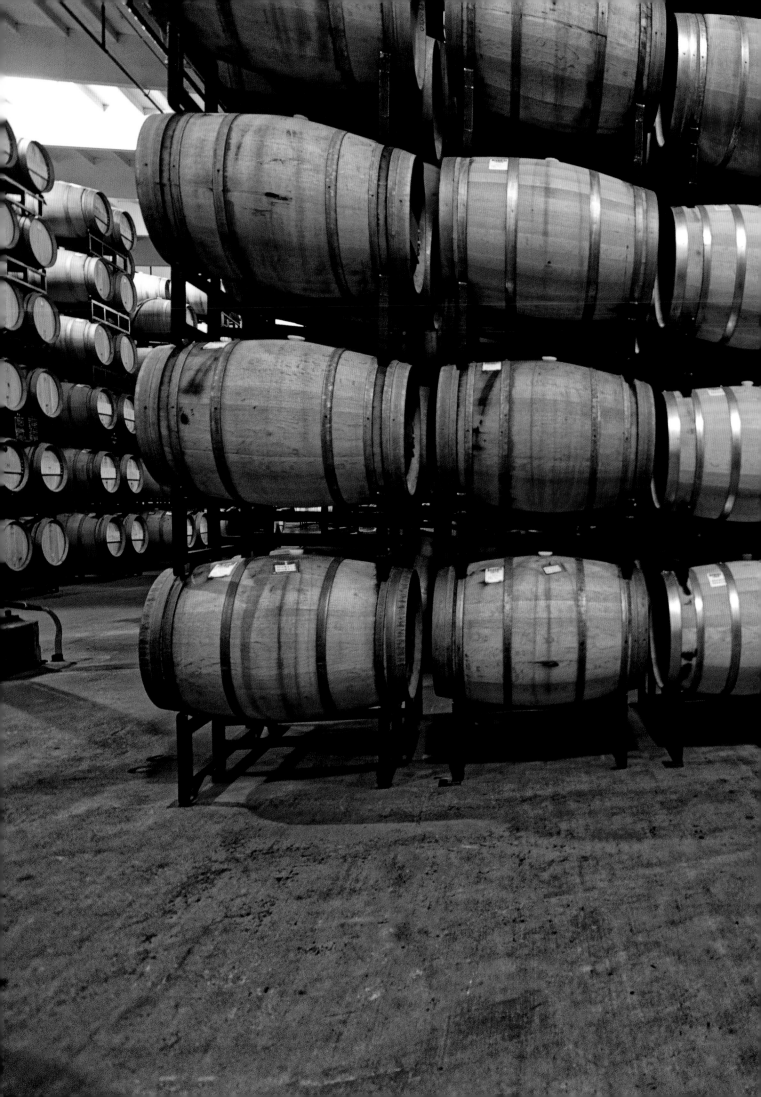

And here again, Destiny was by Joe's side...

By the start of 1976, while Joe and Walter's inaugural Insignia was resting quietly in its oak barrels, a whole new era was coming to American wine. Thanks to the rising quality of many Napa Valley wines, the heyday of those lowly wines like Ripple and Night Train was becoming ancient history, and with consumers now having a wider choice of wines, and better wines too, the market dominance of jug wines was fading as well. Public interest—and sophistication—about wine was also on the rise. To help advance the education process, in April of 1976 a wine lover named Bob Morrissey, based in San Diego, launched a tabloid called *Wine Spectator*, featuring reviews of wines and stories about individual wineries. Three years later, as the popularity of wine kept rising, a shrewd entrepreneur named Marvin Shanken took it over and promptly turned *Wine Spectator* into an industry powerhouse and the most influential voice in the emerging story of American wine.

All that said, at the start of 1976 America was still light-years from being the wine-loving nation that we are today, and both here and abroad few knowledgeable wine lovers would ever mention the words "Napa Valley" in the same breath as the words "Bordeaux" or "Burgundy" or "Tuscany." To do so would be to invite ridicule on the grandest of scales. Indeed, in the eyes of the international wine aristocracy, the ultimate verdict on our American wines had been issued several years before by none other than the Baron Philippe de Rothschild, the lion of Château Mouton de Rothschild and one of the most famous and influential winemakers in the world.

"American wines," The Baron famously said, "all taste the same. They all taste like Coca-Cola." Ouch!

And then it happened.

At the start of 1976, as we in America prepared to celebrate our 200th anniversary as a free nation, a British-born, Paris-based wine merchant named Steven Spurrier organized something that he felt would be both appropriate and fun: a blind tasting of French and American wines. France, after all, had been our steadfast ally in our 1776 war of independence from Britain, and it was French artisans who had created for us our Statue of Liberty, the enduring symbol, in the eyes of the world, of the values for which we stand. So what better way to pay tribute to 200 years of Franco-American friendship and to our shared political, eco-

nomic, and cultural ties? What better way to celebrate July 4th, 1976, than to raise a glass to the Land of Liberty and to the land of Liberté, Egalité, Fraternité?

For this momentous event, Steven Spurrier set the stage perfectly. He recruited a panel of nine esteemed French judges, and he chose a five-star venue: The InterContinental Hotel. The hotel is located in the very heart of Paris, close to The Louvre, The Place Vendôme, and an easy walk from Spurrier's own wine shop in the Place de la Madeleine. And for the competition he chose some of France's finest wines. For the morning portion of the tasting, devoted to white wines, he chose some of the very best that Burgundy has to offer: a Bâtard-Montrachet, a Puligny-Montrachet, a Meursault-Charmes, and a Beaune Clos des Mouches. To taste and appraise against those, Spurrier chose six white wines from California, including four from the Napa Valley, wines that he and an aide, Patricia Gallagher, had chosen during a recent tasting trip in California.

Spurrier's salute to America's Bicentennial opened with a distinctly festive air, but the morning portion of the tasting, the white wines, did not go as expected. In one of the InterContinental's exquisite banquet halls, the nine distinguished French judges set to work, sniffing, swirling, tasting, and appraising, writing down their notes and scores as they went. And what white wine did these eminent judges select as The Best of The Best? Was it a world-renowned white wine from Burgundy? No, they chose a 1973 Chardonnay from the Napa Valley, crafted by Miljenko "Mike" Grgich for Chateau Montelena, in the north of the valley. What was this? In the eyes of the French judges, and most everyone else there, this was obviously a mistake, a fluke, nothing more than a slight aberration.

Few in the room had any doubt that the afternoon tasting of the best red wines would set matters right. And Steven Spurrier himself knew how deftly the deck was stacked: to taste against his selection of American reds, Spurrier had drawn from the absolute crème de la crème of the Bordeaux wine aristocracy: The Baron Philippe de Rothschild's Château-Mouton Rothschild, the justly fabled Château Haut-Brion, a Château Montrose, and a Château Léoville Las Cases. Perfect! How could any wine crafted by those raw upstarts in America compete favorably with any of those?

Well, after an extravagant French lunch, the judges reconvened for the red wines, and again they studiously sniffed, swirled, tasted, and appraised. The entire proceeding took barely an hour. And what red wine did the judges deem to be the winner, the Best of The Best? Alas, it was not from the Bordeaux ranks at all. It was a full-bodied and very elegant Cabernet Sauvignon, one that danced gracefully on the palate, and it was crafted by Warren Winiarski at his Stag's Leap Wine Cellars, located on the Silverado Trail, in the very heart of the Napa Valley. *Mon Dieu!* Two such aberrations in a single day! How in the world could this happen? Was this game rigged? At least one of the judges believed so, and said so publicly, and others surely believed it too.

But as Spurrier himself assured everyone, the tasting had not been rigged. The simple truth was this: the quality of American wines was now on the rise, and it was the vintners of the Napa Valley who were leading the charge. For centuries, French wines had been the standard against which all other wines were judged. And then came this dramatic upheaval. On America's Bicentennial too!

Still, few of the French judges involved in the tasting—and few winemakers across France—imagined that Spurrier's little event would have any lasting significance. Yes, it was a pleasant way to raise a glass to their American friends on the occasion of their Bicentennial, but most of them figured —and surely hoped—that the whole event and its surprise outcome would slip away unnoticed, never to be mentioned or repeated again.

Alas, that hope did not last very long. As fate would have it, there was an American journalist attending the event: George Taber, a Paris-based correspondent for *Time* magazine. Taber watched the entire proceeding and interviewed some of the participants during and after the event. And when the results came in, Taber knew he had a good story, and he rushed back to *Time*'s office and filed a story to his editors in New York. They, in turn, would boil it down to its essence. That was *Time*'s way. In the end, Taber's story, aptly headlined "Judgment of Paris," was only four full paragraphs long, but it created a sensation—not so much in France or the rest of Europe, but certainly in America and among the vintners in the Napa Valley. All of their collective hard work was paying off, and thanks to *Time* magazine, the whole world now could see it!

In the popular mythology that has since taken root in American wine circles, there is an anchoring belief that those few hours at the InterContinental Hotel seized the wine world's attention and will now stand for eternity as the watershed moment in the rise of the Napa Valley and American wine. Such is the power of America's PR machinery, turning a festive tasting into an event of Earth-shaking importance, one that has even been memorialized in exhibitions at the Smithsonian in Washington D.C. There is some truth in that. But several other important developments were also on the way, including one coming to life in Joe and Walter's French oak barrels.

For Joe and Walter personally, as for many other Napa Valley vintners, The Paris Tasting was an event of little consequence, beyond the welcome recognition it brought to the valley. Instead, Joe and Walter were now focused on how best to handle their 1974 Insignia, their baby now quietly nestling in its barrels. Many other winemakers, I'm sure, would be eager to rush the wine out into the marketplace, if only to expand their product line and boost their cash flow. But Joe and Walter refused to be rushed. After all, they had a lot riding on the success of Insignia. So their watchword was: Patience! Patience! And, after all, second best would never do.

Through this period, Walter was impressed by Joe's calm, careful approach to handling Insignia. "He was a great thinker," Walter told me. "He was always very thoughtful about what he was doing. And he had great judgment. Together we achieved great things."

For a long time, via periodic tastings from the barrel, Joe and Walter followed the maturing of their Insignia, and they fussed and second-guessed as expectant parents are inclined to do. But in January of 1977, they finally decided their inaugural vintage of Insignia was ready to bottle. After that, though, they decided to wait still another year before releasing it to the public. Why?

One reason was that Joe had yet to find the ideal name. But another reason flowed from the results of The Paris Tasting. In the eyes of the world, and in the eyes of the marketplace, the quality of Napa Valley wines was now clearly on the rise. And Insignia would be the very first Bordeaux-style proprietary blend created in the Napa Valley. It was, in sum, a unique, ground-breaking wine. And here Joe's business acumen rose to the fore: with those formidable assets, he believed he could price Insignia at $20 a bottle—much more than even some of the finest Napa Valley

Cabernets of the period. And that elevated price, in itself, would send to the entire wine world a message of quality and distinction.

And how, in the end, was their first vintage of Insignia received?

The early reviews were by no means fabulous. Still, as the wine aged, the reviews for that 1974 vintage kept getting better and better. And then along came a gentleman named Robert Parker.

Parker was born in Baltimore, into a family with no pedigree in wine. In fact, his father worked in the construction industry, as a salesman. His son, though, was not interested in concrete and steel; his heart was in history and culture. At the University of Maryland, he majored in history, with a minor in art history. From there, Parker earned a law degree at the University of Maryland and was headed full-bore into a career in law—until he went to France and fell in love with France and fine wine. That changed his life, just as it had for Joe.

In 1975, Parker began writing a book on wine. Three years later, though, in search of a more supple and powerful platform, Parker launched a direct-mail newsletter that would soon turn into *The Wine Advocate*. In those pages, Parker wrote detailed reviews of fine wines—French, American, and more—and he rated wines on a 100-point scale. Parker's reviews and his discerning palate soon made *The Wine Advocate* a must read for wine industry leaders and insiders, not just here in America but also in France, Britain, and far beyond. Before long, *The Financial Times* would pay him the ultimate compliment: Robert Parker, the paper declared, had "the world's most prized palate." Later, a biography of the man went even further: it crowned Robert Parker "The Emperor of Wine."

And how did The Emperor of Wine rate Joe's landmark Insignia?

By his own admission, Parker was not bowled over by his first tasting of the 1974 Insignia. Much later though, in 2013, he returned to that first vintage to see how well it was aging. This time, like those judges back in Paris, he carefully sniffed, swirled, tasted, and appraised, and then he bestowed on Joe's first vintage of Insignia a score of 99 points. Almost a perfect score! A 99 ranking from Robert Parker was rare enough; that it was awarded to what at the time was a brand new wine from a brand new winery, well, that was historic in itself. Indeed, Parker now regards the launch of Insignia as a signal event in the history of the Napa Valley and the history of American wine:

"Joseph Phelps was one of the great visionaries of Napa Valley," Parker later wrote. "His legacy is one of extraordinary quality. He was one of the first to see the merit in blending, which his legendary Insignia has proven year after year. It remains one of the world's finest Cabernet Sauvignon-dominated blends."

Other prominent wine writers have come to the same conclusion. In 1997, *The Wine News* also returned to the 1974 Insignia and it too was lavish in its praise: "The 1974 is still deep in color and very much alive, but more importantly from our vantage point nearly a quarter century later, it set a tone." In 2001, the *Connoisseur's Guide to California Wine* also gushed, calling the 1974 Insignia "A red wine for the ages." In the years that have followed, Insignia has continued to wow the critics. Indeed, in 2005, the *Wine Spectator* compared 100 leading wines and selected the 2002 vintage of Insignia as the No. 1 wine in the world.

What stunning accomplishments! Few wineries, anywhere in the world, ever earn such accolades! And Joe did all this in his first few years in the wine business. Amazing.

1974 AND
2013 INSIGNIA
WINE LABEL

And there is one thing more. As we said, Joe's Insignia was the Napa Valley's first high-end proprietary Bordeaux-style blend—but it was not the last. Indeed, Insignia blazed a trail that many others soon would follow. An illustrious case in point: just a few years after Insignia made its storied debut, Robert Mondavi joined hands with the Baron Philippe de Rothschild, the lion of Château Mouton, and together they brought forth their own proprietary blend, a little venture they named Opus One. If, as they say, imitation is the sincerest form of flattery, Joe could not ask for anything more.

◆

AN EXUBERANT
JOE, WITH
HIS NEW
WINERY IN THE
BACKGROUND.

St. Helena,
1976.

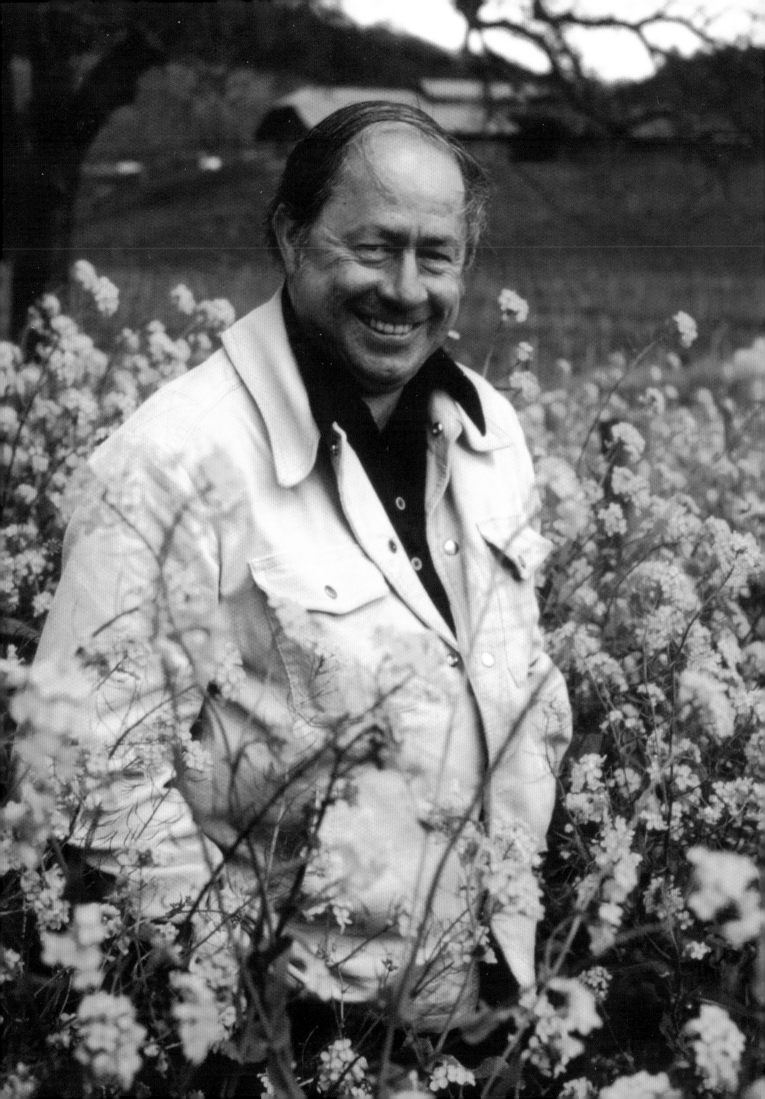

THE JOYS OF THE TABLE

Joe rarely did anything half-way. If something excited his interest or his passion, he was all-in. Take tennis, for example.

When Bob Ruyle and others back at the office in Greeley began playing some tennis in the afternoon, to take a little break from their punishing pace, no one expected hard-driving Joe to come join them. So when he was spotted in the local sports shop buying a racket, the news spread like wildfire through Hensel Phelps. And then Joe really surprised them: he took up tennis with a vengeance and became a very respectable player. And Joe even went a step further: he took over a little-used lot on the HP property and built an indoor tennis court there and two racquet ball courts as well, for everyone to use. That was Joe: all-in.

And then bicycling. When he was spending more and more time in the Napa Valley, building his winery, Joe decided to take up cycling as a way to get some exercise and kick-back time. But did he cycle around the hills of his property, or up the steep Howell Mountain Road that ran behind his property? Oh, no. That would be too easy. For Joe, a proper outing was to pedal from St. Helena west, across rugged terrain, then all the way across Sonoma County to Bodega Bay and the edge of the Pacific Ocean. About 50 miles. Pure Joe!

And then food. Few of his other passions rivalled Joe's passion for fine food, especially French food. When I joined him in his kitchen for our working sessions, Joe was often crowing about the cassoulet or the coq au vin he had enjoyed the night before at Bistro Jeanty, the classic French restaurant located close by in Yountville. One day he was especially excited because Evelyne Deis, his former assistant, and her husband Ken were coming

over to prepare a proper French meal for him right in his kitchen. To be enjoyed, of course, with a selection of vintage wines drawn from his cellar.

Joe's passion for good food began very early in life. As you might remember, he loved the fried chicken they served on Sundays back at the family's church in Maysville, and he loved the special cookies that Nita baked at Christmas time. And fine, interesting food was a feature of their family life when Joe and Barbara were raising their four kids at their home in Greeley, as their daughter Lynn recalls:

"One of my first memories of Dad in the kitchen was on weekend mornings making what he called 'The Master,' scrambled eggs or an omelette with green peppers, onions, Velveeta cheese, and Spam... We were the only people I knew from Greeley who went to Trader Vic's in Denver on a regular basis."

Like many Americans in the late 1960s and 1970s, Joe's family soon evolved from Velveeta and Spam. "When Dad started to travel, both he and Mom began to look for sources for fresher meats, fish, and vegetables," Lynn recalled. "Dad used to bring Dungeness crab from San Francisco, and we started a new tradition of crab for Christmas eve. Mom started packing a cooler with ice and picking up fresh fish on her trips to Denver and bringing it back to Greeley."

Soon Joe was applying his mastery of process to the art of making pasta and basil pesto. "It was almost an epochal event, the pasta making," Lynn said. "Timing was crucial, almost to the second. The pesto had to be finished exactly as the pasta was finished. The bowls had to be warmed, and we had to eat immediately!" Joe was also fanatical about the tools of expert cooking. "He started making frequent visits to Williams-Sonoma, and soon we owned just about every kitchen gadget to be had there," Lynn recalled, and that was just the beginning.

"Then they started going to Europe and it was all over. All of our meals changed," Lynn said. "Mom started taking cooking classes and became a very accomplished cook. Dad was on his own a lot in The Schoolhouse and I know he cooked a lot too. Their styles were very different. Mom was precise and deliberate. Dad did a lot of improv. And he had an uncanny knack for knowing what flavors would enhance what we were eating."

JOE LOVED TO COOK, HE LOVED TO SHARE, AND HE LOVED TO ENCOURAGE HIS KIDS TO EMBRACE COOKING AND THE JOYS OF THE TABLE.

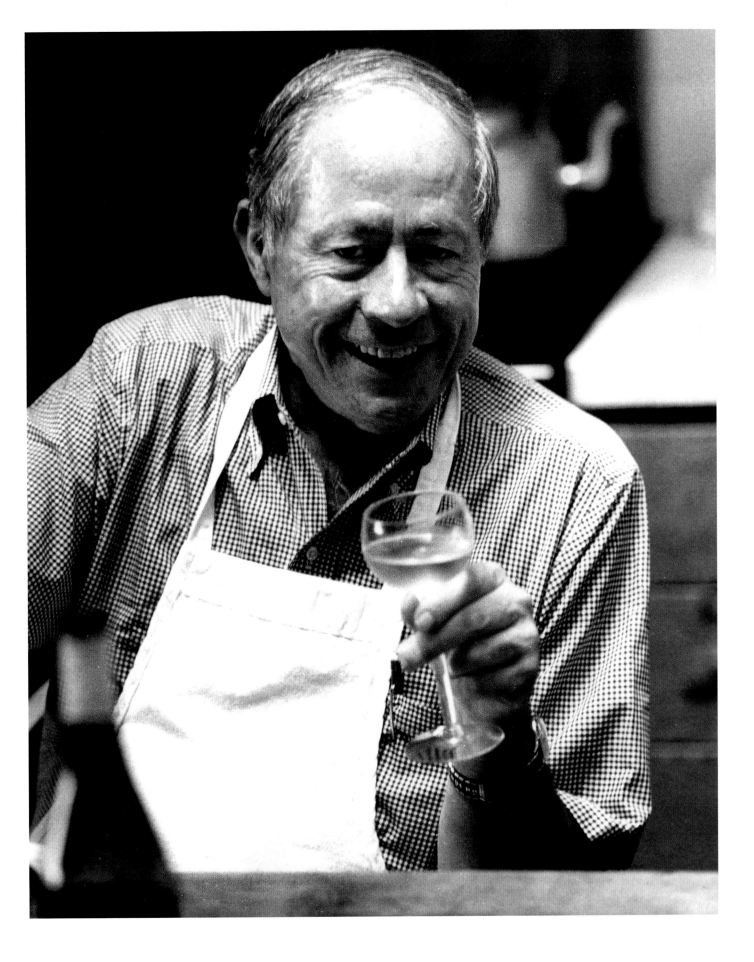

Mentoring, too, was part of Joe's passion for food, starting with his kids. "He would sit on a stool sharpening knives and giving us instructions on how to build the salad dressing or sauce," Lynn recalled. "He always lectured us on the condition and proper use of knives." Joe was passing along skills, of course, but also his own passion for gourmet food. Later, his daughter Laurie worked at a French restaurant in Greeley, and Laurie and Lynn worked at the cheese counters in gourmet markets. According to Lynn and Laurie, Joe also passed along to them his taste for many French delicacies that were not common to the American table: sweetbreads, patés, exotic gourmet cheeses, and special glazes for meat.

The joys of the table, of course, were among the primary reasons that later in his life Joe built a house in the south of France. For years, he happily made long trips to France, enjoying the food and wine and recharging his batteries. Later in life, when his health deteriorated, he would go to France for a few months at a time, and he often took several members of his family with him, plus a team of caregivers too. For those trips, Joe preferred to travel by private jet, and he often organized his flight plan with culinary adventures in mind, for the pleasure of everyone coming along. According to Cheli Morrison, who helped organize Joe's trips from her post at the airport in Napa, en route to France Joe often had the pilot make a stop in Wisconsin, so he could stop and pick up some authentic bratwurst, to be enjoyed with a cold beer. On his return trips home, Joe liked to travel via Maine or New Hampshire, so he could have some fresh lobster brought aboard for the remainder of the flight to Napa, to be enjoyed with a crisp white wine, of course. Like Ernest Hemingway, Joe believed that life should be "A Moveable Feast."

And the business upshot here was downright inevitable.

By 1975, when his winery was up and running, and when Joe and Walter were already crafting award-winning wines, America itself was enjoying a parallel surge in the quality of its cuisine and its ingredients, thanks in large measure to one woman of exceptional talents and spirit, Julia Child. Right here I want to take a moment to bring Julia into Joe's story, for she would have a profound impact on what Joe and others would soon bring forth in the Napa Valley.

Julia was born Julia McWilliams, the daughter of a prominent family in Pasadena, California. For high school, she went to the Katharine Branson School north of San Francisco—the same

school that Joe's oldest daughter Leslie attended many years later. After graduating from Smith College in 1934, Julia moved to New York City to work in an ad agency. But with the attack on Pearl Harbor and America's entry into World War II, Julia went to work for the Office of Strategic Services, the OSS, the forerunner to today's CIA.

Julia started out as a typist, but savvy and resourceful as she was, she was soon working as a top-secret researcher for William "Wild Bill" Donovan, the legendary head of the OSS. Then in 1944 she was posted to Ceylon, now Sri Lanka, where she helped manage communications traffic among the OSS's clandestine operations centers across Asia. Yes, Julia Child, secret agent. Who knew?

From there, Julia's path in life in many ways mirrored Joe's. After the war, Julia married Paul Child, a fellow officer in the OSS, and in 1948 the couple was posted to Paris. While Paul carried out his duties for the U.S. Foreign Service, Julia attended Le Cordon Bleu, the fabled French cooking school—and her awakening to the joys of the table began right then and there. Soon she mastered the techniques and the artistry of French cuisine, and she came to see how central fine food and wine are to French life and also to French history, culture, and tradition, and even to France's larger sense of its standing in the world. *Vive La France!*

Before long, Julia forged for herself a galvanizing mission: to bring the artistry, tools, and techniques of French cooking to kitchens, restaurants, and markets all across America. At that stage, in the 1950s, many American families filled their cupboards with products like Wonder Bread, Velveeta Cheese, Chef Boyardee, and Folger's Coffee, and Julia was determined to show them a better way. She wanted to champion a whole new understanding of how good food, artfully prepared with fresh, healthy ingredients, can improve our nutrition, our health, our happiness, and our overall quality of life. In sum, Julia had come to believe, just as the French do, that "The Art of Living" begins in the kitchen and right at the family table.

To advance her cause, Julia put down on paper everything she had learned in France, and in 1961 the esteemed New York publisher Alfred Knopf brought forth her 726-page work, *Mastering The Art of French Cooking*. The book created a sensation and over time it became one of the biggest successes in American publishing history. Next came Julia's landmark TV show on PBS, "The French Chef," carried in many cities and towns across America.

With her off-beat humor, her warbly voice, and her mastery of French cooking, Julia enchanted viewers, and her show soon became one of the biggest successes in the history of American television. In 1966, *Time* magazine did a celebratory cover story on Julia—a three-star salute to her growing influence on American taste and culture.

Then came Alice Waters, with Joe soon to follow.

Alice was born and raised in New Jersey, but then she came West for college. After a stint at UC Santa Barbara, she transferred to UC Berkeley, when it was an epicenter of the cultural turmoil of the 1960s. At Berkeley, Alice became a political activist, and she also spent a year studying in France, where—you will not be surprised to learn—she awakened to the joys of French food and wine and the culture that supports them. In France, Alice lived at the foot of a market street, and she enjoyed shopping for the freshest, locally grown fruits and vegetables and making them a centerpiece of her daily diet. Almost by osmosis, she absorbed it all and—again you will not be surprised to learn—she returned home to Berkeley with a galvanizing mission: to bring her passion for fresh, locally grown produce and fresh breads, pastries, and other culinary delights to the American table. Good-bye, Wonder Bread; hello fresh baguettes and croissants coming straight from the oven. And thus was born, in 1971, Chez Panisse, her now legendary bistro in Berkeley.

Almost immediately, Chez Panisse became far more than a popular, kick-back place to enjoy fresh, inventive cuisine; it became a hive of innovation and a powerful magnet for young creators and growers throughout Northern California. Early on, for instance, a young woman named Laura Chenel came to Alice with something that she had crafted in her garage in Sonoma County: a light, flavorful goat cheese, made from the milk of a few goats she kept in her backyard.

At that stage, few people in America produced or ate goat cheese, but Alice loved the taste and texture of Laura's creations, and she began featuring them in some of her salads at Chez Panisse. Bang! Laura's business took off, and soon a whole new industry was busy being born. In a similar spirit, Alice gave early support to Bill Niman, a young rancher who was raising grass-fed, hormone-free cattle on his land in Bolinas, California, north of San Francisco. The quality of Bill's beef was superb, Alice featured it at Chez Panisse, and Bill went on to become a major

ALICE WATERS'
HISTORIC CHEZ
PANISSE

Berkeley, CA.

force in the cattle and pig industries. In the eyes of respected food writers like Michael Pollard and Joyce Goldstein, these young pioneers helped usher in a transformative era in American food, farming, and ranching, an era they have termed America's "Gourmet Revolution."

And then Alice met Joe.

The story of their meeting merits a special place in the history of Joseph Phelps Vineyards. Their meeting was arranged by Bruce Neyers, who was then working for Joe on the marketing side and forging relationships with the better restaurants up and down the state of California. As Bruce tells the story, he and his wife Barbara had become regulars at Chez Panisse and they had also become good friends with Alice. One night while he and Barbara were having dinner there, Alice told them she was in a bit of a pickle. She and Jerry Budrick, her boyfriend of the time, had planned to launch a house wine for Chez Panisse, and to that end they had lined up a load of high-quality Zinfandel grapes from Frank Dal Porto, a respected grower in Amador County, east of Sacramento. They had also lined up a Napa Valley vintner to craft the wine. At the last minute, though, the vintner pulled out. What now? And what could Alice do with that load of prized Zinfandel grapes?

What could she do? Talk with Joe, of course!

With Bruce as go-between, Joe invited Alice to have a quiet lunch with him in the Napa Valley, specifically at The Schoolhouse, at the foot of Joe's property. Alice agreed, and for the lunch she brought along her trusted assistant, a talented young chef named Jeremiah Tower. Alice intended to explore a possible arrangement with Joe, while Jeremiah would be left to hammer out the business specifics. Over lunch, Alice and Joe, both of them born innovators and creators, explored what they could do together, and by the end of the convivial lunch they shook hands on an informal alliance. And that alliance quickly produced creative gold for both of them.

Alice finalized the purchase of the grapes, Joe and Walter crafted her house wine, and then Alice asked an old pal, David Goines, a gifted artist and graphic designer based in Berkeley, to create a special label for her new private label Zinfandel. In response, David came up with a fresh, distinctive design for the label, and then Joe and Walter's creation made its debut at Chez Panisse,

with this announcement right on the label: "Produced and Bottled by Joseph Phelps Vineyards." Quite a coup for a start-up winery!

Alice was thrilled. Her customers loved the quality of the wine, and Alice felt its freshness and elegance were a perfect complement for her culinary creations. Joe was thrilled as well, especially by the exposure and stature that Alice and Chez Panisse brought to his young winery. And that inaugural 1975 Zinfandel was just the beginning. For years, Joe continued to craft house wines for Alice, and in 1981, when Alice celebrated the 10th anniversary of Chez Panisse, she did so with a big celebratory bash at Joe's winery. As legend has it, the party went deep into the night, and many of the revelers wound up sleeping right in Joe's vineyards. Likewise, for years to come, David Goines designed labels and posters directly for Joe, including a poster for the Rhône-style wines that Joe was creating and marketing under the name Le Vin du Mistral.

Alice and Joe collaborated in other ways too. When Joe put on harvest parties or special winemaker dinners, it was often Alice's sous-chefs who prepared the cuisine. And when Joe decided to install a proper kitchen in his winery, for special events and promotional wine and food pairings, it was Jeremiah Tower who helped design the kitchen. There is another key point here: at that stage, very few wineries in the Napa Valley saw the value and virtue of forging relationships with top-quality restaurants, and in this regard Joe was helping blaze an important trail. Indeed, for his alliance with Alice, Joe earned a very respectful salute from Joyce Goldstein in her authoritative book, *Inside The California Food Revolution, Thirty Years That Changed Our Culinary Consciousness.*

All that said, in the world of food, Joe was just getting started.

In 1978, just as his inaugural vintage of Insignia was moving out into the world, Joe spotted another golden opportunity: the Oakville Grocery. The grocery was a true Napa Valley institution, with roots tracing all the way back to 1881, and for decades it had been a convenient, pocket-sized local market, offering specialty items you couldn't find in the supermarkets further south in the town of Napa or further north in St. Helena. Also, the Oakville Grocery had a tiny U.S. Post Office on site, making it a helpful stop for people living in or near the hamlet of Oakville. By the mid-1970s, though, as more and more tourists began coming to the Napa Valley, and as more and more Americans were awak-

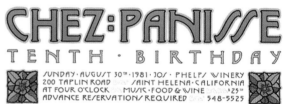

CHEZ PANISSE'S
10TH BIRTHDAY
POSTER

CHEZ PANISSE
HOUSE WINE
LABEL

Designed by David Goines.

CHEZ:PANISSE
HOUSE WINE
1 9 7 5
AMADOR COUNTY
ZINFANDEL
CALIFORNIA
FRANK DAL PORTO
VINEYARDS

PRODUCED & BOTTLED BY
JOSEPH PHELPS
VINEYARDS
ALCOHOL 12 PERCENT BY VOLUME

ening to the joys of fine wine and farm-fresh gourmet food, the Oakville Grocery was in desperate need of fresh vision and fresh energy. And who stepped in to help?

Joe, of course.

By then, Joe had become totally passionate about his work in the kitchen, and the joke among some of his pals was that he and a few partners bought the Oakville Grocery for only one reason: to give Joe a convenient place to buy the fresh fruits and vegetables he needed for cooking, plus abundant supplies of the fresh breads and croissants he adored. But the truth was a bit more complicated. According to Joe's son Bill, two culinary entrepreneurs—Tom May and John Michels Jr.—had begun revitalizing the place, but Joe then added a further jolt of investment capital and creative energy. For Joe, it was another shrewd business move, and, as usual too, his instincts and timing proved to be downright prescient. Why?

Because by 1978, big things were happening in the Napa Valley with regard to food and also tourism. Two years before, Robert Mondavi and Margrit Biever, his indispensable creative partner and soon to be his wife, launched a high-profile cooking initiative called "The Great Chefs of France." This was a series of cooking classes and tastings designed to teach young American chefs and sommeliers the essentials of French cooking and the art of wine pairing. And for their guest list of French chefs, Robert and Margrit recruited The Best of The Best: Simone Beck, Paul Bocuse, Michel Guérard, Gaston Lenôtre, and Jean Troisgros, among others. The series was a major success, exciting food and wine professionals across the country and earning wide attention in the national press. Indeed, the series was so successful that the Mondavis then launched a "Great Chefs of America" series, and who were the lead chefs? Julia Child, of course, and also Alice Waters, Jeremiah Tower, Wolfgang Puck and many others—and their star power helped fuel the Napa Valley's reputation as a rising force in the world of gourmet food.

Against that backdrop, Joe moved shrewdly to make the Oakville Grocery a vital part of the emerging gourmet scene. Specifically, he sought to turn the grocery into a fun, innovative gourmet shopping experience, one that would appeal to local shoppers—his customer base—and also to the many visitors who were now streaming into the Napa Valley. To achieve those aims, Joe and his managerial team, including Steve Carlin, a smart young new-

comer to wine and food, moved quickly to upgrade their staff, their products, and even the spirit of the place. Be innovative, build a winning team, build a roaring business—again Joe proved that he knew just how to do all of it. And at the Oakville Grocery, they were able to do it all quickly.

One person who saw it all first-hand was Mary Ellen Bruno. She and her husband Robert had run a small wine, cheese, and gourmet market near Milwaukee, but in 1980 they were irresistibly drawn to the Napa Valley. "For anyone interested in wine, as I was, the Napa Valley was the place to be," Robert told me. "It was the center for everything that was happening in American wine." Once in the valley, Robert opened a small, highly respected wine shop in the town of St. Helena. And Mary Ellen soon found her place as well:

"The minute I walked into the Oakville Grocery, I said, 'I have to work here!'" she told me. "Joe and his team were brilliant business people, and they created a wonderful experience for everyone—the shoppers and the staff. It became a dream place to work. And it was so exciting: the grocery became the epicenter of everything that was happening with wine and food in the Napa Valley."

In terms of philosophy and products, Joe was very much in line with what Alice Waters was promoting at Chez Panisse: eat fresh, eat healthy, and, as much as possible, eat local. To that end, the grocery shelves featured locally crafted breads, cookies, pastries, and chocolates, locally grown fruits and vegetables, and an array of locally crafted mustards, olive oils, chutneys, and patés, plus, of course, a wide and varied selection of Napa Valley wines.

The formula worked. For the morning crowds, the staff served gourmet coffees, fresh croissants, and special breakfast plates. For the lunch crowd, they prepared gourmet sandwiches, soups, and salads, and all day long they offered homemade takeout specialties like meatloaf, roasted chickens, unusual pastas, and the like. Often times, too, the staff would prepare box lunches for whole busloads of people coming in from New York and other parts of the country. In sum, business was good—and about to get much better.

Back in 1969, the Robert Mondavi Winery launched its summer concert series, and that brought many of the greats of American jazz and contemporary music to the Napa Valley: Ella Fitzgerald, Tony Bennett, Sarah Vaughn, Harry Belafonte, Dave Brubeck, Lou

Rawls, Oscar Peterson, Dizzy Gillespie, Charlie Byrd, and many, many more. The concerts attracted crowds from across the Bay Area and far beyond, and many visitors chose to spend the entire weekend in the valley. This proved to be a business bonanza for Joe and the Oakville Grocery, located as it was just south of the Mondavi Winery. By 1980, just two years after Joe took over the place, his staff could barely keep up with the weekend crowds.

Soon, too, stars from Hollywood and the world of sports moved into the Napa Valley. In December of 1981, CBS TV launched Falcon Crest, a soap opera set in the valley and chronicling the trials and tribulations of a prominent wine family. Joe's teams at the Oakville Grocery often provided basket lunches for the entire cast and crew. Likewise, Robin Williams, who had a second home in the valley, became a regular at the Oakville Grocery, coming in for his special "Neptune Drink," a healthy medley of fresh fruit juices.

Francis Ford Coppola and his wife Eleanor were now in the valley as well: in 1975, three years after he brought forth "The Godfather," Coppola bought Inglenook, the historic winery built by Gustave Niebaum back in 1879. Soon Robert Redford took up residence in the valley, as did champion race car driver Mario Andretti, while San Francisco 49er legend Joe Montana became a frequent visitor as well. These stars of American pop culture and sports kept very much to themselves, but they brought glitter and prestige to the Napa Valley—and more and more customers to the Oakville Grocery. Indeed, the Napa Valley was now becoming high chic, and that had a profound impact on the wider image of American wine. For many Americans, especially young people, the era of cheap jug wines was now a fading memory, and the era of Ripple and Night Train was being totally erased from our national consciousness.

How far had we come? A quick stop at the Oakville Grocery would immediately show you the answer:

"By the early 1980s, the Oakville Grocery had turned into a 'must-stop' for the many young, well-heeled professionals who were now driving up from San Francisco for a weekend of relaxation, wine tasting, and gourmet dining," Robert Mondavi wrote in his memoir, Harvests of Joy. "On Saturday and Sunday mornings in the summer, you couldn't get near the Oakville Grocery. Scores of visitors, young and not so young, would be packed into the place, ordering cappuccinos and croissants... Many of them would put

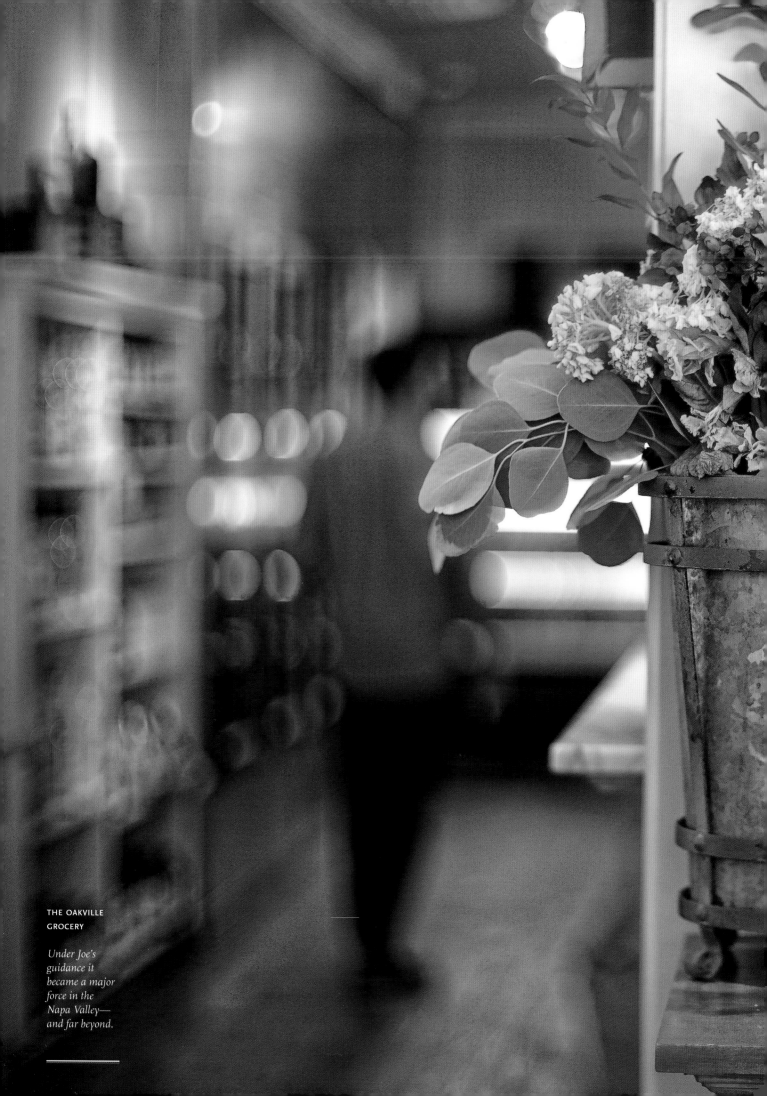

THE OAKVILLE
GROCERY

*Under Joe's
guidance it
became a major
force in the
Napa Valley—
and far beyond.*

together gourmet picnics for later in the day. Then they would pick a winery for a tour and a tasting. Some local wineries even set out picnic tables to attract the revelers to their tasting rooms."

At his kitchen table, Joe and I talked at length about what he had achieved with the Oakville Grocery. It was a perfect fit for his own evolving passion for gourmet food and fresh ingredients, but what Joe said was his greatest source of satisfaction was being a part of something much larger, namely the rise of the Napa Valley as a renowned center of fine wine and gourmet food. At the same time, America itself was maturing in its appreciation for fine wine and food—just as he and Barbara had dreamed when they had tasted their way across Italy and France.

"By the early 1980s," Joe told me, "we were enjoying truffled paté, escargot, steak tartare, and beautiful cheeses at different bistros and restaurants here in the valley. It was just like being in France. And we were working closely with innovative chefs like Alice Waters and Cindy Pawlcyn at Mustard's. What was happening was very exciting, and we were a part of all of it."

With the high-profile success of their store in Oakville, Joe and Steve Carlin, who had worked hard and become president of the Oakville venture, then opened Oakville Groceries in Healdsburg, Walnut Creek, Palo Alto, and Los Gatos—all of them up and coming communities around the Bay Area. With the exception of the shop in Los Gatos, all the stores flourished, and they became both a delightful shopping experience and a driving force in the culinary evolution of Northern California. And here is an essential lesson for every aspiring entrepreneur:

None of this happened as originally planned.

As Joe tells the story, his original idea was to create small food markets in different locales across the United States, starting with the Scottsdale area. Joe and his wife Barbara had bought a home in a desert area north of Scottsdale, but as he soon discovered, the area was also a desert in terms of fresh food and basic kitchen necessities. Even in nearby Phoenix, he couldn't find fresh seafood, or fresh mushrooms, or even spices like saffron or fresh basil. What to do? Seize the opportunity!

To help develop his idea, Joe sought out John Michels Jr., a partner at the Oakville Grocery, and their original thought was to create a chain of small markets called Le Fleuron—at the time, Joe had

a line of wines by that name, and the potential synergies seemed like a natural. But the concept never gelled, and after three meetings, John proposed an alternative: he was a part owner of the Oakville Grocery. What if Joe bought out his interest and then together they could open an Oakville Grocery in San Francisco? How about that? And that is exactly what they did. But the location proved difficult, especially for parking, and the venture was short-lived. Still, they learned valuable lessons along the way, lessons that helped them tailor the Oakville model to serve the different needs of each location. At their Walnut Creek store, for instance, they put in a pizza oven and made it more of a sit-down place. And it thrived. The lesson? Learn as you go. Be smart, be nimble, be creative.

Still, with the Oakville Grocery, the core elements of Joe's blueprint for success remained immutable. Just as he had done with Hensel Phelps Construction and then at Joseph Phelps Vineyards, he and his team went out of their way to make working at the Oakville Grocery an exciting and rewarding experience, the better to build team loyalty—and build customer loyalty at the same time. And as Mary Ellen Bruno told me, the result was supremely effective. She worked at the Oakville Grocery for six happy years, as manager of their cheese and charcuterie departments. Eventually she left to pursue her life's dream of becoming a nurse, but even today a piece of her heart remains with the Oakville Grocery: "Those were good days," she told me. "Even now when I drive by, I tear up."

How many companies build that kind of bond?

Still, I couldn't help but wonder: what was the lasting impact of the trend-setting Oakville Grocery on the greater Bay Area and even on the creation of other gourmet markets across the country?

In search of answers, I went to see Steve Carlin, who had been so essential to the rise of the Oakville Grocery. I figured Steve would have important stories and insights to share about Joe and the success they built. I also knew that Steve had gone on to great things after moving on: he became the founder and guiding CEO of the Oxbow Public Market, in the town of Napa. In many ways, the Oxbow Market is the spiritual and commercial stepchild of the Oakville Grocery, and by almost any measure it is today the hottest gourmet shopping experience in the whole of the Napa Valley.

Steve and I met at the Oxbow Market early on a Tuesday morning, and the place was hopping. Gourmet coffees, luscious gourmet tacos, farm-fresh produce, locally crafted olive oils, a spice shop, a cheese shop, fresh sushi, an oyster bar, a juice bar, even a quality bookstore—all under the same roof. The Oxbow Market has it all. And as Steve made clear to me, his guiding vision for Oxbow came straight from his experience with the Oakville Grocery:

"When I look back at what Joe and I were doing," Steve explained, "the Oakville Grocery was less about the food and more about the experience. As we learned, the concept of organized clutter is really important to retail. There and here, we are putting the consumer in an environment where they really feel happy and energized. People come here to the Oxbow Market to experience food, yes, but they also come because they feel good here."

Yes, that's the secret: make your customers feel good. And make clear that what you're offering is far more than just gourmet tacos, cheese, or sushi. You are offering people "The Joys of The Table."

Steve's experience at the Oakville Grocery tells us a lot about Joe and why he was so successful in business. As Steve told me, he was born in Manhattan, and his awakening to the joys of the table did not come in Italy or France; it came aboard a cruise ship that had a gourmet program as part of the entertainment. "James Beard was the guest host," Steve said. "And when we got back, I decided to go into the wine business." From there, Steve came to the Napa Valley and applied for a job at three different wineries —and got turned down by all three. Then he met Bruce Neyers, who sent him on to the Oakville Grocery. "They offered me a job on the spot," Steve said. "At $5 an hour, plus commission. I was 25 years old."

Raw though Steve was, Joe saw something in the young man, and he took him under his wing at the Oakville Grocery. This was pure Joe: don't hire based on a paper resume or any typical credentials; hire someone based on their character and on the potential you see inside. With Steve, that approach paid off handsomely. But it took tough-minded, supportive mentoring to turn Steve into a mature, self-confident leader and entrepreneur. "Joe was very gracious with me," Steve said, "a true father figure and mentor."

With Joe's support, Steve took command of the Oakville operation and later he worked for Joe at the winery too. By the year 2000, though, the expansion of the Oakville Grocery chain had

run out of steam, and the operation was losing money. So with considerable heartache on both sides, Steve and Joe decided to sell the business and go their separate ways. But the feel-good experiential model they had created for the Oakville Grocery kept right on spreading, as you can see now in the growing popularity of gourmet markets and farmers' markets. Indeed, just as Joe had hoped years before, many of the features of gourmet life in France have now taken happy root in cities, towns, and communities all across America.

As I left Steve and the Oxbow Market that Tuesday morning, I was thinking about Joe and his fellow pioneers in the Napa Valley, and I was shaking my head in wonder. As Steve's own example had made clear, what Joe and Julia Child and Alice Waters and Robert and Margrit Mondavi were all promoting was something far more than wine or food; they were promoting a joyous, uplifting, creative approach to life and business, and they were showing all of us, big and bold, what people of vision and conviction can achieve when they come together in common cause and common purpose. And their purpose, their galvanizing mission, was now brilliantly clear:

They wanted to make the Napa Valley the very best it could be, an inspiring model for other communities to follow, and they wanted to have an absolute ball in the process. A noble mission indeed!

All this said, as my conversations with Joe deepened, I came to see a layer of darkness beneath his multiple successes. With his "all-in" approach to business and life, Joe had worked so hard, and at such a punishing pace, and he had achieved so much in every domain he chose to enter. But at what price?

In 1975, while he was immersed in building his winery, he was also immersed in running Hensel Phelps Construction. The company his dad had started from scratch. The company Joe himself had worked so hard—days, nights, and weekends and holidays too—to build into an industry leader. But where was his heart? Where was his future? In Napa? Or in Greeley? As Joe told me, at that point he felt miserably conflicted. His work and his life had been slashed in two. In the end, he decided to step back from Hensel Phelps and place the presidency and daily management of the company in Bob Tointon's capable hands, while Joe stayed on as chairman of the board. As Joe said, that was a good decision. A workable solution.

OXBOW PUBLIC
MARKET

Napa, CA.

But another of Joe's conflicts was not so easy to resolve. As he sunk roots in the Napa Valley, and pulled away from his life in Greeley, Joe was doing far more than fulfilling his business and artistic aspirations; he was totally transforming his life. And the happier he became with his new life in the Napa Valley, the more unhappy his marriage became. With Joe shuttling back and forth to Colorado, Barbara became more and more determined to stay put in Greeley. Her life was there, her roots were there, and those of her children as well, and she did not want to overturn any of that. As all of her kids explained it to me, "Mom was never comfortable with change." Whereas Joe, of course, constantly craved change and fresh creative juice. And so it was that after three-plus decades of marriage, and after raising four wonderful children together, Joe and Barbara decided to part and go their separate ways.

Joe went on to marry three more times, and twice to the same woman. But as Joe told me one day at his kitchen table, none of those marriages brought him true and lasting happiness. As Joe put it, in his usual wry way, "My love life has been a little rugged."

Rugged indeed. And so it was that at the age of 87, despite all the love and support he was receiving from his children and their children, and from his friends and caregivers too, Joe was without an intimate partner; in the deepest sense he was totally alone. In shedding his old life, Joe may have given birth to "The Artist Inside," but he had lost something extremely precious in return. A poignant irony for all of us to pause and consider.

◆

JOE AND HIS FAMILY, IN 1978.

Top row: Joe, Barbara, Bill and Leslie. In front: Laurie and Lynn.

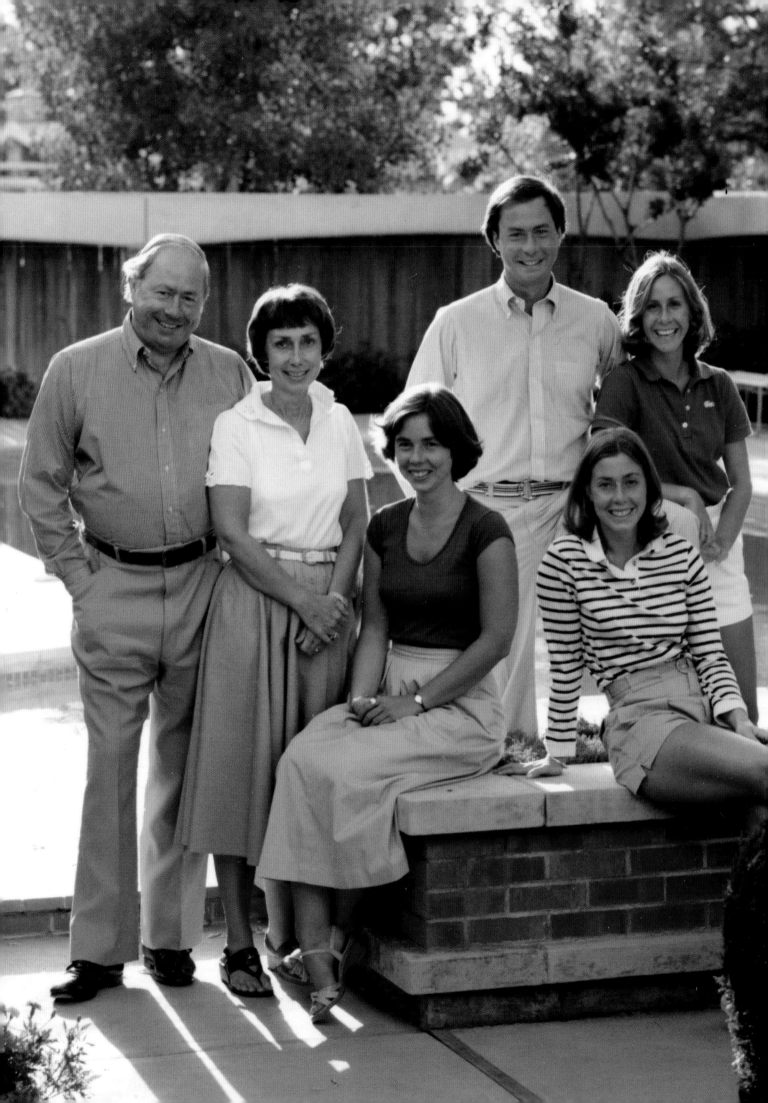

GRAPES OF GOLD

GRAPES OF GOLD

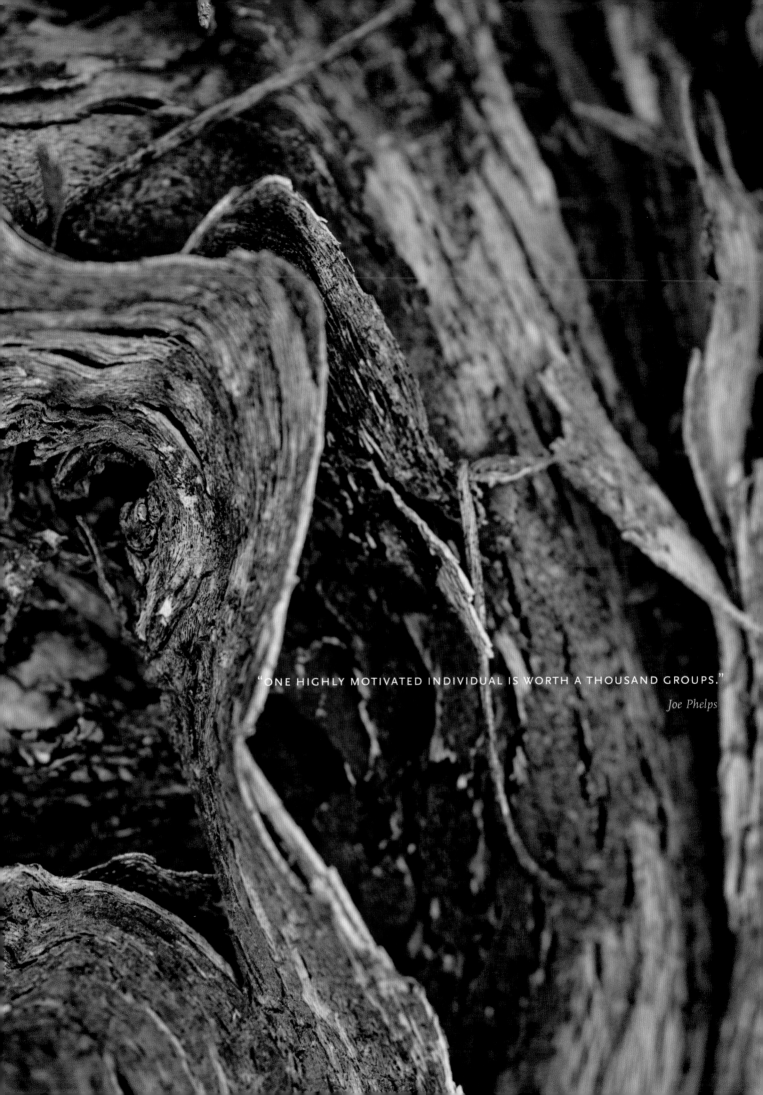

"ONE HIGHLY MOTIVATED INDIVIDUAL IS WORTH A THOUSAND GROUPS."

Joe Phelps

BUILDING COMMUNITY

Beyond crafting fine wines, beyond developing gourmet markets, there was a whole other dimension to Joe's life and work in the Napa Valley, and to help you see it in perspective, I want to bring into Joe's story another true American pioneer, John Muir.

John Muir was born in Scotland in 1838, and even as a boy he loved Nature and being out in the wilderness. When he was 11, his family came to America and started a farm in the tiny rural community of Portage, Wisconsin, located north of Madison. The Muir family was staunchly religious, followers of the Church of Scotland, but as a boy John found his spiritual inspiration not in church but in being outdoors, amidst the beauty and wildlife he found along the rivers and marshlands surrounding Portage. From those happy boyhood roots, John Muir went on to become America's preeminent advocate for respecting Nature and protecting our natural environment.

In 1892, John Muir and a group of fellow hikers and outdoorsmen started The Sierra Club, and Muir served as its president for the remaining 22 years of his life. The club began as a social club, but it quickly became America's most influential voice for protecting our forests, parklands, and other environmental treasures. And John Muir's ongoing message came down to this:

"Respect and Protect."

Respect Nature. Protect her riches. And nowhere is that message more deeply ingrained than it is in the fields and vineyards of the Napa Valley—and in the wisdom and legacy of one Joe Phelps.

To help you understand, let me start back in 1944, some three decades before Joe came to the Napa Valley. That year, a group of

winemakers joined hands and created the Napa Valley Vintners Association. Like the Sierra Club, this began as a social club but it soon evolved into a wine industry marketing and advocacy group, often working hand in hand with local and state political leaders to forge ways to respect and protect the valley's natural beauty and agricultural wealth. And they succeeded, often against ferocious opposition.

In 1967, for instance, a group of vintners in the valley became deeply concerned about what they had seen happen to Santa Clara County, south of San Francisco. Santa Clara had long been one of California's most prosperous agricultural areas—until unbridled commercial and real estate development turned it, in their view, into an unappealing mix of parking lots, office buildings, shopping malls, and housing complexes. In the vintners' minds, what happened to Santa Clara represented an epic struggle: the vintners and farmers vs. the developers. The protectors of the land and its natural riches vs. big business and quick-buck opportunists.

Could the Napa Valley suffer the same fate? Prominent vintners like Jack Davies of Schramsberg Vineyards feared just that, and they charged into battle. In 1968, with the backing of several influential vintners, the Napa County Board passed an historic ordinance establishing America's first "Agricultural Preserve." The ordinance was built on one core principle: that agriculture was "the highest and best use" of Napa Valley land. To serve that principle, the ordinance mandated that within the carefully defined Ag Preserve—which excluded valley towns and the city of Napa—the only commercial activity allowed would be agricultural. Also, to protect farmlands from being cut into pieces, the ordinance mandated that no parcels of land smaller than 20 acres would be granted zoning approval. That ceiling was later raised to 40 acres and eventually to 160 acres.

The pro-growth, pro-commerce forces in the valley were virulently opposed to the creation of the Ag Preserve, but to no avail. In the end, the measure effectively prevented the Napa Valley from being overrun with commercial development, with all the dangers that could pose for the valley's natural beauty and its agricultural riches. John Muir would surely approve.

And that brings us now directly to Joe.

In 1973, when Joe and architect John Marsh Davis began planning the design and function of Joseph Phelps Vineyards, they zoomed in on a critical issue: the storage and shipping of the finished wines.

In Joe's eyes, those core winery functions posed a series of thorny questions related to cost and also to aesthetics and environmental protection. To wit: why use precious vineyard acreage for a large, perhaps unattractive storage facility? And what about air quality? Clean air is essential to the health and vitality of the grapes—and to the enjoyment of tasting fine wine—so who wants heavy trucks driving in and out, constantly spewing diesel fumes in their wake? And then cost: what would be the cost of training and maintaining a staff capable of managing the complicated array of state and federal regulations governing the interstate shipping of wine?

Given all these costs and potential headaches, wasn't there a better way to handle storage and shipping, a way that would be good for Joe, good for other vintners, and good for the community as well?

Indeed there was a better way, and Joe saw it, defined it, and set it in motion. I speak here of a pioneering Napa Valley institution that few outsiders know anything about: The Wine Service Cooperative.

This was one of Joe's proudest accomplishments, and the Co-op, as it is popularly known, merits a prominent place in the history of Joseph Phelps Vineyards—and in the history of the Napa Valley. The basics of the venture are these: back in 1972, a group of five valley vintners joined hands to facilitate the shipping of their wines up and down the state of California. The effort was led by two of the valley's most influential winemakers and thinkers: Chuck Carpy, founder of Freemark Abbey Winery and later Rutherford Hill Winery, and Jack Davies, a Harvard Business School grad who, with his wife Jamie, had taken over Schramsberg Vineyards and built it into one of America's premier producers of sparkling wines.

Their concept was simple: shipping wines was a very expensive proposition. So instead of each winery doing its own shipping, the five vintners agreed to drop off their cases at a central location in St. Helena, and then consolidate their cases into a single truck load or container for shipping, thus saving time and money for all of them—and saving wear and tear on valley roads as well. It was a smart, far-sighted concept, and the five put it in motion, using Chuck Carpy's Freemark Winery as their central shipping hub.

For the next three years, their shipping collective puttered along nicely. But when Joe arrived, and began building his own winery, he felt their concept had far greater potential. So he sat down and wrote a six-page memo outlining a much bigger concept, with far greater advantages for everyone. Specifically, he proposed building a large central warehouse that members could use for storing wine, long-term if need be, as well as for shipping. With that warehouse, he and other valley vintners would not have to build and maintain their own large storage facilities. And Joe envisioned the facility serving not just five or six wineries, but many others across the valley. Shared storage. Shared shipping. Shared costs. And shared dividends for the whole community too, namely with regard to Napa Valley roads and landscapes. In sum, everybody would win.

It took some time, but eventually Joe's concept won wide approval. At a meeting in February of 1976, Chuck Carpy, Jack Davies, and the other original Co-op members agreed to establish The Wine Service Cooperative. In line with Joe's concept, they constructed a 40,000 square-foot warehouse to handle their members' needs with regard to storage and shipping, plus inventorying and accounting, and other related services too. The location? On Dowdell Lane, on the southern edge of St. Helena, a spot that provided quick access to Highway 29, the main road for commercial traffic up and down the valley. Joe arranged funding for the project and lent his expertise to the construction process. And in January of 1977, the big tractor-trailers began streaming in and out of the new Wine Service Cooperative, an event viewed today as a milestone in the rise of the Napa Valley and its pioneering wine industry.

"Those trucks were carrying much more than boxes of wine," Sara Cakebread later wrote in the *Napa Valley Register*. "They were carrying the core of one of our community's most vital institutions, a place often referred to as 'the original center of the Napa Valley.'"

Joe's concept quickly proved its worth. From the original five, the Co-op membership soon swelled to 30 wineries, and then 40, and soon more would join as well. By 1978, only a year after its launch, the Co-op's storage area was already full, so they added another 70,000 square feet. And while the original plan was to serve only the wineries up-valley, the Co-op today serves wineries up and down the whole of the valley, with much larger storage and shipping centers located at the southern end of the valley, in an industrial park close to Napa Airport —and far away from most

of the vineyards. The result has been good for the vintners, and good for the valley. John Muir, I'm sure, would heartily approve.

One afternoon in his kitchen, Joe and I talked at length about his role in launching the Co-op. As I set forth its history above, it all seemed to happen rather easily: a group of vintners got together to share the duties and costs of storage and shipping. It sounds so simple. But think about it: many of those vintners were direct competitors in the marketplace. Would Budweiser help Coors ship its beer? Would Honda and General Motors set up a joint facility for handling any aspect of their operations? I am exaggerating, of course, to make the point: companies big or small do not often join hands like that. So what was different here? Part of the answer, I was sure, was the wider spirit of sharing in the Napa Valley. But that was not all of it. So I asked Joe, how do you draw people together like that, in common cause and common purpose? And what thinking along those lines was built into your concept?

Joe sat back for a moment, reflecting, and then he shared with me a core precept that he had formulated and used successfully during his many years in the construction industry:

"Whenever you bring a lot of people together in a project of major importance, everybody has to win," Joe explained. "And you always have to balance personal greed, collective prosperity, and the larger good of the community."

In my eyes, this was a crucial formulation, and it certainly helped explain the success of the Co-op venture: balancing personal greed, collective prosperity, and community good. In sum, everybody won. As Joe told me, the success of the Co-op brought him deep personal satisfaction, and one key part of it was this: Chuck Carpy, Jack and Jamie Davies, and Jack and Dolores Cakebread represented the business, social, and philanthropic elite of the Napa Valley. And as the new guy in the valley, the success of his concept for the Co-op earned him an important measure of acceptance and influence.

"It was the right thing for a newcomer to do," Joe told me. "It gave me an immediate connection to community leaders that I might never have met. And they were the leaders of what I call 'the humanitarian caste,' the men and women really intent on building the Napa Valley in the most responsible and humanitarian way."

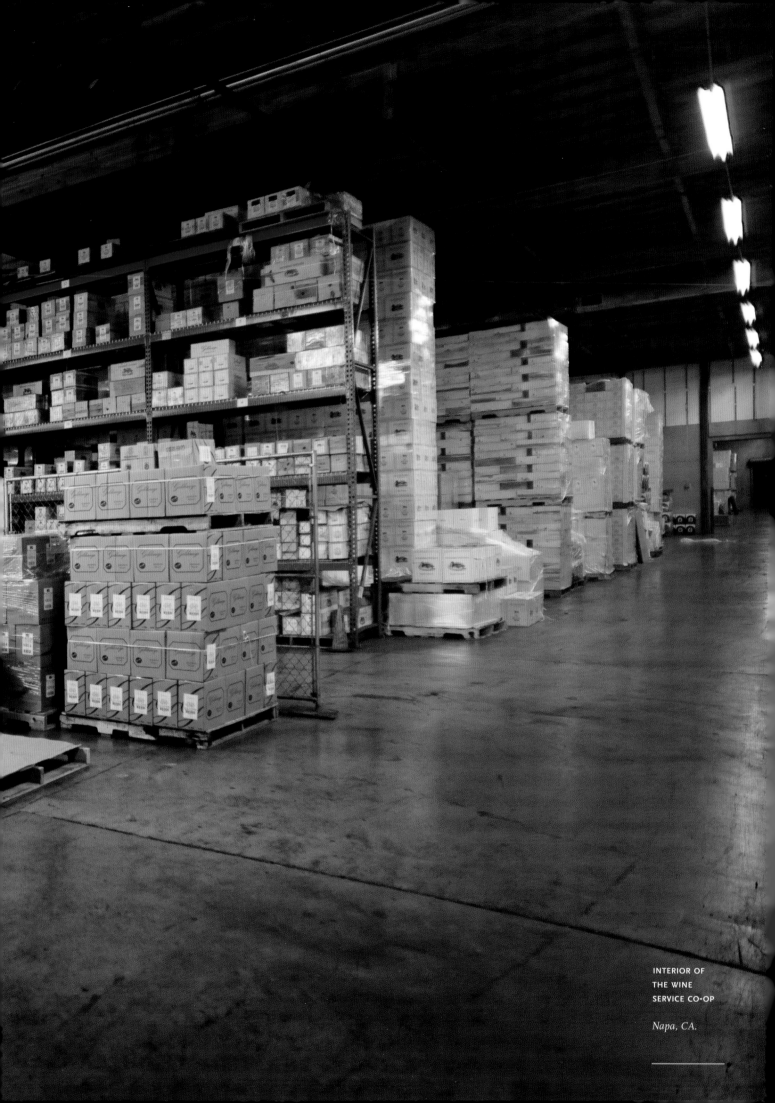

INTERIOR OF
THE WINE
SERVICE CO-OP

Napa, CA.

This was illuminating. As I now realized, what Joe wanted to do in the Napa Valley extended far beyond creating beautiful wines and trend-setting gourmet markets. He loved this valley, he loved its unique spirit of sharing and cooperation, and he wanted to use his wealth and his business skills to help the community grow and prosper. And as you know by now, Joe would do it his way: always quietly, always avoiding the limelight. Do the work, get it right, and let the results speak for themselves.

Once I had a basic understanding of the Co-op and its creation, I was ready for more. I wanted to see the Wine Service Cooperative in action and talk with the people who ran it. After all, this was a key Napa Valley institution, a part of Joe's legacy, and I was eager to see if it shed more light on Joe and his guiding wisdom.

With that in mind, a few mornings later I drove into the Co-op complex, and fixed right at the front door was a brass plaque: "In dedication to Joe Phelps, from fellow members of the Wine Service Co-op, for seeing the need and providing the answer." As I was now learning, that phrase characterized much of Joe's community work across the valley: "See the need and provide the answer."

The Co-op is a vast, cavernous warehouse, and when I arrived it was a hive of activity. Workers with forklifts were bringing cases of wine to the loading dock, ready for shipment. Another worker was checking the temperature and humidity levels at different points in the warehouse; to protect the wine during storage, those must be carefully monitored and regulated. And then I was greeted by Bob Holmes, who has been the General Manager and guiding force at the Co-op for most of its existence. Bob is a tall, modest, engaging family man, and as he walked me through the facility, he told me about how one day Joe had come along and transformed his life.

As Bob told me, he was born in Willows, California, in the north-central part of the state, and he and his family had moved to the Napa Valley in the early 1960s. Bob had four brothers and a sister, and his parents had little money to spare. "I knew early in life," Bob told me, "that if I wanted something, I'd have to work for it."

And work he did. As a boy, he picked prunes to earn pocket money, and before he was 16 he was working at the local Chevron station in St. Helena, pumping gas, training as a mechanic, and falling

in love with motorcycles. As Bob described it, life in St. Helena back in the 1960s and early '70s was good, in many ways as good as it gets.

"It was a sleepy town," Bob told me. "We worked hard, took care of cars, and for fun we'd go over to the A&W for a root beer." In the midst of all this Bob discovered exactly what he wanted to do with his life: become a truck driver. It took him a lot of hard work, and a few setbacks too, but finally he passed the necessary tests to drive a big rig. And then, just as he hoped, he landed a job right there at the Co-op, loading and driving trucks. He was all of 20 years old.

And then he met Joe.

By then, Joe had managed the building of the Co-op and he was overseeing its operations—on top of developing his wine business and keeping his hand in at Hensel Phelps. Joe had very capable help at the Co-op: John and Doris Jensen, a couple that for years had worked for Joe back in Greeley. In fact, Doris had been Joe's personal assistant, and John had been one of his most trusted project managers. Doris and John had been eager to move to California, and Joe had helped smooth their way: he brought John in to help build the Souverain winery and then build Joe's own winery too. From there, Joe put John in charge of running the Co-op's operations, while Doris ran the office. An excellent formula.

Then one day something terrible and unexpected happened: John suffered a heart attack at home and died. He was only 45 years old. John's death hit everyone hard, Joe in particular. The two men had worked shoulder to shoulder for so many years—and now he was gone. And at such a young age. For Joe, John and Doris were like family; you can imagine how he felt.

Still, John's death raised a pressing question: Who could step in now and run the Co-op? With his skills and savvy, John Jensen was not going to be easy to replace. But what about this young fella Bob Holmes? He was still raw, but Joe saw something in Bob, a spark, a determination to succeed, and Joe decided to give him a chance.

"Instantly, I became a warehouse guy," Bob told me. "I was 21 years old, and suddenly I was essentially running the show. I was a project for Joe, and, believe me, it was tough."

To help Doris, Joe's daughter Leslie came in briefly to help out in the office. And to give Bob a hand on the operations side, Joe sent over Bruce Neyers, his close aide at the winery. For Bob, though, this was his moment, his chance to prove what he could do—and he didn't want any outside interference. "I called Joe and said, 'I can do this! Get Bruce out of here!'" And Joe, impressed by the young man's mettle, did just that. And Bob has run the place ever since.

But it was by no means easy. By then, the Co-op already had 15 or 16 member wineries and it was growing rapidly. And each member had his own needs and demands. To handle the workload, Bob and his staff held to a simple formula: "We just did what was in front of us." But then came the real challenge. When the wines of Warren Winiarski and Mike Grgich stunned the world at The Paris Tasting of 1976, the Napa Valley suddenly looked like it was paved with gold, and a host of aspiring winemakers rushed in looking for their share. And many of them eagerly joined the Co-op. "Suddenly the industry was taking off," Bob said, "and we had to fight to keep up."

How did Bob and his colleagues cope? By being smart, nimble, and creative—and always responsive to the needs of their members. All that was right out of Joe's own playbook. And something else was key: the tough-minded mentoring and support that Joe gave to Bob.

"Joe put his faith in a lot of people he saw something in, and he helped them grow and succeed. I'm a prime example of that," Bob told me. "Joe was a builder, but he was also a builder of people."

For me, that was a brilliant insight. And then Bob went further:

"Joe had vision," Bob said. "He had the ability to know what was the right thing to do. And he had conviction. That said, he was tough. You didn't go into Joe's office with a half-baked idea. He'd tear it apart. But in the process he made you a better person in business and in life. Day in, day out, you had to perform."

With Joe's support and mentoring, Bob matured into a very able manager and leader, and here is one of the best parts of the story: Bob has taken what he learned from Joe and applied it to his own training and mentoring of the people he works with. For instance, what Bob looks for in a job candidate is not a fancy diploma or a polished resume. Instead, he looks for grit and determination,

CASES OF
INSIGNIA READY
TO BE SHIPPED

BOB HOLMES
AT WORK

*General
Manager, Wine
Service Co-op.*

and if he senses the right stuff, Bob will gladly take a chance on an unproven young man or woman, and then he will give that person the respect and guidance that we all need to grow and succeed. As I was now coming to see, Joe's legacy at the Co-op extended far beyond the loading docks and all those cases of very fine wine.

I left the Co-op deeply impressed. But I was just beginning to understand what a deep and lasting mark Joe had made on the Napa Valley community—and on people like Bob Holmes, Steve Carlin, the Jensens, and so many others whom Joe had guided and mentored. And then, eager for more, I went to see Evelyne Deis.

"You have to meet Evelyne," Joe had told me. "She knows more about me than I care to admit!"

Indeed she did. Now retired, Evelyne had worked for Joe for four decades, as his personal assistant at Joseph Phelps Vineyards. And Evelyne had done it all: she managed Joe's schedule, fielded his phone calls, took his dictation, typed his letters, and served as his personal gatekeeper. As many people told me, if you wanted to see Joe, you first had to get past Evelyne. Later on, she also managed Joe's personal wine cellar and helped him set up his houses in the south of France and on the island of Maui. If anyone knew Joe and understood what made him so special, I knew it was Evelyne Deis.

And what a story she had to tell.

I met with Evelyne one morning at her home in St. Helena. She is a gracious and very charming woman, perfectly bilingual, and with the polish and easy sophistication of so many French women. As her husband Ken ducked in and out, Evelyne and I sat down at her dining room table and dove right in.

Evelyne was born and raised in Levallois-Perret, a middle-class suburb northwest of Paris. At school, she focused on the practical: studying business, accounting, shorthand and typing, and learning English too. She polished her English during a stint as an au pair in London, and then she met Ken, who was then serving in the U.S. Air Force. They married, and after eight months in Toronto, the couple moved to Fresno, in central California. There at Fresno State University, Ken studied viticulture and oenology and trained to be a winemaker. Their next logical stop: the Napa Valley.

In 1975, as they were settling in, Evelyne met Joe. And Joe wasted no time: "He was looking for a secretary, and Joe hired me pretty much on the spot. I think he liked the idea that I was French."

Working for Joe, especially as her first big job in America, was by no means easy. "Joe had a vision and was a very hard worker," she explained. "He always looked calm, never rushed, but he got a lot accomplished. For me, it was a very steep learning curve."

Mastering business English was part of the challenge. "I spoke English, but I was taking a lot of dictation and I had to become an American. The dictionary became my best friend. We had no spell-check. And everything had to be typed in duplicate. And I had to learn everything about the wine business too." Evelyne also had to learn to be more resourceful and self-reliant: "One day Joe sent me to Berkeley on a errand, and I had no idea where Berkeley was!"

Like a proper Parisian, in the beginning Evelyne addressed Joe as "Mr. Phelps." But that did not fit with the family-like feeling that Joe wanted to foster inside his new company, and one day he laid down the law: "You have to call me Joe. I don't want to hear this 'Mr. Phelps' anymore!"

According to Evelyne, Joe's expectations were always extremely high. He would treat you well, and generously reward your efforts—provided you gave him your all. And she did: "Joe wanted 100 percent—I gave him more." In return, Evelyne said, Joe not only rewarded her generously, he transformed her life in the process:

"I don't think I would have had the life I've had, if it wasn't for Joe. He gave me a great opportunity. And he did that with so many of us. It was one big family, and that comes from the top."

Something else came from the top: Respect and Protect. "I was the first employee at the winery to become pregnant," Evelyne said, and while she and Ken were elated, she also had a concern: what about her job? She loved working with Joe, but what would happen after the baby was born and she wanted to take time off? At that stage, there was no formal policy at the winery regarding maternity leave or flex-time. That was true in much of America as well. Still, Joe gave her a three-month leave. "Joe was very good to me," Evelyne said. "He hired a temp, while he held the position open for me."

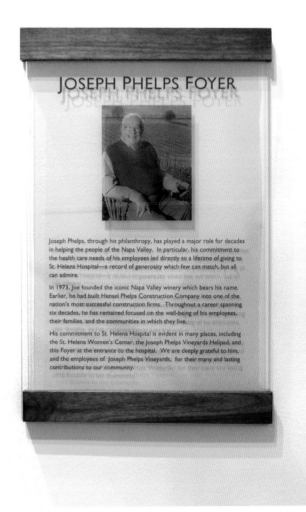

JOSEPH PHELPS FOYER

Joseph Phelps, through his philanthropy, has played a major role for decades in helping the people of the Napa Valley. In particular, his commitment to the health care needs of his employees led directly to a lifetime of giving to St. Helena Hospital—a record of generosity which few can match, but all can admire.

In 1973, Joe founded the iconic Napa Valley winery which bears his name. Earlier, he had built Hensel Phelps Construction Company into one of the nation's most successful construction firms. Throughout a career spanning six decades, he has remained focused on the well-being of his employees, their families, and the communities in which they live.

His commitment to St. Helena Hospital is evident in many places, including the St. Helena Women's Center, the Joseph Phelps Vineyards Helipad, and this Foyer at the entrance to the hospital. We are deeply grateful to him, and the employees of Joseph Phelps Vineyards, for their many and lasting contributions to our community.

And later came the real test: breast cancer.

Yes, after years of working for Joe, Evelyne was diagnosed with breast cancer. She was scared stiff. And she was facing months of doctors' visits and treatments, all of them costly. Again, Joe stepped right up: "What can we do?" he asked. "What can I do financially?"

For much of her medical care, Evelyne had to go to hospitals in San Francisco; the clinics and hospitals in the Napa Valley did not have the specialized staff and equipment that she required. With that care, Evelyne made a full recovery, but Joe was far from finished. Seeing the need, he provided the answer: he funded the creation of a specialized breast health program at The Women's Center of St. Helena Hospital. It was his hope that no woman in the valley would ever have to go outside the valley to get proper diagnosis and treatment for breast cancer or any other difficult health issues.

JOSEPH PHELPS
FOYER

*St. Helena
Women's Center.*

EVELYNE DEIS

*Joe's longtime
personal
assistant.*

Joe's gift to the hospital—and to other institutions in the valley —was substantial, but few people heard about it. As Evelyne told me, "He gave so quietly that no one knew how much he gave. He was a very generous man. If you needed help, Joe tried to do the best he could. He wanted to give back, to the people who worked for him and to the community, and he was determined to give where it would do the most good."

And Joe did plenty of good at St. Helena Hospital. The facility, a prominent part of the Seventh-day Adventist community anchored in the north of the valley, was formally launched 125 years ago under the name "Rural Health Retreat," and over time it has evolved into a highly respected, multi-faceted medical institution. And Joe has helped. As Steve Lundin, a fund-raiser for the hospital, told me, "Over time, Joe has given us more than $2.5 million. And he has given with a farmer's ethic: work from the ground up."

As Steve explained, "working from the ground up" meant this: choose your ground carefully, then plant, nurture, and harvest. At the hospital, Joe planted a lot of seeds: a program to help people stop smoking, another to help people lose weight, another to teach holistic approaches to medicine, and another to encourage women to go in for regular check-ups and cancer screenings. The result? The Women's Center at St. Helena Hospital has grown into a major success: it is now considered one of the finest in the state.

Later, Joe spotted another need: the hospital served a wide swath of territory, extending far beyond Napa County, and one of its main duties was emergency care: treating heart attacks, life-threatening injuries from traffic accidents, and the like—episodes where speed of treatment is of the essence. The hospital had a small heliport to handle such emergencies, but one day, following a heavy rainfall, a mudslide destroyed the heliport. Joe immediately stepped in and funded the construction of a new, expanded heliport, located on a platform just above the hospital's main facility and its ER unit. Again, that was Joe: see the need, provide the answer.

Elaine John was the chief fund-raiser at St. Helena Hospital for 20 years, and she worked closely with Joe in his efforts to improve the hospital's services and improve women's health care throughout the Napa Valley. And Elaine was deeply impressed by Joe's approach.

"One day Joe called our CEO and said he wanted to make an end-of-year contribution. Could we come up with a proposal?" The hospital did just that, and they also provided Joe with copious information about the history of the hospital, their objectives, and their successes in treating different forms of illness. They laid it all out, Elaine John told me, with the expectation that Joe would step up and make, at most, a small contribution, something in the realm of $10,000. At a follow-up meeting, though, Joe shocked them.

"He had read everything we gave him, including our health system's latest Annual Report," Elaine recalled. "And he had a concern: in our literature, Joe noted a lack of diversity within our institution." As he made clear, that ought to change—a message that Elaine and the other administrators immediately took to heart. Still, Joe went ahead and made a contribution: $25,000— and that would be only the first of Joe's many investments in St. Helena Hospital. And one key thrust of all the programs he supported was Education, with a capital E.

"Joe helped us set up a bank of computers where women can come in and get the latest reliable information about breast cancer diagnosis and treatment options, as well as other women's health illnesses," Elaine told me. That turned into an ongoing effort to build a library where women can learn about the latest advances in preventing, diagnosing, and treating breast cancer and other diseases unique to women. Later, with Joe's funding, the hospital set up a "Breast Health Navigator," another educational tool for women's health issues. "Joe was the person who helped launch that," Elaine said. "And now it's a tradition at St. Helena Hospital."

But Joe was just getting started. To further support women's health care throughout the Napa Valley community, he donated $250,000 to improve breast cancer diagnosis and treatment at the Queen of The Valley Hospital, located in the town of Napa. Elaine John was again deeply impressed:

"Joe was a very generous man, but he did not make superficial donations. He was very targeted with what he wanted to achieve... Joe had a need to make a difference, and he felt very fulfilled by seeing the results of what he had invested in."

As Elaine saw first-hand, Joe's commitment and generosity helped set into motion something much larger: a multiplier effect that reached all across the Napa Valley community. "Generosity breeds

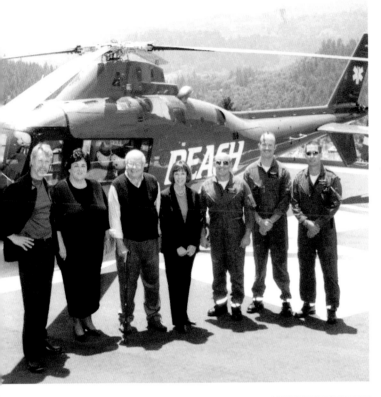

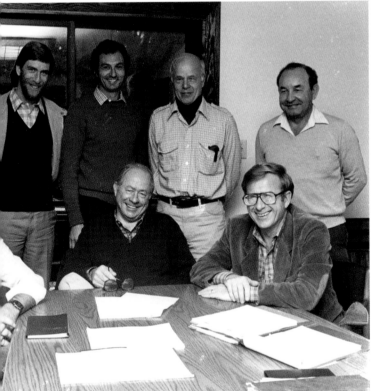

THE LAUNCH
OF ST. HELENA
HOSPITAL'S
HELIPORT

NAPA VALLEY
VINTNERS BOARD,
1982.

generosity," Elaine explained. "If a leader of Joe's stature makes a significant investment in an organization that benefits the community, you want to follow his lead and also give back. That's good for everyone. And it helps create a culture of generosity."

"A culture of generosity." Yes! That's vision. That's leadership. That's community building at its most effective. Again, everybody wins: rich, poor, and anyone who needs top-quality health care.

And that brings us back to Evelyne Deis. As you can imagine, she was deeply moved by Joe's response to her struggle with breast cancer. He had seen her need and provided answers—not just for her, but for the larger good of the community and for women's health issues in particular. That said, Evelyne was not surprised; earlier on, she had seen Joe respond to another community need: the health and safety of the valley's vineyard and cellar workers, so many of whom came from Mexico and other parts of Latin America.

As Joe well knew, these men and women were the backbone of his winery—and the backbone of the entire Napa Valley wine industry. Rain or shine, they protected and nourished the soil, pruned the vines, dealt with pernicious rodents and molds, and at harvest time they worked tirelessly—often in the dead of night —to pick the grapes while they were still cool, rush them into the winery, and then pass the baton to their colleagues hard at work in the cellar.

Yes, the wine industry's Latino workforce did all that, but did these hard-working men and women get the respect and protection they needed and deserved? In the 1970s, even as the valley's wines were rising in prestige and value, many people felt the answer was a resounding "No!" Soon, though, a group of Napa Valley vintners, community leaders, and policy makers decided they had to do a better job of including everyone in the valley's rising success, their Latino farm workers in particular.

To support that cause, in 1981 the Vintners Association organized an auction of rare wines and other items to raise money for local hospitals. The event drew enthusiastic support and raised $141,000. The effort was so successful—and for such a good cause—that the Vintners Association decided to go several steps further.

In 1984, they launched the Napa Valley Wine Auction, and soon it became an annual, must-attend event on the Napa Valley calendar. Year after year, local wineries offer lavish parties, concerts, barrels of wine, even fabulous trips and wine tours, all to raise money for the community. Since its inception, the Wine Auction has raised over $170 million for local hospitals, clinics, schools, learning programs, boys' and girls' clubs, and other laudable valley programs—many of them directly serving the Latino community. I see the Wine Auction as a shining symbol of that "culture of generosity."

During this period, Joe was a leading member of the Napa Valley Vintners Association. Indeed, in 1983 as they were planning the Wine Auction, Joe served as president of the association. And for Joe, the auction was a natural extension of the way he treated his Latino staff at the winery. In his eyes, they were like family. As a result, many of them, like Humberto Martinez, his cellar master, and German Corro, the vineyard specialist known fondly as "El Maestro," worked for Joe for more than 30 years. And Ruben Contreras, Joe's beloved personal aide, worked for Joe for more than a decade. All good. But each year there was still an issue...

HUMBERTO
MARTINEZ

*His portrait at
the winery.*

GERMAN CORRO

RUBEN
CONTRERAS

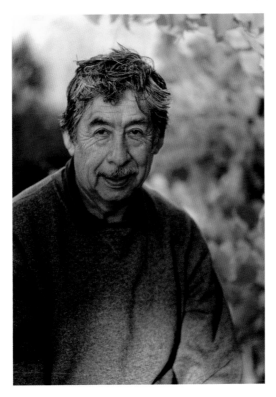

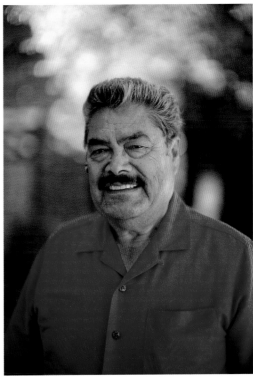

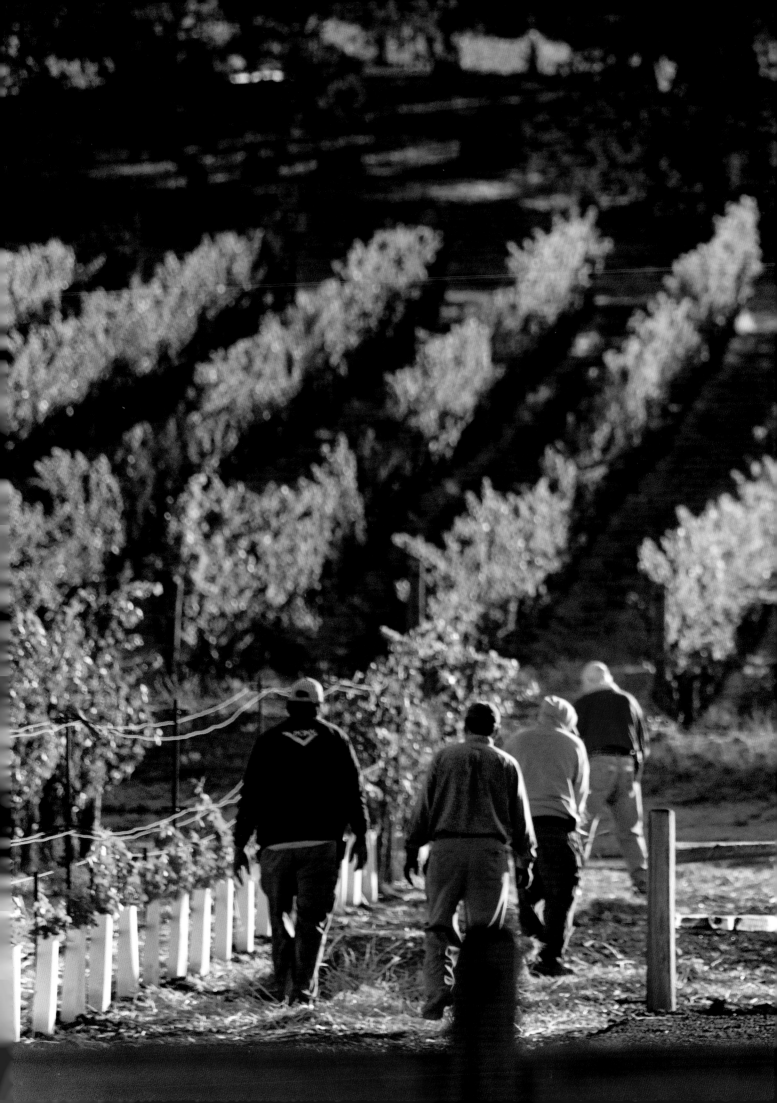

At harvest time, Joe, like most of the other vintners in the valley, needed extra help. Harvesting was a big job, and most vintners relied on crews of migrant workers to help pick the grapes and haul them to trucks waiting to rush them to the winery. The work was brutal, darn near back-breaking, and the heat was often brutal too. With nowhere else to stay when they finished in the fields, many migrant workers just camped out along the banks of the Napa River—and not in the most hospitable or sanitary of conditions.

"When Joe learned that vineyard workers were sleeping by the river or under bridges, he knew he had to step in," Evelyne Deis told me. And Joe did not simply write a nice check or raise the issue with the Napa Valley Vintners Association. No, Joe saw the need—and provided the long-term answer: in 2001, in line with a wider county initiative, he donated eight acres of his own valuable land to Napa County, to build proper housing and support facilities for the migrant workers. The result?

Today, across the Silverado Trail from Joe's property, you find the River Ranch Farmworker Housing Center, a complex with spacious grounds and offering migrant workers clean private rooms, three meals a day, and laundry and recreational facilities too. The charge for workers: about $13 a day. Today the wine industry supports two similar housing centers in other parts of the valley. The three centers provide over 50,000 stays a year and the vintners pick up the tab, initially assessing themselves an annual tax of $10 per planted acre. That was later raised to $15 per planted acre. This is another example of the valley's "culture of generosity."

Naturally, I asked Joe about his gift of land for the River Ranch project. And just as naturally, he made light of it all. "We had the land," Joe told me, "and we were able to solve a problem for the community. It was the easiest gift I ever made."

See the need, provide the answer—yes, that was Joe. And do it all with no public preening. Thanks to Bob Holmes, Evelyne Deis, and Elaine John, I had learned a lot more about Joe and what he had done to help build the Napa Valley community and serve its people. Part of Joe's work in the community flowed directly from his guiding ethos: Work hard and share; we're all in this together. But at his kitchen table, Joe shared with me a deeper truth: giving to others, serving their needs, gave him something that no money

and no business success could ever buy: a profound and lasting sense of true meaning and purpose. As Joe aptly put it:

"Share what you've got, and you will get back a thousand times whatever you put in."

"IF YOU GET, GIVE. IF YOU LEARN, TEACH."

Maya Angelou

TEACH & INSPIRE

As Joe and I worked at his kitchen table, week after week, drawing together the many chapters and guiding themes of his pioneering life, something glorious was going on just a few steps down the hill.

There, skilled construction crews were hard at work upgrading the original winery and transforming a large part of it into an exquisite new venue for tasting and appreciating the art and beauty of the finest of wines. As always with Joe, it had to be the best it could be.

In line with Joe's guiding ethos of respect and protect, his architects and work crews were maintaining the basic redwood and glass look and feel of John Marsh Davis's original design, and the winery's iconic redwood trellis was being maintained as well, albeit with new steel reinforcements under the beams and joints. Inside, the crews were building a whole new array of wood-paneled greeting halls and tasting areas, including a magnificent wine library with floor to ceiling racks for Joe's most storied wines. Outside, the crews were hard at work on what would be a painter's dream: a sun-dappled terrace looking across a vast stretch of artfully planted vineyards, creating for us all a perfect place to celebrate life and the myriad treasures that Mother Nature so humbly brings to our lips.

So as not to miss a beat business-wise, the winery had set up an interim tasting terrace and welcoming center at the foot of the property. And even with all the heavy construction going on, the enveloping landscapes and hillsides remained unspoiled, thanks to a decision that Joe had set in motion many years before: move all the processes of winemaking and barrel storage to a new

facility on the property but totally hidden from sight behind a small hill.

It was easy now to see the wisdom behind Joe's decision. His crews had completed construction of the new facility back in 1989. But as their business and wine production grew, Joe's teams expanded the facility in 1996, and by 2006 all of their production tasks were handled at the new facility, with none of the construction and upgrading ever visible to the wine-loving public. For a name, Joe found his inspiration in a poem by William Butler Yeats. In that poem, Yeats refers to a small, picturesque isle called "Innisfree," and Joe happily applied the name to his new production facility. As an added touch, Joe brought out a lovely Cabernet Sauvignon under the very same name. That was pure Joe: poetry, fine wine, and smart, far-sighted business moving harmoniously hand in hand.

As I watched the new tasting venue move toward completion, with every detail carefully considered and polished, I often thought:

How far Joe's come. How far we've come as a nation.

Indeed, as you now can see, the arc of Joe's life tells an amazing story. As a boy back on the farm in Maysville, Joe had seen and felt the wrath of the Dust Bowl years. He had seen what those storms had done to countless farms across the American heartland, ripping up topsoil, ruining crops, killing farm animals, and leaving farmers like Hensel with broken backs and broken spirits—just as John Steinbeck had depicted in his novel *The Grapes of Wrath*. Back then, we were still in the grip of The Great Depression and we were just emerging from Prohibition. And back then elegant wines were something crafted by the artisans of Europe—and never by us.

And now?

As Joe's impeccably maintained vineyards silently proclaim, we are now enjoying a whole new era in American farming, in American winemaking and wine appreciation, and, more widely, in American taste and culture. Long gone is the disastrous ignorance of the Dust Bowl era; our farmers have learned how to cultivate, plant, and harvest in advanced, far-sighted, and sustainable ways, working in harmony with Nature and the rhythms of the seasons. They have learned how to rotate crops and use cover crops to keep our soils properly protected and nourished, even in harsh drought,

and we have made incredible advances in our ability to protect our water resources, our animal habitats, and the beauty of our landscapes. In Joe's vineyards, like most others across California wine country, everything is now done as naturally and sustainably as possible—without reliance on chemical-based fertilizers, insecticides, harsh additives, or anything else that could upset the natural eco-system of the vineyards and eventually find its way into the wine.

There's more. In 2015 the Phelps winery installed a large array of solar panels to supply most of its energy needs and thus reduce its reliance on traditional electrical power. Likewise, the winery has planted hundreds of olive trees and fruit trees on its properties, to promote biodiversity, and Joe's vineyard crews maintain nesting boxes for owls, to help naturally control pests and rodents. And like many other wineries in the Napa Valley, at Phelps they now use compost made of grape skins and stems to add vital nutrients to the soils in their vineyards. Respect and Protect.

It has been the same in the realm of winemaking. As a sip or two of Joe's wines will tell you, the era of jug wines and cheap wines with a mule-like kick is now gone; thanks to our many advances in grape growing and winemaking—and the can-do spirit of our pioneers—we in America are now making wines that stand proudly next to the very best in the world. And as the Napa Valley's parade of fine bistros, restaurants, and wine bars demonstrate, Americans by the millions have come to appreciate fine wine and elegant cuisine—and the artistry and quality of life that they happily represent. Yes, just in Joe's lifetime we in America have moved from the woeful era of *The Grapes of Wrath* to a new and exciting era in American life and culture, an era that can quite rightly be titled *Grapes of Gold*.

Education has been the key. UC Davis and other fine institutions around the country now offer world-class training in viticulture, winemaking, sustainability, and environmental protection. But as we saw earlier with Lee Stewart and André Tchelistcheff, in the Napa Valley it has often been the grape growers and winemakers themselves who have led the on-site research and experimentation, often working hand in hand with the valley's associations of grape growers and vintners. Work hard and share; together we rise.

Here Joe stands as an illuminating case in point. As we have seen, Joe taught himself the rudiments of winemaking, starting in his

basement in Greeley and later working directly with Walter Schug. But that was just the start. Through my conversations with Joe and many of his top aides, I came to see that inside his winery Joe had created something truly special: a culture of ongoing research and experimentation, a culture of constant learning, teaching, and mentoring. The goal: a continual elevation of his team's capacities in grape growing, winemaking, and every other aspect of the wine business. In the realm of charitable giving, Elaine John had seen Joe foster what she called a "culture of generosity," and as I now could see, inside his winery Joe had fostered a "culture of ongoing education and collective uplift."

This was classic Joe. Back at Hensel Phelps Construction, he had fostered a similar culture of education and uplift. And, as we saw, to help ensure the longevity of that culture, he took special care to reward his staff and earn their long-term loyalty. Remember those yellow hard hats he used to reward loyal staffers for their years of service? And remember Joe's system of profit-sharing and employee ownership, leading to those 240 golden geese in the company's board room? In providing those incentives and rewards, Joe was not only treating his staff with the respect he felt they deserved; he was helping to perpetuate an orderly transmission of knowledge, values, and wisdom, from his more senior people to the newcomers, from one generation of his employees to the next. Teach and Inspire. Smart leadership! Smart business! And Joe did the same thing at his winery, again with profit-sharing, employee stock ownership, and in many cases scholarships for his best employees and their children. And Joe himself was often the lead teacher and mentor.

In this regard, Bruce Neyers is a revealing case in point; let me take a moment to tell you his story. Bruce was born in Delaware, and he studied chemistry at the University of Delaware. In 1968, at the height of the Vietnam War, he enrolled in ROTC and soon became an officer in the U.S. Army. His postings took him to Texas, South Korea, and then to the Army's critical facility at The Presidio in San Francisco. Once in the Bay Area, Bruce and his wife Barbara became interested in fine wine and food, and they struck up a friendship with Alice Waters. Inspired, Barbara began an informal apprenticeship in cooking, and Bruce began learning about fine wine and the wine industry. After his army service, Bruce worked with a group of French wine importers, and he broadened his experience by working at a wine shop and also at Mayacamas Vineyards. Then Bruce met Joe and his life abruptly changed.

The timing was crucial, for both men. On March 1st, 1975, exactly two years after Joe purchased the Connolly Ranch, and just as he and Walter Schug were ready to bring their first wines out into the marketplace, Joe bestowed on Bruce a huge responsibility: he made him his captain of sales and marketing. It would be no exaggeration to say that the future of Joseph Phelps Vineyards was riding, to no small extent, on Bruce's shoulders. And how did Joe prepare Bruce for the difficult challenges ahead? In a way that was pure Joe:

"Joe had given a lot of thought to my job description," Bruce told me. "And on a typed sheet, point by point, he had carefully set forth my specific duties and responsibilities. And there were 40 of them!"

I had to laugh: 40! But by this time I knew Joe's methodology. This was the same approach and wisdom that, back at Hensel Phelps, had given birth to Joe's cherished Standardized Subcontractor Agreement: before the work even starts, make clear the specific requirements of the job and the specific points for which the employee or contractor will be judged and held accountable. In sum: have total clarity about duties and responsibilities. As Bruce described him, Joe back then was often gruff and to the point, and he was not inclined to suffer fools—a trait that he felt Bruce would do well to emulate. As Bruce recalled, one day he was sharing some business problem with Joe, and Joe cut right to the heart of it:

"Bruce, you have to understand: with folks like that, we're not in the wine business. We're in the alibi-elimination business!"

Gruff or not, that's teaching. That's mentoring. And it embodied a wisdom that Bruce quickly made his own. "That comment really stuck with me," Bruce told me, "and it's something I tell my own people now: The first thing you want to do is eliminate the alibi."

As was typical of Joe, much of his teaching and mentoring with Bruce came after the traditional workday had ended—and over glorious meals and wines. In those early years, Joe was living at The Schoolhouse and Bruce and his wife Barbara often invited Joe to come to their home for a convivial dinner. "Joe often arrived in his pajamas," Bruce laughed, and while the dinners were always enjoyable and often high-spirited, the lessons and guidance were always serious and to the point. As Bruce summed it up for me:

"I earned my MBA from Joseph Phelps."

Through this process of teaching and mentoring, the two men became close, and Bruce thrived under Joe's guiding hand. Joe kept giving Bruce more and more responsibilities, and Bruce kept on learning and growing, so much so that Joe eventually made him president of Joseph Phelps Vineyards. And as he had at Hensel Phelps Construction, Joe expected Bruce and his other key aides to work for him on Saturdays and often Sundays and holidays too, to deepen their knowledge and their commitment to the cause. And through Bruce and his other "students," Joe hoped that his special culture of education and collective uplift would radiate far beyond the walls of his own winery. And here too he was successful:

"One day Joe told me something that was really important," Bruce told me. "He said that one thing the wine business had never been able to do was develop a cadre of professional business men and women. Joe wanted to change that. And he did. Joe brought a keen business sense to the Napa Valley, and he helped develop that cadre. In fact, that was one of the most important things that Joe helped us do."

In terms of Bruce's own learning and personal development, there was more. Much more. In 1979, he received an enticing offer: a group of attorneys was starting a wine company and they wanted Bruce to come join them. And they were offering him an equity position in the company, with a track to become a partner in the business. To Bruce it seemed a golden opportunity, and he went to Joe and told him he was going to accept the offer. But Joe would not hear of him leaving. Bruce's training, experience, and deepening wisdom were valuable assets, too valuable to lose. So Joe stepped right up, wallet in hand. "He came back with a counter-proposal: to create a new winery together," Bruce told me. "If I opted to stay, he would fund the launch of our new winery, with the profits to be shared between us. And that was the start of Neyers Vineyards."

Think about that for a moment: to incentivize Bruce to stay at the helm of Joseph Phelps Vineyards, Joe helped Bruce set up his own winery—and he bankrolled the launch too. How many business executives would do such a thing? Or even consider it? But that was Joe. And this was where Joe's "culture of generosity" joined hands with his "culture of education and collective uplift"—to everyone's long-term benefit.

Later on, Bruce and Barbara were eager to buy a new home, and they found a place they loved, close to Joe's own property. But Bruce felt the price of the home was beyond his reach. Enter Joe. Calculator in hand, and scrawling on a pad of construction paper, Joe worked the numbers and he showed Bruce, step by step, exactly how to handle the negotiations. And thanks to that bit of mentoring from Joe, Bruce was able to close the deal. And he and Barbara have lived there happily ever since. Pure Joe: everybody won.

For a time anyway. Over the next 12 years, Bruce and Joe ran Neyers Vineyards together as partners, helping it become one of the most respected wineries in the Napa Valley. For Bruce, though, the workload and stress were brutal. As he built Neyers Vineyards, Bruce continued to handle his ongoing responsibilities as president of Joseph Phelps Vineyards. As Bruce told me, with a laugh: "This was Joe's creative way of getting me to work even more nights and weekends, on top of everything else I was doing!"

By 1992, it was all too much, and Bruce and Joe decided to go their separate ways. Bruce left Joe's winery, and Joe left Bruce's. It was not an easy decision for either of them, and I gather that, for a time, there was a cooling between them. But in talking with me, neither man had an unkind word to say of the other. Just the opposite:

"I spent 17 years of my life working with Joe and learning from him," Bruce told me. "When we went our separate ways, it left a terrible hole in my life. I still miss him every single day."

And Joe said the same about Bruce. But with one added thought: he knew that one day Bruce would want to go out on his own. Indeed, Joe felt that, sooner or later, Bruce needed to go out on his own. For his own personal growth and his own sense of fulfillment. This was in line with one of Joe's golden maxims:

"We all need pride and self-respect. And one common denominator of pride and self-respect is ownership. To know you've earned a piece of the action—or all of it. Ownership brings those rewards."

For Joe, those were not empty words; they were a core operating principle. In line with that principle, in 1986 Joe and Bob Tointon completed an orderly transfer of their remaining stock in Hensel Phelps to their co-workers, finalizing the transfer of ownership of the company to succeeding generations of employee-owners.

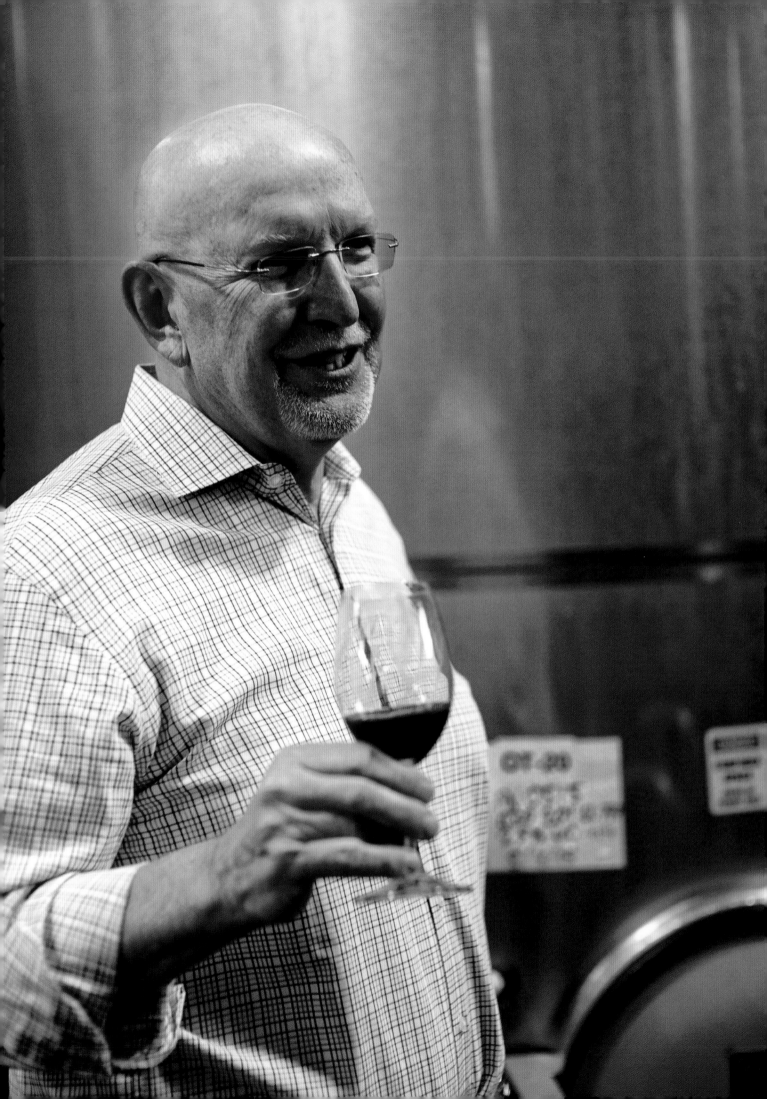

That transfer brought Joe enormous personal satisfaction:

"They earned it," Joe told me, and Bob Tointon told me the exact same thing. As part of the arrangement, Joe and Bob created their own joint enterprise, Phelps-Tointon, and through transfers of stock some of the subsidiary companies that Joe and Bob had created while at Hensel Phelps were brought under the new umbrella as well. As part of the deal, Joe was also able to bring into his own hands all the stock from Stone Bridge Cellars, the subsidiary he had created to help him buy the Connolly Ranch and launch his own winery. As Joe and Bob both described it to me, those transfers consititued a very complicated restructuring of Hensel Phelps, with advantages for all sides. And, in the end, everybody won.

Damian Parker was another beneficiary of Joe's wise teaching and mentoring. And Damian's story, like that of Bruce Neyers and Bob Holmes and Steve Carlin, tells us a lot about Joe and the culture of education and collective uplift that he fostered inside his winery and far beyond.

Damian was born in North Dakota. He had two older brothers, and two younger sisters. His father had only an 8th-grade education, but he was a fast learner, good with his hands, and he had rock-solid Midwestern values, just like Joe. Damian's dad worked a lot of jobs, and then he became an inspector for the U.S. Army Corps of Engineers, a career that took the family to different parts of North and South Dakota, to West Virginia, to Montana, to Fort Irwin in southern California, and finally to Healdsburg, when Damian was a junior in high school. At that stage, the wine industry in Sonoma County was still in its infancy, but during his summers and after college, Damian worked at a few local wineries, including Chateau Souverain, the winery that Joe and his Hensel Phelps crews had built from scratch.

On those jobs, Damian gained experience in the vineyards and on the bottling line, and by 1979 he was eager for more. So he applied for a job at Joseph Phelps Vineyards. But he didn't get it. In July of 1981, though, just before the start of harvest, he got a call from Craig Williams, the assistant winemaker at Phelps: "Damian, would you be interested in running our bottling line?"

Yes he would! From there, Damian was interviewed and hired by Walter Schug and Craig, his young assistant. But Damian knew that the guiding philosophy had come from the top, right from

Joe: "Joe was a very observant man, and that's what I think good managers are," Damian told me. "He led by example. And he hired by instinct. There was never any set of rules for hiring. And he had an innate ability to choose good people."

As Damian soon saw first-hand, Joe was far too busy, both at the winery and back in Greeley, to be a fastidious micro-manager or a meddlesome overlord. Instead, he gave full power to his supervisors and managers to run their specific domains as they saw fit, and, moreover, full power to teach and mentor their teams and hold them accountable. Distill that down and what is the essence?

Ownership. Again. Give your people total ownership of their specific domain and total ownership of the results. And if they deliver, reward them accordingly. Yes, as Joe knew and as Damian now saw, instilling that sense of ownership was key: it built good people. It built good companies. It built good results. And it built loyalty as well, helping to ensure the long-term success of the enterprise.

Joe was also a great believer in the virtue—and business wisdom—of being generous with your people. And Damian again saw this first-hand: "I was often offered other jobs at other wineries," he told me, "but with Joe's generosity—enabling us to buy shares and be gifted shares and be an owner—I was never inclined to leave." That was Joe's formula: Ownership. Pride. Self-respect. Loyalty. And in response, Damian worked his tail off and was happy to do so:

"At harvest time and beyond, we worked 10–12 hours a day, often more, day after day after day. And we had no scheduled days off. Ever. Time off was all spur of the moment. If we saw a break in the workload, we might grab an afternoon or a few hours off."

The pace was indeed grueling, but the work was fun, and for an hourly employee like Damian the rewards were substantial: loads of overtime pay, and often double-time pay as well. "I was logging 500 hours of overtime a year, and making beaucoup bucks in the process," Damian told me. "This place had marching orders, there was no dilly-dallying around. Walter was very systematic. And so was Joe."

All this, of course, was perfectly in line with Joe's larger blueprint for success, be it in construction or wine or gourmet markets, and almost by osmosis he was inculcating his values in young

Damian, including Joe's own personal generosity. Later in his life, Damian devoted significant time and financial support to a variety of charities and community causes, a service-minded ethos that Damian said flowed directly from his own parents and from Joe:

"Watching Joe being incredibly generous to so many charities and good causes—it's just part of the culture here, and it's pretty hard to not have some of that rub off on you."

Joe instilled something else in Damian: the long-term value of owning land. Again, the learning came by osmosis. On the job, Damian spent much of his life working in the different vineyard properties that Joe had purchased over the years. Those included the Backus Vineyard, which produces an exquisite estate-grown Cabernet Sauvignon, and seven other vineyards in the Napa Valley, plus another 100 acres of vineyard on the west coast of Sonoma County. Today, prime vineyard land in the Napa Valley is valued at $400,000 an acre or even more, making Joe's holdings a handsome legacy asset, to be passed from one generation to the next.

"Joe had an amazing ability to recognize quality, in people or in land," Damian said. "And he always said, 'Don't ever be in a hurry to sell property.' His whole focus was on building, not selling."

There's that key word again: "building." As Bob Holmes told us, Joe was not just a builder of buildings and successful businesses, he was also a builder of people. And Damian was another vivid case in point. From his humble roots on the bottling line, and with Joe's support and guidance, Damian steadily learned and matured, eventually becoming the lead winemaker and then vice president of all winery operations. Later he also became a trusted member of Joe's board of directors. And as he matured, Damian also developed into an inspiring teacher and mentor in his own right.

Just ask Ashley Hepworth. Or Justin Ennis.

Ashley and Justin are gifted young winemakers whom Damian took under his wing and helped bring to the very pinnacle of American winemaking. Ashley is now the lead winemaker at Joseph Phelps Vineyards, and Justin is the lead winemaker at Joe's Freestone Vineyards and Winery over in Sonoma County. Their stories help illustrate the wisdom and power of the special culture of education and collective uplift that Joe fostered inside his company, and they also help illustrate the broader vision

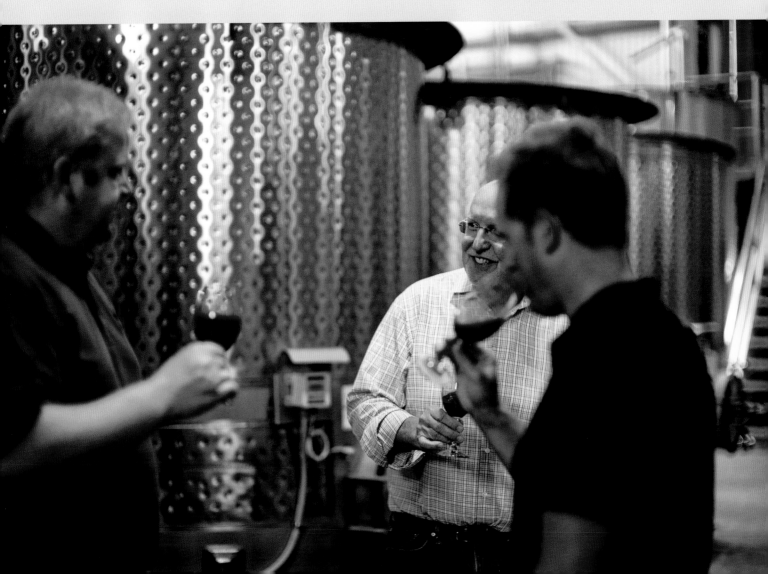

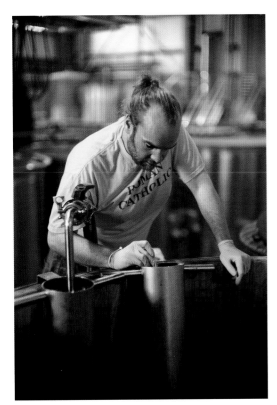
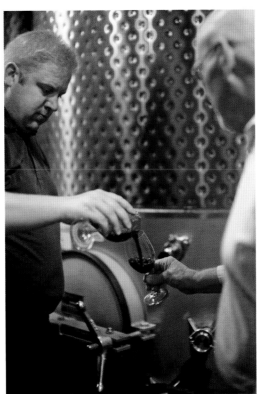

and methodology that made Joe such an effective business and community leader.

In the next chapter we'll meet with Justin at Freestone, but let's start with Ashley Hepworth. What was her background? How had she come to Joe? And, from among all the other winemakers in the world, how had Joe and Damian chosen and groomed her to craft Insignia and the other signature wines of Joseph Phelps Vineyards?

Now, if you imagine Ashley working in some luxurious corner suite of the original John Marsh Davis building, you would be sadly mistaken. Ashley works on the second floor of the Innisfree facility, in a cramped little office beside the wine lab and just up the stairs from the racks and racks of French oak barrels where her wines are gently maturing and gaining the character and refinement that so deeply impress the Robert Parkers of the world. For Ashley, it may be cramped, it may be cluttered, but her tiny office is close to heaven itself, and there is no place on Earth she would rather be.

"My father told me, 'You need to follow your bliss,' and that is what I've done," Ashley told me. "This is the best winery in the Napa Valley, and this is exactly where I want to be."

KELLY FIELDS,
GRAHAM PARKER,
JUSTIN ENNIS,
DAMIAN PARKER,
AND SAM BURTON.

(Clockwise).

Where did it all begin? As Ashley told me, flanked by pictures of her husband and son, her path to Joe was anything but conventional. She was born in Denver; her father was a geo-technical engineer and her mother loved to cook. Like her dad, Ashley had a passion for science, and she studied chemistry and biology at Fort Lewis College in Durango, Colorado. But like her mom, Ashley also loved to cook, and on Sundays she often created special dinners for her family, complete with several courses and hand-written menus. It became a family tradition, a touch of French and Italian culture and tradition right there in Denver. "I love that tradition," Ashley told me, "and I have incorporated it into my own family life now."

In college she became interested in nutrition and the relationship between good food and good health. She also worked for a time at a bakery and at Seasons, a restaurant in Durango. "I was interested in sports, health, and food, and I was looking for ways to tie all of those together." Her next natural step: become a chef. In Chicago:

"I graduated on a Saturday, I drove on a Sunday, and I started work on that Monday." Where? At a fabled house of fine wine and cuisine: Charlie Trotter's, which had earned two stars from the very persnickety Michelin Guide. "I have a theory," Ashley said, "that if you're going to work anywhere, you only work for the best."

And Charlie Trotter's proved to be just that—and a great training ground too: "I was a chef in the kitchen. I worked in the 'garde manger' station, in charge of cold dishes like salads, pâtés and terrines. I worked in the fish station. In the grill station. Charlie ran the place like a traditional French or Western European kitchen: everyone rotated. So it was great; you got to learn from every area in the kitchen. It was like a free culinary school."

As Ashley described it, Charlie Trotter's was a place with its own special culture of education and collective uplift: "It was exhausting working for a celebrity chef, and we were working no less than 10 or 12, even 16 hours a day. It was great experience, but it was not sustainable. Still, I had a lot of respect for Charlie, and that was at the height of his career. It's amazing how many of his protégés now have their own top restaurants. I felt very fortunate to work there."

And one exciting part of her learning experience was wine. "I was very intrigued by wine, and at Charlie's I was working closely with

the master sommeliers. It was there that I learned the breadth of the wines that were then available, from all over the world. And every few months, we would get another big shipment of wines. We were very team-oriented, we all wore toques, and we would all line up and pass the cases of wine, hand to hand, down to the wine cellar. It was a wonderful education. We tasted the wines too, and that's where I developed my palate."

Ashley worked at Charlie Trotter's for almost two years, and then she got restless—and eager to move back into the sciences. But how? Where? Well, one day in the late spring of 1999 her father back in Colorado suggested she write to someone he knew well: Joe Phelps. Intrigued by the idea, she wrote Joe a note, telling him she was eager to learn everything she could about wine—and learn from the ground up: "I told Joe I wanted to come work the harvest."

Joe was impressed by her letter, and his response was this: "Talk to Damian." From there, Damian made a place for her on his harvest crew—at $8 an hour. The same as they paid the other day laborers hired for the harvest. It was back-breaking work, but Ashley loved it, she loved having her fingers deep in the soil, loved seeing how the grapes themselves demanded an ongoing process of learning and uplift: Agri-culture. Viti-culture. Culture. Cultivate. Educate. Elevate. The entire process was right there at her fingertips.

Still, for Ashley or any young apprentice, learning the many crafts and sciences that go into the art of winemaking is no simple task. To craft beautiful wines, a winemaker and his or her teams in the vineyards and wine cellars have to gain deep expertise in botany, biology, chemistry, water tables, soil composition and protection, and how to manage wildlife habitats, water resources, and difficult weather conditions. Beyond that, they have to master every step in the growing of grapes and the making of wine, from de-stemming and pressing—what kind of press to use? Basket, bladder, or other?—then every step in the process of fermentation and barrel aging, including the selection of the proper oak for the barrel: French or American? And then there's the art of the barrel. How is the barrel to be treated to enhance the aging process and to bring forth the accents and layers of flavor that the winemaker hopes to elicit from the intrinsic nature of the blend or the given varietal that she or he is trying to bring to the peak of its glory? Whew! What a challenge!

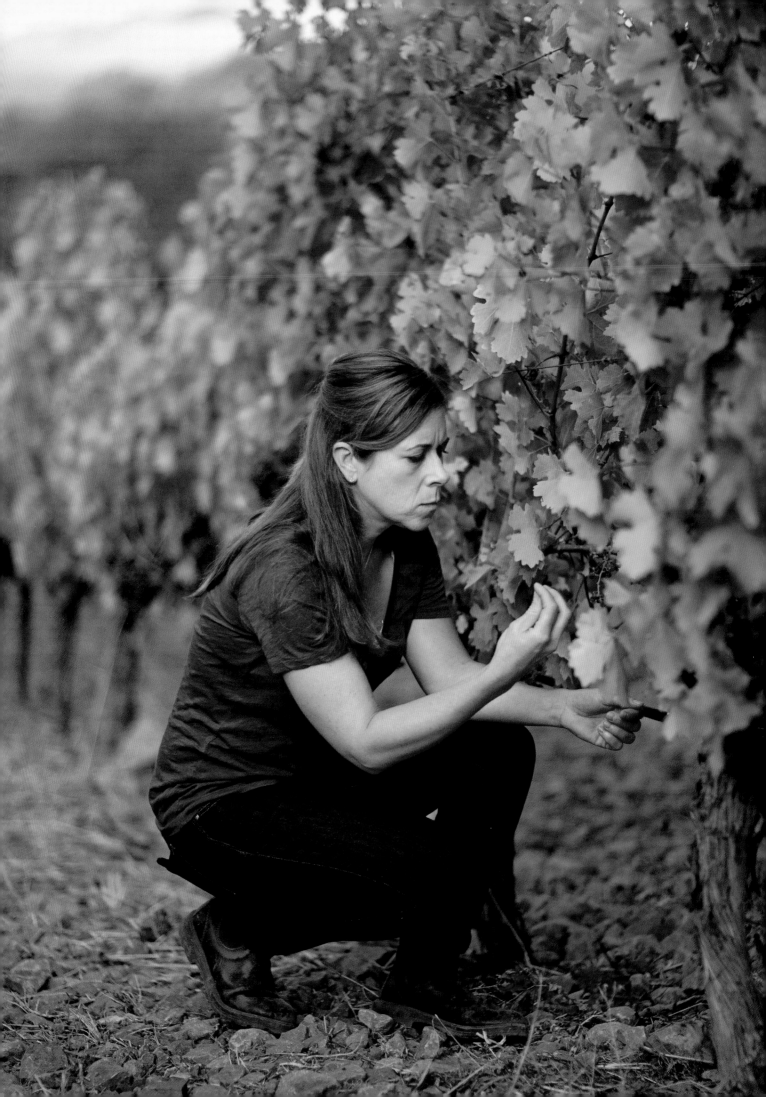

With so much to learn and so much to master, it takes time—often years and years—for winemakers to rise to the top of their field. So it is no wonder that across Burgundy and Bordeaux you often here this ancient adage: "The older the winemaker, the finer the wine."

But even time is not enough. Each year, in quality wine programs around the world, legions of aspiring young winemakers study the core elements of viticulture and oenology and they graduate with the right knowledge and training. And legions of them then go on to apprenticeships with quality wineries in Europe, the United States, or in so-called "New World" wine-growing countries like Chile, Argentina, and New Zealand. Still, after all of that training, how many of those aspiring winemakers will have the necessary feel—and the necessary artistry and palate—to bring forth the finest of wines, the ones that ignite our senses and make our spirits dance with delight? How many, in sum, will become the Picassos or the Mozarts of the high art of making beautiful wines? Very, very few.

After she worked her first harvest, out in the fields with her fingers in the dirt, Ashley spent time rotating through different parts of Joe's winery, a bit in sales and marketing, a bit in the retail room. But nothing excited her more than the art and science of crafting fine wines. Still, she had no training in wine-making, no degree in viticulture or oenology. So as a next step she told Damian she would go to UC Davis, learn what she needed to know, and then she would come back to Joseph Phelps Vineyards. It was a sensible plan—and Damian wouldn't hear of it: "You don't need a degree," he assured her. "You will learn far more right here. And the learning will be in the doing."

Like Joe, Damian wasn't looking at her resume or her academic credentials. He saw something in this young woman, a spark, a ferocious determination to learn and succeed, so he chose to take a chance. From there, Damian, as lead winemaker, took Ashley in hand, and with a patient, but tough-minded process of mentoring and grooming, he helped her build her knowledge and skills in the craft of winemaking, and he helped her develop her confidence and her own innate artistry too. And the rest, as they say, is history.

In short order, Ashley earned the post of assistant winemaker, and in 2008, when Damian moved on to wider responsibilities, she

ASHLEY
HEPWORTH

was awarded the golden crown: the position of chief winemaker at one of the finest wineries in the world. She was all of 33 years old.

As you can see, Joe's culture of education and continual uplift had worked its magic: Joe had mentored and inspired Damian. Then, in turn, Damian had mentored and inspired Ashley. Yes, in an almost seamless way, an inspiring torch had been artfully passed, first from one generation to another, and then on to a third. Perfect! And then Joe, proud as he could be, stepped in and bestowed on Ashley his own personal seal of approval:

"Joe put me in charge of his private wine cellar, up at the house," Ashley told me, "and I was in charge of that for many, many years. I considered that a very high honor: Joe only put people in charge of his wine cellar that he really trusted. Later it was Françoise Larum, another of Joe's most trusted aides. I handed the baton over to her."

The passing of the torch. A crucial step in the continuing success of any collective enterprise. And as I wrote down Ashley's words, I immediately thought of Bruce Neyers' words: "I earned my MBA from Joe Phelps." Now I felt like I was earning an MBA from Joe as well, and I imagine that many of you now feel the exact same way.

All this said, life being as it is, Joe's skillful teaching and mentoring did not always turn out as happily as he hoped. In his later years, for instance, Joe gave a lot of thought to how best to protect the future of his winery and how to properly reward the people who had been so helpful and so loyal to him over the years. And what better way than ownership? To give his people an ownership stake in the dream enterprise they had worked so hard to build? So, just as he had done so successfully at Hensel Phelps Construction, Joe set in motion a generous equity-sharing plan, and he turned to two of his closest aides to implement it: Craig Williams and Tom Shelton.

Both men had good track records with Joe. Craig Williams had been trained by Walter Schug, and after Walter left back in 1983, Craig became lead winemaker. Tom Shelton had joined Joe in 1992, as vice president of sales, but after he proved his worth, Joe promoted Tom to president of the company. Together, Craig and Tom had helped build the quality, sales, and prestige of the Phelps portfolio of fine wines, and in 1999 Joe rewarded them with equity positions in the company. Then, when Joe decided to

give a full 49 percent of the company to his employees, he asked Craig and Tom to manage a proper and just allocation of shares, and he counted on them to do so in line with Joe's usual guiding ethos: Everybody wins.

Well, this time nobody won. As it turned out, many on Joe's staff, including some who had worked for Joe for decades, were irate at the way Craig and Tom allocated those shares, and Joe himself was deeply disappointed too. The upshot? A wrenching, costly, and very divisive legal battle, and one that caused great pain on all sides. One day at his kitchen table, I asked Joe about it all, but he had no desire to revisit the episode. It had happened years earlier, and he was determined to leave it in the past. When I kept pressing, all Joe did was give me a little shrug and say, "Live and learn."

It was with a similar eyes-forward mindset that Joe talked with me about his four marriages. In our chats, we talked at length about Joe's decades with Barbara, about the life they had built together. After their divorce, though, Joe had married three times more, first to Patricia Vadon, and then to Lois Rudick, and then once again to Pat. His final marriage lasted less than four years. With me, Joe was not inclined to delve into any of those three later marriages. In this realm too, his focus was entirely on the future, not on the past.

Yes, that was Joe: eyes forward, live and learn. Whether we were talking about his successes or his disappointments, he was showing me the fiber and sinew that made him who he was. And as we have seen throughout his story, Joe was a man of courage and conviction, a man who was never afraid to blaze his own trail or to follow his passions wherever they might lead. In a life like that, a few scrapes and disappointments are downright inevitable; the key for Joe was to keep right on going, to keep building and creating and striving to be the very best we can be. As Bob Dylan so artfully put it:

"He not busy being born is busy dying."

"NEVER SIT STILL. KEEP LEARNING, KEEP BUILDING."

Joe Phelps

THE RISING TIDE

I loved working with Joe.

We would sit at his kitchen table, sipping coffee or orange juice or maybe a beer in the late afternoon, and as we chatted we often let our conversation fly wherever it might, like hawks in the wind, but we always came home to one constant anchor: Values. The enduring values that had guided Joe throughout the course of his life.

Talking about his family life back in Maysville, for instance, Joe told me about the wonderful warmth he had enjoyed on the farm, in cooking and playing in the kitchen with Nita and his sisters Mary and Margaret and his older brother John. And from those boyhood memories we distilled out the value that Nita held most dear: "Dare to be true. Nothing can need a lie." And from there we distilled out another value that Nita and Hensel held dear and had passed along to their children: "Work hard and share; we're all in this together."

Likewise, in talking about his family's new life in Greeley, after losing the family farm, Joe recalled how generous and supportive Earl King, the owner of King Lumber, had been with Hensel when he was starting life over as a general contractor. Earl King had given Joe's dad a hand up when he needed it most. And during World War II, the entire Greeley community had pulled together in the exact same spirit: "Together We Rise." And there was another value that Hensel had passed along to Joe, by his own sterling example in running his business: "Your word is your bond."

And then there was Ike. Modest, self-effacing Ike. As Joe and I talked about how he had met General Eisenhower aboard the USS Helena, during the fighting in Korea, Joe drew out the values that so impressed him about Eisenhower as a leader: Total competence. And total humility. And as Joe saw, that combination brought forth magnificent results: it inspired a fierce loyalty from Ike's troops and a fierce commitment to their common cause. As Joe himself saw, and felt, no one ever wanted to disappoint a leader like that. To the contrary, his troops would give their all to Ike—and to America. Honor, Duty, Country. All for one, one for all, in the service of freedom and individual liberty. "We the people…"

Then, of course, there was Florence, the home of Leonardo and Michelangelo, of Brunelleschi and his inspiring Duomo. Make it beautiful and build it to last—Renaissance values that Joe brought to his own life in construction. And as we saw, Joe was so inspired by what he had seen in Tuscany that he even considered buying property there, and you will remember how he had remodeled his house with Italian marble and carved doors, all to bring a measure of the Renaissance spirit and aesthetics back home to Greeley.

And then there was France. The artistry of the wines and foods and vineyards. Joe's awakening to the civilizing power of Education and Culture. In our chats, Joe and I often marveled at one key element in the rise of the Napa Valley and American wine and food: how Joe and so many of his fellow pioneers—Robert Mondavi, Julia Child, Alice Waters, and later chef Thomas Keller—how each of them had had a similar awakening in France, and how each had returned home to America with a common dream and a common purpose: to plant the best of French culture and values deep in the American soil. Cultivate, educate, elevate, for the greater good of us all.

When he came to the Napa Valley, Joe brought this tapestry of wisdom and values with him, and as we talked about wine and food and the joys of the table, one further value kept threading its way into our conversations: the value of simply sitting down together at the family or the community table. The harvest parties Joe threw were legend, and so were many of the festive dinners he hosted at his homes in St. Helena, France, and Maui. And here Evelyne Deis shared with me an insight that cast a beautiful light onto Joe and his guiding spirit: "Joe could not be happy if he couldn't share what he had with other people. And what better way to share than with good food and good wine?" Perfect!

As we saw in the previous chapter, there was no quit in the man; he valued work and he needed to feel productive. Even in his 80s, and even in declining health, Joe was still dreaming, still building, still searching for fresh creative juice. Indeed, at a stage in life when most people are content to rest on their laurels, Joe was still hard at it, and in the world of wine there was one daunting challenge he had yet to master: crafting a world-class Pinot Noir.

As we've seen, Joe was one of the most successful innovators in the history of American wine. Insignia was a ground-breaking creation, as was his Syrah, and the Rieslings and Gewürztraminers that he and Walter Schug created were of a quality and finesse that far surpassed what was being created in California at that time. Later Joe would bring forth an elegant Viognier and then would come another major innovation: Eisrébe. This was a sweet dessert wine made in the tradition of German and Austrian *eisweins*, wines that are made from grapes that are left in winter to freeze on the vine. But freezing temperatures rarely happen in the Napa Valley; what to do? Joe and his team found the answer: pick the grapes at their peak of ripeness and balance, and then take them to a refrigeration facility in Sacramento to freeze them in winter-like conditions. And their resulting dessert wine is a true delight, with an apricot-like aroma and sweetness that dance from the glass.

Joe's ambitions for Pinot Noir were not so easily realized. Walter Schug had grown up on an estate in Germany that specialized in Pinot Noir, and from the outset he and Joe had high hopes for crafting a first-rate Pinot Noir in the Napa Valley. Early on, they did produce a fairly decent Pinot from grapes from one vineyard in the valley, but it never met their highest expectations and a few years later they stopped making it—a frustrating setback, to say the least. And Joe and Walter were not alone in their frustration. Pinot Noir is a finicky, temperamental grape and it does not do very well in the blazing heat that characterizes most of the summers in the Napa Valley, especially on the floor of the valley. What to do?

Keep learning! Keep trying! Keep searching for the right climate, the right vines, the right terroir, and the right winemaker. The process took years, and more frustration, but after all that effort and searching, what were Joe and his team finally able to produce?

So that I could see—and taste—the result first-hand, one day Joe's son Bill picked me up in Napa and then we drove an hour west,

across the midriff of Sonoma County to the tiny town of Freestone, about 10 miles inland from the Pacific Ocean. We drove through the town, then up into a woodland paradise, with stately redwoods rising majestically around us. On a far hill, we made our way up through artfully sculpted vineyards, and near the top, in a clearing, we came to Freestone Vineyards and Winery, a small, high-tech winemaking facility where Joe's dream of creating a world-class Pinot Noir had finally come to beautiful fruition.

But getting there had not been easy. On the drive over, Bill had described the many difficulties they had had in finding just the right spot and then in purchasing the property. And the physical winery was just one part of a larger mosaic: most of the grapes that go into the Joseph Phelps Pinot Noirs come from two nearby estate vineyards, Quarter Moon and Pastorale. From those vineyards Joe's team makes two single-vineyard designate wines, plus a blend of the two called simply "Freestone." Critics rave about all three.

To give me a proper feel for what goes into the wine, Bill and Justin Ennis, the winemaker at Freestone, took me on a walking tour of both Quarter Moon and Pastorale. And what treasures they

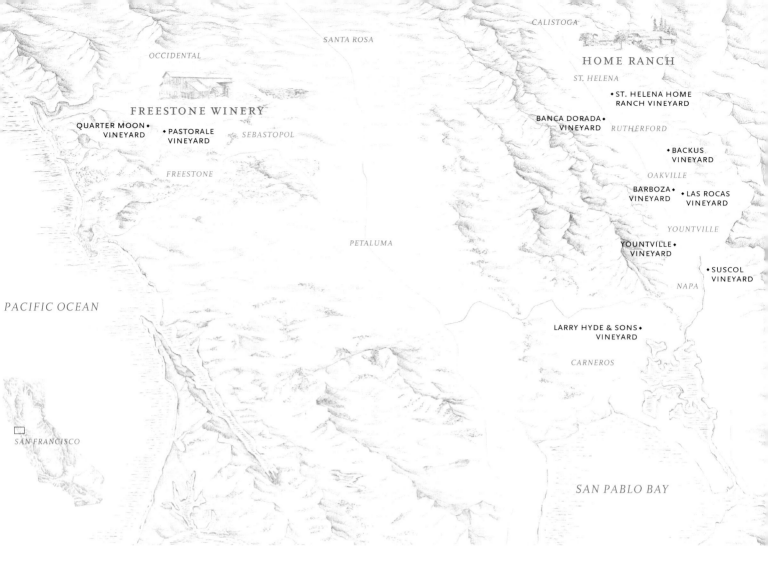

are: 100 acres of pure winegrowing gold. The terrain of both is steep, and as we hiked up, the sheer beauty of the vineyards, with the redwoods rising beyond, very quickly put a lump in my throat.

Up at the top, the view was magnificent, and we could look across a vast expanse of Sonoma County and see the Pacific Ocean. Yes, Horace Greeley had it exactly right: "Go West, young man, and grow up with the country," and with his Freestone properties Joe had continued to do just that. And the freshness of the air! In the mornings and late afternoons, Pastorale and Quarter Moon are often shrouded in ethereal mists and maritime fog, bringing the ripening grapes a welcome respite from the mid-day heat. In sum, these are ideal conditions for growing Pinot Noir—and the entire setting is enough to make any French winemaker green with envy.

After our hike in the vineyards, Bill and Justin showed me the Freestone physical plant—compact and spotless, ideal for a small vineyard and winemaking crew—and then we had lunch together at a nearby restaurant. Over lunch, and in a later chat, I got to know Justin and I could see why his qualities as a winemaker had melded so easily into the wider spirit and culture of Joe's operation.

FREESTONE
WINERY,
SONOMA
COUNTY

MAP OF
JOSEPH PHELPS
VINEYARDS

Justin Ennis is a big, burly man, with roots deep in the Sonoma County soil. He grew up in Santa Rosa, the county seat, and even as a boy wine was a large part of his family life. "My grandparents had a place over in Healdsburg," he told me. "They grew grapes and every year they made homemade wine. So growing up, wine was in my life, but I still never imagined going into the business."

Like Damian Parker, though, in high school Justin began working harvests, and he soon discovered that he loved the work and that it suited his skill set. He was physically strong, a quick learner, and a tireless worker. "I started on the ground floor, harvesting," Justin told me, but then came his real break: two caring, skillful mentors came into his life and tutored him in the essentials of fine wine.

After finishing high school, Justin landed a job at Kendall-Jackson, a Sonoma County institution and one of California's most esteemed wine companies. And there he was taken in hand by Dan Goldfield, a highly respected winemaker and a specialist in Pinot Noir and Chardonnay. Goldfield was a graduate of Brandeis University, and then he had earned a master's degree in oenology from UC Davis. From there, he honed his craft first at Kendall-Jackson, then at La Crema, and soon he was helping develop a new winery, Hartford Court, in Forestville—and Justin became one of his first recruits.

"Dan gave me my first full-time job," Justin told me, and Dan gave him much more too: "He gave me the tools I needed," Justin said, "and we had good lines of communication. It was a good foundation, all based on Pinot Noir."

While at Hartford Court, Justin was taken in hand by another caring mentor, Bob Cabral. Working with Bob, Justin's education in wine deepened, and in 1998, when Bob was named lead winemaker at Williams Selyem, another Sonoma County winery known for its Pinot Noir, Justin eagerly followed him there. For the next eight years, the two men worked side by side. "I was Bob's go-to guy," Justin said. "We had a unique connection, and he could rely on me."

Eventually, though, Justin became frustrated; without a formal degree in oenology, he feared that his future at Williams Selyem might be limited. Eager to craft his own wines, Justin dreamed of finding a place that prized talent, grit, and hard work—not fancy diplomas. And by now you know exactly where that place turned out to be: on Joe's team. Under the tutelage of Damian Parker.

"Damian offered me my first real opportunity as a winemaker," Justin told me. "And Damian saw a lot of himself in me. We had similar backgrounds, and he knew what I was capable of doing."

And so it began for Justin, another level of skilled mentoring and personal growth, just as Joe himself had provided for Bob Holmes and Bruce Neyers and Damian, and just as Damian, in turn, had provided for Ashley Hepworth. As always too with Joe, his team's collective goal was crystal clear: "We wanted to make top-quality Pinot Noirs, and we had good ideas about how to do that."

Under Damian's tutelage, Justin deepened his expertise in both viticulture and winemaking. And in an important later step, Sam Burton, who succeeded Damian as Director of Operations, taught Justin how to master the business side of Freestone, including how to be more adept at budgeting and managing the winery's finances. The result? Through this patient process, Justin Ennis grew into another shining example of the virtues of proper mentoring and of Joe's own special "culture of education and collective uplift."

And what exceptional wines young Justin produces! His Pastorale and Quarter Moon have different nuances, but they both elegantly express the richness of their grapes, soils, and climate. And so does the Freestone blend of the two. Call me a hopeless romantic, but when I taste Justin's wines I can see in my mind the beauty of the landscape and the vineyards, and I can even hear the distant roll of the Pacific Ocean. And when you know the full sweep of Joe's story, you can also see something more: the unique wisdom and spirit that finally brought Joe's dreams for Pinot Noir to glorious fruition.

And there's more. The success of Joe's creation in Sonoma County has much larger dimensions, and I had the pleasure of learning about them from a remarkable woman named Marimar Torres. Let me take a moment now to tell you her story.

Marimar was born into one of Spain's most esteemed wine families. Her great grandfather and his brother began making wine back in 1870, and from there Bodega Torres, the family business, grew into one of Spain's most prestigious wine producers. In Spanish society today, Marimar's family enjoys an almost royal stature, and if she were of a different spirit, today she would be living a life of wealth and comfort, with a staff of helpers always at her beck and call. But Marimar was made of very different stuff,

and in 1973 she packed up and moved to San Francisco, when, as we already saw, the Bay Area was in a state of creative ferment, especially with regard to fine food and wine.

At that juncture, Freestone was a rustic backwater and Sonoma County was widely known as redneck country. There were few wineries in the county, and few good places to eat. But change was coming, profound change—and Marimar would soon be a part of it.

When she first came here, Marimar did some work in sales and promotion for the family company back in Spain. And she was very successful at it. But when her very traditional father refused to accord her the same respect and benefits as he gave her brothers, Marimar said, "Enough!" With that, she issued her own personal Declaration of Independence and struck out on her own, determined to create a whole new life for herself in America. To give herself a proper foundation, Marimar studied viticulture and oenology at UC Davis, and soon she found a dream spot to put down roots and build her own signature winery: right there in Freestone, close to where Joe would later build his.

As she was finding her way, Marimar had the good fortune to meet Joe and Walter Schug—she admired both men—and she also met Robert Mondavi and many of the other early pioneers of California wine. And what a healthy awakening they brought her! As Marimar told me one day over lunch at her Marimar Estate, she was deeply impressed by those intrepid pioneers, especially by their special spirit of sharing and collective uplift. She had seen nothing like it in Old World Europe.

"When I arrived here," Marimar explained, "right away people shared their knowledge with me, they shared whatever I needed. Everyone was so open and generous. That spirit is what made the Napa Valley, first, and then it made Sonoma County too. Here, the culture is win-win. And I just relish it. That's America. The best of America. I'll share with you what I have, and you'll share with me what you have, and together we'll build something truly special."

Yes, that's it exactly. This cooperative spirit is indeed "the best of America," and Marimar and Joe and Damian and Justin and others have built something truly special in Sonoma County. Today, where once there were few, there are now more than 400 wineries across Sonoma County, and many are making an array of wines that are first class by any standard. Likewise, in the towns

of Healdsburg, Sonoma, Santa Rosa, and Glen Ellen there is now a wide variety of restaurants and bistros that feature farm-fresh, inventive cuisine—delicious proof of the rise of all the boats in Sonoma County.

In the Napa Valley, of course, it has been the same. Back in 1973, when Joe got started, there were only 30 wineries in the whole of the valley, and very few were making top-quality wines. Today, there are more than 500 wineries in the Napa Valley—and almost all of them are making wines that can stand proudly among the best in the world. And in terms of food, the Napa Valley has gone from being a culinary desert to what is today: a dream destination for food and wine lovers from all over the globe. And gone now are the days when aspiring young chefs and sommeliers from around the world dream of doing apprenticeships in London or Lausanne; now they dream of doing them in the kitchens of the Napa Valley.

As we have seen time and again, success breeds success. And in this case, the star-spangled success of California Wine Country just keeps rising and radiating outward. Very few people realize it, but today in America we are making fine wines in every state in our union—yes, all 50! Likewise, our rising expertise and technological strength in grape growing, winemaking, environmental protection, and energy and soil conservation keep radiating outward as well. Again few people know it, but today in America we are exporting our winegrowing technology and knowhow to dozens of other countries around the globe, and even to France. Imagine that!

As Marimar Torres has seen first-hand, the success of California Wine Country and its special culture of sharing and collective uplift are also helping to transform other wine cultures around the world, including that of her native Spain. When she was growing up, rival families in wine would never dream of sharing their knowhow and expertise. But as Marimar told me, the times they are a-changin'. "Here, people in wine open doors for you," she said. "In Spain back then, people closed the doors. That was true in many parts of Europe, but especially in Spain. Happily, that's changing now."

The Napa Valley today is a vivid showcase of this cultural openness and the energizing cross-fertilization that it fosters. Indeed, drive up the Silverado Trail today and you will pass wineries with owners from France, Chile, Japan, Spain, Iran, and Switzerland,

and on side roads are wineries owned by people from China, South Korea, Germany, Argentina, and more. And it's the same right inside Joe's winery. The CFO, Robert Boyd, comes from Scotland. Sam Burton, the director of operations, comes from Australia. And, as we saw, Humberto Martinez, the cellar master, and German Corro, their beloved vineyard specialist, come from Mexico. And the same is true at many of the finest wineries across California Wine Country. Also, during the winter months here, many young staffers go to Chile, Argentina, New Zealand or beyond to help with the harvests and advance their own learning process, not just in the tools and techniques of fine wine but in the special culture that supports it.

What is the upshot of all this cultural cross-fertilization? Well, it's easy to see. Just spend a leisurely morning or afternoon out on the terrace at Joseph Phelps Vineyards, tasting the lovely wines that Ashley and Justin and their teams produce, and just listen to the guests sitting near to you. On any given day, you are apt to hear an amazing symphony of languages and accents. This is the world of wine today in the Napa Valley, and it is just as true in upstate New York or Virginia or Oregon or Washington State. Yes, the joys of drinking and appreciating fine wine now transcend borders of language and culture, they bring people of different nationalities and backgrounds together in a common spirit of celebration, and this was a source of the deepest satisfaction for my friend Joe.

"The true beauty of wine," Joe told me one day, relaxing at his kitchen table, "is that it brings people together. And we now see that every single day. Who in the world could ask for more?"

◆

"EAT THY BREAD WITH JOY, AND DRINK THY WINE WITH A MERRY HEART."

Ecclesiastes

THE BEST WE CAN BE

The man loved to fly.

Flying was speed. It was adventure. It was freedom.

And being at the controls of your own plane, mastering everything there is to master in the cockpit, and doing it all as you're soaring into the heavens at 200 miles an hour, what greater high, what greater rush could there be for a man who grew up with *Popular Mechanics* in his hands and a constant stirring in his heart?

"Joe loved to fly," Bob Zachary, his flight instructor, told me. "He loved flying more than just about anyone I ever knew."

Hal Morrison was the guy who first put Joe into the cockpit. At the time, Hal ran Bridgeford Flying Services, which was home to all the pilots and crews and private jets that were flying in and out of Napa County Airport. "Joe was in love with flying, in love with the challenge," Hal told me. "That's just the kind of man he was. And everyone at the airport loved him."

Joe started flying at the age of 60, a time of life when many men and women are content to be safely at the controls of a golf cart. But not Joe Phelps. "He started when most pilots are retiring from flying," Hal said. "He couldn't care less about the comfort of the plane. He loved talking to the pilots. He loved looking at the instruments. And he became totally focused on learning how to fly."

Early on, Joe rented planes for his flight lessons. But soon, as the thrill and challenge of flying grabbed him by the throat and refused to let go, Joe had to have his own plane, and he put Hal in charge of finding him the right plane, the right set of wings.

As Joe told him, "I have more money than I have time. So find me a good plane."

Hal found him the perfect starter plane: a Cessna 182 RG, a four-seater turbo prop that could cruise comfortably at 175 miles per hour. "He flew that for about a year," Hal told me. But as Joe's skills and confidence grew, and after he passed his instruments training and test, Joe wanted more. "He wanted state-of-the-art instruments, better auto-pilot, and GPS for easier navigation," Hal said, so he then began hunting for a more advanced plane for Joe.

And soon he found a beauty: a bigger, faster Cessna 210, with a pressurized cabin, allowing for higher altitude flight, and an easy cruising speed of 200 miles an hour. Hal thought it was perfect, but Joe hated flying it. "Hal," he said, "it has a big, heavy feel to it. It's no fun to fly!" And with that, Hal's spirits immediately sagged:

"I said to him, 'Joe, you're never going to take my advice again, are you?' Joe just laughed. 'Yup, that's right, Hal. Never again.'" That's the way it was between them: pilots and pals, both loving to fly.

Jesting aside, Hal got the message. What Joe wanted was a plane to fly around the state, as he looked at vineyards and maybe more properties to buy. Above all, what he wanted was thrill and feel. "I realized he wanted a smaller plane, one that was more like a sports car. That 210 was more like a truck." The solution: Hal found Joe another Cessna 182, but this one had a pressurized cabin, improved brakes, and advanced radar equipment. Joe was delighted to be at the controls of this new plane, and Hal was enormously relieved:

"Early on, Joe told me, 'I trust you.' And from then on, I worked just as hard as I could to make everything as perfect as I could for him. That's the kind of guy Joe was. And it helps you understand why he was so successful in everything he did. With Joe, everything had to be perfect. And it made you feel so good to please him."

That is an almost perfect summation of Joe's gift for motivation, for inspiring others to give him the very best they have inside. Just as Hal explained, Joe wanted perfection—second best would never do—and for Joe there was no motivating tool more powerful than those three simple words: "I trust you."

I know. On more than one occasion in our conversations for this book, Joe and I hit a sensitive area—sensitive for him and for his family—and I wasn't at all sure how to handle it. But Joe would just put his hand on my shoulder and say, "Handle it however you think best, Paul. I trust you." Then I would work doubly, triply hard to make sure I got everything right, down to the last detail. And many people who worked with Joe told me similar stories, with similar results. Together We Rise, yes, but when you earned Joe's trust, you worked even harder. The result: Together We Soar.

Yes, that was Joe. And that was central to his gift for leadership and for team-building, motivating, and inspiring, and, just as Hal Morrison said, for succeeding at everything he set out to do.

As we saw with Bruce Neyers, Damian Parker, and Bob Holmes, Joe deftly transmitted his wisdom and spirit to many of the people closest to him, and we saw that too with what he achieved in the realms of charitable giving and helping build the Napa Valley community. And Joe also managed to pass along his wisdom and spirit to his own children, as I had the privilege of seeing first-hand.

I saw it with Joe's oldest daughter, Leslie. Over the years, Leslie had worked with Joe at Hensel Phelps, and then at the winery too. She had Joe's entrepreneurial flair, and later she left to start her own travel company down in southern California. But when Joe's health slipped, Leslie stepped up and took charge of managing his health care, his support staff at home, and the organization of his many trips back and forth to his homes in southern France and on the island of Maui. For this book, Leslie was indispensable. She offered valuable insights, and it was Leslie who found Nita's diaries and took charge of getting them to me. And she did the same with most of the family photos that you find in these pages.

Joe's daughters Laurie and Lynn also carried forth their father's spirit and values, first and foremost in raising their children, but also in helping me with this book. As you saw earlier, Laurie and Lynn took me to see the family home back in Greeley, with its stained glass windows, its Italian fireplace, and those splendid carved wooden doors inspired by Lorenzo Ghiberti's "Gates of Paradise." Then Laurie and Lynn organized something else for the three of us: a trip to Colorado State University, to show me what their dad had done for his alma mater. And that trip proved to be illuminating, to say the least.

For that trip, I flew into Denver, then Laurie and Lynn picked me up and we headed for Ft. Collins and the campus of Colorado State. On the way, Laurie and Lynn brought me a deeper understanding of their family, starting with the women. "The women in our family were very strong," Laurie said. "Nita, of course, and our Mom, and Joe's sisters Mary and Margaret. They were smart, resourceful women and each of them commanded a lot of respect. They still do."

Nita, of course, was a veritable rock of Gibraltar, raising her eight brothers and sisters when their parents passed away at very young ages. Then Nita raised her own four children, all the while helping Hensel through his hard times and broken back. And what about Barbara, their mom? You already know some of what she went through: her whirlwind romance with Joe, giving birth to Leslie and Bill while Joe was off serving in the Navy, and then raising their four kids, oftentimes alone, while Joe was off working days, nights, Saturdays, even holidays too. Barbara was a strong, courageous woman, but always gentle and gracious. As Laurie and Lynn told me, after the divorce their mom opened her own gift and card shop in Denver and she made it a success. "She remade her life," Laurie told me as we drove, and in so doing she set an inspiring example for her three daughters and for her grandchildren as well.

As Laurie and Lynn also made clear to me, Joe was always a huge presence in their lives, even when he wasn't physically present. He was strict, and he had a way of making his life lessons stick. When Lynn was a teenager and out on a date, Joe would always wait up for her—often sitting in a chair parked right at the front door. One night when she came home late from a date, Joe saw that she was deeply upset. Why? Because the young man she had been out with that night was rowdy and irresponsible: out driving on a country road he slammed into a cat—and then he had just sped off without giving it another thought.

"Do you know what Dad did?" Lynn told me. "Then and there he grabbed a shovel and flashlights and we went back and found the cat. And we gave him a proper burial." That was Joe. Respect and Protect. And giving Lynn a life lesson she would never forget.

Soon we arrived in Ft. Collins and at the campus of Colorado State University. When Joe first started there just after World War II, the school was small, with just over one thousand students, and most of them were studying agriculture and related sciences. But

talk about progress: CSU now has 24,000 undergraduates and the campus itself is large and sprawling, with street after street of classrooms, research labs, and student housing complexes, many of which were built by Hensel Phelps Construction. Joe's work.

When we arrived, Mike LaPlante, one of the university's directors of development, gave us a warm welcome and then led us straight to Guggenheim Hall, the headquarters of CSU's esteemed School of Construction Management. When Joe first arrived, the School of Construction Management was in its infancy; indeed, Joe was one of its very first students. Later, as I explained back in Chapter Ten, Joe became a major force in the program's development. First, he brought CSU professors to Hensel Phelps to help train his staff. Then Joe and the School of Construction Management launched a pioneering partnership whereby high-performing CSU students are able to advance their training with six-month apprenticeships with leading construction companies across the American West.

Inside Guggenheim Hall, Mike showed us several fitting tributes to Joe and his work. We saw Joe's name above doorways. We saw it on plaques saluting the school's major donors. And in one classroom the name Hensel Phelps Construction was spread across an entire wall. Joe's name was also prominent at the department's placement office. There, two full-time staffers carefully evaluate student work and then take great pains to pair students with the appropriate construction company. As we learned, this muscular partnership with private industry gives CSU students what they need, and it gives participating companies what they need: access to a pool of highly qualified graduates. As usual with Joe, everybody wins.

From there, thanks to Mike LaPlante, we were able to talk with the construction school's instructors and professors and we even got to sit in on a few classes. And as we saw first-hand, CSU students get both theoretical grounding and practical training in every step of the construction process. So while they learn hands-on skills like carpentry, welding, and how to handle rebar, concrete, pipes, and electrical cabling, they also get expert guidance in leadership, motivation, budgeting, team building, accountability, and financial management—pillars of Joe's own real-world blueprint for success.

In one class we visited, students were learning about the flow of streams, rivers, and underground water sources, and how those

can affect and sometimes endanger construction sites. What to do? Plan! Manage! Assess the situation and devise ways to protect the water sources and the building under construction. As we saw, there is no fluff here, none: this what students need to master the challenges they will face in the construction industry. And along the way, their teachers often drive home a larger lesson: the need to build in ways that respect Nature and protect the environment.

There are only a few other schools in the United States that offer programs in construction management. And how do CSU students stack up against the competition? As we learned, each year there are regional and national competitions where teams from different schools come to show what they have learned. Typically, competing teams are given a challenging project to design and build, on paper or now with computerized models. Then, under tight deadlines, the student teams have to plan, budget, and execute every step in the construction process. And the goal is always the same: get the job done on time, on budget, and to the total satisfaction of the client.

Joe himself could have designed the tests.

And how do CSU teams score in these competitions? Consistently at or near the very top. And that speaks volumes about CSU's stature throughout the American construction industry. As Dr. Mostafa Kattab, head of the School of Construction Management, told us, "According to our industry advisory board, ours is the top program in the country today."

For that level of performance, Dr. Kattab gives much of the credit to one Joe Phelps. "Joe really changed the course of this program," Dr. Kattab told us. "Through our partnership with private industry, and through our system of apprenticeships that Joe did so much to put in place, our students get training that many other schools are simply not able to provide. And once they graduate, our students are able to hit the ground running with the leading companies in the country." To help further the process, Joe endowed a professor's chair here at his alma mater, from where he graduated in 1951.

For his vision, commitment, and generous support over the years, in 2004 Colorado State awarded Joe an honorary doctorate degree. As Joe told me, this was an honor he cherished—and it carried a welcome measure of redemption for that high-spirited lad who had once been tossed out for torching the lawn of a sorority house.

JOE BEING
HONORED AT
COLORADO STATE
UNIVERSITY

JOE AND HIS
LONGTIME
BUSINESS
PARTNER
AND FELLOW
PHILANTHROPIST
BOB TOINTON

Dr. Albert Yates, who for many years served as president of CSU, saw first-hand Joe's impact on the university and its students and faculty. "Joe's advocacy and support helped us create a world-class educational program in construction management," Dr. Yates told me. "His personal creativity and commercial success inspired countless students and faculty, and his selfless generosity will continue to turn dreams into reality for many generations to come."

And here again, Joe's personal generosity inspired others to follow in kind, including his longtime friend and business partner, Bob Tointon. With his wife Betty, Bob created the Tointon Institute for Educational Change, based at the University of Northern Colorado.

The Tointons' main goal is increasing student achievement. Like Joe, Bob and Betty emphasize the practical: through summer teaching programs, their institute provides leadership training for principals and teachers throughout Colorado's public school system. So far, the Tointon Institute has trained more than 1,300 principals and teachers. For their work, the Tointons were honored in 2015 with a CASEY Award, the top award from the Colorado Association of School Executives.

In Bob and Betty's view, our collective future here in America must be built student by student, by giving each girl and boy the skills, guidance, and self-confidence they need to succeed in school and in life. To serve that noble goal, the Tointons also started and support a dropout prevention program at two of Greeley's high schools. Thanks to their program, 80 percent of the students who were failing as freshmen went on to graduate with a high school diploma.

"I look at my own experience," Bob told *The Greeley Tribune*, "and I think that a good public education opened up The American Dream for me, and I want to see more and more young people today have that same opportunity."

Amen! And to me, what Joe, Bob, and Betty have done to advance the cause of education in America represents the highest form of leadership and community service. And it also represents a core American value, a value that I often fear we have failed to properly honor and uphold: Work hard and share; we're all in this together.

Thanks to Laurie and Lynn and Mike LaPlante, what a beautiful day we were having at CSU, and still to come was the golden

crown. Later that afternoon, to culminate our visit, Mike brought us to a quiet, tree-flanked space at one end of the main quad. And there we stood before the Danforth Chapel, an intimate place of worship and respect, of serenity and peace amid the bustle of a great university.

Inside the chapel, there was a wonderful feeling, with its orderly rows of wooden benches and that same whoosh of uplift that you feel, on a much grander scale, at Notre Dame in Paris or up under the canopy of Joe's beloved Duomo in Florence. For me, though, this was even better, and while Laurie and Lynn chatted quietly with the chaplain, I sat and watched the late afternoon sun turn the stained glass windows into a shimmering mosaic of light and color.

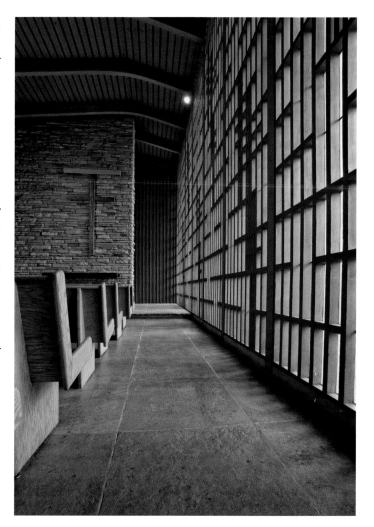

I could not imagine a more perfect place for letting my thoughts wander across the arc of Joe's life. His great grandfather leaving the farm in Ohio to join Abe Lincoln and General Sherman in the fight against slavery, and then being left for dead on the battlefield. And then Nita and Hensel, in a chapter straight out of Steinbeck, forced to leave their farm in Missouri and start all over in Colorado.

And then, on top of all that, Nita and Hensel losing their son John in a car accident while he was a student right here at CSU. It was any parent's worst nightmare; how do you ever get past a trauma like that? And what about Joe? He idolized his older brother. John, "The Deacon," as he was known around Greeley, was Joe's pal, his fishing buddy, and his own personal guide through the inevitable scrapes and bruises of growing up and becoming a man. How do you honor a brother like that? How do you keep that flame alive?

Joe's answer was just a few steps away.

Outside, along one wing of the Danforth Chapel, there was a small garden under construction. The work was not complete; the flowers had yet to bloom. But already in place was a small plaque done with a gracious touch. It read: "The John Quincy Phelps Memorial Garden. In loving memory of his brother, these sacred grounds were restored through the generosity of Joseph Phelps, '51."

Again, it was perfect. And right here you could feel Joe's spirit at work. He was honoring his brother. He was bringing final closure to what had been an unspeakable loss for his family. Nita and

Hensel were both gone now, and so were Joe's two beloved sisters, Mary and Margaret. But thanks to Joe, that Memorial Garden and John's memory would now live on for many generations to come.

What a day. After I thanked Mike, and said good-bye to Laurie and Lynn, I got on the plane and poured my thoughts and feelings into one of the notebooks that I always carry, a holdover from my many years as a reporter and foreign correspondent. As I thought and wrote, five words flowed from my pen and I put a box around them:

"The Best We Can Be."

To me, that was Joe, that was his spirit: Strive to be the very best we can be. That was what fueled his work, in construction, in wine, in education, and in everything else he sought to achieve. And as I now suddenly understood, that was also the ultimate message that Joe wanted to instill in our children and grandchildren, and in everyone else he could reach out and touch:

Dream big dreams! Blaze your own trail! And never be slowed by all the naysayers or your own inevitable fears and stumbles. To succeed in life is by no means easy, but each of us has within ourselves the power to learn and grow, to become the very best we can be, and to build our dreams into shining realities. If I can do it, so can you!

Yes, that was Joe's ultimate message, and he hoped that his own journey in life—and the lessons he had learned along the way—would give our readers both practical guidance and the deepest wells of inspiration. And there was something more that Joe believed and wanted to convey: that when dreamers and builders of skill and determination join hands in common cause and common purpose, we can move mountains. We can build up our schools and towns and communities, we can create a better future for all of us, and in the process we can help the whole of America become the very best it can be. Work hard and share; together we rise!

When I got off the plane that day and returned to the Napa Valley, I was able to see Joe in a much fuller light. At his kitchen table, Joe was always so modest, so self-effacing, but somehow seeing all that he had done at Colorado State, seeing all the seeds that he had so carefully planted, I had a much clearer sense of Joe's vision and the extent of his mission. What a guy. And as a parent myself, I could not help but admire how he had managed to instill

his values and sense of mission in his four children. Bill, Leslie, Laurie and Lynn are as personally modest as Joe was, but each in their own way they hold high the same torch. All four now serve on the board of directors of Joseph Phelps Vineyards, and Bill serves as executive chairman and company anchor. And through their winery, and this book, they are all intent on keeping Joe's flame burning long and bright.

You can see that truth for yourself with a simple visit to Joseph Phelps Vineyards. Thanks to Joe's children, the new tasting venue at their winery is both an idyllic wine country experience and a very fitting tribute to their father and what made him so special.

Physically, it is a place of beauty and quiet refinement. With help from architects Don Brandenburger and Hans Baldauf, the new tasting venue honors the original vision of Joe and John Marsh Davis and it does so in a gracious, uplifting way. To enter, you walk along a tree-lined path, with lavender and wild flowers growing in lush array, and then you come under the redwood trellis, with its lively play of light and shadow. Walk further and then opening before you is Joe's special corner of the Napa Valley. As you will recall, Joe fell in love with this spot because of "the spirit of the place," and when you see that view you will immediately understand what he meant.

Inside the winery, the feeling is one of comfort and grace, and when you know Joe's personal story, you can see reminders of Joe's past and of some of the people who helped him on his way. The entryway opens onto a great hall, and there on one wall you see a portrait of Humberto Martinez, Joe's cellar master for 35 years, and nearby is a playful photo of Alice Waters, full of energy and fire. In a front restroom is an elegant poster by David Goines, promoting Joe's Mistral wines, and enjoying a place of pride in the great hall is a sturdy wooden table; it comes from the winery's original kitchen, the starting place for so many of Joe's fabled harvest-time feasts.

There is history, too, in the wine library, with its floor-to-ceiling racks holding vintage bottles going all the way back to the start of the winery in 1973. The first Insignia, the Syrahs, the Viogniers, the house wine they crafted for Alice—it's all there. In the center of the library is a huge round table, a delightful place to taste and share, and it also serves as a reminder of Joe's belief in the guiding virtue of gathering together around the family or communal table.

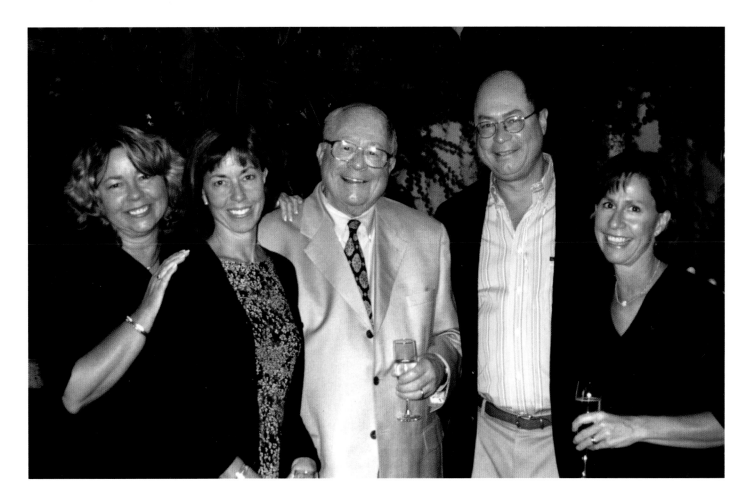

In a parallel great hall, facing the terrace, you see the big oval casks that Walter Schug ordered from Hungary and then used to craft the award-winning Gewürztraminers and Johannisberg Rieslings that did so much to launch Joe's winery and establish its reputation in the world of wine. And remember how, back in his basement in Greeley, Joe used to have his daughter Lynn soak off the labels of the wines he drank, as part of his "sip by sip" education in wine? Well, later on Joe gave up that practice and simply kept the empty bottles, and today those bottles, scores of them, line a ledge that goes all the way around this same great hall, a testament to Joe's unending education and his love of the great wines of the world.

And then there's the terrace, facing West as Joe always did, and I will say nothing more about it. Come experience it for yourself.

As you will see when you visit, Joe's children, with plenty of help from Bill's wife Andrea and others, have done what they set out to do: create one of the most enjoyable and uplifting wine tasting experiences in the whole of the Napa Valley. And in so doing, they have placed a beautiful final ribbon and bow on their father's pioneering life in construction and in wine, and on all of his contributions to the Napa Valley and to the larger cause of American taste and culture. Indeed, when you know Joe's story, spending time at the winery becomes a look-back and a celebration of how far we have come as a nation and as a culture.

JOE'S CHILDREN

Leslie, Laurie, Bill, and Lynn (L–R).

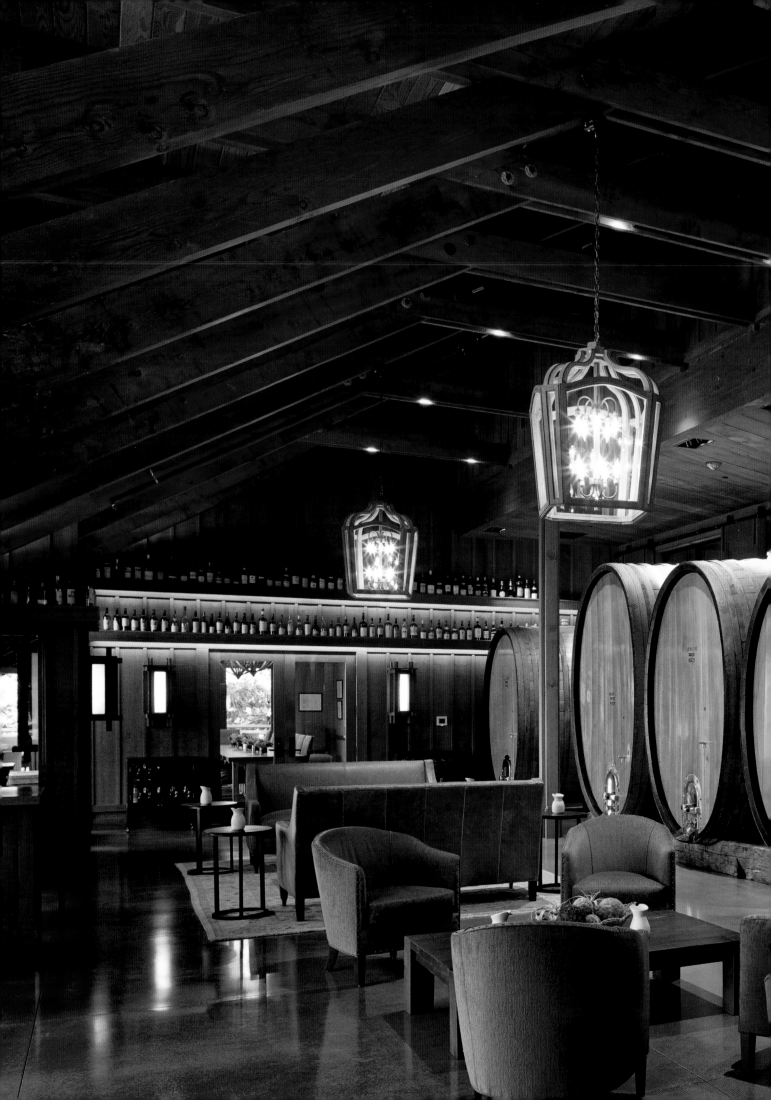

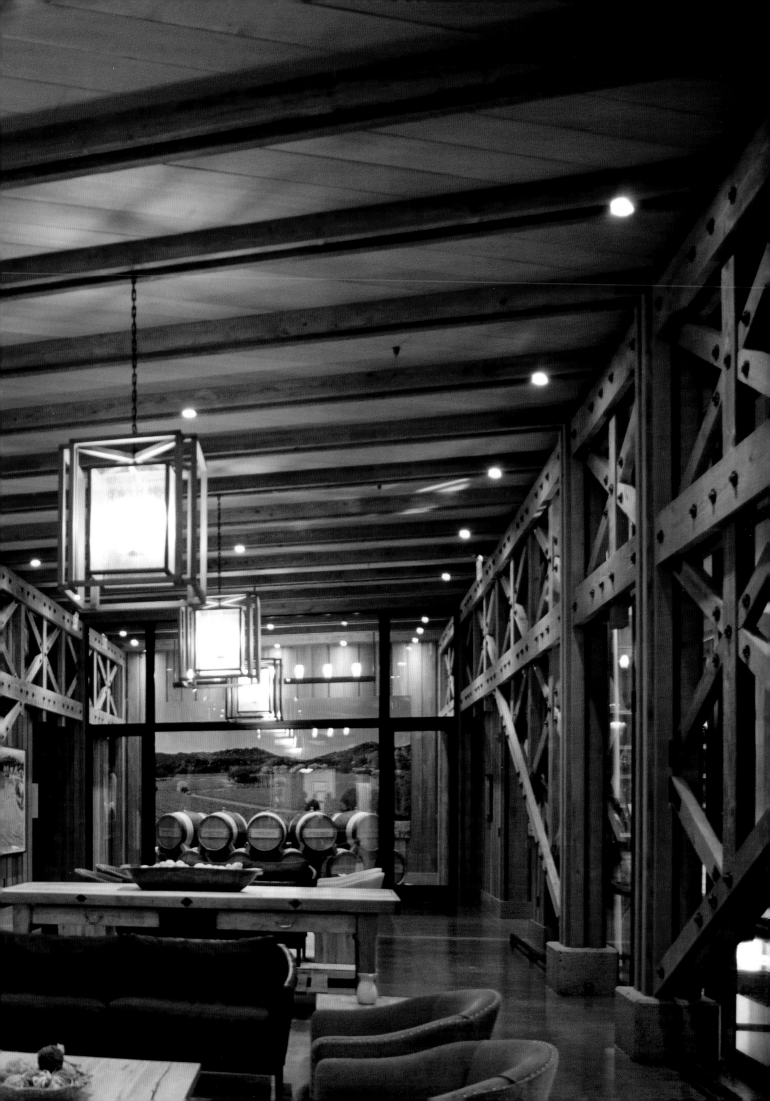

Sadly, Joe never got to see that final ribbon and bow.

Joe fell ill on a Friday, and he died the following Wednesday, on April 15th, 2015. As sad as it was, I believe Joe died as he wished to: his work was complete, and he was surrounded by the love and admiration of his children and grandchildren and by the vineyards and landscapes that had done so much to nourish and inspire him in the final phases of his life.

A short time later, a celebration of Joe's life was held at the winery, under a huge tent placed at the foot of his vineyards. In front of a large crowd of friends and well-wishers, several of Joe's friends and family paid tribute to the man, and there was also a moving video filled with photos and warm remembrances from people who had been close to Joe over the years, in Greeley and the Napa Valley.

To my mind, though, no moments were as poignant as when his granddaughter Elizabeth took the podium and spoke lovingly of her grandfather, or when Bill sat down at the piano, as he had done so many times before, and with all his heart played "Claire de Lune", honoring his father and sending him on the next legs of his journey.

Looking back now, I have one memory of Joe that I will always cherish. One afternoon when I walked into his kitchen Joe was at his usual spot at the table, in a colorful Hawaiian shirt, and he was happier than I had ever seen him. His eyes were crinkled up with joy and his smile was radiant. And immediately I understood why:

Three of his granddaughters were there with him at the table. They were fussing over him, seeking his guidance on this matter or that, and generally showering him with love and affection. He was 87 years old, and breathing through his tube, but surrounded by those beautiful young women, he was dancing inside, a man with an insatiable thirst for the thrill and romance of living life to the hilt.

Yes, that was Joe, their beloved "Seppi."

Seppi?

As I learned then and there, all of Joe's grandkids called him, with enormous feeling, "Seppi." That was short for "Giuseppe," Joe's name in Italian. And I had to laugh; how perfect was that! In a

single word, they had captured something special about Joe and what stirred his heart. In spirit, beneath his modest façade, Joe was All-American can-do. But a part of him was swaggering Italian too, a man passionate about art and architecture and creative zest, and even more than that he loved celebrating life with his family and friends, and always with good food and good wine, in the best Italian family tradition. Yes, down deep he was Seppi to the core.

I treasure the time I had with Joe, and now when I sit out on that beautiful terrace, when I feel the spirit of the place flowing into me, Joe remains very much alive. And I think you will feel that way too. And when you are there, relaxing under the umbrellas, watching the hawks soar and seeing the way the sunlight dances across his vineyards, savor Joe's Insignia, his Backus, his Pinot Noir, and all the other fine wines that he helped bring to our lips. And as you do, please take a moment to raise a grateful glass with me:

To Life!

To Seppi!

And to the enduring power and majesty of The American Dream.

WELCOME TO NAPA CO. AIRPORT

N5457A

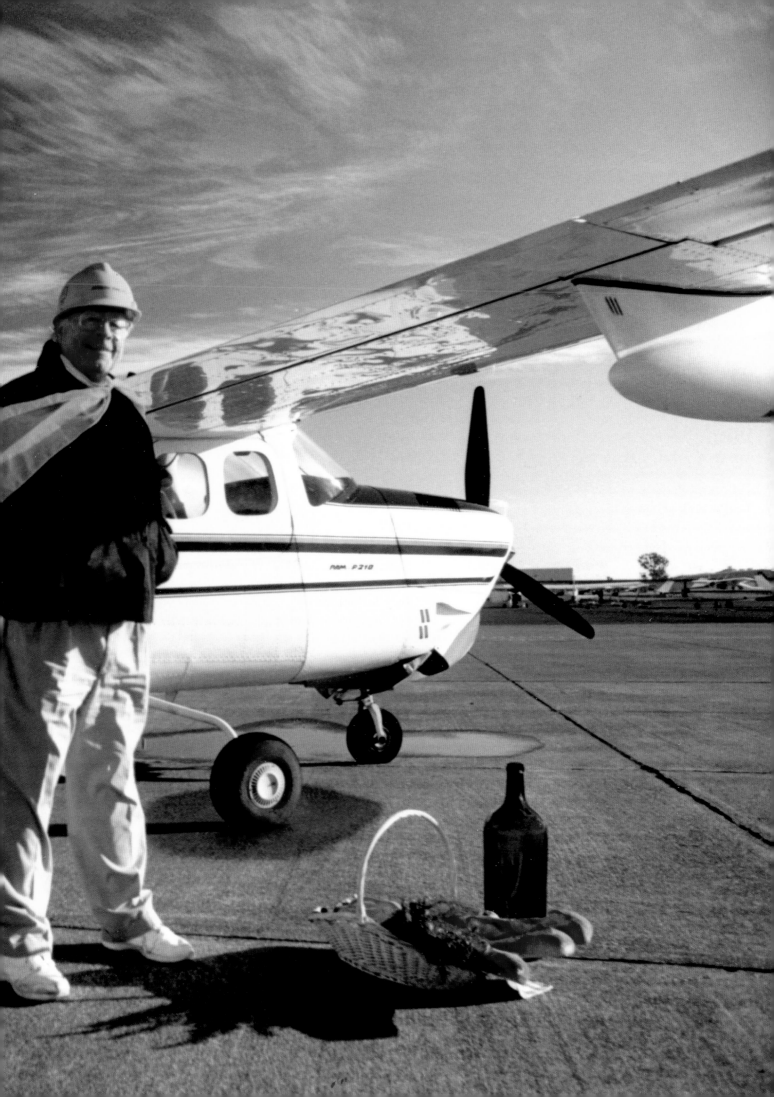

THERE IS A DESTINY THAT MAKES US BROTHERS:
NONE GOES HIS WAY ALONE:
ALL THAT WE SEND INTO THE LIVES OF OTHERS
COMES BACK INTO OUR OWN.

I CARE NOT WHAT HIS TEMPLES OR HIS CREEDS,
ONE THING HOLDS FIRM AND FAST
THAT INTO HIS FATEFUL HEAP OF DAYS AND DEEDS
THE SOUL OF A MAN IS CAST.

From "A Creed," By Edwin Markham

Some books spring forth whole from a lone writer's inspiration and expertise. Not this one. This book is the result of an extraordinary collaboration among scores of individuals seeking to honor Joe Phelps in the finest possible way.

Right here I want to pay special tribute to a few whose contributions and guidance were instrumental in making this book the very best it could be.

First, I want to thank Bob Tointon, Joe's longtime friend and partner at Hensel Phelps Construction. With infinite patience and grace, Bob helped me understand what made Joe so special and he also helped me understand the inner workings of the construction industry and how he and Joe built their company into a dynamic and innovative industry leader. Bless you, Bob!

At Hensel Phelps, I also want to thank Jeff Wenaas, the President and CEO, for his support of this project. And for their hands-on care and assistance, especially with providing us photos of HP projects, I want to salute these HP staffers: Muriel Reitz, Nancy Upchurch, and Doug Bobilya. And I want to offer a special thanks to Joe's dear friends Bob Ruyle and his late wife Lydia.

Also in Greeley, I want to thank Dyani Johnson and Katalyn Lutkin of the Greeley Museum. Their research expertise enabled us to present several important historic photos of Greeley, *The Greeley Tribune*, and more.

My thanks, too, to these individuals at Colorado State University: Dr. Albert Yates, former president of the university; Dr. Mostafa Kattab, head of the School of Construction Management; and Mike LaPlante, a director of development at the university and our resourceful CSU anchor for this book. Together they helped me understand all that Joe did for his alma mater.

At Joseph Phelps Vineyards, there are so many people who deserve a proper salute. But let me single out a few: Mitzi Inglis, director of communications, Damian Parker, Ashley Hepworth, Justin Ennis, Françoise Larum, Robert Boyd, and Sam Burton. My thanks, too, to Bob Holmes at the Wine Service Cooperative, Elaine John at The Queen of the Valley Hospital, and Steve Lundin at St. Helena Hospital. I also offer a grateful bow to Evelyne Deis, Joe's longtime personal assistant, for helping me understand Joe's special spirit and all that Joe did for the good of the Napa Valley community.

This book would not exist without the support of Joe's four children: Leslie, Bill, Laurie and Lynn. You four believed in this project and you believed in me, and I cannot thank you enough. In this same light, I want to thank my friend and fellow author Richard Mendelson. An expert on wine and Napa Valley history, Richard kindly edited this book and offered important suggestions all along the way. Just the kind of help every writer needs.

Finally, lucky me. At Val de Grace Books, I have the honor and pleasure of working with some of the most gifted specialists in American publishing. As always, photographer Matthew Klein brought us a wealth of exquisite images to help us tell the story in a vivid, compelling way. As always too, we had the expert guidance of Tom Hummel, our guru on all matters of top-quality printing and binding. How to draw all these different assets together? Here we had a master's touch: our book designer Connie Hwang. With her uncanny emotional radar and design skills, Connie was able to create a look and feel for the book that captured Joe's taste and spirit and made them visible on every single page. Somewhere, I'm sure, Joe is smiling with delight. Thank you, all!

Paul Chutkow brings a unique perspective to the life and wisdom of Joseph Phelps. Over the course of his career as an author and foreign correspondent, Paul has had the privilege of meeting and writing about a wide array of leaders, creators, and business pioneers, many of them true giants of our time.

As a correspondent in India for the Associated Press, he wrote about the rise and fall of Indira Gandhi, and about the inspirational work of Mother Teresa and her followers. In Paris, writing for the AP, *The New York Times*, and other publications, Paul wrote about the enduring legacies of Pablo Picasso and Ernest Hemingway, and about French cultural icons like The Baron Philippe de Rothschild, François Truffaut, Catherine Deneuve, and Gérard Depardieu.

Once back in America, Paul began writing books. His acclaimed biography of Gérard Depardieu was a bestseller in France, and *Kirkus Reviews* here called it "one of the finest books ever written about film acting."

Next, Paul helped Robert Mondavi write his celebrated memoir, *Harvests of Joy*, and then he wrote *Visa, The Power of an Idea*, the history of Visa and the credit card revolution. Then came *Reaching for The Stars, The Making of Constellation Brands*, how a small family-owned wine company in upstate New York built itself into an international powerhouse in wine, beer, and spirits.

On a lighter note, Paul wrote *Zelda, The Queen of Paris*, the story of a charming little street dog that Paul and his family rescued from the streets of India and took with them to Paris, Italy, and finally to California Wine Country. The subtitle says it all: "The True Story of The Luckiest Dog in The World."

Paul now makes his home in the Napa Valley, and he finds his greatest joy in working with other writers and artists and helping them realize their dreams and become the very best they can be.

Page xxii Portrait of Joseph Phelps: Jock McDonald

Page 16 Bougainvillea in bloom: Pexels Photo

Page 32 America farm scene: Ed Freeman/Getty Images

Page 46 Dust Bowl storm: John Groseclose/Getty Images

Page 49 President Roosevelt talking with farmer: Arthur Rothstein/Getty Images

Page 54 Going West: Universal Images Group/Getty Images

Page 70 Pearl Harbor Attack: Time Life Pictures/Getty Images

Page 71 General Eisenhower and Field Marshall Montgomery: Frank Scherschel/Getty Images

Page 78 The Oval: John Eisele, Colorado State University Photography

Page 100 Hand on the wheel: Cultura RM Exclusive/DUEL/ Getty Images

Page 114 Rocket lifting off: ullstein bild Dtl./Getty Images

Page 124 Worker on high: Paul Chesley/ Getty Images

Page 142 The gold protective disk on Voyagers 1 and 2, photo courtesy of Wikimedia Commons.

Page 156 Top of the Golden Gate: Alan Copson/Getty Images

Page 160 Robert Kennedy campaigning: Lawrence Schiller/Getty Images

Page 161 Rally for Dr. Martin Luther King: Jill Friedman/Getty Images

Page 162 The Happy Bus: Ted Streshinsky Photographic Archive/ Getty Images

Page 163 Stop The War: CBS Photo Archives/Getty Images

Page 172 Fiat in Italian countryside: Martyn Goddard/Getty Images

Pages 174 & 175 Michelangelo's David: piola666/Getty Images

Pages 176 & 177 The Cathedral Dome: Dave Yoder/Getty Images

Page 179 Stained glass at the Duomo: Comezora/Getty Images

Pages 180 & 181 Tuscan landscape: beppeverge/Getty Images

Page 184 Details of a door: Jill A. Bailey, at Flare of Art.

Page 187 The wall of labels: Jill A. Bailey, at Flare of Art.

Page 188 Café in Aix-en-Provence: Gary Yeowell/Getty Images

Pages 190 & 191 Flowers at outdoor market in France: Doug Pearson/ Getty Images

Pages 192 & 193 Under the gate in Aix-en-Provence: L. Valencia/ Getty Images

Page 194 Croissants fresh from the oven: Carolin Voelker/EyeEm/ Getty Images

Page 195 Fresh oysters in France: brytta/ Getty Images

Page 196 Poster for Joseph Perrier Champagne: swim inc 2 llc/ Getty Images

Page 197 Poster L'Instant Taittinger: swim inc 2 llc/Getty Images

Pages 208 & 209 Raid during Prohibition: New York Daily News Archive/Getty Images

Page 271 2013 Insignia wine label: Matt Morris

Page 320 Humberto Martinez's portrait at the winery: Bruce Damonte

Page 354 Freestone Winery: Matt Morris

Page 372 The Danforth Chapel: Joe A. Mendoza, Colorado State University Photography.